Performing
Maternities

Performance and Communities

Series editors: Jessica Moriarty and Kate Aughterson
Print ISSN: 2755-9440 | **Online ISSN:** 2755-9459

The Performance and Communities book series celebrates, challenges and researches performance in the real world. We are committed to publishing diverse texts that explore various modes of performance using voice, body, space, movement, language, sound, texture, shape in work in a variety of spaces and places (from traditional theatres to site specific playgrounds). We look to publish work that responds to social, cultural, academic and physical communities. The series will consider how contemporary performance can engage, build and learn from previous, existing, evolving and new communities of people – practitioners, academics, students, audiences.

In this series:

Storying the Self: Performance and Communities, edited by Ross Adamson and Jess Moriarty (2023)
Socially-Engaged Creative Practice: Contemporary Case Studies, edited by Jessica Moriarty and Kate Aughterson (2024)
Performing Maternities: Political, Social and Feminist Enquiry, edited by Kate Aughterson and Jess Moriarty (2024)

Performing Maternities

Political, Social and Feminist Enquiry

Kate Aughterson and Jess Moriarty

Bristol, UK / Chicago, USA

First published in the UK in 2024 by
Intellect, The Mill, Parnall Road, Fishponds, Bristol, BS16 3JG, UK

First published in the USA in 2024 by
Intellect, The University of Chicago Press, 1427 E. 60th Street,
Chicago, IL 60637, USA

Copyright © 2024 Intellect Ltd

All rights reserved. No part of this publication may be reproduced,
stored in a retrieval system or transmitted, in any form or by
any means, electronic, mechanical, photocopying, recording or
otherwise, without written permission.

A catalogue record for this book is available from
the British Library.

Copy editor: MPS Limited
Cover designer: Tanya Montefusco
Cover image: Xesai. Stock photo ID:1181897425
Production manager: Rosie Stewart (Westchester Publishing Services UK)
Typesetter: MPS Limited

Hardback Print ISBN 978-1-83595-016-6
ePDF ISBN 978-1-83595-018-0
ePUB ISBN 978-1-83595-017-3

Series and Online ISSN 2755-9440 and 2755-9459

To find out about all our publications, please visit our website.
There you can subscribe to our e-newsletter, browse or download our current
catalogue and buy any titles that are in print.

www.intellectbooks.com

This is a peer-reviewed publication.

Contents

List of Figures		vii
Introduction		1
Kate Aughterson		
1.	Maternal Performance: Relations and Embodiments	17
	Lena Šimic and Emily Underwood-Lee	
2.	Experiencing and Knowing from a Mother/Child 'Us'	32
	Ariel Moy	
3.	Still Mothering: Reflections on Life, Death, and Love through the Eyes of Bereaved Mothers	52
	Abby Arnold-Patti	
4.	Mothering in the Peripheries: An Autoethnographic Account of the Challenging Matrescence of a Neurodivergent Woman	67
	Claire Robinson	
5.	Tensions of Maternity	89
	Steve Ryder and Diana Denton	
6.	Remember Me? Creative Conversations with Clothes	108
	Jenni Cresswell	
7.	How to Tell a Tricky Story about Birth Trauma: Transforming My Lived Experience into a Mythical Epic	117
	Michelle Hall and Teresa Izzard	
8.	Rhetorical Uteri: A Comparative Visual Analysis of Next Nature Network's 'First Artificial Womb for Humans' and Ani Liu's *The Surrogacy*	136
	Yvette Chairez	

PERFORMING MATERNITIES

9. Seeds from My Grandmother's Womb 154
 Suzi Bamblett

10. Delivering across Geographies: How Faith, Age, Friends, and Space Carry Birthing 163
 Noor Ali

11. 'These Nipples Are Wasted!' 175
 Chan-hyo Jeong

12. Macomère Narratives: Mothering in Higher Education 179
 Janice B. Fournillier

13. *Bitter-Sweet Embrace*: Documentary Film of Artist-Clinician Sophia Xeros-Constantinides Presenting Her Postgraduate Fine Art Exhibition Exploring the Darker Side of Motherhood 192
 Sophia Xeros-Constantinides

14. *Comadreando*: Entangling the Web of Our Lives 207
 Freyca Calderon-Berumen and Karla O'Donald

15. Interrogating Constructions of Good/Bad Mothers through Popular Spanish Culture: The Case of Concha Piquer (1908–90) 222
 Mercedes Carbayo-Abengózar

16. Looking for Laura: The Generational Transmission of Sexuality 237
 Valerie Walkerdine

17. Maternal Bodies in the Garden: Transit Spaces 250
 Ruchika Wason Singh

Notes on Contributors 253

Figures

2.1:	Ariel Moy, *A Mother's 'I' and a Mother/Child 'Us'*, 2020. Ink and pen on paper. 29.7 cm × 21 cm. Melbourne. © Ariel Moy.	37
2.2:	Ariel Moy, *Moving between Intersubjectivities*, 2020. Ink and pen on paper. 21 cm × 29.7 cm. Melbourne. © Ariel Moy.	42
2.3:	Ariel Moy, *Velocities of Us*, 2020. Ink and pen on paper. 21 cm × 29.7 cm Melbourne. © Ariel Moy.	43
2.4:	Ariel Moy, *Making and Seeing 'Us'*, 2020. Ink and pen on paper. 21 cm × 29.7 cm. Melbourne. © Ariel Moy.	47
6.1:	Jenni Cresswell, *Three Green Dresses*, 2016. Film still.	109
6.2:	Jenni Cresswell, *The DNA Dress*, 2018. Textile.	110
6.3:	Jenni Cresswell, *The Daughter's Dresses*, 2019. Photograph superimposed over textile.	111
6.4:	Jenni Cresswell, *The Daughter's Dresses*, 2019. Photograph superimposed over textile.	111
6.5:	Jenni Cresswell, *The Daughter's Dresses*, 2019. Photograph superimposed over textile.	112
7.1:	Pregnant Clown (Hall 2022).	120
7.2:	Punk Maternity (Hall 2022).	123
7.3:	Opening scene (Hall 2022).	124
7.4:	The haunted cow (Hall 2022).	127
7.5:	Womb dreaming (Hall 2022).	130
8.1:	NNN, AW prototype, 2018. Rubber balloons, wires, wood. Droog Amsterdam. ©NNN. Photo depicts the AW as it was exhibited in a skylighted steel, concrete, and drywall room at *Reprodutopia*.	137

8.2:	*The Surrogacy (Bodies are Not Factories)*, Ani Liu, New York City, 2022. Installation view, 3D-printed polymers, 5.6 × 11.4 × 4.84 inches. ©Ani Liu.	144
9.1:	Suzi Bamblett, *Seeds from my Grandmother's Womb*, 2021. Patchwork appliqué panel.	161
11.1:	Preemie Station (Chan-hyo Jeong, 2023).	177
11.2:	Kangaroo care (Chan-hyo Jeong, 2023).	178
13.1:	*Bitter-Sweet Embrace* fine art Ph.D. exhibition. Image shows detail of Xeros-Constantinides's collage #2 *Veduta della Piazza dell'Annunziata* (2012) from the series *La Figura nella Veduta* ('The Figure in the Landscape'). Grieve & Xeros-Constantinides (2016).	193
13.2:	Coloured lithographic family heirloom print (damaged) on paper, originally owned by the artist's maternal grandmother, *Yiayia* Evdokia, showing *The Tragic Panorama of the Slaughter and Incineration of the Smyrna People*. Artist name (lower right corner) Sot. Chrizidis. Printed in Athens (post-13 September 1922) by Ekthotis K. Alikiotis, unframed size 45 cm × 61 cm (irregular). This archival print was framed and exhibited in the *Bitter-Sweet Embrace* exhibition, hung alongside Sophia's poem to her Uncle Nick entitled 'The Intergenerational Legacy: My Grandmother *Yiayia*'s Asylum-Seeker Baby'.	194
13.3:	Summary of the visual research. Grieve & Xeros-Constantinides (2016).	195
13.4:	The artist speaks about her work and inspiration in front of her print from a collage entitled *Cavort* (2010) from the *Boudoir* series. Grieve & Xeros-Constantinides (2016).	196
13.5:	Six-part drawing by Xeros-Constantinides in charcoal on paper entitled *Foundling* (2009). Grieve & Xeros-Constantinides (2016).	197
13.6:	Detail of *Natura Morta #1* (Veduta dell'Anfiteatro di Arezzo) (2011) from the collage series *Earthly Delights* by the artist. Grieve & Xeros-Constantinides (2016).	198
13.7:	Detail of *#5 Veduta della Porta S. Gallo* (2012) from the series *La Figura nella Veduta* ('The Figure in the Landscape'), collage on found printed paper bifold.	199

FIGURES

13.8: Detail of *Swoon* (2009) from the series *Occasional Images from a Birthing Chamber*, collage on paper. Grieve & Xeros-Constantinides (2016). — 200

13.9: *Succour* (2015), collage on printed paper. — 202

16.1: Remembering my youthful sexuality. — 241

16.2: My grandmother, Laura. — 244

17.1: Ruchika Wason Singh, pod of desire-I, pencil on paper, 18 cm × 27 cm, 2004. — 250

17.2: Ruchika Wason Singh, pod of desire-I, pencil on paper, 18 cm × 27 cm, 2004. — 251

17.3: Ruchika Wason Singh, womb bloom-III, pencil on paper, 69.9 cm × 105.4 cm, 2004. — 251

17.4: Ruchika Wason Singh, wishful, spaces, oil on canvas, 193.04 cm × 254 cm, 2006. — 252

17.5: Ruchika Wason Singh, womb bloom-II, pencil on paper, 69.9 cm × 105.4 cm, 2004. — 252

Introduction

Kate Aughterson

The South African performance poet Lebongang Mashile succinctly speaks about the combined internal, external, and global pressures bearing on the name, the identity, and role of 'Mama' in 'Mama's War':

> Mama's gone viral
> Mama's screen shuffles faster
> Than hashtags invented by Black women
> Who turn tech into culture daily
> Boardrooms and bedrooms are battlefields
> What's today's shareprice for Mama
> Mama's the only profitable stock
> Mama's baby is five years old, mining coltan in Congo
> Mama's foster children's root chakras never healed
> Mama's who George Floyd called out to
> When home is a dangerous place
> How does Mama lockdown?

(2022: n.pag.)

Her eloquent dissection of the intersectional differences juxtaposed with assumed cultural universals about maternal discourses and identities plays out the contradictions and pressures of contemporary maternities. As a poet and a mother, Mashile's voice scratches at the problematic: how to both be a mother and the speaker outside that identity – a performer, a poet, an artist, a writer? This question has been asked by women artists and writers for centuries – from Mary Wolstonecraft to Alice Walker, Virginia Woolf to Angela Carter, Alice Neel to Louise Bourgeois to Andi Galdi Vinko's recent *Sorry I Gave Birth Disappeared But Now I'm Back* (Vinko 2023) – the list could go on (Philips 2022). Now nearly a century old, Cyril Connolly's 'There is no more sombre enemy of good art than the pram

in the hall' (1938: 116) conjures up both the monstrous assumptions of western patriarchal models of maternity and the material reality of those assumptions and expectations.

Performing Maternities acknowledges and weaves in contemporary debates about and challenges to maternity and the maternal through fusing philosophical, critical, and creative writing and art – aiming at articulating and realizing a maternal imaginary that speaks to this upsurge of voices about valuing maternal performance and the fracturing of voice, self, and work in maternity and art in our contemporary globalized world. As Šimić and Underwood-Lee eloquently discuss in their recent book *Maternal Performance: Feminist Relations*, maternal performance can be defined by its actual and conceptual reliance on both material and ideological notions of 'others' and 'othering' (2021: 8). The body bears an-other inside it, carries its burden as self and other fused for a time, and then breaks apart that physical connectedness in birthing, brings it back in caring and nurturing, conscious simultaneously of both intersubjectivity and subjecthood.

I first discovered Adrienne Rich and her *Of Woman Born* after reading sonnets she dedicated to a woman lover, and the fact that she was also a mother blew my mind. Rich was the first person to say to me that both these desires and identities were possible and compatible, and that we could write about these with both honesty and raw joy. I was blown away then by her eloquence about the painful and powerful emotions of maternal and personal experience, by her deep scholarship about the history and culture of maternity, and converted by her nuanced feminism. When I reread her work a few months ago, those same emotions recurred: but at the same time, her ideas and insights, her advocacy for new visions and valuations of maternity and different ways in which society and culture should change and the problematic of the fractured identity of the speaking mother in a neoliberal patriarchal world are still (depressingly) present in the accounts and demands set forth in these chapters.

The chapters in this collection emerged from a conference held at the University of Brighton in the autumn of 2020, a long-planned event which, like many in that year and 2021, had to be held online. It was an emotional and traumatic time for many – my own mother had died only six weeks previously after a rapid illness, and for myself and many attendees, the processing of the personal and collective grief and pain of our post-COVID selves was mingled with the laughter and joy of sharing maternally performed stories. The conference produced many rich conversations and performances[1] – but looking back, what struck us was how many were and are richly informed by both the theoretical and creative work of those women who are now seen as founders of an interdisciplinary academic movement – variously known as 'motherhood studies' and 'maternal studies'[2] which first emerged in the 1980s

and early 1990s – writers such as Adrienne Rich, bell hooks, Gloria Anzaldua, Marianne Hirsch, Patricia Hill Collins, Shari Thurer, Nancy Chodorow, Dorothy Dinnerstein, and Susan Maushart. In the very changed world of TikTok, #MeToo, Insta-mums, global twitter debates, and pop-up political activism, this return to the grandmothers of a movement is an inclusive and necessary part of notions of a shared (but often forgotten) history of performing maternities. The 'maternal turn' which Šimić and Underwood-Lee (2021) celebrate is at least 40 years old.

What do we mean by 'maternities'? Throughout this book writers use the terms associated with maternity in a number of differing ways: the experience of birthing; parenting; the continued identity we might have after we have finished that initial parenting; the metaphors we associate with cultural and ideological values associated with caring and/or with the physical act of bearing children; the ethics of 'interruption' and caring (Baraitser 2008) which more broadly infuse our social and emotional lives. Throughout we as editors have aimed to be inclusive, using, for example, Stephens's (2011) adaptation of Ruddick's theory of 'maternal thinking' (1989: 134) as degendered – so that the maternal is transposed to mean any kind of 'preservative love' including 'the needs and pleasures of any animal or plant' (1989: 36). As Dally argued, and this continues to be true: 'There have always been mothers, but motherhood was invented' (1983: 17). Our world of birth mothers, egg-mothers, adoptive mothers, lesbian mothers, queer mothers, trans mothers, foster mothers, grandmothers, great-grandmothers, mothers without children, mothers with students, othermothers has been transformed by a combination of technology and social change – we have extended the term maternal to mean so much more than a bearing and nurturing body – and a good thing too. Yet as Snitow explains – if we do not acknowledge the embodiment, the physical experience of the maternal, we also lose something material:

> We give up something, a special privilege wound up in the culture-laden word 'mother' which we will not instantly regain in the form of freedom and power. We're talking about a slow process of change when we talk about motherhood; we're talking about social divisions which are still fundamental. Giving up the exclusivity of motherhood is bound to feel to many like loss.
>
> (1992: 13)

Rothman's deconstruction of the ideology of western mothering's ideologies as core to a globalized, postcolonial world ('an ideology of patriarchy; an ideology of technology; and an ideology of capitalism' [1994: 139]) opens up possibilities of semantic inclusivity (mothers and fathers can mother), while Hansen's (1997) dissociation of the term 'mother' from the body or even action of birthing fully

places mothering as a performative social act (as the chapters by Creswell, Ryder and Denton and Fournillier here suggest).

Rich's *Of Woman Born* was a radical intervention in 1976, born out of second-wave feminism and radical lesbianism. Her intervention was two-fold, one intellectual and one methodological – and it is both of these approaches that have ensured her ongoing influence and her radical future-looking model. The first was an analysis of ideas and terminology surrounding motherhood, making a conceptual distinction between three semantic and experiential understandings of 'motherhood': as an experience or role; as an institution and ideology; and as an identity or subjectivity. Yet her second innovation was equally significant and crucial for the questions this book asks about creativity – she chose to write in a style that intermixed philosophy, poetry, diary reflections and quotations, conventional historical writing, and literary criticism. This intermixed style was immediately immersive for the reader and stood apart from any history or literary criticism I had read before 1982. In our view, it was both these radical innovations – the conceptual and the methodological as practice – that make Rich still so relevant in today's sphere of maternal writing, where this intermixing of style, experience, and poetics forms the basis of works such as Maggie Nelson's *The Argonauts*, Rachel Epp Buller's *Inappropriate Bodies* (2019), Sarah Knott's *Mother Is a Verb*, as well as the work of Šimić and Underwood-Lee (2021) and Marchevska and Walkerdine (2019) – some of whom write new work for this collection. Rich's implicit plea was to find another language, another form that might speak alternative truths about and from outside the patriarchal constructions of the maternal. Such a mode and language can express that otherness in ways that make us stop and think – creativity and juxtapositioning of style, image, and communication disturbs our ways of thinking normatively and conventionally – and that make us ask questions about what our assumptions about identity (and maternity) are. This is a profound originating source for the concept of 'performing maternity' – Rich's analytic separation of social roles, ideology, and personal experience which is echoed in her creatively/critically fused writing – that foreshadows but does not explicitly articulate Butler's theory of performing identity in *Gender Trouble* (1990). While some triumphalist neoliberals claimed we were in a 'postmaternal' age at the turn of the century (Stephens 2011; Fanin and Perrier 2018), the revived inclusive discussion of the notion of the maternal and its associated words and ideologies seems alive and politically active (see Klein 2019, for example).

Key conceptualizations about motherhood and maternity which continue to resonate, be rediscovered, and feel current include Hill Collins's inclusive and communitarian notion of 'othermothers' (1994); bell hooks's celebration of 'homeplace' (1990) as a space for radical action and agency; Chodorow's 'reproduction of mothering' (1990) to theorize mother's place in a capitalist world; Ruddick's idea of

'maternal thinking' (1989) to ground a philosophical and potentially non-gendered subjectivity; Thurer's deconstruction of the myths of the good/bad mother (1995); Maushart's 'mask of motherhood's Althusserian take on imposed and acquired identities (1991); Juffer's notion of the mother as domestic intellectual (2006); and Anzaldua's 'borderzone' (1987, 2012) as space where ambiguities of experience, identity, and language might reside and speak, all continue to inform contemporary writings on motherhood. Even a brief survey of recent work illustrates this continued legacy and life; for example, the opening of O'Reilly's mistressful survey of maternal thinking (2021); Stephens's spirited confrontation of the ideologies of 'postmaternal thinking' (2011); Rose's fluid and passionate personal account of the subjectivities of maternal experiences (2019); and Fanin and Perrier's reminder to acknowledge the continuity of our feminist histories of conceptualizing the maternal (2018) are communal testaments to the power of those past knowledges and ways of finding to speak differently, non-patriarchally about those experiences.

Perhaps the reason we return to these particular authors – hooks, Anzaldua, Rich, Hill Collins, Maushart – is that they were often outliers to second-wave feminism and wrote from outside the structures and places of normative compulsory white European maternity? As black, queer, lesbian, single women, they articulated a standpoint that seems prescient to our contemporary intersectional sense of feminism. Their versions of maternal identity and agency were culturally complex and rich, spanned history and borders, acknowledged the power of oral and folk history in the daily lives of mothers and othermothers (queer and straight), as well as more fluid senses of how a maternal body might provide a model for intersubjectivity in contradistinction to the autonomous subject of late capitalism – a fluidity which has also informed the emergence of practices and concepts of trans-parenting.

How and what then is *performing* maternity(ies)?

Implicit in our title *Performing Maternities* is a four-fold acknowledgement of the intersections between performing and maternity/ies: first, of these foremothers who showed us how the analytic account of motherhood within patriarchal structures and discourses enabled us to see those roles and identities as socialized identities to be challenged and deconstructed; secondly that maternal subjectivities cross and are inflected by genders, sexualities, differing abilities, ethnicities, cultures, and histories – are plural as well as subjective; thirdly that the 'metaphor' of performance also acknowledges and valorizes a-doing, a practice of maternity; and finally that in making such performances self-conscious – whether through public formal performances (on stage, media, film, screens) or informal in our own sense of our own identities and practices as mothering – we are playing out Rich's plea to enhance maternal agency through self-conscious 'empowerment and political activism'.[3]

What seems like a postmodern notion (performing maternity) can be traced back through our foremothers and grandmothers: Simone de Beauvoir's *The Second Sex*'s rallying cry 'one is not born, but rather becomes woman' ([1948] 2011: 330) fuelled the feminist theorization of gender as constructed – emphasizing the generic identity of 'woman' in the absence of the concrete article before the noun ('woman', not 'a woman') and equally inspired Butler's (1990) work on performing gender. de Beauvoir's concept of the socialized construction of identity also 'queoried' the maternal: 'It is as Mother that the woman was held in awe; through motherhood she has to be transfigured and subjugated' ([1948] 2011: 225), encapsulating simultaneously the west's reverence for the fructive and creative power of a birth-bearing birth-creating body and the simultaneous oppression of that insight and body through the institution, economies, and structures of patriarchy, religion, and capitalism. Jacqueline Rose's *Mothers: An Essay on Love and Cruelty* opens 70 years later with an echoed plea:

> [M]otherhood is, in Western discourse, the place in our culture where we lodge, or rather bury, the reality of our own conflicts, of what it means to be fully human. It is the ultimate scapegoat for our personal and political failings, for everything that is wrong with the world, which it becomes the task – unrealisable, of course – of mothers to repair.
>
> (2018: 1)

There have been five (interrelated) strands in developing a critical perspective on performing identities: anthropological accounts of play as a natural human characteristic; (feminist) literary theory influenced by structuralism and post-structuralism; psychoanalytic theory about human identity, behaviour, and trauma; Critical Race Theory which uses concepts such as 'passing' and 'masks' as metaphors for the subjected ways in which non-white people have and do live in a society where power is predominantly white (see hooks, Hill Collins, Anderson, Anzaldua); and queer and trans theory, which is indebted to all of these.[4] These critical-theoretical positionings implicitly inform all the chapters in this collection – which take such theorizing into the realm of creative practice.

Models of thinking about maternity and performance can liberate parents from the ideological pressures of maternity and parental roles. Maushart's critical argument about 'masks' is flipped on its head when she suggests that stories and storying might be appropriated as liberating tools:

> If a society existed in which the way of the mother were the norm, tales of mothers would predominate the way tales of heroes do in cultures throughout the world.
>
> (Rabuzzi 1988: 63)

INTRODUCTION

Yet the way of the mother *is* the norm, and that's the infuriating part. This heroic journey, this steepest of learning curves, this drama of birth and rebirth – whatever fine metaphors we choose to dress it up in, the processes entailed in mothering children lie at the very cores of what it is to be human. The fact that it needs saying at all is quite remarkable. And enormously revealing. Like a superior athlete or (to use a more appropriate metaphor) a gifted actor, we make it all look so easy. So that instead of being seen as something we do, the work of mothering is something we are: the dancer become the dance.

(Rabuzzi 1988: 280)

The critical intersections of sociology, psychoanalysis, linguistic and literary myth analysis in Maus's work on 'masks' illustrates how the maternal crosses over many aspects of human experience and identity: but it is arguably in stories – and the performance and reperformance of stories – that we can 'tell' (simultaneously narrate, count, and measure) the doing of motherhood. Just as Adrienne Rich wove her personal stories through with historical and sociological ones, so does Paula Caplan (2000) who explicitly address cultural assumptions of blaming mother for social/personal ills through her use of creative play text of her own dramas to illustrate and intersect with theoretical performative notions in her play *Call Me Crazy*. This rich tradition – rich in sources, impact, and intent – informs much of the work in this collection.

The following chapters both build on and create anew debates about maternal performance. For example, Šimić and Underwood-Lee (Chapter 1) use epistolary writing to challenge the binary between critical/creative, public/private, self/other, reader/writer, performance/audience as an explicitly political act. In particular, they see this emergence into the public sphere as a performance: '[I]t is in the retelling that performance becomes a public act' simultaneously leaving open the question of the risk of making the maternal public. Their epistolary form enables the audience to problematize both private and the public:

I wonder about the danger in bringing the maternal out beyond our rarefied spaces. Is that the truly transgressive and resistant potential of maternal art? [...] Performances are not things but a kind of intervention into the world, a provocation that makes a difference, creates a new vision, a new narrative, upsets the flow. The maternal performances we write about affect as well as create new thoughts.

(20)

Baraitser (2008) develops a notion of 'interruptive ethics' to describe both the material experience of parental identity and the kind of art and writing that might emerge alongside it – fractured, juxtapositional, multivoiced, and multitonal – perhaps

the equivalent of Cixous's 'white ink' (Cixous 2008) – a formal, linguistic, and aesthetic expression of the 'other' experiences of maternal life. Moy's account of postpartum depression (Chapter 2) uses her personal trauma as the route into knowledge about a 'radical' intersubjective identity through a combination of drawings and critical theory and shows that performative creative practice enables a radical maternally based knowledge about the self as non-unitary and intersubjective. Through the notion of 'holding' she posits a new subjectivity of 'us' – a perception through her artistic practice that echoes philosophical accounts of maternal intersubjectivity and maternal thinking as well as those linking this philosophy to arts-based practice (Ruddick 1987; Marchevska and Walkerdine 2021; Ettinger 2007; Baraitser 2007). Her exploration of a mother/son relationship in terms of intersubjectivity, and 'through a non-attachment lens', nuances and explores ways in which future masculinities might emerge from creative and philosophical acknowledgements of the fluid intersubjective spaces of 'us':

> [T]he 'us' that has emerged from my artmaking and those of others unfolds a new terrain of exploration, one that asks mothers what it is like to perform an identity that is larger than the 'I'; a performance of two.
>
> (Moy, 48)

Autoethnography is a key methodological strand within contemporary arts practice research and echoes the methodology writers from de Beauvoir and Rich onwards have discovered as a way of crossing boundaries between self and other, private and public, the felt and the known. Lackey (Chapter 3) reflects on their own experience of stillbirth and the questions this raised for her about what motherhood means. She asks:

> [W]hat does it mean to mother when there is no child to mother, what does it mean to mother a memory, and how do mothers exist and perform motherhood within the tensions of remembering, forgetting, and continuing to live without their children as time passes?
>
> (52)

For Lackey, autoethnography helps weave her story into that of other bereaved mothers with whom she has worked, to remind and remember how loss and grief and trauma are part of the maternal story and experience. By using autoethnographic methods (as do O'Neil; Robinson; Ryder and Denton; Cresswell; and Bamblett in this collection), and through their punning adverbial title ('still mothering'), Lackey suggests that the 'performing maternity' model can be applied to

INTRODUCTION

anyone who functions in/as a caring role at any point in their lifecycle. We are never not mothers – and her layered writing performs that task for us all.

Maushart's (1991) work on the mask of motherhood informs Robinson's account (Chapter 4) of their own experience of a late neurodivergence diagnosis in conjunction with her mothering experience. Robinson uses autoethnography to problematize and expose how 'masks' of expected identities are both enabling and destructive. Like Ettinger's (2005) concept of 'matrixial space', she advocates the time and space of the maternal as one to be reconceptualized by acknowledging 'matrescence' as an 'experience of dis-orientation and re-orientation […] in multiple domains', including the physical, psychological, social, and spiritual … it evokes a sense of becoming or unfolding over a period of normative adaptation (71). Robinson uses Athan (2020) to argue for reproductive identity as a 'life transition marked by disequilibrium and adaptation along with an opportunity for greater psychological integration and self-awareness akin to post-traumatic growth' (71). In using notions of transitional spaces and times and focusing on the pressures for and of 'performing maternity', Robinson shows how the maternal can be more inclusive of different models of identity and subjectivity. In using autoethnography theory and practice, she shows materially how cultural norms can be challenged by writing and art – performing maternities both deconstructs the norm and reveal alternatives: '[T]he pressure to perform is keenly felt by disabled mothers and mothers of disabled children, who experience guilt and self-blame over their perceived inadequate mothering' (80).

Ryder and Denton (Chapter 5) explicitly show how having to conform to 'the performance of maternity' can be mutually challenged by co-writing as queer son and feminist mother in dialogue. They deconstruct the 'masks' and conventions of maternity through performative and rememorying inquiry. The nature of this autoethnographic enterprise demands an innovative methodology – performative enquiry – and enquiry enhanced and deepened by the choral repetitions of both authors. Writing and reading in a collaged patchwork of letters, prose, poems, and diary entries become part of the process and space of multiple performances of the maternal, and the reading experience echoes that interruptive enquiry.

Cresswell's work (Chapter 6) uses the physical touch, feel, and representation of clothes as a way of accessing and creating memories: as an artist who is not a birth mother, she creates a 'real/not real' daughter through clothes, arguing that the emotions and intensities of maternal identity can be accessed and traversed by women not able to bear children. Like Walkerdine (Chapter 15), Cresswell proposes that the performance of identity through objects enables more inclusive and nuanced versions of the maternal to emerge. Epp Buller's (2019) work on using art and performance to both destabilize conventional models of the maternal and

simultaneously to make them more inclusive has influenced many of the writers for this book. A new version of the 'maternal imaginary' (Jacobus 1995) enables a freeing of identities.

Michelle Hall and Teresa Izzard similarly argue that they are 'repurposing maternal narratives' (Chapter 7) by using a pregnant clown in a carnivalesque unveiling of some of the traumas of birth experiences re-enacted on stage. Like the Irigarayean model of mimicry and the Butlerian of repetition as consciousness, Hall invents a 'punk maternity' parodying the yummy mummy image and identity through 'in-yer-face' theatrical performance theory and practice. By using the age-old metaphor of conception and birthing to describe (much longer) creative processes of both parenting and artmaking, she asserts and break a connection between 'maternity' and 'creativity'. The formal circularity of her writing re-enacts their past (and past notions of identity) at a number of levels – diary/retelling/performance description. In the process, 're-enact'ing becomes a process of knowing, accommodating, reimagining, experiencing. Similarly, by appropriating the Persephone/Demeter myth, they actively address a cultural and historical 'matrophobia' through performance as direct action.

Chairez (Chapter 8) analyses a model of the world's first artificial womb and the accompanying publicity around it to consider how we assess and think about bodies, birthing, and creativity. She shows how the rhetoric surrounding the medical invention still grounds the experience in masculinized sci-fi notions of future birth as a clinical experience removed from the mess of biology. She then asks the question, does the philosophy and practice of the post-human actually eliminate women? This is a reminder that there are some aspects of a non-binary and inclusive version of the maternal which does not address the very real stories and experiences of women who give birth and their physical and material experiences.

Bamblett's resonant story (Chapter 9) of three generations of women's experience of the maternal interweaves the voices of three women – grandmother, mother, and daughter. It uses literary devises, moving from first to third person and incorporating time changes over a 60-year period from 1953 to 2011. She interweaves the personal and the statistical, the immediacy of the first person with the distancing of the factual, to remind and immerse readers in the material experiences of loss, creation, and renewal.

In some ways, Ali's story (Chapter 10) echoes this reminder that stories anchored in time, space, and experience are key ways of mapping an inclusive story of maternity. At the same time, she shows how that personal experience differed in three different countries, where culture, religion, and science all thought about the maternal and birthing very differently. Filtered through her own experience, this gives a rich authenticity to the way a self-conscious performance of identity is dependent on context and culture.

Jeong's comically immersive chapter (Chapter 11) takes the reader through the maternal/parental experience of bonding with a premature baby through the focalization on breastfeeding as an ultimately false signifier of the maternal experience while simultaneously showing the guilt-tripped grief many women feel at not meeting or performing this expected 'norm' of the maternal. Through comedy and self-deprecation, Jeong performs the anti-story to dominant versions of the maternal experience.

Fournillier (Chapter 12) appropriates the status and name of 'mother' to describe her Caribbean feminist relationship to her students and to pedagogy. By suggesting that teaching is a form of caring and mothering, she radically destabilizes both notions of the teacher and notions of the mother – taking us back to the work of hooks (1990) and Juffer (2006). In her incorporation of multiple voices, she traverses formal boundaries of academic and creative writing, as she argues does the role of teacher and mother in traversing private/public boundaries of self and other. Form and philosophy, aesthetic and pedagogy mutually interact and intersect.

Xeros-Constantinides (Chapter 13) provides a link to her fourteen-minute documentary film which readers are asked to view alongside her commentary and some stills, linking their own experience as a clinician with memories and the history of her refugee grandmother's childbearing and losses. In doing so she moves between ideological analyses of the 'masks' of maternity into material images of the 'cost' of maternal labour on individuals, historical, and contemporary through showing bodies as undone and lost. Maternal labour has concrete history and hauntings through remembering past experiences as (part of) present performance.

Abengozar (Chapter 15) uses Spanish popular music to show how the 1980s intensive motherhood movement replicated conventional patriarchal notions of femininity, specifically under a patriarchal dictatorship (General Franco in Spain):

> However, history demonstrates that the transition to motherhood is not necessarily driven by an innate maternal instinct, and the emergence of motherhood studies as a unique and interdisciplinary field of inquiry has highlighted the significance of social and cultural (particularly religious) forces in shaping notions of mothering. Concepts of good and bad motherhood have been understood as patriarchal constructions.
>
> (227)

Calerdon-Berumen and O'Donald (Chapter 15) use Critical Race Theory and 'duoethnography' (a disruption of metanarratives) and 'conocimiento' (Anzaldua 2013) in their concept of 'comadreando' to show through their communication between women friends on matters of personal relevance – gossip – a reworking of intersubjective relations. The authors cleverly note that their practice is

a rereading/rewriting of the 'madre' perhaps buried in the 'comrade'. They use non-standard fonts, two languages (English and Spanish), and layout for their dialogue to show the ways in which silence can be worked to politicize speech, identity, and language. This self-named 'queer' practice draws attention to the intersection between their personal politics and performative practice in writing, teaching, and performing, as well as suggesting this might lead to more inclusive practices of performative maternity:

> Duoethnography, by being polyvocal, challenges and potentially disrupts the metanarrative of self at the personal level by questioning held beliefs. By juxtaposing the solitary voice of an autoethnographer with the voice of an Other, neither person can claim dominance or universal truth.
>
> (218)

Similarly, Walkerdine (Chapter 16) uses Ettinger (2005) and Hirsch (1989) as conceptual inspirations to reimage and reconceptualize her own relationship to family maternal history through the use of photographs, embodied re-enactment, and reflection. Thus, she experiments with the visceral transmission of affect, making the performative historical and affective. She expands Ettinger's 'matrixial borderspace' to encompass affective connections we can make across time with our maternal foremothers as a radical way of rewriting, reimage(in)ing, reconceiving patriarchal histories – where inter/trans-subjective identities intersect, a concept which arguably enables us to read many of the artistic productions in this collection.

Ruchika Wason Singh's richly evocative artwork emerging from her conceptual and physical weaving of maternity, creating, and gardening in an eco-maternal aesthetic deservedly sits as our journey's finale (Chapter 17). Wason Singh's work resonates internationally and locally and allows the viewer/reader to contemplate simultaneously the familiarity and the otherness of ours and others' bodies in the world.

Many of the chapters in this collection remember and name maternal experiences and memories as integral to human identity and experience. If we are not mothers (in its most inclusive senses), we once had – happily, perhaps, still have – a mother (in the same senses). These chapters are a current upsurge of the radical domestic build on the past 40 years of writing and thinking and help us define and find new communities and transgressive models of using the maternal as ways to change our world. When my mother died in 2020, my children astonished me with their wisdom and care – a standpoint they have learned from her, indirectly through me, and her mother and grandmothers. Her death gave them adult life. Andrea O'Reilly presents mothering as 'an explicitly and profoundly political-social practice, transformative and transgressive' (2006: 13), and as

INTRODUCTION

Stephens (2011) and Fannin and Perrier (2019) argue, the notion that we are in a 'postmaternal' world is as dangerous and as laughable as the notion that we are in a post-feminist one. The 'matrixial borderspace' is the utopian, creative, inclusive, supportive, caring, well-resourced, and socially constructive space of all of us othermothers and mothers whose collective voices, stories, and actions help us all survive. Phyllis Chesler radically articulated the 'otherness' and cultural erasure of motherhood and maternity in 1981, which demands we keep telling and performing these stories:

> [P]regnancy and childbirth are savage tests of your ability to survive the wilderness alone. And to keep quiet about what you've seen. Whether you're accepted back depends on your ability to learn without any confirmation that you've undergone a rite of passage.
>
> (1981: 286)

Let these stories show that survival in the wilderness and then the stories and knowledge this brings are skills all our mothers are bringing to the rest of the (male)stream world as acts of transformation – social, technological, economic – a view shared by so much of the recent work on maternal creativity and maternal thinking (see Shiva 2020; Marchevska and Walkerdine 2019; Šimić and Underwood-Lee 2021; Epp Buller 2019; Knott 2021). As Naomi Campbell's recent photography for the cover of *Vogue* (March 2022) shows, the maternal imagery and imaginary can be powerful for everyone[5] (accessed 4 December 2023) – and this collection of different versions and problematizations of that imaginary reverberates into that future.

NOTES

1. Those specifically relating to experience during 2019 and 2020 have been published in two specially themed COVID-19 edition of the journal *Performance and Ethos* (2022 and 2023); others feature in this publication.
2. See O'Reilly's lucid account of the development of this movement (2019: 1–3). Those 'foundational' mothers were: Rich (1976), Badinter (1981), hooks (1981), Hirsch (1989), Ruddick (1980, 1989) in the 1980s, and Hill Collins (1994), Thurer (1995), Maushart (1997) in the 1990s.
3. Green (2011: 31), as O'Reilly (2019: 2) acknowledges.
4. For accounts of the field more generally, see Demetriades (2005: 1–19); Barkataki-Ruscheweyh and Lauser (2013: 189–97); Sikes (2007); Borthelo and Ramos (2013).
5. https://www.vogue.co.uk/fashion/article/naomi-campbell-british-vogue-interview. Accessed 12 December 2023.

REFERENCES

Anzaldua, Gloria ([1987] 2012), *Borderlands/La Frontera: The New Mestiza*, San Francisco, CA: Aunt Lute Books.

Athan, Aurélie (2020), 'Reproductive identity: An emerging concept', *American Psychologist*, 75:4, pp. 445–56.

Baraitser, Lisa (2008), *Maternal Encounters: The Ethics of Interruption*, New York and London: Routledge.

Barkataki-Ruscheweyh Meenaxi and Lauser, Andrea (2013), 'Performing identity politics and culture in Northeast India and beyond', *Asian Ethnology*, 72, pp. 189–97.

Borthelo, Teresa and Ramos, Iolanda (2013), *Performing Identities and Utopias of Belonging*, Newcastle upon Tyne: Cambridge Scholars.

Butler, Judith (1990), *Gender Trouble: Feminism and the Subversion of Identity*, New York and London: Routledge.

Caplan, Paula J. (1989), *Don't Blame Mother: Mending the Mother-Daughter Relationship*. New York: Harper & Row.

Chodorow, Nancy (1999), *The Reproduction of Mothering: Psychoanalysis and the Sociology of Gender*, 2nd ed., Berkeley, CA: University of California Press.

Cixous, Helene (2008), *White Ink: Interviews of Sex, Texts and Politics*, New York: Columbia University Press.

Connelly, Cyril (1938), *Enemies of Promise*, London: Andre Deutsch.

Dally, Ann (1983), *Inventing Motherhood: The Consequences of an Ideal*, Tel Aviv: Shocken Books.

de Beauvoir, Simone ([1948] 2011), *The Second Sex* (trans. C. Borde), London: Vintage Books.

Demetriades, Greg (2005), *Performing Identity/Performing Culture: Hip Hop as Text, Identity and Lived Practice*, New York and London: Routledge.

Epp Buller, Rachel (2019), *Inappropriate Bodies: Art, Design and Maternity*, Ontario: Demeter Press.

Ettinger, Bracha (2005), *The Matrixial Borderspace*, Minneapolis, MN: University of Minnesota Press.

Fanin, Maria and Perrier, Maud (2018), *Reconfiguring the Postmaternal: Feminist Responses to the Forgetting of Motherhood*, New York and London: Routledge.

Green, Fiona Joy (2011), *Practicing Feminist Mothering*, Winnipeg: ARP Books.

Hansen, Elaine Tuttle (1997), *Mother without Child: Contemporary Fiction and the Crisis of Motherhood*, Berkeley, CA: University of California Press.

Hill Collins, Patricia (1994), 'Shifting the centre: Race, class and feminist theory', in E. N. Glen, G. Chang and L. R. Forcey (eds), *Mothering: Ideology, Experience and Agency*, New York and London: Routledge, pp. 45–66.

Hirsch, Marianne (1989), *The Mother/Daughter Plot: Narrative, Psychoanalysis, Feminism*, Bloomington, IN: Indiana University Press.

hooks, bell ([1990] 2014), *Yearning: Race, Gender and Cultural Politics*, New York: South End Press.

INTRODUCTION

Iragaray, Luce (1981), *This Sex Which Is Not One* (trans. C. Porter), Ithaca, NY: Cornell University Press.

Jacobus, Mary (1995), *First Things: The Maternal Imaginary in Literature, Art and Psychoanalysis*, New York and London: Routledge.

Juffer, Jane (2006), *Single Mother: The Emergence of the Domestic Intellectual*, New York: New York University Press.

Klein, Jennie (2019), 'The mother without child/the child without mother: Miriam Schaer's interrogation of maternal ideology', in R. Epp Buller (ed.), *Inappropriate Bodies: Art, Design and Maternity*, Bradford: Demeter Press, pp. 71–90.

Knott, Sarah (2021), *Mother is a Verb: An Unconventional History*, London: Sarah Crichton Books.

Kristeva, Julia (2014, 'Stabat mater', *Poetics Today*, 6:1&2, pp. 133–52.

Marchevska, Elena and Walkerdine, Valerie (2021), *The Maternal in Creative Work: Intergenerational Discussions on Motherhood and Art*, New York and London: Routledge

Mashile, Lebongang (2022), 'Mama's war', *The Guardian*, 16 February, https://www.theguardian.com/lifeandstyle/2022/feb/16/living-in-a-womans-body-mamas-war-an-original-poem. Accessed 4 December 2023.

Maushart, Susan (1991), *The Mask of Motherhood: How Becoming a Mother Changes Everything and We Pretend It Doesn't*, Harmondsworth: Penguin.

Morales, Helen (2020), *Antigone Rising: The Power of Ancient Myths*, San Francisco, CA: Bold Type Books.

Nelson, Maggie (2016), *The Argonauts*, New York and London: Melvile House.

O'Reilly, Andrea (2006), *Rocking the Cradle: Thoughts on Motherhood, Feminism and Empowered Mothering*, Ontario: Demeter Press.

O'Reilly, Andrea (2009), *Maternal Thinking: Philosophy, Politics, Practice*, Ontario: Demeter Press.

O'Reilly, Andrea ([2007] 2021), *Maternal Theory: Essential Readings*, 1st ed., 2nd ed., Ontario: Demeter Press.

Phliips, Julie (2022), *The Baby on the Fire Escape: Creativity, Motherhood and the Mind-Baby Problem*, New York: Norton.

Rabuzzi, Kathryn Allen (1988), *Motherself: A Mythic Analysis of Motherhood*, Bloomington, IN: Indiana University Press.

Rich, Adrienne (1976), *Of Woman Born: Motherhood as Experience and Institution*, New York: W.W. Norton.

Rose, Jacqueline (2019), *Mothers: An Essay on Love and Cruelty*, London: Faber.

Rothman, Barbara Katz (1994), 'Beyond mothers and fathers: Ideology in a patriarchal society', in E. N. Glenn (ed.), *Mothering: Ideology, Experience and Agency*, London and New York: Routledge, pp. 139–57.

Ruddick, Sara (1989), *Maternal Thinking: Towards a Politics of Peace*, Boston, MA: Beacon Press.

Sikes, Alan (2007), *Representation from Versailles to the Present: The Performing Subject*, New York: Palgrave Macmillan

Šimić, Lena and Underwood-Lee, Emily (2021), *Maternal Performance: Feminist Relations*, New York and London: Palgrave.

Shiva, Vandana (2020), *Reclaiming the Commons; Biodiversity, Traditional Knowledge and the Rights of the Mother*, Santa Fe: Synergetic Press.

Snitow, Ann (1992), 'Feminism and motherhood: An American reading', *Feminist Review*, 40, pp. 32–51.

Stephens, Julie (2011), *Confronting Postmaternal Thinking*, New York: Columbia University Press.

Thurer, Shari (1995), *The Myths of Motherhood: How Culture Reinvents the Good Mother*, New York: Penguin/Random House.

1

Maternal Performance: Relations and Embodiments

Lena Šimic and Emily Underwood-Lee

In this chapter, we consider the performance of care and the blurring of private and public found in performance artworks by Hannah Ballou, Amanda Coogan, Lynn Lu, and Nathalie Anguezomo Mba Bikoro. These performance artists examine the private and make it publicly available. They allow the two to bleed into each other in palpable, provocative, and visceral ways which, we will argue, allow us to think together in a relational encounter towards a new affective vision of the future enacted through the repetitive, daily acts of maternal care and compassion.

We have chosen to employ epistolary writing in this chapter to mirror this blurring of public and private, allowing for a public performance of our (edited) private selves. We have edited the letters while trying to hold on to some authenticity and immediacy in the writing, with our informal style retained, purposely exposing how we come to ideas together as both co-researchers and friends. Liz Stanley notes that letters are 'dialogical', 'perspectival', and 'emergent' (2004: 203). The performance of self in the letter is one in which we construct ourselves in relation to our imagined or intended reader. We project ourselves through both time and space and consider how we want to be read through our letters. Similarly, as we have discussed elsewhere, in both performance and maternal life, we engage with our other through dialogic, embodied, and durational exchanges (Šimić and Underwood-Lee 2017). In the performances we explore here, we are presented with a public showing of the artists' private and intimate relationships with their others – be that other a child they are carrying, have carried, or their maternal lineage of predecessors and future generations – both biological and social. The performances we explore in the following letters ask us to exist with a performer in the particular moment of the live encounter, and yet they bring to that present a maternal relationship which can only be developed through repeated and embodied actions over time – the daily labour of caring which works

to constitute a maternal identity or, as Lisa Baraitser has argued, the 'suspended' time of unending tasks that go into raising a child combined with the ever-present notion of futurity that the child represents through their development (2017: 79). The letters we share here are written and rewritten during the particular time of the COVID lockdowns in the United Kingdom in 2021 which engendered a renewed public debate around the role of care in society. Being specific about our geographic, cultural, and temporal locations enables us to frame a public version of our intimate exchange and maternal concerns. Likewise, in their performances, Ballou, Coogan, Lu, and Anguezomo Mba Bikoro share a considered aesthetic construction of their personal maternal identities in their own particular times and places (Ballou's *goo:ga* and *goo:ga* II were performed in 2016 and 2021, respectively; Coogan's *Yellow* was performed in 2008; Lu's *Tend* was shown in 2015; and Anguezoma Mba Bikoro's *How Many Stones Can Free* was a live art event performed in 2013).

Hannah Arendt's political theorizing of the public and private in *The Human Condition* ([1958] 2018) gives us a lens through which to explore the power of the domestic, made centre stage through performance art. Arendt's work has gained a new currency in our current times, where a mass blurring of the public and private has been experienced and care work has gained a new prominence in relation to COVID. In 2020 and 2021, there were a plethora of major research events around the topic of mothering and care, for example the 'Maternity and Wellbeing' online symposium at the University of Brighton in November 2020, the 'The Missing Mother' two-day online conference in April 2021 at the University of Bolton, and our own series of five maternal events under the title 'ENGAGE ... Conversations Conceived across Performance Studies and the Maternal' in late 2020, part of the AHRC-funded Performance and the Maternal research project.[1] In 2021 the *Studies in the Maternal* journal launched its tenth anniversary issue, and Demeter Press, a Canadian publishing house focusing on publications concerned with mothering, celebrated its fifteenth anniversary. All of this activity might be termed the 'maternal turn' in academic debate in recent years. Alongside this maternal focus, we have also been aware of a growing interest in care prompted not least by the COVID-19 pandemic and subsequent lockdowns, which saw many mothers struggling on to keep everything afloat, while often balancing caring responsibilities for their children, older relatives, or extended families with their other professional and personal commitments.[2] Through the experience of lockdown, quite suddenly, all of our private and domestic lives were made public through online technologies. Interruptions and bodily intimacies sneaked into the workplace and the classroom, intentionally and unintentionally. Carers', and in particular mothers', invisible daily lives were made visible. The private and public, the domestic, and the international started mixing in very new ways.

Liverpool, Tuesday 6 April 2021

Dear Emily,

We are still on Easter break, with our children in/out of the rooms. We promised to speak on maternal performance and its relations and embodiments. We named Hannah Arendt. We said, drawing on Arendt's distinction between the private realm of labour and the public domain of action, we will argue that performance is able to make visible the quotidian and often invisible experience of the maternal and present it as worthy of intellectual and political consideration, which is a radical act of resistance. We said public considerations through performance art. We named Amanda Coogan, Hannah Ballou, Lynn Lu, and Nathalie Angeuzomo Mba Bikoro. The public presentation of the oozing maternal body, with leaking breasts, bloody uterus, and various other bodily excretions, is routine in the daily action of caring for a dependent other, and yet becomes radical when placed in the public domain for consideration as the site of meaning.

What do we mean by radical? The invisible, the unsayable, the missing? Earlier this week, we received an e-mail from Hannah Ballou, a mother/artist/researcher working in the forms of live art and comedy. Ballou is currently fundraising to make a film about her second pregnancy titled *goo:ga II*.[3] In 2016, she created her *goo:ga* performance while in the eighth month of her pregnancy, and during the performance's live event, she found out the sex of her unborn child. Ballou is now pregnant with her second child. *goo:ga II* was supposed to be, in her words, 'a very sensitive, live performance', but COVID time is such that film might be a more appropriate medium. In her e-mail and crowd fundraising page, Ballou informs us that she has found out that her unborn baby has an exceptionally rare and serious heart anomaly – pulmonary arteriovenous malformations, which is an almost unheard-of diagnosis in utero. She writes:

> I'm very lucky to be seen weekly by the top doctors at Great Ormond Street Hospital and University College London Hospital, but because it's so uncommon, even they have no idea whether the baby is going to make it to delivery, after which intervention is possible.
>
> (Ballou 2021)

She continues: 'I've always prided myself in being able to turn risky, autobiographical material into comedy gold with a particular emphasis on the liveness of the experience' (Ballou 2021). Here, in the proposed film, Ballou indicates that she will yet again expose the hidden, the intimate, the interior.

Every Friday, we attend the Hannah Arendt Centre reading group on *The Human Condition*.[4] There's something strict about Arendt's thinking, about her categories. There is not much love between her and feminism, is there? Adrienne

Rich asserts: 'To read such a book, by a woman of large spirit and great erudition, can be painful, because it embodies the tragedy of a female mind nourished on male ideologies' (1976: 11). Yet, we return again and again to Arendt when we write about maternal performance; you and I have used her categories of work, labour, and action and to help us argue that the private ought to be exposed in public. Amanda Coogan, Hannah Ballou, Lynn Lu, and Nathalie Angeuzomo Mba Bikoro are all artists who show us the intimate, the hidden. In the text, Arendt discusses 'The Public Realm: The Common' as she names it. She writes how:

> the greatest forces of intimate life – the passions of the heart, the thoughts of the mind, the delights of the senses – lead an uncertain, shadowy kind of existence unless and until they are transformed, deprivatized and deindividualized, as it were, into a shape to fit them for public appearance.
>
> (Arendt [1958] 2018: 50)

She praises storytelling and the 'artistic transposition of individual experiences' (Arendt [1958] 2018: 50). But crucially, she also writes: 'Each time we talk about things that can be experienced only in privacy or intimacy, we bring them out into a sphere where they will assume a kind of reality, which their intensity notwithstanding, they never could have had before' (Arendt [1958] 2018: 50). A couple of pages further on, she claims: 'Because of its inherent worldlessness, love can only become false and perverted when it is used for political purposes such as the change or salvation of the world' (Arendt [1958] 2018: 52). This has somehow upset me and provoked me towards a reassessment of the private and intimate. What should remain hidden? Is there something that we must not disclose? Is that 'something' maternal love? And if so, why is this my immediate assumption? Ballou's new work is so provocative – it hasn't even happened yet – but it's verging on the 'permissible' – as it's reconfiguring the bond and an assumed secrecy between the mother/child dyad. As part of her fundraising campaign, supporters can get certain 'rewards'. I decided to get a signed sonogram of the foetus.

The description of my reward states:

> a signed sonogram image of the foetal star of *goo:a II*. Is that a little creepy? YES! But this baby is a genuine medical anomaly, so it's a true collector's item. Plus, I'm proud of the little tyke in spite of the dodgy ticker so, like every other mum, am keen to push photos on people.
>
> (Ballou 2021)

Is this maternal performance pushing it a bit too far by gifting us the foetus' heart? Or is it a gift that allows us to think the unthinkable, to properly readdress

the human condition, strip it bare? Is it ethical to make us consider human relations and embodiments beyond the expected one? Is this all a bit too much? The maternal as it appears, in its pregnant state or its bloody miscarriage mess, is almost always inevitably too much. It is in your face. Demanding attention. What stays hidden for us as mother/artists or scholars concerned with maternal matters? Should we hold onto something private still? Love? Pain? Is it worth holding onto anything? What is it that we can never give away?

Love
Lena

Cardiff, Thursday 8 April 2021

Dear Lena,

I so much enjoyed receiving and reading your letter. We have developed a way of writing, a rhythm. We can play with public and private, sharing the intimacy of a friendship and a co-authoring relationship in some sort of public space (not quite the public forum that Arendt evokes, but we write to each other while directing this action towards an audience other than ourselves and beyond our private sphere). We might go so far as to say this performance of our letters is also a radical act in elevating our private correspondence to something given a platform in the public domain.

Arendt reminds us that it is in the retelling that performance becomes a public act when she states that '[i]n order to become worldly things, that is, deeds and facts and events and patterns of thoughts and ideas, [action, speech and thought] must first be seen, heard and remembered and then transformed, reified as it were, into things' ([1958] 2018: 95). You ask what it is that we mean by radical. For me, the previous quote by Arendt gets to the heart of this; it is when the private, domestic, and quotidian are transformed into public acts that we are being radical as mother/artists. Our private actions must change from something that the world ignores into something that we demand the world stand up and take notice of; to use Arendt's terminology, they become 'things', even if only in the small world of live art audiences and performance scholars.

I also supported Ballou's performance but chose not to receive a reward. For me, it was too much to think she would gift me something of her experience, and her baby in some sort of private performance. I am happy to receive her film in the public domain but become uncomfortable with this more intimate one-to-one exchange between the artist and the audience. Ballou knows that her work is shocking and seeks to find the humour that comes from breaking taboos around the intimacy of the mother/child dyad when she says that her performance comes

'from inside the throes of a terrifying ordeal and offer[s] an alternative voice for women facing down the unknown; there are not many comedy shows about still-birth' (Ballou 2021). I am somehow thrilled by her work, by being invited into this most intimate experience, but, like you, I also have a feeling that this is too much.

I had a similarly strong reaction to Lynn Lu's 2015 work *Tend*, where she performed one-to-one maternal acts for her audience – cleaning their ears, scratching their backs, brushing their hair, or lying together as she told them a bedtime story. In an interview with us, Lu told us that she preferred working with adults in this intimate way rather than having these encounters with a child, biological or otherwise, because adults could engage in conversation, could give something back (Lu with Šimić and Underwood-Lee 2020: 18). After the interview, we discussed how you and I both found the level of intimacy that Lu is able to offer to her audiences disquieting, and we talked about how we are both uncomfortable overstepping these boundaries, despite both of our predilections for live art, which is often so bodily and intimate. Unlike Ballou's very public film and performance, which are watched as part of a collective audience, Lu asks her audience into a private one-to-one encounter in *Tend*, which only then becomes public in the documentation and retelling. When I think about Lu's work, I am again reminded of Arendt's proposition that it is in the retelling of speech acts that they become public.

Ballou's performance brings the most intimate encounter between mother and foetus into the public domain; Lu's work brings to public attention the daily acts of maternal care that underpin human life (for, as we often discussed before, without someone to care for them the infant child could never survive to adulthood). When we make these acts public, put them into the world for others to receive them, talk about them, and remember them, we are making the private public or the personal political, to use Carol Hanisch's famous phrase ([1970] 2001). We are stating that the maternal is worth talking about and worth remembering. Again and again, Arendt equates domestic, life-maintaining 'labour' with never-ending, repeated activities that do not result in anything 'humanly meaningful' ([1958] 2018: 106). It is work and action that results in tangible things, be those things buildings, tables, books, or remembered speech acts. And yet, these performance artists with their too-intimate acts, exposing the internal action of pregnancy as Ballou does in *goo:ga*, or dealing with the intimate bodily functions of others as Lu does in *Tend*, are making these acts into something tangible, something that is worth remembering and talking about. Following Arendt, we could perhaps even argue that these mother/artists are making history. But I wonder, who has the power and privilege to make these public statements?

I have lately been thinking about Judith Butler's adoption of Arendt to remind us that the capacity to speak out in the public domain is dependent on access to infrastructure and freedom to speak. She states

when we think about the embodied subject who exercises speech or moves through public space, across borders, it is usually presumed to be one that is already free to speak and move. Either that subject is endowed with that freedom as in inherent power, or that subject is presumed to live in a public space where open and supported movement is possible.

(Butler 2016: 3)

In live art, we find spaces in which acts that might otherwise be considered shocking or transgressive become permissible – Lu is able to clean the ears of strangers; Ballou is able to make jokes about the potential still birth of her child. In this chapter, we are able to share our private thoughts as a public act. But is the gallery or the book still something of a private space where we only speak to those who are already predisposed to engage with our work, or, at the very least, those who are interested in maternal politics? I wonder about the danger in bringing the maternal out beyond our rarefied spaces. Is that the truly transgressive and resistant potential of maternal art?

Love
Emily

Cardiff, Thursday 15 April 2021

Dear Lena,

I've been reading Arendt's early essay 'Berlin Salon' ([1932] 2007). In this essay, she discusses the intimate sphere of letters written between members of various salons at the turn of the nineteenth century. Even in this closed exchange, Arendt finds examples of how we avoid being forgotten through something that she sees as social and public (although she doesn't use the word public here and this is before the more complex arguments she develops on the public and private in *The Human Condition*). In 'Berlin Salon', Arendt posits that in order to avoid obscurity 'one can acquire a witness for oneself, a witness who can attest to one's reality when all public esteem has disappeared' and that this witnessing is an act of 'true sympathy with the life of the other' ([1932] 2007: 50). Arendt is here talking about witnessing within the context of personal letter writing and gossip within the salon culture of the late 1800s and early 1900s, but her assertions around the intimate sphere here interest me despite our focus on performance art made more than a century later. Arendt talks of 'gossip' and indiscretion, which she identifies as part of bearing witness ([1932] 2007: 50). These forms of intimate and slightly salacious exchange might traditionally be associated more with women and not with the serious business of the public arena. Indeed, when considering Arendt's

thinking about the public in *The Human Condition*, I always have to remind myself that it is in relation to Greek notions of the public, which excluded women, foreigners, and slaves. Arendt even notes that the salons, which included and were often led by women, were followed by the formation of 'Table Societies', for which a condition of entry was that you were neither a woman nor 'a Jew, a Frenchman or a philistine' ([1932] 2007: 52). And yet, these forms – the letters, gossip, and indiscretions that she briefly examines in 'Berlin Salon' – are still creating something that is both social and public.

When we look at the work of the artists we discuss here, who are revealing their most intimate relationships with their children or exposing the intimate fluids of their bodies, we may well align this with the indiscreet. Their work, which is routinely exposing the private, intimate space of the home, is taboo breaking when placed in the public space of the theatre or gallery (or, perhaps, we should call these spaces semi-public given the accusations of preaching to the choir that I made in my previous letter). And here we are writing letters about performance artists' work, just as Arendt's salon-goers write letters to one another about the people they encounter. Are we bearing witness here in our intimate exchange as Arendt describes? Are mother artists inviting us to a 'true sympathy' with their lives, and with maternal life more broadly, when we engage with, talk about, letter-write, or even gossip about their work?

Love
Emily

Liverpool, Thursday 15 April 2021

Dear Emily,

This is in response to your letter dated 8 April. I was just finalizing this letter as your second one arrived into my inbox.

I take on your points regarding Butler and the false assumptions regarding one's ability to speak as a free subject in any given circumstance. Of course, the ability to move through contexts and localities, to shift between disciplines and artforms, neighbourhoods, and people is dependent on various factors, and yet considered so important. But how easy is it for you and me to breathe in certain spaces? How often do you feel yourself as a moving living organism; how often do you really sense yourself free? How often do we become stuck, unable to move, speak out, act in confidence, or feel we have access to the public realm? But does what we say, what we write, matter? And where? Who listens? Which context are we in? Butler reminds us of power structures that are always already in place. There's a comfort here, as you note, in this particular context of maternal art and performance.

It is easy for us to speak out, discuss, critique among one another even, or strengthen our network by challenging each other. What happens elsewhere? Beyond our safe spaces and disciplinary or subject borders?

And then there are children, framed as others. Children, whom we implicitly always refer to in maternal scholarship, through either absence or presence, come from a different world. Do they not? What is their reasoning? Do we mythologize them as the 'other'? Do we work with and against them? I find that in my mothering, I am pushed towards my boundaries, to what is permissible, to the edge of rage and anger, annoyance, and love. Towards new contexts, new borders. You support, but you try not to overwhelm. You forbid, but you also encourage. You educate, but you care not to patronize. You facilitate. Mothering is about negotiation. A kind of diplomacy in the private sphere, and a desire to get out ... somewhere, beyond oneself.

Do we admire mother/artists too much? Are we envious of their courage? Is it courage or is it narcissism ... which doesn't necessarily have to be a bad thing? Maybe we are always programmed to cross borders, whatever those are for us, in each particular context. And then move onto another and another? Forever seeking too much, surplus, jouissance? Damned to have no satisfaction.

Labour is such: so bodily, with some satisfaction, but always asking for more, and each day, renewed.

Amanda Coogan's durational performance *Yellow* (2008) sees her washing and scrubbing at her long yellow dress, creating bubbles, oozing, with always more and more toil, endlessly repeating the same old task. She explains:

> I literally take the skirt and shove it in between my legs and into the water that I'm sitting on top of, and then I rub it. As I rub and scrub it, bubbles are appearing. It is like I'm washing something out. There are lots of segments or junctures within that activity. So, I scrub, then I eat the fabric, and kind of spit the fabric out again.
>
> (Coogan with Šimić 2017: 9)

Here we can think about labour in performance, but effectively it is a representation of laboursome activities primarily done in private. However, *Yellow* is a new public action that reflects on the private. It is transformed through representation, or to go back to Arendt's phrasing, 'artistic transposition of individual experiences' ([1958] 2018: 50). However, the performance itself repeats and thus encapsulates its laboursome activity, which is newly done for that context. And it is that labour, which is performed on stage, that allows the performer to slip into a kind of flow, the rhythm of mechanical work. Arendt's account illuminates workers' own explanations as to why they prefer repetitive labour, and the reason lies in its mechanics that require no attention, and thus allows them a space for thinking about something else ([1958] 2018: 146).

Coogan explains in her own words that 'durational performance pushes you beyond'. She adds:

> I'm not going to say pushes you beyond the representation, but I think that when you go over an hour and a half, or two hours, you have to fall off the script because you kind of drop your 'performance'; you drop your mirror face. This is what duration and endurance lends itself to. I would say that you get into flow, and you also drop out of flow very naturally.
>
> (Coogan with Šimić 2017: 11)

Reflecting on the arc of a six-hour-long piece, Coogan describes the first stages as tidy, but the middle part becoming 'the fabulous'. In her words:

> This is when the mirror face or the performed self, the public self, kind of falls away and it falls into a much more private self in a way that you are not so concerned that you are hitting your light.
>
> (Coogan with Šimić 2017: 12)

Here there's a discussion of performed/public self and the emergence of a much more private self.

I agree that the letters we write perform two realms: private and public. Do we assume that there are some even 'more public' spaces? Where would maternal performance be perceived as a radical act? If we are presumed to be 'safe audience', we need different contexts for maternal performance, or more challenging maternal actions, both through artmaking and in thinking/scholarship. This then, possibly falsely, aligns us to the idea of progress and process, an illusion that we are always getting better, getting somewhere ... building, developing, succeeding. Are we? And, laughing at us, the maternal, which is always about starting anew, pushes us back and against the line of progress ... And yet, as the children are growing up and as we are ageing and entering different stages of mothering, a personal change of some kind, call it progress or decline, is so painstakingly obvious.

Spending time thinking about the maternal and natality, the conflation of the private and the public, and its readdress, is so generative to our scholarship. They also push us to be constantly reflective in our experience of mothering and artmaking. Coogan's representative labour in performance gets transformed, and in the process, we glimpse something of the private or the intimate self ... holding it dear.

Love
Lena

Liverpool, Tuesday 20 April 2021

Dear Emily,

I keep thinking about Arendt's assertion that art is aligned to thinking, not feelings. Where is the place of sympathy here? She writes that 'the immediate source of the art work is the human capacity for thought', and that 'thought is related to feeling and transforms its mute and inarticulate despondency' (Arendt [1958] 2018: 168).

I am frustrated by this disconnect between feelings and thinking. Isn't art supposed to affect? Aren't we in the business of feelings? Why are feelings inarticulate? Are they? Don't we have art to help us transport feelings, be compassionate, sympathize? Or is it inevitable that in the process of this transportation of feelings we rely on thought? 'Works of art are thought things, but this does not prevent their being things' (Arendt [1958] 2018: 169). Now performances are more aligned with the category of action, rather than work. They are not things but a kind of intervention into the world; a provocation that makes a difference, creates a new vision, a new narrative, and upsets the flow. The maternal performances we write about affect as well as create new thoughts.

At times I sense that there's a desire for maternal sympathy from mother/artists (Šimić and Underwood-Lee 2021: 147). There's a kind of reaching out that a mother/artist performs, possibly even enacts. A kind of invitation towards understanding. A provocation too, but ultimately a desire for understanding. That's clear in the proposed work of Ballou. With Coogan, given the work's durational format, there seems to be less pressure on the audience to sympathize with the performer. The audience come and go; they are not there for the whole duration of the performance. An odd word 'sympathy', somehow misfitting within our maternal scholarly discourse. Compassion would be more fitting, more opening, more touching. According to Ettinger, compassion is active as opposed to reactive; it is about contact and connection, 'a primal psychic access to the other' (2009: 1). On the other hand, a quick search in online dictionaries has sympathy defined as 'feelings of pity and sorrow for someone else's misfortune', or '(an expression of) understanding and care for someone else's suffering',[5] which is clearly reactive. There seems to be a kind of distance one can uphold from another when it comes to sympathy; there's an understanding there that this is about someone else's narrative ... possibly that's why it is connected with the salon, letter exchange, and gossip. And sympathy makes me think of catharsis, which is concerned with the release of feelings following the 'terror and pity'.

But you ask about our own letter exchange and bearing witness towards these maternal performances and one another. There's something compelling in

making sense of one's life through being in an intimate relation with another. In a way, this kind of letter exchange allows for a deeper connection, a keener understanding of each other's thoughts, which we have previously named as maternal feminist relations (Šimić and Underwood-Lee 2021). There's a care given to each other's existence. With artmaking, the process that each mother/artist enters into might be intimate too, oftentimes bodily, and bear some kind of witness to their own mothering process, their own relationality in the world. Whether those relations are later on impressed upon audiences, I am unsure. Do the audiences come out in sympathy or compassion? Do they come out in a desire to glimpse a piece of the private, as I tried to argue in my previous letter when discussing Coogan's work? And if so, what for? A desire to connect ... again and again.

Love
Lena

Cardiff, Tuesday 20 April 2021

Dear Lena,

You ask 'Where would maternal performance be perceived as a radical act?' and 'Do the audiences come out in sympathy or compassion? Do they come out in a desire to glimpse a piece of the private?' When thinking about your question, my mind turned to an anecdote recounted to us by Nathalie Anguezomo Mba Bikoro. I will share the extract in full to remind you.

> *How Many Stones Can Free?* (2013) was a work I carried to Gothenburg, a game to challenge the expectation of white spectatorship [...]. I skipped bare foot over the glass [...]. The audience [were] threatened and confused, I was harassed with the N***** word, feeling like I betrayed their expectations.
> (Anguezomo Mba Bikoro with Underwood-Lee and Šimić 2020: 12)

Here, Anguezomo Mba Bikoro shares an example of maternal performance that was genuinely risky and transgressive. Not because of the maternal content, not because she disclosed the intimacies of her body – although her blood spilled from her feet onto the gallery floor and her deep feelings about death and violence enacted upon her and her family were shared. Instead, the audience were hostile because the artist turned the gaze back on them. She asked them to confront their own complicity in racial and colonial violence. She turned her maternal gaze and maternal rage outwards.

I want to think more about the implications of this turning outward of the private. The maternal performances we talk about share something of the intimate life of the artist in a public arena, but they also invite us to consider our own intimate selves as audience members, which might in turn elicit sympathy or hostility. Arendt asserts of the body that

> nothing, in fact is less common and less communicable, and therefore more securely shielded against the visibility and audibility of the public realm, than what goes on within the confines of the body, its pleasures and its pains, its labouring and consuming.
>
> ([1958] 2018: 112)

If we follow Arendt and believe that we can never really communicate our bodily and emotional maternal experience through performance, then, when mothers/artists bring the private into the public, perhaps what maternal performance should aspire towards is this act of turning inwards of the audience member and witness so that they reflect upon their own place in the world. It is my optimistic belief that in sharing our thoughts, our bodies, our private and intimate experiences, we create an encounter between the self and another, which can generate a collective public examining of ourselves and our place in the world. I dream this is true, and that together, through making and witnessing maternal performance, we can all come to a position of compassion and accountability. Wouldn't that just be a wonderful world?

Yours in hope,
Emily

We finish this particular exchange of letters with a wish and a question. We long for compassion and accountability that are made manifest through maternal performance. Such maternal performance is witnessed on stage by the artists discussed in the letters, but also reflected on in our daily mothering life. Our hope is that maternal performance can change the world or, at the very least, make us turn inwards, use our bodily thinking, and embrace our relational encounters and exchanges. New considerations of care have emerged in response to the COVID-19 pandemic. Care and maternal thinking have become political hot topics that are not relegated to esoteric academic discussions but part of the mainstream conversation. Arendt suggests that the 'modern age is characterised by lack of a shared political world' ([1958] 2018: 254). Her most urgent call, which she also names simple, is to think about what we are doing ([1958] 2018: 5). Maternal relational politics in the world encourage us to both think and feel with one another, with

compassion and accountability. Maternal performance, in all its embodiment, when able to exist in the world and when received by an open and thoughtful audience, provokes us to consider together our responsibility for our others and to reimagine the world together.

NOTES

1. This chapter was originally proposed for the *Performing Maternity* book edition, and first developed as a series of e-mail letters for 'The Missing Mother' online conference at the University of Bolton, UK, in April 2021.
2. A rather alarming report from the Office for National Statistics has found that in the first weeks of the COVID lockdown in the United Kingdom, women were undertaking two-thirds of all childcare. This statistic does not include the 'shadow work' of planning and holding things together that women may also have been undertaking as children and parents adapted to the 'new normal' (Office for National Statistics 2020).
3. http://www.hannahballou.com/goo-ga-the-film-1.html. Accessed 1 December 2023.
4. Virtual Reading Group is run by Professor Roger Berkowitz, founder and academic director of Hannah Arendt Centre at Bard College, USA. For more information, visit https://hac.bard.edu/programs/vrg/. Accessed 1 December 2023.
5. See online definitions in https://www.lexico.com/en/definition/sympathy and https://dictionary.cambridge.org/dictionary/english/sympathy. Accessed 1 December 2023.

REFERENCES

Anguezomo Mba Bikoro, Nathalie (dir.) (2013), *How Many Stones Can Free?* [performance], N. Anguezomo Mba Bikoro, curated by J. Stampe and J. Stampe, Live Action 8, KonstHalle Museum Gothenburg, Sweden, June 2013.

Anguezomo Mba Bikoro, Nathalie with Lena Šimić and Emily Underwood-Lee (2020), 'Interview with Nathalie Anguezomo Mba Bikoro', Performance and the Maternal, https://performanceandthematernal.files.wordpress.com/2020/12/nathalie-anguezomo-mba-bikoro.pdf. Accessed 24 May 2021.

Arendt, Hannah ([1958] 2018), *The Human Condition*, Chicago, IL: The University of Chicago Press.

Arendt, Hannah (2007), *Reflections on Literature and Culture* (ed. S. Young-ah Gottlieb), Stanford, CA: Stanford University Press.

Ballou, Hannah (dir.) (2016), *goo:ga* [performance]. H. Ballou, Camden People's Theatre, London 2016.

Ballou, Hannah (2021), 'Let's make performance project goo:ga II a film!', Crowdfunder, https://www.crowdfunder.co.uk/googa-ii-the-film. Accessed 24 May 2021.

Baraitser, Lisa (2017), *Enduring Time*, London: Bloomsbury.

Butler, Judith (2016), 'Rethinking vulnerability and resistance', in J. Butler, Z. Gambetti, and L. Sabsay (eds), *Vulnerability in Resistance*, London: Duke University Press, pp. 12–27.

Coogan, Amanda (dir.) (2008), *Yellow* [performance], A. Coogan, solo performance artist, Temple Bar Gallery, Dublin 2008.

Coogan, Amanda with Lena Šimić (2017), 'Interview with Amanda Coogan', Performance and the Maternal, https://performanceandthematernal.files.wordpress.com/2020/10/amanda_coogan.pdf. Accessed 24 May 2021.

Ettinger Bracha L. (2010), '(M)other re-spect: Maternal subjectivity, the ready-made mother-monster and the ethics of respecting', *Studies in the Maternal*, 2:1, pp. 1–24, https://doi.org/10.16995/sim.150.

Hanisch, Carol ([1970] 2001), 'The personal is political', in B. A. Crow (ed.), *Radical Feminism: A Documentary Reader*, New York: New York University Press, pp. 113–21.

Lu, Lynn (dir.) (2015), *Tend* [performance], L. Lynn, solo performance artist, Palais de Tokyo, Paris, 2015.

Lu, Lynn with Lena Šimić and Emily Underwood-Lee (2020), 'Interview with Lynn Lu', Performance and the Maternal, https://performanceandthematernal.files.wordpress.com/2020/10/lynn_lu-.pdf. Accessed 24 May 2021.

Office for National Statistics (2020), 'Parenting in lockdown: Coronavirus and the effects on work-life balance', https://www.ons.gov.uk/peoplepopulationandcommunity/healthandsocialcare/conditionsanddiseases/articles/parentinginlockdowncoronavirusandtheeffectsonworklifebalance/2020-07-22?hootPostID=c488b5fdfb63472a21380c01d9cf3835. Accessed 27 May 2021.

Rich, Adrienne (1995), 'Conditions for work: The common world of women', in A. Rich (ed.), *On Lies, Secrets and Silence: Selected Prose (1966–1978)*, London: W.W. Norton, pp. 203–14.

Šimić, Lena and Underwood-Lee, Emily (2017), 'On the maternal: Introduction', *Performance Research*, 22:4, pp. 1–4.

Šimić, Lena and Underwood-Lee, Emily (2021), *Maternal Performance: Feminist Relations*, London: Palgrave Macmillan.

Stanley, Liz (2004), 'The epistolerium', *Auto/Biography*, 12:3, pp. 201–35.

2

Experiencing and Knowing from a Mother/Child 'Us'

Ariel Moy

I began drawing my mothering experiences when I was admitted into a mother/ baby unit for postpartum depression. My son was 6 weeks old. I could not sleep or eat; I was electric with exhaustion and terrified all of the time. I feared I would not be good enough for my son. A constellation of changing hormones, past experiences, a traumatic birth, lack of support, lack of sleep, and caring for a newborn resulted in desperate helplessness and a dissolution of what I had considered a self.

My maternal identity was immediately constrained and complexified by a diagnosis of postpartum depression. The term 'depression' felt misleading because my experience was of extreme agitation. I've since discovered that this is a hallmark of the diagnosis (Kleiman 2014: 47). Medication in combination with group and individual therapy and ongoing attention paid to our mother/son relationship all contributed to healing and symptom relief but the experience has profoundly shaped me and how I understand motherhood.

I encountered many different mothers over that time, mothers with every kind of label: depressed mothers, mothers with bipolar disorder, schizophrenia, postpartum psychosis, mothers who were young and mothers who were of 'advanced maternal age', gay mothers, straight mothers, single mothers, first time mothers, mothers of multiple children, mothers with eating disorders, mothers who worked outside of the home (paid employment) and 'stay at home' mothers, educated mothers, mothers just out of school, mothers from different socioeconomic, cultural, racial, and religious backgrounds and all possible combinations in between. Though I lived with powerful internalized voices and imagery punishing me for my 'less than' perfect mothering, I was surrounded by the reality that there was no one way to be a mother and no perfect mother/ child relationship.

The drawings in this chapter are a part of a series begun on 14 October 2020. They are the latest iteration of an ongoing inquiry into my relationship with my son and my experience of mothering. What artmaking gives me is a place to express, explore, and make meaning of our mother/child 'us' and the many intersubjectivities I bring to it. As Lynn Kapitan writes 'art is both an object and an event that invites our transformation, our healing and our reconciliation' (2014: 144). I allow my body to draw as I do my best to invite my conceptual mind to take a backseat for a while. The experiential, sensual, emotional, and symbolic forms of knowing take centre stage in these moments, informed by John Heron and Peter Reason's 1997 extended epistemology or multiple ways of knowing.

By making an object of my experiencing I can interact with it, share it, question, argue, develop, and personify it. I materialize what I can't quite articulate as my knowing is not yet conceptual. I engage with pens, pencils, pastels, ink, and paper knowing that new information will arise from parts of me I and those around me so readily dismiss – what is known in the body, in artistic forming, and in relationships. And I can find another way of conveying my experiences that speak to these other forms of knowing within an audience. This is what arts and arts-based research can do (Allen 1995; Barone and Eisner 2012; Hogan 2015; Leavy 2009; Lett 2011; McNiff 2014; Seeley and Reason 2008).

Each drawing in this chapter has given form to emerging qualities of maternal identity, an identity that can bring into awareness profound and particular intersubjectivity. In my research *Maternal Holding and the Mother/Child 'Us'* (Moy 2019) and ongoing inquiry, I explore mother's experiences of holding their children and the ways in which this captures their experience of relationship. What we've noticed is that the mother/child relationship is a space of co-created experiencing, co-created needs, their identification and navigation, and co-created relational stories that help explain our maternal identity to ourselves. These experiences of holding and relationship cannot be understood or explained outside of that particular mother/child dyad (Moy 2019, 2021). I've called this strange but valuable experience of expanding from a sense of self into a self-in-relationship the mother/child 'us'.

The 'us' does not reduce or merge a mother and child's many identities, it does not propose that maternal or child experiences are the same but rather draws attention to what is unique, meaningful, challenging, and *more than* the mother or the child in their relationship. This occurs when mother and child are together holding and being held, or when mother and child are reflecting upon their relationship once apart. In some moments of blissful connection or angry dispute, we are not only ourselves but reside in a third space arising from a visceral awareness of this mother/child 'us'.

This intersubjective experience of 'us' in our maternal relationships has been easier to explore and articulate in artistic form than in language. It is not something that immediately arises in our everyday awareness and yet it is felt at a bodily level as incredibly central to our experiencing with our children and our identities as mothers. This appeared time and again in the artworks participants and I produced.

An expanded intersubjective self is a strange and less well-known quality of maternal experiencing partly because it doesn't easily sit well within the culturally dominant or hard fought for subject/object divide in the politics of identity. It asks us to situate our individual consciousness and sense of self within a myriad of embodied relationships with other beings and objects, with spaces and places, and through language. We are temporally, historically, culturally, and biologically situated and co-created as we inhabit a particular intersection of being in lived space, relationship, embodiment and time (Van Manen 1990).

As Kenneth Gergen writes:

> Rational thought, intentions, experience, memory, and creativity are not prior to relational life, but are born within relationships. They are not 'in the mind', – separate from the world and from others – but embodied actions that are fashioned and sustained within relationship.
>
> (2009: 95)

This profound relationality inhabits multiple theories of being including Barad's (2009) intra-active and entangled agencies (2007), Deleuze and Guattari's rhizomatic ontology (1987), and Nick Crossley's intersubjectivity (1996). However, there are nuances and textures to the mother/child 'us' as lived that are not fully captured by these overarching ethico-onto-epistemologies (Barad 2007).

Whether a mother has carried her child in her womb, has contributed DNA to her child, or has first become a mother in a myriad of other ways, and if the mother is involved in some way in the child's life, there is something that ongoingly emerges in that mother/child relationship that is unique to it. Unlike the deep relationality possible for those in love or in friendship, my lived experiences, research activities, and therapeutic practice with the mother/child relationship have encountered an 'us' that involves a dynamic constellation of qualities. These lived qualities of the 'us' vary in intensities at different times and in different contexts but appear together with, and particular to, this relationship. These qualities include a sense of responsibility, needs navigation, and purpose that begin in deliberate and unequal ways including a sense of maternal responsibility for the child's survival; a far stronger cultural expectation of life-long maternal (and commonly a child's) commitment to the relationship; a complex of familial,

social, cultural and historical prescriptions for the relationship and experiences of embodiment and inter-embodiment (Lupton 2013) that carry the real weight of these qualities. An example is easily made when referring to the mothers of infants: Lupton writes that 'mothers [...] act as an ersatz immune system for their infants by attempting to keep out germs' (2013: 15). Though infants co-create their relationships with their mothers, their level of dependence at this stage is awesome and encompassing. A mother begins her relationship with her child with an ongoing expectation to protect. Even when a child matures through the toddler years, adolescence, and adulthood, there is a historical as well as meaningfully experienced expectation, if not desire, to support children's survival and well-being. There is a sense of durability and significance (or expected durability and significance) to this relationship that will or 'should' weather shared time, experiences, understanding, and events.

In this visual as well as written chapter, I share the wonder, delight, confusion, and difficulties of expansion into a mother/child 'us'. These moments of deeply relational experiencing also include voices and imagery from my past and present that erupt within our relationship but are not created by it.

Two of the drawings (Figures 2.1 and 2.3) are followed by my responses to the making of the art, the finished piece, and the 'us' identity arising from them. Two other drawings (Figures 2.2 and 2.4) are included with a different kind of commentary to highlight the ways language and imagery differ in what and how they communicate. I wish to show some of the struggles when trying to explore and articulate what feels known and communicated in an artwork that resists representation in words. These shorter descriptions are more dialogic and poetic. As Nick Sousanis draws and writes:

> We're concerned with the ways in which we employ visual and verbal modes in order to distil something tangible from the vastness of sense experience. The verbal marches along linearly, step by step, a discrete sequence of words [...] The visual, on the other hand [...] presents itself all-at-once, simultaneous, all over, relational [...] while image *is*, text is always *about*.
>
> (2015: 58, original emphasis)

The immediacy of art expression and its ongoing 'becoming' in relationship with those who encounter it discourages definitive sensemaking. As Levine writes: 'Images possess energy, and they demand that we respond to them with the energy of our own imagination. If we try to think the image, we must find an imaginative, energetic way of thinking' (2009: 2). The invitation in this article is to engage with the words and imagery in a way that provokes wonderings and evokes resonance around maternal identity and the mother/child 'us'.

Please note, I refer to 'mother' and 'mothering' throughout this chapter for ease of reading however this term refers not only to primary carers who are female but to all primary caregivers who identify their experiences as mothering.

A Mother's 'I' and a Mother/Child 'Us'

Made on 24 October 2020 in Melbourne, Figure 2.1 emerged from a simmering backdrop of anxiety as we were coming to the end of our second Stage 4 lockdown during the COVID-19 pandemic.[1] From a tightly held world of restricted movement and interactions, I was about to see my son return to high school after two terms learning from home. I was also in a great deal of pain with endometriosis, my body tense with electric shocks and slowed down by medication.

Aware of the ways my own distress populated our shared space, I drew in order to see my current experiences and to examine how these feelings were manifesting within our relationship.

I often begin with an idea, attempt to draw it, and then give up and allow for a less controlled approach. When I put aside what I think I know, and follow my body and emotions, I am always surprised by what appears on the page. This is guided by the feeling of making. These artworks are spontaneous, quickly made in a day or two, and don't ask too much time of me though they can ask a lot of my emotional self.

I started with the wavy shape on the left and then was shocked to see my face appear in it. I looked sad, inward-focused, and worried but my undulating body appeared too smooth for my emotional state. I attached a jagged shape to me, a broken piece of glass or mirror. A larger shape took up residence behind me and extended across the page holding something within and behind it. I drew and then saw ghosts, and behind these, I saw my son.

He looked at me with concern and perhaps alarm. I saw a tiny, jagged shape on his head as well. I could have stayed with these, there were questions brewing, but at the moment, I wanted to continue on, to fill the page before I started to think, to explore the questions with drawing rather than words.

Large flowers appeared next. With their open blooms, they brought a thick scent. I coloured warm grey into the space behind my son and me, and then framed us within a night sky. Drawing white dots and carefully filling in the background took time, time I felt I needed to be with the images.

On finishing, I decided to walk around the ghosts and start a conversation. I wanted to see their faces because in the drawing their eyes were closed and turned away (like mine). They wouldn't speak and so I knew that what they represented was a sensation, the knowing located in my body more than in my mind and so that was where I needed to look.

FIGURE 2.1: Ariel Moy, *A Mother's 'I' and a Mother/Child 'Us'*, 2020. Ink and pen on paper. 29.7 cm × 21 cm. Melbourne. © Ariel Moy.

Transgenerational trauma haunts us like that (see Sue Grand and Jill Salberg's *Trans-generational Trauma and the Other: Dialogues across History and Difference* 2016). I discovered an image made famous decades earlier by Selma Fraiberg. In *Ghosts in the Nursery*, Fraiberg, Adelson and Shapiro write that these spectres 'are visitors from the unremembered past of the parents' (1975: 387). They manifest as parental ways of being with their child that are unintentional and often unremarkable to the parent; it's just the way things are. These ways of being can go back generations, as each child learns from their parents and adapts to their relational styles in order to maximize survival, generation after generation. These adaptations may have worked when we were younger but may now limit relational possibilities in adulthood. In this drawing I saw my ghosts, but they weren't hungry (perhaps due to many years of therapy), they didn't want to feed off our relationship, shaping it to their will. Instead, they were moving out of the drawing.

I recognized then and now, that our relationship is still informed by my personal past. My mother and then father both left when I was 18 months old. I was raised by my Nan and Pop for a few years before returning to live with my father and stepmother. I frequently visited and stayed with Nan over the years. She was my safe haven (Moy 2020: n.pag.). My biological mother returned when I was 13 years old. We rebegan a fraught relationship, one that she regularly 'ended' until I 'proved' my love and then we would be together again, for a time. This continued into my early twenties. When I was in the mother/baby unit, I longed for someone to mother me as I attempted to mother my son.

Over the years I became extremely sensitized to my mother's suffering, her whims, delights, and demons. I sought to manage these to preserve our relationship and my own sense of self. As an adolescent, I lived with an untenable, ongoing threat of re-abandonment and I did not want this experience for my son. That determination has supported and hindered my maternal experiencing and our relational identity.

When looking at Figure 2.1, I wondered if the imagery before me represented an underlying assessment of 'us'. An instance reminded me that within our intersubjective mother/child experiencing, be it pleasant or painful, we were essentially okay. We might feel sad, distraught, angry, or ugly and our relationship would survive. If there was an artistic measure of mother/child attachment styles like the Adult Attachment Interview (constructed by George, Kaplan, and Main in 1984) or the Strange Situation (the first measure of infant attachment created by Mary Ainsworth in the 1970s) then I hoped and imagined we'd be considered 'secure'. We felt safe within our relationship and our relational stories made sense.

Despite the ghosts heading off the page, I do sometimes doubt the strength of our relationship. I wonder if the intensity of my emotions, my chronic pain, and that early year of postpartum depression has harmed my son. I don't always

say yes when he wants to watch TV together or asks me for a smoothie. I can be preoccupied with my own concerns. I do get angry.

I'm aware that this self-doubt arises from a long and not necessarily personal history of mother-blaming, of providing mothers with prescriptive and fixed identities neither asked for nor helpful. 'Bad mothers' come in all shapes and sizes and their definition often serves their condemners. Caroline Pascoe writes in *Screening Mothers*: '[M]other-blaming theories came to play a critical part in child psychology and psychoanalysis after the Second World War' (1998: 3). One possible use for this blame was to place newly liberated women back into the domestic setting and away from paid employment.

The western medical establishment once scolded women for 'molly coddling' their children by holding them unnecessarily outside of feeding or changing their nappy (Fullerton 1911) but in the last few decades a completely and unattainably child-centred 'intensive mothering' approach (first described by Sharon Hays 1996) has emerged, praising mothers for spending huge amounts of energy and time on their children. When photography first became popular in European and English-speaking countries we posed families with mothers covered in fabrics as backdrops to their children so that they appeared alone. Now we have social media platforms and advertising populated with brightly lit images of blissful, fit, glowing, and gorgeous mothers completely preoccupied with their perfect children. To be fair, we also have an increasing number of voices and imagery in books, magazines, blogs, and cultural artefacts speaking to maternal ambivalence, despair, and distress. The visual and verbal definitions of mothering are omnipresent, often contradictory, and subject to change.

When I inquire into my son's gaze in the drawing it reminds me that we inhabit different realities as well as what can be an intensely shared one when we are together or reflect on our relationship. Sometimes these realities blow up and blow us apart, but sometimes we are also capable of deep, spontaneous, and meaningful connection with one another. We can and do move in and out of this 'us'. We can dwell in a deep embodied sense of connection, of briefly being more than ourselves, that simultaneously acknowledges our many 'I's.

An intersubjective maternal identity and cultural expectations of mothering

By the amount of time and energy I've spent on drawing 'us', I am acutely aware of the value I place on my relationship with my son, to be felt by him, to feel him, and to feel us. This raises questions around 'a mother's place' in her child's life, particularly her son's life as he moves towards adulthood.

Cultural ideals dictate that intimate, shared space in healthy mother/child relationships should develop towards respectful autonomy as that child matures (Dooley and Fedele 1999). With terms like 'mama's boy' and 'helicopter parenting'; closeness and physical intimacy in mother/child relationships is considered troublesome if not damaging. As Kate Dooley and Nikki Fedele note:

> Faced with cultural pressures that suggest restraint and withdrawal, rather than comfort and nurture, many mothers feel conflicted about their desire to stay connected to their sons. Traditional wisdom cautions that holding on will be damaging and create psychological problems for sons. Faced with this dilemma, mothers often yield to cultural pressures and disconnect from their young sons because they think it's the right thing to do.
>
> (1999: 1)

Continuing to exemplify warmth and engagement with our sons during adolescence, even when they pull away, is not necessarily going to result in a co-dependent relationship and a stymying of their growth or our own. For example, Christopher Trentacosta et al. found that during transitional periods in a child's life 'relatively high levels of warmth and openness' in the mother/son relationship are positively associated with 'social competence and socio-cognitive reasoning during adolescence' (Trentacosta et al. 2011: 13).

I suggest that autonomy and agency are unhelpfully equated with separation and disconnection. Part of individual empowerment is the ability to seek out and sustain meaningful relationships. At the root of a radical intersubjective ontology is an understanding that experiences are co-created, we are always, everywhere, in relationship/s. As Nick Crossley writes 'self and other are necessarily relational terms and that neither can be conceived as pre-existing the other [...] radical intersubjectivity is prior to egological intersubjectivity' (1996: 15). Varying levels of an intersubjective ontology have continued to gain traction in modern-day theories of the extended or embodied mind (Clark and Chalmers 1998; Di Paolo and De Jaegher 2015; Fusaroli et al. 2009; Fuchs 2016).

I recognize that my intersubjective maternal identity is shaped by my own experiences of being/not being mothered, mothering my son, our health, socio-cultural, educational, and financial circumstances, amongst many others. I am not like Descartes's thinking being, alone in a vacuum of space with only thoughts for company; I exist within clusters of intersecting entities, senses, and places. I exist in relationship with my son in particular when I consider my identity as mother.

This ongoing and essential relatedness serves a personal purpose: this 'usness' matters to me because of my own history of repeated and painful loss. I have spoken with a number of mothers both in my research, therapeutically, and as

friends. Time and again they've grieved the imagined loss of their children, the day their children will spread their wings and fly away. Children will move out and they will have larger lives than the confines of their childhood home but that does not require a withdrawal of affection on the mother's part or a diminishment to the point of disappearance of the mother/child relationship. Spaciousness in the 'us' is not equal to disconnection.

Mother/child relationships change but mothers can still hold a desire to know and be known by their children. I wonder how a wish as simple as this is so easily pathologized and ridiculed. If my son pulls away, if he wants time in his own universe, I choose to respect his space and can ask that he chooses to respect my space as well but that does not mean that in the next hour or day I cannot offer him a hug or chat, to play basketball or computer games with him, to return to our relationship. When he leaves home, I can still send him a digital hug and offer a catch-up as we reconfigure the shape of our relationship together. My warmth and interest, parts of me and 'us' that I need and treasure, do not have to cease and desist because my child is an adult or male.

Carol Gilligan captures my deeply held belief that maternal connection does not equate with harming our children:

> Theories of psychological development and conceptions of self and morality that have linked progress or goodness with disconnection or detachment and advocated separation from women in the name of psychological growth or health are dangerous because they cloak an illusion in the trappings of science: the illusion that disconnection or dissociation from women is good.
>
> ([1982] 1993: xxvii)

I continue to experience and desire a connection with my child while holding my own concerns. Within the glass and mirrors, heady blossoms and infinite night, ghosts and jagged emotions populating my experiencing, the warm grey material *we make together*, in the middle ground of the drawing, shows our ongoing, living connection and captures us in a moment of intersubjectivity. This fabric of 'us' represents our relational agency, the power both of us have in shaping our relationship.

The mother/child 'us' is not always golden. It can hold deep pain, self-loathing, fear for our children and ourselves, anger, ambivalence, and resentment. My drawing captures qualities of myself as a mother with my own concerns arising from other relationships as well as this one, and yet at this moment I am inextricably in a relationship with my son. He too has his own concerns, sometimes those concerns will be for me and us, most often they'll have nothing to do with me, but they are brought into the space of us as we coexist in a relationship, in this moment. The visual performance I make with my drawings, of my maternal and 'us' identities,

tell a story of ongoing and fundamental relatedness, of a self that expands into a mother/child 'us' when we are together and when we reflect on our relationship.

Moving between Intersubjectivities

What this image gave me at the time of making was a sense of the overwhelm in my entangled mother/child relationships. There was the 'us' of my relationship with my own mother and the 'us' of my relationship with my son. A sweet pungent smoke unfurled into my experiencing of intersubjective selves and yet there remained spaciousness, an 'I' as an expanse of night sky. Within the smoke, I am lined with muscle and static, the spaciousness I seek is afforded further from the house on the hill. I sniff a need to step out of the familiar into my vastness, so I might breathe, move, and see more. There is a compression of my chest, a chaotic multiplicity, an awareness of the 'too bigness' of these feelings, fractured

FIGURE 2.2: Ariel Moy, *Moving between Intersubjectivities*, 2020. Ink and pen on paper. 21 cm × 29.7 cm. Melbourne. © Ariel Moy.

thoughts, and sensations. There is a pain in the stuckness … beauty too. If this drawing spoke in words, it might say:

> Your 'us' is alive with evolving intensities but see how big you, your son and your relationship are [...] a *particular* universe, capable, wild and endless. There is room for all of this.

Velocities of Us

The eleventh drawing in my ongoing series exploring maternal experiences and holding was made between 24 and 25 November 2020 (Figure 2.3). I had undergone a full hysterectomy and was aware of a desire to explore what that was like for me but realized as I was drawing that that wasn't what was appearing on the page. This is not unusual. Part of the benefit of expressing experiencing visually is that I put language and conceptualization aside. I invite a preverbal, tacit knowing that resides in a world of imagery and experience, sensation and emotion. What wants to be seen will present itself.

FIGURE 2.3: Ariel Moy, *Velocities of Us*, 2020. Ink and pen on paper. 21 cm × 29.7 cm Melbourne. © Ariel Moy.

Recovering from the hysterectomy forced me to slow down. I noticed even more than usual my son's way of being when he came home from school; the ways we interacted as my world shrank to the couch. He told me about something important and painful but did not want me to respond to it. I was aware of the power I held in his life and the need for tact in our interactions.

The first lines to appear on the page were the four antennae followed by the bodies of the snail and bird-like creatures (both of these creatures have represented aspects of us throughout my current drawing series). I needed different textures in the drawing, and these became mountains and sky. I wanted to convey movement because the feeling of mothering was, unlike my recovering body, electric, alive. There was doing and being and shifting going on beneath the surfaces of our relationship. And in the distance, a silhouette of a city, as if we were far away from what was known of us. We were changing.

Both at the time of making and of writing this chapter, I could not identify which one was me and which one was my son. They both represent the speeds with which we approach one another. When we are slow, we are often quiet and physically close, existing at a snail's pace, our home upon our backs. Like Peter Gazendam's two bronze slugs in *A Long Conversation (For Oona)* (2017), there's no rush. At other times we flit, glide, and hover around one another, covering vast distances together, enjoying a shared joke, flailing in grumpy disagreement, or leaning in for a quick hug. On the day of the drawing, I felt the differences in how we moved but couldn't tell you who moved fast and who moved slow only that it required a delicate, implicit coordination. My felt sense was of varying tensions within 'us'.

I was aware of my role as mother, using my antennae to feel into which way to respond to him, a looser holding. But I also saw him sensing how to respond to me. We engaged in a reciprocal dance in a moment of connection. This echoes the 'dyadic dance' of so much mother-infant research, therapeutic practice, and theory, right back to the early attachment work of John Bowlby and Mary Ainsworth (Provenzi et al. 2018). As Vangie Bergum writes, mothering is a 'concrete intimacy, in which the mother and child journey together, giving and taking, pausing and moving ahead, like dance partners sensitive to the movement and rhythm of each other' (1997: 169). This is a performance of 'us', mother and son, in intersubjective being.

I spend time with pen and ink exploring my maternal identity and our relationship because while mothering is not the only thing that constitutes my lived experience, it does significantly inform and is informed by my other relationships. Being a mother, for me, is to be a part of an often hard-to-articulate 'us'; an 'us' that has room for a kaleidoscope of intersubjectivities.

Tatjana Takseva in *Mother Love, Maternal Ambivalence, and the Possibility of Empowered Mothering* describes how recognizing, sharing, and normalizing feelings of ambivalence can strengthen a mother's subjectivity

'by acknowledging the intertwined but separate interest of herself and her child' (2018: 164). When I draw, I allow for and illuminate personal and relational contradictions and emotional tensions, something art can do. Mother love need not be incompatible with a range of emotions from joy to anger. I see this when I draw it out. My son and I possess worlds of difference in identity and experiences, we inhabit other intersubjectivities but in some moments, when we're together or reflect on our identities as mother and son, we enter and expand into a strange space of 'us'.

I love this 'us' as painful and challenging as it can sometimes be. When my son comes to me and shares something and then flits away before I can articulate a response, I know that what he's offered is still forming, as fragile as the crisp houses we wear on our snail backs. I remember that at this stage, at this age, I still have a significant role to play in how he makes meaning of things and so I try to ease along gently, spaciously, at a predictable pace. We are both snail and bird, we are the mountains and cities and stars. The drawing entirely shows 'us' in our ever-changing velocities.

Making and Seeing 'Us'

Drawing is one way I pay attention to, reflect upon, and 'perform' my maternal identity, our mother/child 'us'. There are so many ways in which we can explore, express, and come to know mothering. In her research with chimpanzee mother/child dyads, philosopher Maria Botero described how assumptions about 'good mothering', including the expectation that it is communicated in a constant loving maternal gaze, need to be re-examined. She was astounded to notice that chimpanzee mothers conveyed affection and developed their infant's social/emotional functioning while hardly ever looking directly into their eyes, they achieved this via touch and holding. As she writes 'most of the ways we *observe* caregiver and infant interaction, such as observations of attachment or maternal sensitivity, ignore crucial non-visual modes of interaction' (Botero 2020: n.pag., original emphasis). I recognize that this reflection may only be applicable to chimpanzees at this stage of research, the particular ways they mother constrained by their other-than-human bodies and environments, however it might offer us pause. We have an opportunity to wonder about and expand our 'criteria' for mothering and affection and how that affection is enacted. We might consider that there are many potential ways we share, give and receive affection within human mother/child relationships.

Paying attention to what is known just outside of cognition; spending time with knowing held in the body, through proximity and touch, creative expression,

and relationships, can provide nuanced, evocative, simultaneous, and compelling information. At the same time, as Ardra Cole and J. Gary Knowles write:

> The knowledge advanced in arts-informed research is generative rather than propositional and based on assumptions that reflect the multidimensional, complex, dynamic, intersubjective and contextual nature of human experience [...] knowledge claims must be made with sufficient ambiguity and humility to allow for multiple interpretations and reader response.
>
> (2008: 67)

Through experience, therapeutic work, research, and artmaking I become aware of the sensations and conceptualization of the mother/child 'us'. Like a work of art or a dream shared with another, I've found that approaching my maternal identity as an intersubjective entity invites compassion, curiosity and relational agency. This intersubjective identity serves as a radical reply to ongoing and significant tensions around individuality, agency, and mothering in modern western society.

A growing body of research and theory over the last few decades has highlighted the intersubjective qualities of parenting including the ways in which parents' and infants' brains and psychological functioning co-develop (Nugent 2015: 6). The 'social neuroscience of parenting' (Linda Mayes et al. 2012: 84) reflects the ways in which a mother's own attachment experiences come into play and develop as their child's attachment experiences are forming. This conceptualization of mothering might easily lead to mother-blaming, but what I see in it is a deep compassion for the adult mother growing along with and facing just as many challenges as her child. While the responsibility dynamic is quite different, it does not mean that mothers should not be afforded a level of care and consideration provided to their children. In this intersubjective maternal identity, the locus of agency lies within the relationship, what mother and child together make of an experience forms their significant stories of 'us'. What I've described are experiences co-created with my son, we make them together though we may take from them quite different meanings.

My artmaking 'performs' maternity for me before I or others apply language to it. Art gives me the freedom to express without constraint and to simmer within experiencing before and if I conceptualize it. Cultural ecologist and philosopher David Abram (1997) notes the ability to engage humanity in dialogue has for millennia been the property of the sensuous realm as well as the verbal and written. From the animate world to the inanimate, like a rock or a supermarket trolley, Abram (Emergence Magazine Podcast 2020) draws our attention to the ways that:

> Everything speaks [...] all things have their expressive potency, although most don't speak in words [...] the colours shimmering from a blossom speak to me, they effect

my mood [...] with writing a sort of new distance opens between our language and the surrounding language of the land [...] writing is magic [...] that has much more than rational effects upon our experience [...] we tend to fall under its spell [...] and the rest of the sensuous domain begins to fall mute.

(2020: n.pag.)

With this chapter, I have also given room for art to speak to for itself (McNiff 2014). The sensuous encounter with imagery and words invites you into engagement or resonance (Finlay 2011: 265) across multiple domains of knowing and being.

By performing maternity through artmaking I can see, hold, touch, experiment with, evolve, and question my identity as mother. 'Usness' emerged for me in those first moments of holding my infant son. The experience was so powerful that I channelled my curiosity into personal and then later academic, artistic, and therapeutic inquiry with other mothers. My curiosity has not abated and a visual as well as written language is forming so that I might convey the rewarding qualities of experiencing 'usness' and the intersubjective agency at the heart of the mother/child relationship.

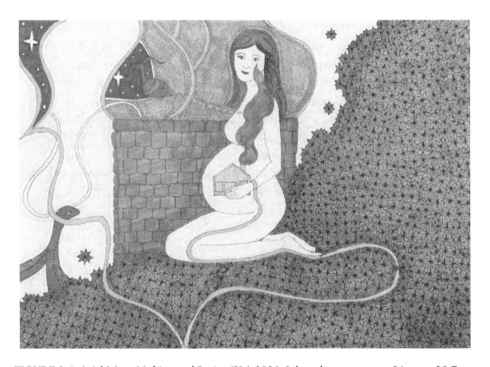

FIGURE 2.4: Ariel Moy, *Making and Seeing 'Us'*, 2020. Ink and pen on paper. 21 cm × 29.7 cm. Melbourne. © Ariel Moy.

I've located maternal identity in the intersubjective mother/child 'us' however I do not expect that that is every mother's experience. The 'us' that has emerged from my artmaking and those of others unfolds a new terrain of exploration, one that asks mothers what it might be like to perform an identity that is larger than the 'I'; a performance of two. In both research and therapeutic spaces, we may consider what it is like to experience and know from a place of 'us'. We might wonder what it is like to build a maternal identity, to grow a relational home, that is irreducible to mother or child but is fundamentally of both.

The homes we create together

A dialogue between the drawing and myself

DRAWING:	Our universe blossoms, we move in and out of intensities. Scent as emotion, a manifold of contractions and expansions.
ARIEL:	Where am I in you?
DRAWING:	A distant star, an antenna, a swollen belly, and a silken smoke. A matryoshka of homes.
ARIEL:	I'm trying to understand …
DRAWING:	You feel losses as your 'us' evolves. Wanting to hold onto that original 'usness' of mother and child. Remember that memories breathe in every moment, there will always be a folding, unfolding and folding again of a past, present and future 'us' in your particular bond, in your particular love.
ARIEL:	The woman looks sad, wistful.
DRAWING:	Yes. Sometimes. Sad and wistful, and multiple and alive in the ongoing 'us' of you and your son. There's room for so much more here than you can yet imagine. Keep wondering …

NOTE

1. https://justiceconnect.org.au/resources/how-the-victorian-governments-emergency-restrictions-on-coronavirus-covid-19-work/. Accessed 12 December 2023.

REFERENCES

Abram, David (1997), *The Spell of the Sensuous: Perception and Language in a More than Human World*, New York: Vintage Books.

Allen, Patricia (1995), *Art Is a Way of Knowing*, Boston, MA: Shambhala.

Barad, K. (2007), *Meeting the Universe Halfway: Quantum Physics and the Entanglement of Matter and Meaning*, London: Duke University Press.

Barone, Tom and Eisner, Elliot (2012), *Arts Based Research*, Los Angeles, CA: Sage Publications.

Bergum, Vangie (1997), *A Child on Her Mind: The Experience of Becoming a Mother*, Westport, CT: Bergin & Garvey.

Botero, Maria (2020), 'Chimpanzees correct cultural biases about how good mothers behave', *Psyche*, 25 November, https://psyche.co/ideas/chimpanzees-correct-cultural-biases-about-how-good-mothers-behave. Accessed 18 February 2021.

Clark, Andy and Chalmers, David (1998), 'The extended mind', *Analysis*, 28, pp. 10–53, http://consc.net/papers/extended.html. Accessed 17 February 2021.

Cole, Ardra I. and Knowles, J. Gary (2008), 'Arts informed inquiry, in G. J. Knowles and A. L. Coles (eds), *Handbook of the Arts in Qualitative Research: Perspectives, Methodologies, Examples, and Issues*, Los Angeles, CA: Sage Publications, pp. 55–70.

Crossley, Nick (1996), *Intersubjectivity: The Fabric of Social Becoming*, London: Sage Publications.

Deleuze, G. and Guattari, F. (1987), *A Thousand Plateaus: Capitalism and Schizophrenia* (trans. B. Massumi), Minneapolis, MN: University of Minnesota Press.

Di Paolo, Ezequiel A. and De Jaegher, Hanne (2015), 'Toward an embodied science of intersubjectivity: Widening the scope of social understanding research', *Frontiers in Psychology*, 6, https://www.frontiersin.org/articles/10.3389/fpsyg.2015.00234/full. Accessed 17 February 2021.

Dooley, Cate and Fedele, Nicolina M. (1999), *Mothers and Sons: Raising Relational Boys*, Work in Progress Publication Series, Jean Baker Miller Training Institute at the Wellesley Centers for Women, https://static1.squarespace.com/static/5caf54214d546e65794e3d89/t/5db9a2d40e18807287f87abb/1572446932661/%281999%29+Mothers+and+Sons.pdf. Accessed 18 February 2021.

Emergence Magazine Podcast (2020), 'The ecology of perception: A conversation with David Abram', Kalliopeia Foundation, Canada, 11 January, https://emergencemagazine.org/interview/the-ecology-of-perception. Accessed 17 August 2022.

Finlay, Linda (2011), *Phenomenology for Therapists: Researching the Lived World*, Chichester: Wiley-Blackwell.

Fraiberg, Selma, Adelson, Edna and Shapiro, Vivian (1975), 'Ghosts in the nursery: A psychoanalytic approach to the problems of impaired infant-mother relationships', *Journal of American Academy of Child Psychiatry*, 14:3, pp. 387–421.

Fuchs, Thomas (2016), 'Intercorporeality and interaffectivity', *Phenomenology and Mind*, 11, pp. 194–209.

Fullerton, Anna Martha (1911), *A Handbook of Obstetric Nursing for Nurses, Students and Mothers*, Philadelphia, PA: Blakiston's Son and Company.

Fusaroli, Riccardo, Demuru, Paolo and Borghi, Anna M. (2009), 'The intersubjectivity of embodiment', *Journal of Cognitive Semiotics*, 4:1, pp. 1–5.

Gergen, Kenneth J. (2009), *Relational Being: Beyond Self and Community*, Oxford: Oxford University Press.

Gilligan, Carol ([1982] 1993), *In a Different Voice: Psychological Theory and Women's Development*, Cambridge: Harvard University Press.

Grand, Sue and Salberg, Jill (eds) (2016), *Trans-generational Trauma and the Other: Dialogues across History and Difference*, London and New York: Routledge.

Hays, Sharon (1996), *The Cultural Contradictions of Motherhood*, New Haven, CT: Yale University Press.

Heron, John and Reason, Peter (1997), 'A participatory inquiry paradigm', *Qualitative Inquiry*, 3:3, pp. 274–94.

Hogan, Susan (2015), 'Mothers make art: Using participatory art to explore the transition to motherhood', *Journal of Applied Arts and Health*, 6:1, http://www.derby.ac.uk/health-and-social-care/research/birth-project/films. Accessed 12 December 2023.

Kapitan, Lynn (2014), 'Beyond self-inquiry: Does art-based research produce real effects in the world?' *Art Therapy: Journal of the America Art Therapy Association*, 31:4, pp. 144–45.

Kleiman, Karen (2014), *Therapy and the Postpartum Woman: Notes on Healing Postpartum Depression for Clinicians and the Women Who Seek Their Help*, New York: Routledge.

Leavy, Patricia (2009), *Method Meets Art: Arts-Based Research Practice*, New York: Guilford Press.

Lett, Warren (2011), *An Inquiry into Making Sense of Our Lives*, Eltham: Rebus Press.

Levine, S. (2009), 'Researching imagination: Imagining research', in *Trauma, Tragedy, Therapy: The Arts and Human Suffering*, London: Jessica Kingsley.

Lupton, D. (2013), 'Infant embodiment and interembodiment: A review of sociocultural perspectives', *Childhood*, 20:1, pp. 37–50, https://doi.org/10.1177/0907568212447244.

Mayes, Linda, Rutherford, Helena, Suchman, Nancy and Close, Nancy (2011), 'The neural and psychological dynamics of adults' transition to parenthood', *Zero to Three*, 33:2, pp. 83–84.

McNiff, Shaun (2014), 'Art speaking for itself: Evidence that inspires and convinces', *Journal of Applied Arts and Health*, 5:2, pp. 255–62.

Moy, Ariel (2019), 'Maternal holding and the storying of the mother/child "us": A collaborative multimodal inquiry', Ph.D. thesis, Melbourne: The Miecat Institute.

Moy, Ariel (2020), 'The way my nan held me', My Blog, 10 May, https://www.holdingmatters.com/post/the-way-my-nan-held-me. Accessed 19 February 2021.

Moy, Ariel (2021), *An Arts Therapeutic Approach to Maternal Holding: Developing Healthy Mother and Child Holding Relationships*, London: Routledge.

Nugent, J. Kevin (2015), 'The newborn behaviour observations (NBO) system as a form of intervention and support for new parents', *Zero to Three*, September, pp. 2–10.

Pascoe, Caroline Myra (1998), 'Screening mothers: Representations of motherhood in Australian films from 1900 to 1988', https://ses.library.usyd.edu.au/bitstream/handle/2123/385/adt-NU1999.0010chapter2.pdf?sequence=7&isAllowed=y. Accessed 19 February 2020.

Provenzi, Livio, Scotto di Minico, Giunia, Giusti, Lorenzo, Guida, Elena and Muller, Mitho (2018), 'Disentangling the dyadic dance: Theoretical, methodological and outcomes systematic review of mother-infant dyadic processes', *Frontiers in Psychology*, 9, pp. 1–22.

Seeley, Chris and Reason, Peter (2008), 'Expression of energy: An epistemology of presentational knowing', in P. Liamputtong and J. Rumbold (eds), *Knowing Differently: Arts-Based and Collaborative Research*, New York: Nova Science, http://www.peterreason.net/Papers/Expressions%20of%20Energy.pdf. Accessed 24 February 2021.

Sousanis, Nick (2015), *Unflattening*, Cambridge: Harvard University Press.

Takseva, Tatiana (2016), 'Mother love, maternal ambivalence, and the possibility of empowered mothering', *Hypatia: Journal of Feminist Philosophy*, 32:1, pp. 152–68.

Trentacosta, Christopher J., Criss, Michael M., Shaw, Daniel S., Lacourse, Eric, Hyde, Luke W. and Dishion, Thomas J. (2011), 'Antecedents and outcomes of joint trajectories of mother-son conflict and warmth during middle childhood and adolescence', *Child Development*, 82:5, pp. 1–23, https://www.ncbi.nlm.nih.gov/pmc/articles/PMC3174687. Accessed 26 February 2021.

van Manen, Max (1990), *Researching Lived Experience: Human Science for an Action Sensitive Pedagogy*, New York: State University of New York Press.

3

Still Mothering:
Reflections on Life, Death, and Love
through the Eyes of Bereaved Mothers

Abby Arnold-Patti

This chapter includes poetry and narratives of mothers of stillborn infants. I offer here my autoethnographic account of stillbirth, woven together with the experiences of women I have come to know over the last ten years. These accounts show how motherhood refuses to be contained by the boundaries of life and death as women express the ways they continue to mother their deceased child. This chapter asks questions like what it means to a mother when there is no child to mother, what does it mean to mother a memory, and how do mothers exist and perform motherhood within the tensions of remembering, forgetting, and continuing to live without their children as time passes. It does not offer answers, but instead invites you into the experience of bereaved motherhood.

All the vignettes and poems included here are based on the stillbirth of my son, Davis, in 2011, except for two: 'The Decision' and 'The Dress'. Those two stories reflect experiences central to child loss that my own story did not contain. 'The Decision' and 'The Dress' are accounts based on the experiences of women whom I served as a volunteer bereavement doula. In that role, I journeyed with them from the point of diagnosis until the death of their child. In this most intimate capacity, I was able to witness indescribable pain and love, and nurture my own wounds by caring for others. Through their experiences, I came to understand my own in new ways. They have generously granted me permission to share the following impressionistic representations of their stories and have chosen to remain anonymous. To provide cover,[1] I have blended their accounts into a layered assemblage of voices and crafted vignettes that are reflections of several lived experiences. The result is a pastiche, kaleidoscope view of the diverse, dancing fractals of grief, joy, and love that encompass bereaved motherhood.

This is not written as a cohesive or linear narrative because bereavement is not a cohesive or linear process. There is no clear beginning or end here. It is jarring, fragmented, and chaotic. These words are intended as poetry that aims to capture experiences beyond symbolic capacity. If you are a bereaved mother, I hope you find comfort in these pages and feel a sense of solidarity and affirmation. If you are not a bereaved mother, consider this an invitation to temporarily experience a relationship so intense and life altering it cannot be contained or constrained, even by death. It is a sacred invitation into the lived experience of another, and a glimpse into a version of motherhood too often unseen.

Still mothering

Being your mother (you, the baby who died in my arms)
means forever dancing (or running, crawling, or being violently thrown)
between the pain and fear of remembering too much
and the pain and fear of forgetting too much.

Still

The heartbeat monitor is still.
I sit still, hoping as the nurse rolls the doppler across the cold jelly on my belly that the monitor will begin to thump and the line on the screen will start to dance. But nothing, still.
Time stands still.
I am unsure what will happen next.
The doctor tells me my baby will be born, still, but that he will be stillborn.
Stillborn. Not a baby, or a boy, or a girl. Stillborn. Like a foreign thing. An object.
Stillbirth is not still, nor is it quiet. It is just as active and messy and loud as any birth.
There is blood, and cries of pain, and the clamoring of nurses and doctors.
There is not the beep-beep-beep of a fetal heart monitor. There is not joyful elation.
There is not the cry of a newborn.
His body lies still and silent on the scale. The nurse wraps him and hands him to me.
He is warm, beautiful, and still.

Time stands still, and I beg it to stop forever. Just let all of the time cease at this moment. Because now the clock has started, and every second for the rest of my life takes me one second further from the only time I held my son, and somehow, I must keep living, still.

The decision

Parenting involves all sorts of decisions, and that is true even when your baby is 'incompatible with life'. *Incompatible with life* is how they described my daughter. That is the medical term for 'not dead yet'. It means she may be stillborn, or I may get a few minutes or a few hours with her, but she will live less than a day. Since my daughter is *incompatible with life*, here are the typical new-parent decisions that I will not make[2]:

1. I will not need to choose a paediatrician for my daughter.
2. I do not need a car seat. She will never ride in my car.
3. I will not need to decide how to decorate a nursery or choose any baby supplies.
4. I do not need to choose childcare.
5. I will not decide between bottle feeding or breastfeeding, or what to feed her. My daughter will never have a meal.

Because I know my daughter will die within the first few hours of her life, I will be making these decisions instead:

1. I must name her but knowing she will die makes choosing her name feel different. There is no need to think about how her name will age. No need to envision an adult with this name. Instead, I consider how the name will look on a tombstone.
2. Who will get to meet her? Who will hold her? I will only have one hour with my child. With whom will I share it? I want everyone to meet her, and at the same time do not want to sacrifice one second of holding her.
3. How will I spend my one day with her? She will only be able to wear one outfit for her entire life, which one will it be? We will not be leaving the hospital, so how will I make a lifetime of memories with her in this cold, clinical hospital room?
4. What will I do with her body? If I bury her, I must choose a plot, choose a casket, and decide on wording for her headstone. If I cremate her, I must choose an urn and decide where to keep it.
5. How and when will I re-enter society? While I have not hidden my pregnancy, my daughter's diagnosis is not something most people know or understand. When will I go back to work? How will I answer questions about the baby?

The one decision I had not considered became the most critical one. If my daughter is born alive, what do I want to happen when it is time for her to die? My daughter is going to die, and as her mother, I must decide what I want that

moment to look like. Who should be there? What do I want the atmosphere to be like? Where should she be when she takes her last breath? Most mothers think of planning their daughter's wedding the way I must plan my daughter's death.

The hospital's social worker explains to me that there will be signs that indicate she is nearing death and asks what I would like her to do when it is time. I am paralysed by grief and fear. Thinking through these other decisions is easy by comparison. After many agonizing days of considering this, I decide I want to be alone in the room with her. I ask for the lights to be dimmed and soft instrumental music to be played. I tell the social worker I want my daughter to be laid on my chest and I want to take a nap with her. I ask to be awakened when it is over. *I just want to go to sleep with my baby*. That was what we did. My daughter laid on my chest, skin to skin. I closed my eyes and wrapped a swaddling blanket around her, and I felt her laboured breaths and faint heartbeat fade. We both went to sleep, and only I woke up.

No parent should have to plan their child's death, but these decisions are some of the only ways I will ever get to mother my child, and I am grateful I was able to make them.

The urn

I sit in my dark bedroom, rocking in an old wooden rocking chair. I hold my now-empty belly. My eyes are puffy and swollen. I am dehydrated from lack of food, blood loss during birth, and tears. My father kneels at my feet, attempting to centre himself in the focus of my distant gaze. 'We have to talk about what we are going to do with the body'. I shudder at the phrase, 'the body', which makes my son, my child, my baby, sound less than human. He is a thing now.

I do not want to bury him. I cannot handle the thought of him being away from me, in the cold ground. 'I cannot bury him. He'll get cold. It's too cold to bury a tiny baby.' It is June in Tennessee. Nothing is cold right now, but my concern over him getting cold on the ground is overwhelming. 'And what happens if I move? I can't have him buried in one place and me living far away. He can't be by himself. I'm not burying him. Just go to the funeral home and bring him home. I just need him to come home'. My father takes my hand and says, 'let's go to the funeral home and talk to the funeral director. He will help us think through this'. I do not want to go, but I also feel a fervent desire to go, as choosing an urn or a casket and writing an obituary are a few of the only ways I will ever be able to mother my child.

All I want to do is have my baby home with me. I know burying him does not feel right. The distance feels too great. I do not like the thought of him being on the other side of town at the cemetery. Although I have no plans of ever leaving our town, the possibility that I could ever have to leave him is more than I can

bear. I've concluded that cremation is the only way forward. With the help of my parents and the funeral home director, I choose a simple mahogany urn for my baby, write his obituary, sign the paperwork, and leave.

I must wait an agonizing two weeks for his ashes to be brought home. My anxiety prevents me from sleeping or eating. I pace most of the day. *What if they lose him? He is so tiny. What if they mix him up with someone else?* When the time comes, my father picks up his cremains for me and delivers his urn to my home. I burst into tears of sorrow and relief. 'He's home. My baby is home'. I rock the urn in my arms and sob as if it were my infant. *It is my infant.*

For the next nine years, his urn sits in my bedroom, within arm's reach. For a time, when I travelled I would either take it with me or leave it with my mother for safe keeping. I had a debilitating fear I would lose his ashes in a house fire, ironically enough. *Ashes to ashes.* In the tenth year, I moved his ashes to the living room, placed alongside photos of his great-grandparents, the furthest he has been from me since his remains were returned to me after his death.

The dress

It was black, sleeveless, and simple. I probably had another one just like it hanging in my closet, but I felt like this event, my daughter's funeral, warranted a new dress. I've known I would have a funeral for my daughter from the moment I found out she would not live, and I suppose if I could have thought clearly, I would have realized I would need to choose something to wear. But I put this off as long as possible, hoping that by some miracle the course of this pregnancy and her life would change, and I wouldn't need a funeral dress. I found myself forced with this unpleasant task just a few days before she is expected to be born and die. This is not how I want to spend the final days of my pregnancy, but I am out of time. I waddle into the boutique, swollen and very pregnant. The woman working the cash register greets me, 'How can I help you today?'

'I'm looking for a dress to wear to a funeral', I reply, not wanting to explain the details. It is important to me that I look nice for her funeral. This will be the first time anyone will see me after her birth and death, and I feel on display. But more importantly, I want to dress up for my daughter.

'I can help with that. What size are you thinking? We don't carry maternity'. I had not considered this practical detail. I have no idea what size I will be just a few days after her birth. I stand in awkward silence calculating how best to answer her.

'I won't be pregnant then'. I choke on the words. The end of my pregnancy marks the end of her life. As long as my body is supplying her oxygen, she can live. Her life will end when her lungs expand for the first time. If I could stay pregnant forever

I would. Stating it aloud – the end of my pregnancy is imminent – is more than I can bear. I break down into tears. The cashier looks at me bewildered and concerned. She starts to walk toward me, 'Oh honey. I'm sorry. Whose funeral is it?' I cannot answer her. I don't have the emotional energy to explain this to her. I just wave her off and leave.

I am sobbing uncontrollably by the time I reach my car. I hurriedly reached for the phone and called my mother. In the time it takes to dial her number and her to answer I have careened into a full-blown panic attack. I do not know where I am or why I am there. My chest is so heavy I feel unable to breathe. My mom answers her phone to hear my sobs and screams. She asks enough questions to figure out where I am and comes to me in the shopping centre parking lot. She drives me home, leaving my car behind, and we decide to try again tomorrow.

The next day mom picks me up to try dress shopping again. I must complete this horrid task, and I am running out of time. My daughter is due in two weeks, and she is likely to come early. The details of her birth, death, and funeral have been planned with the help of my doctor, social worker, doula, and funeral home director. Unfortunately, there is not a person trained and assigned to help a mother choose an outfit to wear to her child's funeral. I realize in retrospect that my mother, my daughter's grandmother, is facing the double agony of grieving for her granddaughter and carrying her daughter through this unimaginable trauma, and that there is nothing more she can do than take me dress shopping.

This time, my mother helps me plan ahead. We will go to a large department store where we are less likely to have to interact with a sales associate. I decide to get a medium and a large of the same dress and to return the one that doesn't fit, and to look for something loose around the middle. Our mission is to get in and get out as quickly and with as little interaction as possible. Explaining what I'm looking for and why is too overwhelming.

We find the dress. It is perfect, and for the rest of my life that dress will hang in my closet, but I will never wear it again. It is a cheap, basic, black dress, but it is special because it was purchased for her big day – the one day the world acknowledged my daughter. I will never get to choose an outfit to wear to her kindergarten graduation, her middle school awards day, or her high school graduation. I will never get to choose an outfit for family portraits with her, or her sweet sixteen party. I will never have a mother-of-the-bride dress. This black dress I bought for her funeral is it for us, and so it is a cherished thing. All the things associated with her brief life, from the funeral dress to the hospital bracelets, become cherished items. The absence of all the things I'll never have like school pictures, homemade art projects, little lace gowns, favourite toys and lovies, makes the funeral dress, and other tangible things associated with her, even more precious to me. That black dress, and the little treasure chest of keepsakes from her life that sits under it in my closet floor are my most prized possessions, as they are tangible reminders that she lived.

Into the liminality

We are women of the in-between.

Not-quite-mothers – we don't change diapers or swaddle babies.

Not-quite-childless – we carried babies, withered in pain birthing them, and held them briefly.

We emerge from the delivery room with postpartum bellies, leaky swollen breasts, and empty arms – a body confused.

We complicate things.

Am I to take parental leave or bereavement leave?

Do we acknowledge the baby's birth date? Birth date. Death date. Is this a happy or sad day?

We observe how people tiptoe around us, afraid to mention our children.

Afraid to not mention them.

Often, we mention them first to put people at ease.

The emotional and intellectual labour bereaved mothers expend making themselves legible to the people around them is significant.

Outdoors

I go outside to find my muse, and I realize it is because I find him there. When I feel the wind on my face and the sun on my shoulders, I feel my son. When I am enveloped in the vastness of the night sky, I feel simultaneously insignificant and connected to the entirety of the universe and that brings him close, crossing time and space like the moonbeams. If the light from stars billions of miles away can reach me, I can reach him. When I stand on the edge of cliffs and my own mortality feels near, so does he. The light bouncing playfully off rhododendron leaves and tumbling into creek beds reminds me of the bouncing toddler I never got to chase. When I'm outdoors, he comes to me and then so do words, songs, and images and all the creative energy that I lost the day he died.

Negative space

I see you in the negative space of all the family photos.

The ones that look complete to all the people who don't know about you.

Three smiling, nearly identical children with widow's peaks and dirty blonde hair.

They don't know about the one missing.

And that's why I can't have a family portrait hanging above the mantle. It would be a betrayal.

Negative space between your 12-year-old sister and 7-year-old brother, where you, a would-be-10-year-old boy should be.

Negative space in the third row of the SUV.

Negative space in the fourth bedroom of the house that has become a mostly unused guestroom.

Negative space in my heart. A hole just your size. One that no other child could ever fill.

Filling negative space

Some of the ways I've tried to fill the negative space:
Exercising
Working
Cleaning
Drinking
Sleeping
Travelling
Partying
Eating
Writing
Planning
Dieting
Shopping
Decorating
Planting
Painting
None of them worked.

Living with negative space

Most days I don't cry. Many days I don't even actively think about him. Of course, he's always there, lingering just beyond my consciousness. Sometimes the dam breaks and the grief rushes in and overtakes me. Those times are increasingly rare as time goes on, and that is a necessary relief that allows me to continue to function. But that relief is tempered with fear that every easy day takes me one step further away from him. Is fresh, crippling pain the only way to mother my son?

Time is both my friend and my enemy. My only hope and my biggest fear. Time does not heal. It just creates distance. At times that distance saves me. Without some distance, I wouldn't survive this. At the same time, that distance pains me. Every moment is a moment further away from the day I had with him. My biggest fear is my memory of him fading. Memories of loved ones who've died are really all that any of us have. The difference for stillbirth mothers is that the memories are so few, and so isolated. No one knew my son but me. My fear is that as time erodes my memory his story will fade with it, and there is no one else to speak of him. When I die, his story and memory will die with me. Mothering him means preserving his memory in whatever ways I can for as long as I can.

I've visited five therapists in nine years, desperate for peace. Frustrated, I make an appointment with a new therapist who offers an 'innovative therapy for trauma survivors'. At our first meeting, she takes my history, listens to my story, and explains the treatment she uses 'dulls the memory of the traumatic event'. I begin to shake and eye the door. Fight or flight takes over my body and I struggle to stay seated. My knee bounces and my muscles tense. I explain to her that I do not want to dull any memory. I tell her how I refused pain medication during labour because I wanted to feel everything I could possibly feel, and I was afraid anaesthesia may distort the memory of the one day I got to spend with my son. I end the appointment and leave. Six therapists in nine years, as I continue my quest to balance the scales of grief, pain, memory, sanity, and love.

Mother's Day

I work so damn hard to be happy on Mother's Day so that my three living children can experience the excitement and pride of showering me with handmade cards and flowers, and so that I can honour my own mother. I spend the entire day performing for everyone else, very aware of the absence. I usually end the day physically exhausted and emotionally drained. No one ever mentions my dead son on Mother's Day.

This year, I wake up on Mother's Day alone. My children are at their biological father's house and my partner is away for work. The children will be home soon for a Mother's Day meal with me and my own mother, but until then I sit in solitude, and I'm thankful. I sip my coffee on the patio and watch it rain. It is one of those southern spring rains that leaves the air crisp and fresh and makes the trees especially vibrant and lush. This is my Mother's Day celebration with the child I'm missing. We sit together, my spirit and his, in the quiet rain. I let the grief wash over me as I wonder who he might have become had he lived. My tears fall. The rain falls. I feel at peace as I watch the leaves dance with the wind. I feel sadness

and guilt that I am not with my living children right now. Social media posts filled with Mother's Day breakfasts-in-bed and husbands' tributes to the mothers of their children exacerbate the pain. My marriage to their father could not withstand the transformative, debilitating nature of grief. We aren't alone. A disproportionate number of bereaved parents end up divorced (Rogers et al. 2008). So, this Mother's Day morning, I am missing all four of my children, as my three living children are celebrating their stepmother right now.

The pain is coupled with gratitude. I have a loving, compassionate partner who holds space for my grief and loves my children. I have three healthy, beautiful children. I have a career and a life I love. Yet, despite all this goodness, I am overcome with sadness. It has taken years for me to learn that gratitude and grief can coexist. Because I'm alone today, I can ride the waves of my emotions without feeling compelled to perform for anyone. I can linger in my feelings of sadness and thankfulness that I'm alone on Mother's Day. I can spend my morning dwelling in the tension of grief for my dead son and gratitude for my living children, in part because I am alone. Only in solitude can I embrace the full range of emotions I feel on this day. Once the family arrives, I will tuck my grief away, thankful to have had this quiet time on the porch with the child I'll forever miss.

Class of 2029

My living children come home on the last day of school excited to show me their yearbooks. I take a little extra time lingering over the photos of the fourth-grade class, even though I do not have a fourth grader. These would have been his classmates, and I know their faces well. I watch them from afar, every morning as they shuffle down the sidewalk into the school building, and I wonder which of these children would be his best friends. What colour backpack would he want? What would be his favourite television shows and hobbies? What would be his favourite subject in school? Watching these fourth graders at my children's school allows me to imagine the possibilities of who he may have been, had he lived to be 9 years old.

These fourth graders, their parents, and their teachers do not know that a little boy is missing from their class, but I do. When they celebrated their kindergarten graduation, I thought about the boy who is missing. When their first day of school photos flood my social media timelines, I feel a mix of emotions as I ponder how my son would be feeling about his first day in a new grade. I watch them grow up from the carpool line, through the yearbooks, and on my social media feeds and it brings a comfortable, familiar sadness. Seeing them does not remind me of my dead son. I do not need reminding. Watching them is like peering through a window into the life we almost had, had he survived. It is a tiny taste of the sweetness of

raising a little boy I will not get to raise, and while it is bittersweet, I welcome it. When the class of 2029 and their families celebrate their high school graduation, I will, in my heart, be celebrating the classmate they never knew they were missing.

The ninth Christmas

The year 2020 was when I didn't hang his stocking. I couldn't manage the pain of seeing it flat and empty on Christmas morning while the others were overflowing with treats. Not the year of the pandemic. I was already feeling enough grief from not spending the holidays with my family. Instead, I felt the guilt of having stockings for my three living children on the mantle all season while the stocking for my dead son lay folded in the closet. The choice was between a few weeks of dull, nagging guilt or a few hours of crippling pain on Christmas morning. I opted for the former. I hung ornaments bearing his name on the tree, I bought myself a beautiful winter bouquet to remind me of him, and I donated to a children's charity in his memory, but I didn't hang his stocking this year for the first time since his birth and death and I wonder if this is the first sign that he is fading away from me; the beginning of his existence being erased. If his mother doesn't insist on his presence in the family, who will?

I'm reminded of the stillborn my great aunt birthed in the 1940s. No one remembers that baby's name, or if it was a boy or a girl. All that remains in the family history is the vague memory that Great Aunt Lurlene had a baby that died. That possibility evokes a fierce fight and defend response in the depths of my soul. My son existed and will be remembered, and as his mother I will be the bearer and protector of his memory. The tension between wanting to protect myself from the grief and wanting to preserve his place in the family narrative is the razor's edge upon which I live every day – constantly searching for reminders of him while simultaneously shielding myself from the debilitating pain of missing my son.

I am still your mother

Even before I went into labour, the flowers started arriving. As people learned my son would be stillborn, the expressions of sympathy poured in, and I am fortunate to have been shown such love. When I returned home, postpartum, broken-hearted, with empty arms, my home smelled like a funeral parlour. There were lovely bouquets on nearly every surface. The smell was nauseating to me, and while I was grateful for the support, I felt numb and I spent much of the first month after his death in my bed, heavily medicated, depressed, and physically drained.

My parents cared for my living children and kept up my house, taking out the floral arrangements as they died. By the time I emerged from my cave of grief and solitude, the only plant still living was a fern someone had sent. It was thriving in the sun-soaked dining room. That fern came to symbolize so much for me. I even began referring to it as my 'Davis-fern', named for my son. The fern became an outlet for my need to love and nurture something.

Ten years after my son died, the fern died. The dead fern sat in my dining room for weeks as I continued to water it, move it around to different parts of the house to vary the sunlight, set it outside for fresh air, and fertilize it, until one day I finally gave up. I tearfully took the fern to the garbage dump, saying repeatedly, 'I'm sorry. I'm so sorry I couldn't keep you alive'. I've cried that same apology to my son countless times. I felt helpless and like a failure. I couldn't keep my son alive in utero, what should be the safest place for him, and I couldn't keep this fern alive either.

At first, I was irrationally inconsolable over this houseplant. Losing the fern was like losing a connection to my son. As a stillbirth mother, those connections are few and precious. As I close in on my first decade as a stillbirth mother, I am finally starting to recognize that my relationship with my son does not reside in, or depend upon tangible, visible things. While it would be nice to have more photos, keepsakes, or houseplants, my connection to my son is internal, eternal, and cannot be contained by time, space, or materiality. I am still your mother, Davis, even though the fern died.

Coming out of the stillbirth closet[3]

'Do you have children? How many?' This common question is one I know is inevitable in most social interactions and one I absolutely dread. There is no safe way to answer this question. I'm not even sure what is an honest response. How many living children or how many children total? Do you want to be comfortable, or do you want to know the truth? I always must evaluate the likely duration and depth of the relationship as I consider my answer. If I say three now, at the beginning of our relationship, will you think I have lied to you later when you learn of my fourth child who has died? If I say four now, will you ask where the fourth one is when you only see three? Will you ask how old they are? If either of these questions are asked, then I must explain that one of my children died and deal with your response, and often I end up comforting you. The emotional toll it takes on me is rarely worth it, and the labour of negotiating these disclosures (or lack of disclosures) in every new social interaction is taxing.

I have been accused of oversharing and making people uncomfortable when I am honest about how many children I have. I have been accused of being deceitful

and I feel disloyal and inauthentic when I fail to mention my deceased son. There is no way to win. The exhaustion of telling my story repeatedly leads me to just give the simple answer. The guilt of leaving out one of my children brings me back to being vulnerable and honest, even in impersonal interactions. The stress of negotiating these tensions with every social interaction is one of the invisible burdens of bereaved motherhood.

Insisting on our motherhood

As a bereaved mother, it is an act of resistance to insist upon my motherhood in a world that would prefer I not acknowledge it. Historically, mothers like me have been told to move on, get pregnant again, and not speak of their babies who died. Just a generation ago, stillbirth mothers were often not allowed to see, hold, or name their child. Many never knew if they had a son or a daughter. While that has changed, the silence and stigma surrounding stillbirth has not. People are uncomfortable acknowledging that pregnancy does not always end happily and that babies die.

Every time a bereaved mother says her baby's name, it is an act of protest. When she reminds the world her baby existed, those who hear her must face their own fears, mortality, and discomfort with the realities of life, death, and love. Movements uniting bereaved mothers, such as memorial walks, fundraisers, and social media campaigns, act as sites of affirmation for bereaved mothers who too often feel alone, and as sites of contestation in a society uncomfortable with death (Arnold 2020). Individual acts of memorialization such as tattoos, displayed photos, or social media posts too frequently draw condemnation, as bereaved mothers are judged harshly for being 'stuck' in their grief and unable to move on with their lives.

I will forever say his name, insist on my motherhood, and resist the erasure of his existence. Being his mother is an active thing, every day, even a decade after his death. His spirit is all around me. My love for him is visible in the sadness in my eyes and in my smile when I recall the way he felt in my arms. My grief is an extension of my love and therefore it will never end, nor do I want it to. For me, grieving is mothering, and I insist on my right to do it.

Conclusion

A child without a mother is called an orphan, but what is the word for a mother without her child? It is an experience so unfathomable that it has

no name, yet we exist, persist, and insist on mothering our children. We still live, even though our child does not. We keep breathing even when doing so feels impossible. We are warrior mothers who love with such strength and ferocity that even death cannot separate us from our children. We seek them in memories, cherished possessions, nature, poetry, and activism. Although they have died, we move through life with them in our minds and hearts, always close to us, though invisible to others. We carried them in utero, and we carry them still.

Acknowledgements

Thank you to the women who have shared their stories and their children with me. I cherish them. I'm most grateful for Chris Patti and his unending devotion, love, and support. Thanks to my parents Bobby and Sheila Arnold and to my living children Sean, Lucy, and Noah, who have carried me through my darkest days. This chapter is dedicated to Davis, whose life changed the entire world. Thank you for teaching me, dear son. I love you forever.

NOTES

1. Ethnographic cover provides an ethical way to provide co-participant anonymity while still presenting detailed accounts of personal experiences by blending two or more stories into one account, each providing 'cover' for the other in such a way that the representation is an accurate reflection of the lived experiences, however no one experience can be easily extracted from the other.
2. These 'lists' were inspired by the work of Keith Berry.
3. While the disclosure of stillbirth does not carry the same risks, the labour of (re)negotiating the disclosure of child loss in various social contexts echoes the disclosure of sexual identity.

REFERENCES

Adams, T. (2011), *Narrating the Closet: An Autoethnography of Same-Sex Attraction*, Walnut Creek, CA: Left Coast Press.

Arnold, A. (2020), 'Birthing autoethnographic philanthropy, healing, and organizational change', in A. Herrmann (ed.), *The Routledge International Handbook of Organizational Autoethnography*, New York: Routledge, pp. 209–24.

Berry, K., Gillotti, C. M. and Adams, T. E. (2020), *Living Sexuality: Stories of LGBTQ Relationships, Identities, and Desires*, Boston, MA: Brill Sense.

Rambo, C. (2019), 'Cultivating mystery/concealing and performinvg identity: Strange accounting as queered autoethnographic praxis', *Symposium on Autoethnography and Narrative Inquiry*, St. Petersburg Beach, FL, January.

Rogers, C. H., Floyd, F. J., Seltzer, M. M., Greenberg, J. and Hong, J. (2008), 'Long-term effects of the death of a child on parents' adjustment in midlife', *Journal of Family Psychology*, 22:2, pp. 203–11, https://doi.org/10.1037/0893-3200.22.2.203.

4

Mothering in the Peripheries: An Autoethnographic Account of the Challenging Matrescence of a Neurodivergent Woman

Claire Robinson

This piece charts how I embarked on my matrescence alongside recognition of being neurodivergent and the pursuit of medical diagnosis and support. I will relate the gifts and challenges of autistic mothers, and how masking tendencies inform their rendering of a 'good mother' performance. My navigation of motherhood will be explored as I develop in self-understanding and a sense of sisterhood; forging and maintaining meaningful connections yet still feeling immensely overwhelmed. My perspective is woven with the influences I drew strength and insight from, including the fields of motherhood studies and matricentric feminism. I will highlight the commonalities of my experience with other late-diagnosed or self-recognized autistic women, many of whom have neurodivergent children, and the growing academic and professional understanding of them. This is presented alongside the development of peer-led supportive spaces for neurodivergent mothers, which represent changing narratives and technologies, with forums accessible to the most marginalized and soul-saving to many. This context facilitates the construction of authentic identities and the formation of communities of self-advocacy, sharing, and peer support, permitting a growth in voice-giving opportunities and promoting autistic-led research and activism. This runs parallel to the growth in mothering advocacy and matricentric activism, with some overlap. There has been an expansion of literature on the importance of identifying and meeting the needs of autistic mothers. Autistic representation has the power to influence the course of theory, healthcare pathways, and popular discourse.

Hidden in plain sight

My younger self pursued a life set apart from the 'despicable feminine void' (McAuley 1986) of being a mother. If children were to feature in my future, I envisaged their arrival only after carving out and consolidating a career. Aside from it being something I understood as oppressive and limiting, I just felt motherhood was not for me – it was what others did, and I always felt detached from them. Anne Enright speaks of a glass wall facing her in her thirties, which resonates with me:

> On my side were women who simply *were*. It didn't seem possible that I would ever move through the glass – I couldn't even imagine what it was like in there. All I could see were scattered reflections of myself; while on the other side real women moved with great slowness, like distantly sighted whales.
>
> (2004: 13, original emphasis)

In my mid-twenties, I undertook some midwifery training, experiencing pregnancy and birth vicariously; gaining insight to equip me if I ever did join the others in procreating. At 35, I became a mother. Following the birth of my second child, at 39 I was diagnosed as neurodivergent (autistic with ADHD), after nearly eighteen months of waiting for an assessment and many more months seeking a referral. As I write this initial draft I am about to welcome a third child into the mix, with a year of pandemic parenting behind me. The past six years have provided me an education into myself and other women, cultivating insights and connections to sustain me through considerable challenge.

Donna Williams's fruit salad interpretation of autism provides a useful model of what it means to be autistic (Williams 2008), which involves 'trouble with' connections, tolerance, and control (Williams 1996: vii), while Sarah Hendrickx identifies three areas of challenge for autistic people; sensory, social and change (Hendrickx 2019). I am one of an increasing number of women recognizing themselves as part of a 'hidden pool' of autistic women having lived difficult lives with unmet needs in these areas, never recognized as being neurodivergent (Autie 2018a; Grant 2015, 2017; Hill 2016; Parker 2019). Many only reach this self-awareness after having children.

I can speak to the immense challenge of living as an undiagnosed autistic; with a sensitive nervous system establishing a default state of 'high anxiety' and a need to access and maintain various coping mechanisms for survival. For me, this meant constructing a way of life providing time and space to recover from social and sensory activity, including plentiful sleep. It involved practising sensory conservation and demand avoidance; limiting exposure to sensory input and meeting (or shedding) obligations on my terms (often accompanied by guilt and shame).

I micromanaged life, with exhausting planning, scripting, and processing of daily activities and interactions, combined with intense interests involving study and rumination (often around the nature of being or being a social being). For nearly two decades, this was coupled with recourse to various unhealthy habits and self-stimulatory activity; smoking, substance (mis)use, and ill-judged efforts at attaining social approval. My twenties were an extended adolescence; a confusing time spent missing social milestones and establishing addictions and other coping strategies; 'no one told [me] when to run, [I] missed the starting gun' (Pink Floyd 1973). The trajectory I undertook must baffle any reader of my CV, which tells a story of unrealized potential across two incomplete degrees (one at Oxford) and countless career *cul-de-sacs* and social failures, all underpinned by a tendency to perform highly in an area and subsequently reach burnout, unable to sustain the effort involved to conceal my needs and difficulties. My usual means of retreat was a sudden exit from a work situation, severing all connections amid much shame and low mood; wintering myself often (May 2020b).

Being a mother meant the impossibility of accessing such time-honoured habits, simultaneously adjusting to this loss and the acquisition of unprecedented responsibility, physical and emotional demands, and a relentless state of flux. Mothering brought rapid growth in sensory stimuli, sources of anxiety, social expectations, and accountability, alongside reduced opportunities for sleep and decompression time. The smoking stopped too. As Sarah Hendrickx notes, motherhood

> is life-changing and all-encompassing for any woman. For a woman with autism, additional challenges arise. There are expectations for socializing her child [...] all of which mean not having much time to herself, which may be crucial to her functioning and wellbeing.
>
> (2015: 189)

Like other autistic mothers I sought to do the best by my child in all things; undertaking wide research to allay my perfectionism and need for control amid a child's ever-changing needs (Craft 2018: 107–20). I introduced new social and sensory expectations onto myself, attending various groups and activities. My brain was busy fathoming out new unspoken rules within the social world of mothering, while contending with an abundance of painful sensory input, feeling vulnerable to every sound and light source.

An understanding of sensory processing is foundational to understanding autistic experience, as it underpins our relationship with the world. Williams describes sensory hypersensitivity as hypersaturation of information, due to poor filtration of input and inefficient processing, leading to confusion, anxiety and frustration (Williams 1996: 202, 205). I can relate to experiencing painfully acute hearing

and 'shocking' touch. Laura James describes 'sensory issues magnified to a terrifying extent' following the birth of her second child, where 'the slightest noise, a cupboard door closing, a distant car, felt like an explosion' (2018: 83). After my first birth, on a busy postnatal ward I 'felt [my]self nearly explode with exposure' (Robinson 2018b). Like Sarah Hendrickx I found the ward 'hell on earth' and breastfeeding proved difficult cognitively and sensorially (2015: 186–87). Like others, as a parent I struggled with judging danger and experienced terrifying risk aversion (Hendrickx 2015: 191–94). Bearing the mental load of a household takes its toll on any mother (Emma 2017; Hogenboom 2021) but is particularly challenging with executive dysfunction. The practical demands and logistics of mothering were an endless set of tasks to be fulfilled, with little space to experience joy; 'my enjoyment of my children [was] overshadowed by the sheer effort of parenting [...] a feat of endurance and obligation' (Hendrickx 2015: 192).

The pay-off from my perfectionism (or efforts to perform at an expected level) was the emergence of frequent anger-laden meltdowns. These were often directed to inanimate objects or my partner and could involve self-injurious desire, aggression, and swearing, with stimming such as rocking or flapping to regulate my emotions. I was rarely able to retreat into a shutdown state (a meltdown's quieter flipside). I remember countless 'arguments' erupting and incidents including breaking furniture, snapping hairbrushes, and taking chunks out of a teething toy. I sought to limit my children's exposure to these distress behaviours but they did witness some. I always tried to apologize and explain myself afterwards but will take considerable shame and regret to the grave. Meltdown behaviour is a much misunderstood 'fact of autistic life' amounting to 'complete loss of emotional control' (McKay 2017). As adrenalin-fuelled fight or flight responses they differ from tantrums (Autie 2018b). They are 'involuntary explosions' emanating 'from frightened, uncontrolled and often traumatized neurodivergent people who have reached their limit of endurance' (Thompson 2021: n.pag.). It has been postulated that meltdowns arise from epileptiform activity (Memmott 2019: n.pag.), adding an interesting dimension to understanding autistic neurobiology (very much a physical matter) and rebutting the common conflation of autism with mental disorder. Mental ill-health often arises from autistic experience, particularly in light of masking or trauma, but is not an inherent feature.

Examining matrescence, mothering, and motherhood

Soon after becoming a mother, I attended a Mothers Uncovered peer support and writing group which supported me to process the transition, consider the identity shifts at play, and initiate important connections with other women (Robinson

2018: 87). I later encountered the term matrescence, which has increasing prominence within mothering quarters of the internet. An anthropological concept, matrescence refers to an 'experience of dis-orientation and re-orientation [...] in multiple domains', including the physical, psychological, social, and spiritual (Raphael 1975). Like adolescence, it evokes a sense of becoming or unfolding over a period of normative adaptation. The term has been reintroduced to the academy within the emerging field of maternal psychology alongside calls for more intensive inquiry (Athan and Reel 2015). Aurélie Athan has also presented a concept of reproductive identity concerning a 'life transition marked by disequilibrium and adaptation along with an opportunity for greater psychological integration and self-awareness akin to post-traumatic growth' (Athan 2020). This points to the self-actualizing potential of matrescence, although this may be realized over the course of a lifetime and not apparent amid the seismic changes of new motherhood. As my own experience has shown, '[t]he unforeseen crises of reproduction can upend life expectations and lead to disrupted biographies marked by loss of previous identifications, feelings of unreadiness, demoralization, and eventual self-compassion and self-acceptance' (Letherby 2002).

I began approaching mothering and motherhood as fields of study. Just as midwifery training aided my navigation of maternity services, this acquisition of knowledge and reflection fostered a sense of control, or at least an understanding of the commonality and rationality of my feelings, which writing helped me to process. My feminist consciousness had already led me to consider the mother's role in relation to structural oppression and connect to an online sisterhood. I looked to social media, discovering many mother commentators and supportive forums and exploring a developing community of autistic women.

Women have long been motivated to study motherhood by their lived experience, with most identifying feminism as the conceptual framework to understand it. Building on a legacy of second-wave feminist scholarship, most notably Adrienne Rich's *Of Woman Born*, Andrea O'Reilly brought motherhood studies and matricentric feminism into the academy, identifying the category of the mother as distinct from woman, and arguing that the issues mothers face under patriarchy are specific to their mothering role and identity; 'mothers need a feminism that puts motherhood at its centre' (O'Reilly 2016: 2). Rich applied an important distinction between mothering as practice (lived experience) and motherhood as an institution under patriarchy. Recently a third dimension of identity (subjectivity) has been added by some (Brock 2017). Rich highlighted 'the oppressive and empowering dimensions of maternity as well as the complex relationship between the two' (O'Reilly 2016: 19), understanding how 'the woman's body is the terrain on which patriarchy is erected' (Rich [1976] 1995: 55). She documents her mothering experience in terms of suffering and endurance, echoing my experience:

My children cause me the most exquisite suffering [...] of ambivalence: the murderous alternation between bitter resentment and raw-edged nerves, and blissful gratification and tenderness. Sometimes I seem to myself [...] a monster of selfishness and intolerance. Their voices wear away at my nerves, their constant needs, above all their need for simplicity and patience, fill me with despair at my own failures, despair too at my fate, which is to serve a function for which I was not fitted. And I am weak sometimes from held-in rage. There are times when I feel only death will free us from one another, when I envy the barren woman who has the luxury of her regrets but lives a life of privacy and freedom. And yet at other times I am melted with the sense of their helpless, charming and quite irresistible beauty [...] *I love them*. But it's in the enormity and inevitability of this love that the sufferings lie.

(Rich [1976] 1995: 21–22)

Rich notes that 'the words are being spoken now, are being written down, the taboos are being broken, the masks of motherhood are cracking through' ([1976] 1995: 24). By 1998 there was growing recognition of motherhood research as a distinct field of study (O'Reilly 2016: 9). The 'unmasking' of lived experience has since been evident within sociological study and popular writing (including poetry, polemic, memoir, blogs, and social media content). Indeed, we 'find ourselves at a time when virtual villages are assembled – gin-raising, hat-tipping and advice- (and selfie-)sharing spaces for mothers – vital networks of women who support and sustain their peers in the face of the continual challenge that is motherhood' (Robinson 2018c). This has supported matricentric activism, although there has 'arguably been a fetishization of motherhood occurring alongside the faux liberation of women within labour markets' (Robinson 2018c).

In 1979 sociologist Ann Oakley gave voice to women's stories, documenting their experience of new motherhood and the domestic division of labour ([1979] 2019). In *The Mask of Motherhood*, Susan Maushart elucidated the disparity between expectations and experiences of motherhood, exploring how women denied and repressed the reality of their experience, and misrepresented it, even to themselves (Maushart 1999). More recently Naomi Stadlen brought attention to new mothers' need for outlets of expression, in her Mothers Talking group and interview collection *What Mothers Do* (Stadlen 2004). Her work inspired the Mothers Uncovered format, which brought forth my voice and an anthology of mother's words (Gordon-Walker and Naughton 2018). Katherine May, an autistic writer, curated *The Best Most Awful Job* essay collection. Her introduction presents 'the true dirty business of motherhood [as] a constellation of experiences. That is the only universal: everybody finds their own way through' (May 2020: x). She acknowledges that such writing 'invites sneering: these ungrateful, ineffectual, selfish mothers, airing their dirty laundry in public' but that 'many of us

are ready to weather that storm in order to tell some necessary truths' (May 2020: xvii). Such sneering accords with the critical response Rachel Cusk encountered to her memoir *A Life's Work*, which exhibited her ambivalence and anger as a new mother, capturing motherhood as a wilderness women hack through 'part martyr, part pioneer, a turn of events from which some women derive feelings of heroism, while others experience a sense of exile from the world they knew' (Cusk 2001).

Naomi Stadlen provides the foreword to Vanessa Olorenshaw's *Liberating Motherhood* (2016) which invokes a movement to 'balance and bring justice to the scales of judgment against mothers' (2016: 19) while maintaining 'there has to be a political, visible, active, in-yer-face movement' to tackle the motherhood penalty and raise the value of mother work (2016: 23). In 2021 signs of such a movement in the United Kingdom were evident in the campaigning of Pregnant Then Screwed (Brierley 2021) and represented politically by Stella Creasy MP (Creasy 2021).

Seeking diagnosis and support

I was conscientious in seeking professional help for my distress after having my second child. I accessed my health visiting service, benefiting from supportive chats with kindly women who to some degree 'had been there', and a postnatal mental health group. I attended the latter only once – the group was overwhelmingly large, and its leaders had the misguided notion that belly dancing was an appropriate first session for a bunch of beleaguered new mothers. I self-referred for talking therapy and was turned away on arrival – it was apparently inappropriate to undertake therapeutic work with a newborn in tow lest they distract me, or I traumatize them (never mind that I was breastfeeding and lacked any means of childcare). The therapist was also reluctant to see me as I believed I was autistic (standard Cognitive Behaviour Therapy [CBT] is ineffective for autistic minds). I was sent away with my suicidal ideation.

Later I visited my GP in a distressed state, following a morning meltdown, which should have demonstrated the extent of my struggles. I presented as angry and sweary; operating wholly on adrenalin – it can take 90 minutes as the nervous system finds its equilibrium following the adrenalin release of a meltdown state. Despite my well-reasoned request for a referral for an autistic spectrum condition (ASC) assessment on account of lifelong struggle and suffering, the GP sought only to pacify me, suggesting medication and/or a perinatal mental health referral. Weeks later a perinatal mental health support worker listened to me and initiated a referral to the neurodevelopmental service who later diagnosed me. However, this was at a cost; my honest conveyance of the emotional dysregulation I could

exhibit led to a Multi-Agency Safeguarding Hub (MASH) referral. I had to satisfy social workers that I did not present a risk to my children. All while receiving no support to manage the needs I had clearly expressed across different services.

Pursuing a diagnosis was a means of seeking validation and appropriate support. At times I had high hopes of massive change through therapeutic intervention, but there is little professional support available. I was eventually offered CBT which was unhelpful and counterproductive in triggering stress responses. The social care and health sector is unequipped to support autistic people effectively, particularly where they appear 'high functioning' and lack an accompanying learning disability. The tide is turning somewhat in that autism training is becoming mandatory for most health and social care staff (Health Education England 2019; Department of Health and Social Care 2019). For me, an important benefit to diagnosis is that it might inform the care and understanding I receive as I age while providing an appropriate lens for my children to appraise me with. Anna Wilson's memoir of her mother, *A Place for Everything* (Wilson 2020) is a sobering tale recounting being mothered by an undiagnosed autistic woman and supporting her during her demise. The intergenerational impact of her mother's distress behaviours and the misunderstanding her mother experiences during her last stage of life is starkly drawn, conveying horror that any autistic mother would feel determined to prevent. She dies alone in a care service isolated from her children and husband. Autistic women and their families deserve to have hopes for better futures.

I expected a diagnosis to support greater understanding from my family and partner, whom I alienated regularly through outbursts of rage that reflected my inability to communicate my distress effectively. However, my diagnosis fell on deaf ears – with my quite valid sensory and social needs dismissed frequently. I was accused of using it as an excuse for poor behaviour where I offered it as an explanation for my inability to cope, or sustain coping abilities, and a means of understanding my unmet needs. I have been told to 'get a grip' when I most needed compassionate understanding and practical childcare support. My efforts at providing learning opportunities about sensory overload and emotional dysregulation (sharing links to relevant articles) were derided or ignored. This caused further deterioration in those relationships, so I was grateful for the lifeline of online communities of women, particularly closed Facebook groups for autistic women, autistic mothers, and feminists. My engagement therein varied – sometimes I lurked and learned, enjoying the comfort of like-minded women; sometimes I shared of myself or supported others.

Kristy Forbes, an autistic mother of four, eloquently expresses the benefit of late diagnosis: 'we've worn labels of disorder [...] we are autistic women [...] when we have that answer, it is life changing [it] answers every single question we ever had

about ourselves [...] normalizes every perceived abnormality' (Seeing the Unseen 2019: n.pag.; Kristjánsson and Lúðvíksdóttir 2019). For late-diagnosed women diagnosis often brings grief; for those years lost in pretence of being 'normal'. I had to process anger and sadness around insufficient family support. I believe my family bring their own neurodivergence to things, and over generations have operated in denial of the elephant in the room of autism. I recognize my mother's struggle to engage with my diagnosis and appreciate her own experience of being an autistic mother under patriarchy; 'she is my mother, and I am her daughter, and we are sisters' (Dworkin 1982: 7). I seek to endow my children with an understanding of neurodivergence, by issuing appropriate apologies and explanations, to restrict the intergenerational trauma I pass on and promote their own self-understanding. However, my efforts will be forever limited by the reality of my functioning, and I cannot control my sensory environment and responses alone.

A key forum I engaged within was established by Lana Grant in 2005. A late-diagnosed autistic woman and mother of six, she has written insightfully on mothering (Grant 2015). She had struggled to identify any sources of support or connection for autistic mothers – all online searches yielded only resources on parenting an autistic child. In one year, Grant's Facebook community amassed 140 mothers. Membership currently stands at 4.8K (2021). The group was conceived as a safe forum for mothers to share their lows and highs with non-judgemental peers. Grant's experience echoes mine; she 'finally found the peer group [she] was seeking' (2017: n.pag.). She speaks of pre-diagnosis mothering creating anxiety levels leading to breakdown and being 'sent away with patronizing smiles' from GP visits (Grant 2017: n.pag.). Fortunately for autistic women Grant achieved diagnosis and has advocated strongly for autistic mothers, raising awareness and informing studies that seek to improve the professional support available to autistic women in pregnancy and beyond (Scottish Autism 2016: n.pag.).

Mask dropping and maternal rage

Understanding autistic females requires an appreciation of what it is to mask; the artificial (often unconscious) performance of socially acceptable behaviour and/or hiding of that which could be deemed unacceptable. Masking forms a protective coping strategy to hide difficulties and confusions, enhance social functioning, and avoid negative social consequences including alienation or bullying. It is distinct from code-switching and involves suppressing the instinctive self with camouflage and compensation; controlling impulses, acting neurotypically, rehearsing conversations, and mimicking others (Russo 2018). Using intelligence and performance to navigate the social world demands considerable emotional

and physical energy, proving exhausting over time, and causing deteriorations in mental health and burnout. The phenomenon of autistic burnout as experienced by autistic parents is clearly summarized by Zoe Williams for the charity Autistic Parents UK (Williams 2022).

Autistic masking has made social chameleons of many late-diagnosed women, who upon diagnosis feel confused and unable to locate an authentic sense of self. As with the motherhood mask, 'when the coping mechanism becomes a way of life, we divest ourselves of authenticity and integrity. We diminish our knowledge, our power, our spirit' (Maushart 1999: 6). Online groups for autistic mothers enable access to peer support within circles of other autistic women, who can empathize directly with their lived experience and provide support through their problem-solving natures. Such environments permit autistic women to drop their masks and derive a sense of belonging and authenticity (Jurkevythz et al. 2020: 186).

In brief slithers of time around the needs of my children and working life, I became immersed via smartphone in neurodivergent culture alongside an exploration of motherhood and a resurgence of the feminist consciousness I had held since my youth. In online connections I found solidarity, moving towards an authenticity of self that fostered a sense of peace and belonging hitherto unknown. Over time more autistic voices emerged, many of whom are advocates and activists articulating the particularities of autistic parenting. Kahukura (aka More Than One Neurotype) puts it succinctly: 'I am but layers of encrusted burnout solidified by time and necessity' (Kahukura 2021b: n.pag.). She expands here:

> [Y]ou may question why 'suddenly' you went from being able to manage life (reasonably ok, at least), but now it's so much harder and not just the usual 'parenting is hard' harder, but a deeper, more exhausting, tired to the bones harder. [We] adapted our lives without even knowing it. We likely had rules and rituals that allowed us to recover. [This] all changes [and] on top of having to process a total change in what we knew before all that recovery time is gone. The rules and rituals are gone.
>
> (Kahukura 2021a: n.pag.)

Kristy Forbes shares her mothering experience and the challenge of supporting the needs of neurodivergent children alongside her own. A brave voice, she acknowledges that her children feared her as she 'exercised extreme control and held an unyielding power of instability that oozed fear into [her] family home [due to] an active threat response when [her] drive for autonomy and freedom [were] compromised' (Forbes 2021: n.pag). This pattern of behaviour is the uncomfortable reality inhabited by many neurodivergent women. Forbes 'began to live in alignment with [her] needs and to show up in the world in [her] unique autistic expression', easing her desperation and need for control (2021: n.pag.). To handle mothering

children who share her delicate responses she reframed her family relations; doing things 'differently as a result of doing typically for a long time first and experiencing trauma, disconnection, pain, loss and grief' (Forbes 2021: n.pag.).

When I first accessed Facebook (*c*.2006) I found it a frightening place, taking years to add friends or post content. Confusing as it was, it provided a platform to observe the interactions of others and learn some rules of social engagement. It also had the benefit of allowing processing time within communication, although this was set against the risk of exposure and misunderstandings. I surprised myself in finding closed groups where I felt comfortable enough to occasionally share my experience and I also began to share my mothering life in a way I never imagined, by posting photographic updates of my children. My younger self would have baulked at parading my offspring with such 'sharenting', yet it felt appropriate to document the cause and outcome of my intense efforts – pleasingly one of my favourite feminists agreed (Glosswitch 2015: n.pag.). However, I do relate to Gemma Painter's perspective here on social media and the performance of new motherhood:

> I enter the world of social media under misapprehensions of solidarity; and leave full of unfavourable comparisons, cut adrift and thoroughly unsure [...] I don't know how to process these moments [...] to record them in a way to properly capture their essence [...] without a trail of public announcements and accompanying photographs, does your infanthood really exist at all? [...] I mourn time's passing before we've even begun. A year's maternity leave [...] is sliced up [...] The presupposed itinerary stretches in front of us and we act out each phase as it dawns. I field an endless list of enquiries [...] I become more reluctant than ever to share these details with the world.
>
> (2018: 47)

My rage has kept me warm throughout my life, and thoughts of escape from a punishing existence often bring solace. Thus, it has been helpful to explore the matter of maternal rage and suicidal ideation within expositions of mothering and treatises on the weight of motherhood as an institution. Adrienne Rich located her own suppressed rage within a long lineage of mothers, quoting Alcott's *Little Women* where Marmee tells Jo 'I am angry nearly every day of my life, Jo; but I have learned not to show it; and I still hope to learn not to feel it, though it may take me another forty years' (Rich [1976] 1995: 46). A host of voices on social media are acknowledging and exploring maternal rage, including self-advocates, writers, poets, sociologists, and psychologists. Annie Broadbent, a psychotherapist, presents as 'dark_side_of_the_mum' noting 'a collective urge towards violence at times, wanting to shake one's baby, putting the baby down on the bed a little

roughly, imagining throwing them out the window' (2019: n.pag.). Katherine May's anthology provides this:

> We don't talk about maternal rage [...] that simmers under the surface of countless women; the kind that makes you dig your nails into your fists in an attempt to stop the fury from entering your hands, because if you don't stop it now, it will turn into something shameful.
>
> (Mir 2020: n.pag.)

Lucy Pearce's *Moods of Motherhood* compiles her blog posts on mothering. Pearce has recently started describing herself as neurodivergent. Motherhood has clearly been a 'special interest' to her (Olorenshaw's treatise was published by Pearce's publishing house). In one post Pearce describes herself as 'Not Normal', declaring 'motherhood for the normal is hard [...] when you're not normal it's several degrees harder' (2012: 63). She cites episodes triggered by hormonal upheaval, sleep deprivation, and placing the needs of others above herself, describing being challenged daily and chased 'to utter despair and back again' (Pearce 2012: 29), at times 'entertain[ing] secret fantasies of throwing [her]self off the cliffs' (2012: 61). In times of overwhelm Pearce depicts herself lashing out and screaming, with a need to decompress and desire to physically remove herself to a 'private dark corner [...] until the storm subsides' (2012: 189).

I have explored such extreme emotion in poetry. In the early days with my first child, I found myself relating to extreme examples of mothers at crisis point; from a recent high-profile suicide and other cases of so-called puerperal psychosis to those labelled evil or criminally insane for child neglect or abuse. My first maternal eruption took place in the early hours of my second night with my child in hospital as she struggled to feed. I have documented my birth story and that moment in the unpublished poem *Giving Room*, which explores the process of accommodating a child and acknowledges the impossibility of ever again possessing a room of one's own.

> I was removed to a six-bedded bay
> In the early hours
> As the mania of low iron and lost sleep
> Rose in me alongside her yellow hunger cries.
> Sandwiched between the intrusion
> Of other people's noise
> The insufficiency of curtains to shield me
> From a rage and fright that would persist
> Beyond that terror-shook night.

My response to that memory now is to acknowledge the autistic woman struggling alone in an entirely unsuitable environment; her nervous system threatened to meltdown by the social and sensory stimulation around her while physically compromised and scared to the bone. A casual observer could be excused for writing me off as being thoroughly unpleasant and overly aggressive.

In the first few days at home with my child, I started questioning:

Who speaks of the fear and rage that burn
in a new mother's mind's eye,
behind bashful smiles, weary groans and coy pride?
Who sees her sleep-eluded;
high on adrenalin, duty and grief
attending her precious little thief;
[...]
Who sees the white hot rage writhing and wailing,
wanting to shake, squeeze and smother?

(Robinson 2018e)

In an effort to be seen, I wrote a version of myself, wrestling with what would be termed intrusive thoughts alongside a keen sense of mortality, while processing the overwhelm of birthing my new self, physical complications, and hitherto unknown joy.

After welcoming my second child I described myself as being 'a body that ballooned twice, and still inflates in rages' (Robinson 2018a) in a piece composed as I rage-walked my two infants away from yet another domestic disturbance that had escalated around the desperation and disintegration of my prior self, which had shifted once to accommodate the demands of one child and was blindsided once more in the wake of their sibling's arrival and the need to develop new routines. On top of the expected rise in anxiety and sleep deprivation, I was overwhelmed with the sheer physicality of it all; the pain, strain, and sensory challenge of inhabiting 'a body that barely sits or shits, with bulbous veiny tits that itch from hungry mewling scratching. A body with wrists swollen from care and a spine dutifully contorted during the death of each day's life' (Robinson 2018a). Mothering, and breastfeeding specifically, rendered me objectified and feeling less than human. To me, this less-than condition was the state of womanhood writ large. In nature's sweet oppression and societal ambivalence, I felt doubly bound. It is those recognitions, reinforced by the words of the aforementioned truth-tellers that reignited my feminist heart and refused to accept the various injustices at play throughout the mothering experience. I expect my autistic rationality and abhorrence

of injustice is responsible for the extreme emotion attached to that discourse and my radical feminist leaning. Like the realities of pregnancy and birth, those feminist voices who impart the reality of women who mother bring into stark relief how mothering and motherhood are entirely sexed phenomena. By this, I do not imply biological essentialism, rather the pervasive and enduring subjugation of a female sex class and sex role socialization. Mine and other generations of girls were duped into believing they could 'have it all' within egalitarian load-sharing relationships, yet the reality for those in heterosexual partnerships is that 'having it all' often equates to bearing the full unremitting weight of any offspring in all its unruly, crushing glory (alongside increased threat of male violence, medical trauma, and suicide).

Good mother performance

Sophie Brock conceptualizes a hegemonic maternality theory, explaining how motherhood shapes mothering in terms of Goffman's 1959 model of the performance of self and a Foucauldian conception of power (Brock 2017). Women seek affirmation and acceptance from their 'front stage' audience as they perform the role of a good mother. The Panopticon analogy depicts the operation of control through observation and surveillance. Most mothers could relate to being policed by and internalizing the regulatory 'gaze of others' (Ruddick 1989), becoming socialized to police other mothers (Robinson 2018c). The pressure to perform is keenly felt by disabled mothers and mothers of disabled children, who experience guilt and self-blame over their perceived inadequate mothering (Malacrida 2009; Brock 2017) while fearing negative consequences ranging from disapproval and alienation to child removal. I felt this sense of surveillance as a new mother. Having felt my social performance under observation throughout my life, motherhood sharpened the gaze. An early good mother performance is expressed here:

> [T]he health visitor breezed by [...]
> [she] concocted a confident smile to good effect,
> before offering a cup of tea;
> presenting as worthy, capable and kind; *just SO tired.*
> She knew it best to keep very schtum
> over the prevailing hum that rattled
> in her head as they were nattering
> and guessed it wise not to mention
> so many things that were really mattering.

She proved capable of ticking the boxes
To secure an acceptable Edinburgh score.

(Robinson 2018e)

In a similar vein, Katherine May has shared how her health visitor 'decided not to give [her] the postnatal mental health questionnaire because she could see [she] was fine' (May 2021), when in fact May was self-harming and suicidal. Autistic masking and communication differences combine to keep autistic women below the radar of healthcare professionals.

Women with disabilities go to 'creative and extraordinary lengths [...] to be seen as complying with ideal motherhood' (Malacrida 2009). The stakes are high for autistic women seeking support for themselves and families – they have been open to charges of Fabricated Illness Syndrome, Factitious Disorder or Munchausen By Proxy, and subject to child protection interventions (Roches Rosa 2016; McDonnell and DeLucia 2021). The experience of autistic families has been framed in terms of human rights violations concerning unwarranted interference and lack of reasonable adjustments (Blakemore n.d.). Many autistic mothers exhibit intense connections to their children (Dugdale et al. 2021; Burton 2016), living 'for [their] children and try[ing] to analyze and improve [them]selves every day for them' (Jurkevythz et al. 2020: 15). An autistic mother describes creating another identity as 'a tight-lipped, light-hearted, capable superstar who could soar through the sky of parent groups [...] and numerous other outings and obligations, with ease' (Craft 2018: 107). After a decade of living 'a fraction of myself' she experienced physical disability from chronic pain and 'imploded' with a 'nervous breakdown' as she looked back on the 'terrifying early years' of motherhood (Craft 2018: 108).

The way forward

I know of many autistic women researching autistic motherhood and have contributed my testimony to some studies. It is heartening to see them contributing their insight and intellectual rigour to support greater awareness of autistic mothers. Tanya Burton's work highlights how autistic mothers experience themselves as different and the impact of this on their experience (Burton 2016). Burton speaks to the importance of diagnosis to aid the recognition and support of individual needs, citing the benefit of labels in a society where the medical model is prioritized, particularly where 'difference is not obviously visible but can lead to difficulties in communication or differences in behaviour' (Burton 2016). As in my experience, women exhibit a reliance on using a diagnostic label 'to facilitate understanding from others and for themselves and as a way of legitimizing their difference in

order to access support or resources' (Burton 2016). The growing number of referrals for diagnostic assessments and actual diagnosed women can only improve the integrity of the data that social care and health commissioners and educators organize their priorities and resources around. Like me, Burton hopes that the need for labels will lessen in time 'through developing understanding of difference, rather than deficit' (Burton 2016).

There are emerging efforts all round to expand the evidence base around autistic motherhood and improve service provision, or at least signal the need for such improvement, including acknowledgement within midwifery of the need to understand the existence and needs of autistic mothers (Turner 2017). A recent literature review identified thirteen studies on pregnancy and parenthood in autistic adults, finding they reported 'difficulties and dissatisfaction communicating with health care providers [...] depression, higher rates of complications, lower parenting competence [...] higher rates of involvement with child protective services and the desire for increased support' (McDonnell and DeLucia 2021). The authors conclude with a need for further research in partnership with autistic adults to develop approaches to assessment and intervention that promote parental wellbeing.

There is a clear need for greater understanding and acceptance from professionals, alongside tailored support for autistic mothers (Pohl et al. 2020; Dugdale et al. 2021). Autistic self-advocates have addressed this need directly, offering practical advice for professionals when dealing with autistic mothers of autistic children (Roches Rosa 2016) and advocating clearly for practical supportive measures to promote the well-being, dignity, and self-actualization of autistic mothers and their families. Cynthia Kim recommends interaction with other autistic mothers for social support and validation, structured coaching or mentorship, family communication assistance, and access to advocacy (Kim 2014). Hopper and Smit have contributed a valuable addition to the literature, studying the factors impacting the mental health of autistic parents and exploring the influence of childhood trauma. They conclude that professionals should consider that autistic parents may be parenting through a lens of historical trauma and that professionals should be trained in trauma-informed approaches for providing support (Smit and Hopper 2022).

The reasonable guarantee of timely identification of neurotype for girls and women is essential in that it supports self-understanding and access to supportive interventions or adjustments in education, work, and social care and health services. It is vital to prevent misdiagnosis or dismissal of female autistic presentations (as mental health or personality issues), to limit masking and trauma and their sequelae (including enduring mental ill-health, eating disorders, suicidality, self-harm, body/gender dysphoria, unrealized potential, and intergenerational trauma). This requires autistic-led training for professionals capturing the lived

experience of women and girls, presenting their strengths and challenges. This is particularly important within perinatal and family support services. Given the increasing attention afforded to perinatal mental health, we need to guard against misdiagnosing (and medicating) mothers who are struggling as experiencing post-natal depression or puerperal psychosis, when in fact an autism assessment might prove illuminating. It is important to ensure those swans gliding under the radar of professionals as they convey their 'good mother' performance can be identified kicking frantically below the water.

When an autistic mother is granted access to self-understanding her relief is immense. The potential for living a life in keeping with her needs increases. Autistic women who can do so can often perform highly, balancing their gifts and challenges to achieve great things and feel fulfilled (Cook and Garnett 2008: 118–20). There is a moment in Katherine May's memoir where she realizes her husband and son are not unhappy being parted from her regularly as she undertakes lengthy walks – her household benefited when her needs were fulfilled (May 2019). Sarah Hendrickx promotes her wellbeing with a framework supporting her natural strengths and limitations; a low-arousal lifestyle, job suiting her needs and skills and supportive partner. Crucial to her coping ability is the 'scaffolding' holding up her public persona – routines, schedules, support, time out (Hendrickx 2019).

Sylvia Plath's depiction of her child's birth as 'love set you going like a fat gold watch' (Plath 1965) echoes my experience of having children. It marked the onset of an unforgiving series of duties, with my offspring often seeming the timekeepers of my diminishing days. It is my hope that autistic mothers can locate the joy to be had in mothering and find peace with their practice of it, while offering the best of themselves and their insight to their (likely neurodivergent) children. Rebecca Simmons, an autistic mother and the enlightened professional who diagnosed me encapsulates this beautifully:

> She joins her little girl who is spinning patterns in shadows around the quiet of their garden. They spin and weave together and sing noises to the birds and dance their toes through the Velcro grass. They are so alike and there is kindness and truth between them. She is consumed with love for her and she would fight tigers for her right to spin […] The rules of motherhood were hard to line-up. She likes the order of them now.
>
> (Simmons 2020: n.pag.)

REFERENCES

Athan, Aurélie (2020), 'Reproductive identity: An emerging concept', *American Psychologist*, 75:4, pp. 445–56.

Athan, Aurélie and Reel, Heather (2015), 'Maternal psychology: Reflections on the 20th anniversary of deconstructing developmental psychology', *Feminism & Psychology*, Special Issue: 'Deconstructing Developmental Psychology Twenty Years On', 25:3 pp. 311–25.

Autie, Agony (2018a), 'Autism women & girls: What's that?!' *YouTube*, 8 November, https://www.youtube.com/watch?v=sW3lbehEH_Y/. Accessed 18 May 2021.

Autie, Agony (2018b), 'Autistic meltdowns & overloads: What's that?' *YouTube*, 15 November, https://www.youtube.com/watch?v=87jly_A_AlU/. Accessed 18 May 2021.

Blakemore, Monique (n.d.), 'Report to UK Human Rights Committee: Human right violations against parents that are autistic, have an autism spectrum condition', *Autism Women Matter,* https://tbinternet.ohchr.org/Treaties/CCPR/Shared%20Documents/GBR/INT_CCPR_CSS_GBR_20656_E.pdf/. Accessed 14 May 2021.

Brierley, Joeli (2021), *Pregnant Then Screwed: The Truth about the Motherhood Penalty and How to Fix It*, London: Simon & Schuster.

Broadbent, Annie (2019), 'Violence: The heart of maternal darkness', *Instagram*, 16 May, https://www.instagram.com/dark_side_of_the_mum/. Accessed 15 May 2021.

Brock, Sophie (2017), 'The experiences of women who mother children with disabilities: Maternality, relationality, subjectivity', Ph.D. thesis, Sydney: University of Sydney.

Burton, Tanya (2016) 'Exploring the experiences of pregnancy, birth and parenting of mothers with autism spectrum disorder', Ph.D. thesis, Staffordshire: Staffordshire and Keele Universities.

Cook, Barb and Garnett, Michelle (eds) (2018), *Spectrum Women: Walking to the Beat of Autism*, London and Philadelphia, PA: Jessica Kingsley.

Craft, Samantha (2018), 'A real parent', in B. Cook and M. Garnett (eds), *Spectrum Women: Walking to the Beat of Autism*, London and Philadelphia, PA: Jessica Kingsley, pp. 107–20.

Creasy, Stella (2021), 'Some MPs wax lyrical about motherhood, yet stay silent as mothers are driven out of the workplace', *iNews*, 8 March, https://inews.co.uk/opinion/covid-19-women-pregnancy-workplace-discrimination-childcare-burnout-902140/. Accessed 15 May 2021.

Cusk, Rachel (2001), *A Life's Work: on Becoming a Mother*, London: Fourth Estate.

Department of Health Social Care (2019), '"Right to be heard": The government's response to the consultation on learning disability and autism training for health and care staff', 5 November, https://assets.publishing.service.gov.uk/government/uploads/system/uploads/attachment_data/file/844356/autism-and-learning-disability-training-for-staff-consultation-response.pdf/. Accessed 14 May 2021.

Dugdale, S.-A., Thompson, A. R., Leedham, A., Beail, N. and Freeth, M. (2021), 'Intense connection and love: The experiences of autistic mothers', *Autism*, 12 April, https://journals.sagepub.com/doi/10.1177/13623613211005987/. Accessed 30 May 2021.

Dworkin, Andrea (1982), *Our Blood*, London: Women's Press.

Emma (2017), 'The gender wars of household chores: A feminist comic', *The Guardian*, 26 May, https://www.theguardian.com/world/2017/may/26/gender-wars-household-chores-comic/. Accessed 18 May 2021.

Enright, Anne (2004), *Making Babies: Stumbling into Motherhood*, London: Jonathan Cape.

Forbes, Kristy (2021), 'Untitled timeline post', *Facebook*, 12 April, https://www.facebook.com/inTunePathways/posts/810859562856472/. Accessed 13 May 2021.

Glosswitch, aka Victoria Smith (2015), 'In defence of "over-sharenting": Post as many baby updates online as you like', *New Statesman*, 27 October, https://www.newstatesman.com/science-tech/social-media/2015/10/defence-over-sharenting-post-many-baby-updates-online-you/. Accessed 13 May 2021.

Gordon-Walker, Maggie and Naughton, Charlotte (eds) (2018), *The Secret Life of Mothers*, Cirencester: Silverdart.

Grant, Lana (2015), *From Here to Maternity: Pregnancy and Motherhood on the Autism Spectrum*, London and Philadelphia, PA: Jessica Kingsley.

Grant, Lana (2017), 'Autistic women, pregnancy and motherhood', *Spectrum Women*, 16 February, https://www.spectrumwomen.com/parenting/autistic-women-pregnancy-and-motherhood-lana-grant/. Accessed 10 May 2021.

Health Education England (2019), 'Core capabilities framework for supporting autistic people', https://www.skillsforhealth.org.uk/images/services/cstf/Autism%20Capabilities%20Framework%20Oct%202019.pdf/. Accessed 14 May 2021.

Hendrickx, Sarah (2015), *Women and Girls with Autism Spectrum Disorder*, London and Philadelphia, PA: Jessica Kingsley.

Hendrickx, Sarah (2019), 'Girls and women with autism: What's the difference?' *YouTube*, 2 May, https://www.youtube.com/watch?v=yKzWbDPisNk/. Accessed 18 May 2021.

Hill, Amelia (2016), 'Autism: "Hidden pool" of undiagnosed mothers with condition emerging', *The Guardian*, 26 December, https://www.theguardian.com/society/2016/dec/26/autism-hidden-pool-of-undiagnosed-mothers-with-condition-emerging/. Accessed 13 May 2021.

Hogenboom, Melissa (2021), 'The hidden load: How "thinking of everything" holds mums back', *BBC*, 18 May, https://www.bbc.com/worklife/article/20210518-the-hidden-load-how-thinking-of-everything-holds-mums-back/. Accessed 18 May 2021.

Hopper, Jeremy and Smit, Simone (2022), 'Love, joy, and a lens of childhood trauma: Exploring factors that impact the mental health and well-being of autistic parents via iterative phenomenological analysis', *Autism in Adulthood*, 21 September, http://doi.org/10.1089/aut.2021.0101.

James, Laura (2018), *Odd Girl Out*, London: Bluebird.

Jurkevythz, Renata, Campbell, Maura and Morgan, Lisa (2020), *Spectrum Women: Autism and Parenting*, London: Jessica Kingsley.

Kahukura (aka More Than One Neurotype) (2021a), 'But you used to be able to do it', *Facebook*, 10 February, https://www.facebook.com/morethanoneneurotype/photos/a.128081471927893/499082898161080/. Accessed 19 May 2021.

Kahukura (aka More Than One Neurotype) (2021b), 'Autistic parenting motto', *Facebook*, 5 May, https://www.facebook.com/morethanoneneurotype/posts/590513485684687/. Accessed 10 May 2021.

Kim, Cynthia (2014), 'Motherhood: Autistic parenting', Autistic Women and Non-binary Network, 22 January, https://awnnetwork.org/motherhood-autistic-parenting/. Accessed 14 May 2021.

Kristjánsson, Kristján and Lúðvíksdóttir, Bjarney (2019), *Seeing the Unseen*, Iceland: Icelandic Autism Society.

Letherby, Gayle (2002) 'Challenging dominant discourses: Identity and change and the experience of in fertility and in voluntary childlessness', *Journal of Gender Studies*, 11:3, pp. 277–88.

Malacrida, Claudia (2009), 'Performing motherhood in a disablist world: Dilemmas of motherhood, femininity and disability', *International Journal of Qualitative Studies in Education*, 22:1, pp. 99–117.

Maushart, Susan (1999), *The Mask of Motherhood*, New York: New Press.

May, Katherine (2019), *The Electricity of Every living Thing*, London: Orion.

May, Katherine (ed.) (2020a), *The Best Most Awful Job: Twenty Writers Talk Honestly about Motherhood*, London: Elliott and Thompson.

May, Katherine (2020b), *Wintering*, London: Rider Books.

May, Katherine (@_katherine_may_) (2021), 'My health visitor decided not to give me the postnatal mental health questionnaire because she could see I was fine. I was self-harming and suicidal', Twitter, 29 April, https://twitter.com/_katherine_may_/status/1387693409448734721/. Accessed 17 May 2021.

McAuley, Eileen ([1986] 2018), 'The seduction', Perth Academy English, December, https://english-perthacademy.files.wordpress.com/2018/12/The_Seduction.pdf/. Accessed 13 May 2021.

McDonnell, Christina G. and DeLucia, Elizabeth (2021), 'Pregnancy and parenthood among autistic adults: Implications for advancing maternal health and parental well-being', *Autism in Adulthood*, 3:1, pp. 100–15.

McKay, Ashlea (2017), 'The M word: We need to talk about adult autistic meltdowns', Medium, 25 September, https://medium.com/@AshleaMcKay/the-m-word-we-need-to-talk-about-adult-autistic-meltdowns-fec98f60157b/. Accessed 13 May 2021.

Memmott, Ann (2019), 'Autism: Some vital research links', Ann's Autism Blog, 11 January, http://annsautism.blogspot.com/2019/01/autism-some-vital-research-links.html/. Accessed 13 May 2021.

Mir, Saima (2020), 'Maternal rage', in K. May (ed.), *The Best Most Awful Job: Twenty Writers Talk Honestly about Motherhood*, London: Elliott and Thompson, p. 15.

Oakley, Ann ([1979] 2019), *From Here to Maternity: Becoming a Mother*, Bristol: Policy Press.

Olorenshaw, Vanessa (2016), *Liberating Motherhood*, Ireland: Womancraft.

O'Reilly, Andrea (2016), *Matricentric Feminism: Theory, Activism and Practice*, Bradford: Demeter Press.

Painter, Gemma (2018), 'Too fast', in M. Gordon-Walker and C. Naughton (eds), *The Secret Life of Mothers*, Cirencester: Silverdart, p. 47.

Parker, Lucy (2019), 'The truth about being autistic and a mother', *Motherly*, 2 April, https://www.mother.ly/life/the-truth-about-being-autistic-and-a-mother/. Accessed 13 May 2021.

Pearce, Lucy H. (2012), *Moods of Motherhood*, Ireland: Womancraft.

Pink Floyd (1973), *'Time', Dark Side of the Moon*, CD, UK: Harvest.

Plath, Sylvia (1965), 'Morning song', in T. Hughes (ed.), *Ariel*, London: Faber & Faber, p. 3.

Pohl, A. L., Crockford, S. K., Blakemore, M., Allison, C. and Baron Cohen, S. (2020), 'A comparative study of autistic and non-autistic women's experience of motherhood', *Molecular Autism*, 11:3, pp. 1–12 http://doi.org/10.1186/s13229-019-0304-2.

Raphael, Dana (ed.) (1975), *Matrescence, Becoming a Mother, a 'New/Old' Rite de Passage. Being Female: Reproduction, Power, and Change*, The Hague: Mouton.

Rich, Adrienne ([1976] 1995), *Of Woman Born*, New York and London: W.W. Norton.

Robinson, Claire (2018a), 'Bodily integrity', in M. Gordon-Walker and C. Naughton (eds), *The Secret Life of Mothers*, Cirencester: Silverdart, p. 17.

Robinson, Claire (2018b), 'Her first few days', in M. Gordon-Walker and C. Naughton (eds), *The Secret Life of Mothers*, Cirencester: Silverdart, p. 9.

Robinson, Claire (2018c), 'Holding up the world', in M. Gordon-Walker and C. Naughton (eds), *The Secret Life of Mothers*, Cirencester: Silverdart, pp. 94–97.

Robinson, Claire (2018d), 'Loss adjustment', in M. Gordon-Walker and C. Naughton (eds), *The Secret Life of Mothers*, Cirencester: Silverdart, pp. 87–90.

Robinson, Claire (2018e), 'Primip', in M. Gordon-Walker and C. Naughton (eds), *The Secret Life of Mothers*, Cirencester: Silverdart, p. 60.

Roches, Rosa and Shannon, Des (2016), 'Could do better: To professionals working with autistic mothers of autistic children', *Thinking Person's Guide to Autism*, 15 April, http://www.thinkingautismguide.com/2016/04/could-do-better-to-professionals.html/. Accessed 14 May 2021.

Ruddick, Sara (1989), *Maternal Thinking*, Boston, MA: Beacon Press.

Russo, Francine (2018), 'The costs of camouflaging autism', Spectrum, 21 February, https://www.spectrumnews.org/features/deep-dive/costs-camouflaging-autism. Accessed 30 May 2021.

Scottish Autism (2016), 'Autistic women and girls: Resources for professionals – Being a mother', https://www.scottishautism.org/sites/default/files/downloads/Being-a-Mother.pdf. Accessed 10 May 2021.

Seeing the Unseen (2019), 'We are proud autistic women', *Facebook*, 1 January, https://www.facebook.com/unseenautism/posts/1106341893111343/. Accessed 10 May 2021.

Simmons, Rebecca (2020), 'Camouflaging', *Challenging Stereotypes: Novel Perspectives on Autism*, Brighton and Sussex Medical School, May–June, https://www.bsms.ac.uk/_pdf/research/autism-symposium/rebecca-simmons-camouflaging-blog.pdf/. Accessed 14 May 2021.

Stadlen, Naomi (2004), *What Mothers Do*, London: Piatkus.

Thompson, Harry (2021), 'Harry Thompson: PDA extraordinaire timeline post', *Facebook*, 3 May, URL since deleted. Accessed 3 May 2021.

Turner, Lesley (2017), 'Supporting women with autism during pregnancy, birth and beyond', *MIDIRS Midwifery Digest*, 27:4, pp. 462–66.

Williams, Donna (1996), *Autism: An Inside-Out Approach*, London and Philadelphia, PA: Jessica Kingsley.

Williams, Donna (2008), *The Jumbled Jigsaw: An Insider's Approach to the Treatment of Autistic Spectrum 'Fruit Salads'*, London and Philadelphia, PA: Jessica Kingsley.

Williams, Zoe (2002), 'Autistic burnout in parenthood', Autistic Parents UK, 28 December, www.autisticparentsuk.org/post/autistic-burnout-in-parenthood. Accessed 28 December 2022.

Wilson, Anna (2020), *A Place for Everything*, London: Harper Collins.

5

Tensions of Maternity

Steve Ryder and Diana Denton

Our work reflects a vulnerable collaboration in which neither author considers themselves first. We note how the academy asks for this declaration of hierarchy from us and challenge this authorized assumption of our contribution to and being in academic spaces.

Introduction

Using poetry and autoethnography, we recall performances of maternity through the feminist and queer lenses of our lived experience. The feminist questions patriarchal order, especially when imposed upon female bodies. The queer challenges authoritative assertions (Butler 1993) about what is against what could be. Together, we reveal some of the violence done to bodies, often ours but not exclusively so. Our accounting recognizes that we, too, have been socialized to behave in harmful ways in exchange for our place in the master's house (Lorde 1984, 2007). We tell our stories because we must. We tell them to make visible and to transcend the violence in our wake. We tell these stories so that one day the house might fall. We tell them knowing that other risks and uncertainties loom beyond these walls and that we have an ethical responsibility to kindle hope while swinging the hammer.

An autoethnographic approach to research and writing 'uses personal experience to describe and critique often injurious cultural experiences, beliefs, and practices; identify weaknesses of existing research; and ascertain instances of injustice, privilege, and social harm' (Boylorn and Adams 2016: 87; see also Boylorn and Orbe 2016). We engage autoethnographically to skirt limitations of traditional methods of knowledge creation, and foreground issues of ethics, social identities, and research/identity politics (Adams et al. 2015; Ellis 2007). We seek to disrupt traditional modes of conducting research and representation (Spry 2001; see also Holman Jones and Harris 2019; Denzin 2018) by using the diverse, creative, and experimental form of poetry and

evocative short stories (Bochner and Ellis 2016). At the heart of autoethnography is an evocative telling and examination of personal experiences, using vulnerable and open storytelling with a heightened attention to emotion (Bochner and Ellis 2016). Scholars' personal 'epiphanies' (Bochner and Ellis 1992; Denzin 1989) and 'turning points' are often of particular interest. In these ways, autoethnographers lay bare the unique, private, and sensitive details of lived experience that mainstream and normative modalities of conducting research often overlook to illustrate the complex connections between the personal and the cultural (Ellis et al. 2010). In these ways, autoethnography pursues more inclusive and humane ends to re-engage with and reimagine maternal intersections, bonds, and boundaries. Our stories excavate lived experience around kernels of choice to juxtapose history with dreams.

I (*Diana*) am a 'good' mother, yet disruptions and betrayals challenge my performances of that 'good'. The shattering of accepted norms of mothering. The mothering instinct gone awry. I find my own mother's shoes do not fit. Across my life text, the imposition of a patriarchal voice asserts certainty – yet neither has nor delivers any. 'You will never be able to conceive.' 'You must abort.' 'You must marry.' 'You must stay together for the children.' For 'him', I have lost my way, but I have never been lost. Being a mother is more than a vocation. It is a calling.

I (*Steve*) love that mum stays at home. I am the outcome of her doting intelligence, kindness, and presence, often in the absence of a father who leaves the house for work early in the morning and returns late, hungry, and tired. I adore mum yet lament that the many good experiences she produced during my youth will become increasingly rare. Many parents work in contemporary families, especially in those that have broken free of binary and social expectations of what families are and can be. Who might stay at home, like my mum did? Who might want to? Who should?

COVID-19 resurfaces the tensions of being the 'stay-at-home mum' from a standpoint of health and concern. It could be dangerous to venture out, shunning the pleas of loved ones to stay at home. Where is the harm? How do we negotiate and nurture the ongoing performances of maternity, mitigate impediments to self-determination, and make sense of who we become together on the journey toward liberation?

As daughter, mother, and now grandmother, I (*Diana*) have navigated choices. Some felt forced and beyond my control whereas others held inherent risk (and possible harm) but called to me, offering hope. With COVID-19, choice, responsibility, and risk surface new tensions of maternity. I become a greater presence in my young grandson's lives. I make a conscious choice to visit, to take off my mask, and embrace time with them. I hear of others of a similar age who choose to be distant and reclusive, separated by closed doors from those whom they love. My gestures of intimacy come with additional risks in a COVID-19 world. Yet, as we all must stay home, I choose risk. I treasure the warmth of a gentle young touch, an innocent gaze – my own maternal instinct stirred. In such warmth,

I straddle risk and hope, courting the possibility of severe illness, yet knowing that our connection is integral to any hope of wholeness. I choose to take off my mask so that I don't alienate my young grandsons, aged 2 and 3, at the outset of COVID-19. Yet, for some, the mask becomes the only form of intimacy available – the only way to connect. We wear masks so that we may see each other. We wear masks, erect walls. Are these shields that constrain and separate us or expressions of compassion, healing, and hope? Masked or unmasked, within or outside these walls, where do we find the good mother?

As a son, I (*Steve*) recall telling mum about my diagnosis with a chronic illness, HIV. She remained silent yet gently placed a hand upon my knee as we sat talking. I'll never forget the look of concern in her eyes. She would have given me her own good health in exchange. I felt it in her gaze and in my bones as she fought back tears. At the onset of COVID-19, she declined vaccination and shut herself off from the world outside. As an octogenarian, she's at elevated risk from COVID-19. I am torn over her choices but respect her agency. I saw her twice, in person, during the two and a half years that followed and interacted with her a few more times by telephone and video chat. Our conversations excavate anew the many happy stories of years passed. The future is too uncertain and painful to discuss. No new stories. Foreclosure. Her exit was in sight. Too many of my friends, themselves HIV-positive, withdrew from public life and then died. I wonder, is this how the good mother's story will also end?

A good mother

I (*Diana*) am a 'good' mother. Yet often the rebel. The eldest of four, and the only girl, I worry my own mother's mothering. Frequently venturing on alternative avenues of life … not quite fitting in … yet, sometimes succumbing to the patterns of a 'normal' family. Dad goes to work; mum stays home with the children and the house – ever the nurturer. Dad has a career; mum, constrained by circumstance and societal norms, does not. She is the foundation that holds us together as a 'family'. Yet there are undercurrents of struggle. What holds *her* together?

I carry the fruit of my mother's mothering as a memory, a calling, a legacy that is sometimes a burden. When my mother was briefly ill, I became the mother at 16 – caring for my infant brother for six months – called to the maternal norms I had witnessed. Yet, at 18, I leave home, and by 19 am hitchhiking from Toronto to California – in search of a 'spiritual' teacher.

> I arrive in California in the late spring of 1974. I am nineteen. Two months earlier, my grandmother drops me on a highway near the outskirts of Toronto. Leaving me

at the roadside with my knapsack, sleeping bag, and thumb, she slips me twenty dollars in change, 'Call home', she says.

(Denton 2005: 753)

It is my grandmother who mothers the rebel in me, who understands a deeper calling. This journey marks a life that is one of always seeking – the unknown, the alternate deeper stories of living, the sacred, a deviation from the norm (Denton 2011, 2014), transformations of orientation. Sara Ahmed writes:

Even when orientations seem to be about which way we are facing in the present, they also point us toward the future. The hope of changing directions is always that we do not know where some paths may take us: risking departure from the straight and narrow, makes new futures possible, which might involve going astray, getting lost, or even becoming queer.

(Ahmed 2006: 554)

Perhaps because I watched my own mother struggle in the life she chose as a mother, I can never quite settle. Yet, she was truly a 'good' mother; she instilled this goodness in me.

In later years, I loved to run in the early morning before teaching my university classes. A friend once remarked that I had always been a 'runner' ... running away from or perhaps towards ... something unseen but written in my blood ... a complicated legacy. As an academic and auto-ethnographer, I draw on phenomenological perspectives, inquiring into the mystical, the spiritual, the poetic, and feminist roots that drive and inform my work and lived experience.

Stay at home, mum

Stay-at-home mum is once upon a time – like any fairy-tale begins – a vocation and a trap. It's mum's choice. Yet, I regard it as the insistence (of men) that counters the liberatory feminist call that arose during the 1960s when mum is beginning her family. I feel these sentiments renewing in our COVID-19 bound world as my mum, now an octogenarian, cloisters herself away. History repeats.

As a child, I (*Steve*) loved having mum stay at home. I spend most of my time with or near her. I look to her for instruction, support, and affection. Her firstborn, she dotes on me. I wonder, now, if this led to the relationship with my younger brother being so fraught. My trust of and dependence upon mum is often in the absence of a father, who leaves for work early in the morning and returns home late, hungry, and tired. Mum stays at home to raise *her* family. I never explicitly

questioned her 'choice' of being home instead of working. When I move away to university, I feel her heartache at our parting. When I come out as gay a few years later, I don't fully appreciate the foreclosure on the possibility of grandchildren and feel, from her, a sense of disappointment. She gave us, her family, so much. Is this disappointment one of the rewards for staying at home?

While at university, a student peer in my programme challenges me. We discuss women's issues ahead of a weekly feminist gathering she attends when I exclaim that my mum has 'found her niche' by being a stay-at-home mum. My peer is livid.

'Her *niche*?'

I fail to understand her anger. Her brow furls; her eyes glare. The conversation ends. She strides away to join her group. As the glass-paned door to the meeting room swings closed behind her, those attending fall silent. I see them looking toward her as I turn to walk away. Instead of wondering further about our exchange, I leave feeling that I have done nothing wrong. I love my mum. She loves me. I don't own her choice to stay at home. She genuinely seems happy to do so. Maybe it's the word niche that so questionable. I think to refresh my understanding of its meanings. I'll look it up in the dictionary when I return to my dorm room. To paraphrase the *Oxford English Dictionary* (1989), someone who finds a place to which they seem best suited has found their niche. I wonder anew about the consequences of a man attesting, second hand, to a woman having found her place.

Years later, I took a theatre class and we worked through D. H. Hwang's Tony Award winning play, *M. Butterfly*. One of its most provocative passages attests that, 'only a man knows how a woman is supposed to act' (Hwang 1988, 2.7: 63). I flashback to my conversation about my mum having found her niche. I am embarrassed. I thought I was *only* happy for mum having found a way of being about which she seemed genuinely happy. Taking care of her 'boys' is 'enough' (Blommaert 2013). Isn't it? Instead, I begin to glimpse the plurality of meanings: in celebrating my mum's performance I am also endorsing the normalized paternal order in which men work, are cared for, and have few cares about giving back. Giving back is something that happens on Mother's Day, on International Women's Day, or her birthday and not typically on any of the other 362 days of the year. Niches are problematic. However, I am thankful for niches as representations of 'oppressive systems that, because of their oppressiveness, give us a story to tell' (Adams 2008: 181).

In telling our stories we lean into the tension between two story arcs that evolve and play with and through our standpoints and experiences of performing maternity. I (*Diana*) contend with feelings of betrayal that sanction and constrain 'bad' mothers' performances; I (*Steve*) celebrate those same sanctions and constraints for giving me a mum that stayed at home while simultaneously recoiling at the prospect of reducing mum to a butterfly in a display case (Barthes 1981).

PERFORMING MATERNITIES

A pastiche of storied Tensions

(1)

Diana:

(i)
Echoes of the good

she stands
in her mother's
shoes

masked

in a performance
of certainty

of maternal instinct

the 'good mother'

poised & unwavering

(ii)

The mask slips

the shoes don't fit

the performance
is ruptured

a deeper instinct
calls

betrayals of the
good (mother)

poised & unwavering

Steve:

A 12-year-old boy struggles to return to its proper place a greasy bicycle chain. It has jumped from its track beside the pedals and is now lodged between cogs and frame. My pre-pubescent fingers lack both dexterity and experience as they try and fail to loosen it. The banana seat anchors one side of the inverted bike on wet, slippery grass. My right foot, in well-worn Adidas sneakers, presses against the dirty, rubber grip of a handlebar. I crane once more and slip, setting the free-swinging pedals into abrupt and unexpected contact with my groin. In pain and anger, I hoist the bike into the air and throw it to the ground a few feet away. When I look up, I see my mum watching from the bay window of the kitchen where often she is found. She is expressionless, poised and unwavering, and calmly looking on.

I immediately regret having thrown my bike.

An echo of my mum in that window frame continues to come forth to guide me in times of stress. She is silent, all knowing, never judging. She encourages me to channel frustration into less violent outbursts. As calm prevails, I manage to right the bicycle, return the chain to its track, then ride off.

(2)

Diana:

At the age of 21, I am told I cannot conceive. An unexpected pregnancy follows months later. And another shortly after. 'Abort!', he says. I marry, when my firstborn is 9 months old, and my belly heavy with my second – 'for the children'.

(performances of the good mother)

Nine years later, in the final 6 months of our marriage, we stay together 'for the children'.

In a house of ice, deadened by all that is unsaid, it is the children who interrupt our slippery surface of sanctity. One pulls out a large clump of hair – a wound that sprouts from his head. Another begins to wet the bed – a new nightly ritual. And my third cannot sleep.

Ruptures that punctuate my consciousness – fracturing a heart. One day I cannot go home.

(betrayals of the good mother)

Where are the regions of certainty?

Leaving my children – the mothering instinct gone awry [...] 'for the children'.

PERFORMING MATERNITIES

Steve:

I spend the last year of high school working to pay for university and not speaking to my father. Teenagers rebel: dad is the target of my frustrations with this small-town, my becoming a man, and my unvoiced, social irritation over not quite fitting in. When it's time to graduate, I rent a tuxedo. My mum wears a gorgeous, grey, one-piece pant suit. I carefully pin a corsage of white Cattleya orchids to her sleeve. She radiates. She slips a small Kodak camera into her purse just before we leave the house. Though I have never known her to take photos without capturing a finger or thumb in front of the lens, tonight I sense she will be graduating, too. My father stays home, still silent. Mum would not miss this rite of passage; despite the betrayal it might signal to her husband, children come first.

On Labour Day, I leave home for university. Mum is tearful. I am first to leave her nest. As the term begins, I call home on weekends. In between, I write letters to avoid the cost and emotion of speaking by telephone, especially when it's time to hang up. Every time, it's a game of not being the first to hang up. The metaphor of hanging up on the person who has given you so much in life is too raw.

As the second Monday in October approaches, Canadian Thanksgiving, many of the students I have met in the dorms exclaim how great it will be to escape the mass-produced, cafeteria food we've been forced to endure for a home-cooked meal. From my dorm window on the Friday of that weekend, I watch them hauling over-stuffed suitcases toward the cars and buses that will whisk them homeward. I feel guilty to have made no similar plans then remind myself that my family needs no queer son returning home. Haven't spoken to my dad in months. My brother for years. Only my mum will miss me, but she won't know why I can't be there right now. I'll try to call, I guess. For now, staying at home will spare her the perceived grief of knowing that I turned out gay.

(3)

Diana:

Years later, I bring a mothering instinct to my teaching. Director of a rapidly growing communication program, I host students at gatherings in my home. We build a sense of community. The offspring of my labors grow. I am tasked with creating a new interdisciplinary transformative graduate program.

(performances of the good mother)

Yet, the institution grows uncomfortable with our growth; and the graduate program is stillborn, never seeing the light of day.

Seasoned male colleagues, behind closed doors, tell me that if I had been a man, the obstacles thrown in my path, in the attempted creation of this MA program, would have dissolved. It is my gender that has foreshadowed its demise.

My colleagues and I do not fit in. We are troublesome. A home cannot be found for us. We are asked to perform the 'good' in a box that does not fit. Others contort, misshapen bodies pinned to these walls, moving in ways that I cannot. I step outside the box, outside the classroom. I step down as Director. The safe harbor of the Ivory Tower, suddenly ruptured.

(betrayals of the good mother)

Where are the regions of certainty?

Leaving my students – the mothering instinct gone awry [...] 'for the children'.

Steve:

My first attempt at university is expensive and ends in unmitigated disaster. I can tell by looking at my peers that I'm no Physicist. So many of my classes are large format lectures. I'm just a number in a sea of hundreds. I'm gay. I struggle to make sense of sexuality, begin to skip classes, and rack up poor grades. With the cost of tuition mounting, I abandon dreams of clawing toward a doctorate for the mundanity of regular work. I imagine, now, these alienating experiences as the manifestation of separation anxiety. The bonds to mother never break, only stretch, like her belly once did in giving me life.

(4)

Diana:

How I do rupture the performance of the good mother – in the calling that interrupts the accepted norms, the status quo. As mother, I am scorned; the gaze of the other scorches. These betrayals of the mother usurp my place in the grace/gaze of the good.

What is the good?

Where is the good?

 ('May all good things come to you'

 'Be a good girl'

 'She is a good wife')

Boxes of the good (entrap)

Steve:

'Mum?' I walk up from behind as she stands peering off into the distance through the large bay window ahead of the sink which catches the precisely peeled potatoes for tonight's supper.

I'm of an age when my height matches her five foot two inch frame inch for inch. She turns her head only slightly to engage. Her continuing to peel is an endorsement that mothers multitask often silently and with aplomb.

'Am I a robot?'

The peeling stops abruptly.

'I mean, I'm not a real boy, right?'

She looks at me puzzled. Speechless. The blade of the paring knife kisses the wet surface of the spud in her hands, a swath of its brown flesh, half-removed, dangles in limbo.

'What do you mean? Of course, you're real', she says.

I see the stretch marks on her tummy every summer in bikini weather yet something I see, unsupervised, on television compels me to question my origin and purpose.

'I've never seen my insides. How do I know it's not just all circuits and stuff?'

Her eyes moisten. She doesn't have an answer that will satisfy me. She should come and watch TV with me, but supper can't wait.

'What difference would it make if I'd never been born?'

She turns to resume peeling. I start toward the television. I know she's sobbing, quietly, but a robot has no emotions to console her.

(5)

Diana:

My first child is born in hospital. Despite my carefully orchestrated plans for a natural birth (and all that that entails), as soon as he emerges, the nurses whisk him away.

'It is cold', they say, though the days in early August are still heavy with heat.

They leave me alone in a barren operating room – the touch of my son, not yet a memory.

Two hours later, returned to my room, I rise and find my infant son, swaddled and alone. To the horror of the nurses, I whisk him away. He is three hours old as we leave the hospital, emerging into the warmth of the day.

(betrayals of the good mother)

My two other children are born at home, surrounded by mothers and midwives. Their warmth permeates the room. My first son, now 16 months, discovers the

TENSIONS OF MATERNITY

container of salt left in preparation for my sitz baths to come. As I am in the final throes of labour, he empties it on my bed, like white sand on a sea of silk, as his brother appears.

Five years later, I drink herbal tea and eat fresh baked bread, minutes after my daughter's birth – skin to skin we are still almost as one. Yet, outside this room, in the distance, where the status quo still reigns, many others frown on my choices; the risks, blinders to the beauty of these visions.

My children are born in the late '70s and early '80s. I breastfeed my first and third children for three years. My second, does not give up the breast until he is 4 years old. Others scorn me, but the intimate connection between child and mother is profound.

Steve:

My younger brother is born at home, delivered by a midwife. I recall her arrival, on a large, black, clumsy bicycle, as I look out of the second-floor window of mum's bedroom to the walkway and sidewalk below. Dad is at work.

I recall few if any details of his arrival. No doubt, I am shuttled to another part of the house to wait with granddad who distracts me, upon his knee, with stories.

I recall the feeling imparted, but not the explicit command, I am supposed to love my brother. I do.

Over the years, mum makes sure that each of her boys gets an equal share of food, clothing, […] candy. One for you; one for me. Dad obliges but this lesson is hers. The equality is carefully measured, but anachronistic. For instance, when I turn 10, I notice my brother's bedtime is nearly 9:00 p.m., the same as mine. When I was his age, two years and four months ago – mum reminds, as custodian of all statistical information she always has an accurate accounting of time and relationship – I'd be sent up to bed by 8:00 p.m. Equality slips.

I wonder, now, about the pedagogy behind her planning. What would I do if I had children? How do I perceive of difference in the larger world and within the world created within such a framework? Mum. World-builder. *Some conditions may apply.*

(6)

Diana:

I take his name. I wear it proudly. I am now an appendage to my husband and house. I am a house-wife – but I have stature – a place, a name, a home.

(performances of the good mother)

The identity I was seems to slip away.
('a rose by any other …')

I take his name.

Cloaked in my new persona, I am firm in my stance as the 'good mother'. It will always be so. I cling to a certainty, to my mother's ways. I put my undergraduate degree in English aside. I stay at home. I cook, clean, shop and read nightly to my children. I *am* the good mother.

My compliancy mirrors back a growing brittleness – my mother's brittleness. She had several 'breakdowns' in my childhood. But she stayed.

I stay.

My body becomes heavy; my carriage stiff. I feel old – but I am only 28. Gazing into the back garden at 31, I am empty. I have lost the taste for life.

Where are the regions of certainty?

I put my recipes aside. I close the brightly colored picture books. I take back my name and walk away.

(betrayals of the good mother)

I bend, but do not break.

Steve:

In 1987, I don't know which is the epiphany: the choice to come out as gay to my parents or the coming out itself. Both were liberating. *Some conditions still apply.*

In early 2021, the world is still wracked by COVID-19. I have not seen my mum physically in over a year. My brother takes loving care of her. I am thankful, but they are both reclusive.

My brother's brief medical crisis thrusts me back into her physical presence. We sit upon the couch in her living room – a stylish couch that I recall being purchased in the early '80s which shows few signs of wear or decline from fashion – wearing masks, keeping an obligatory social distance except for my hands on her bare feet as she reclines against the couch's armrest, her body turned to face me. I rub them gently, longing for the intimacy and trust we've always shared to be renewed through the connection. Skin to skin.

'Your feet are so soft!' I say. 'Do you use that Aveda cream that I got you for Christmas?'

'Oh, that ran out months ago. I still moisturize daily, though.'

Her skin, though aging, looks and certainly feels better than mine. She's taken care of herself. Though she laments each time I see her that this may be her last year, she shows every sign of outliving the rest of the family.

'I've let you down, haven't I? I know my being gay took you a while to get used to. You would have loved to have had grandchildren. You'd have been a great nana.'

Her eyes squint, the mask hiding what I suspect is an affirming smile beneath.

'No. It's alright, Steve. I love you. I love you just as you are.'

'But you still would have liked to have grandkids!'

'Yes. I would have. But I wouldn't trade you for them. I love you. I. Love. You.'

We rarely talk of intimate things, like my sexuality, though I always feel that we can. However, such private things are not expected to continue beyond the local setting in which they occur. As such, the acceptance she has for the authentic me stays between us. I wonder about her choice to remain so private. I see it as limiting, especially in how relationships with extended family unfold – or fail to. Maybe she doesn't have it within her to give anymore. She gave everything she had to her family and seems happy in that choice.

'Are you happy, mum?'

(7)

Diana:

I take a similar stance, years later at the university. I put my recipes (plans) aside. I close the classroom door and walk away.

(betrayals of the good mother)

I bend, but do not break.

Steve:

I am lucky to have returned to university in time to discover Diana. Serendipity! From strangers to professor and student, then academic collaborators, and now dear friends. I take a Small Group Communication class with her and remember a lesson during which she introduces the ways that a group can address its own function.

'Notice the silence', she says.

There are so many silences all around us. They can scarcely be noticed unless you look for them.

Her words stay with me again, three years later in a capstone course – Performative Inquiry – that led to my first published, single-authored, journal article (Ryder 2010).

'Honour where your attention goes.'

These words have become a calling.

(8)

Diana:

The story has twists and turns of complexity – many more than my narrative can render. There are layers of experience – negotiations with self, other, and circumstance.

PERFORMING MATERNITIES

One year of shared custody.

1987 (Toronto): Divorce – it arrives slowly. It's insidious scent permeating conversations long before we know it is coming. Now our children pass between us on alternating days. At night the silence ruptures my sleep. Some nights I keep the radio on – an assurance of human presence. My body's companions: anger, fear and despair (Denton 2006: 133).

Another year of sole custody and then a sudden absence – no custody.

1989 (Toronto): I'm a graduate student. I wake to the sun trickling through gray-filmed glass – the legacy of my divorce – a dingy one-bedroom apartment in a string of high-rises – 'divorce alley'. The shared custody of my three young children is more a memory now than anything else. I struggle to exist – to pay the rent and my tuition, hoping for a better life [...] and my children. My days are punctuated with solitude, the silence of empty rooms, weekly visits of young voices: Sunday dinners (Denton 2006: 134). The good mother gone awry.

(9)

Diana:
After an unsuccessful year at university, two of my children return home. I have my own house and my own name now. They come to live with me and graduate from the university where I teach.

(performances of the good mother?)

I watch my daughter, at 28, unmarried, childless, degree in hand. She resists and yields to old patterns, in cautious performance of the good.
Will she bend or break?
Where are the regions of certainty? [...] for the children.

(10)

Diana:
Now, at 37, my daughter has two young sons. And a husband. She is a good mother. Following in all the footsteps, I could not. She works from home, charting a career that suits her own rhythms. She has immersed herself in motherhood, as if some unconscious pattern leapt from a life she never knew. My grandsons, on the other side of this legacy, reap what I had sowed. A life she yearned for – a mum who stayed home.

Yet, there are perils, even in staying home. It has been more than a year, in their early lives, where the threat of COVID-19 has plunged us into a world of uncertainty. Now we all must stay home. With schools closed, and work lives undone, the threat is ever present.

In COVID-19's first summer, her youngest, at 2 years old, is in a playground. It has just reopened – deemed safe. She cleans the swing (and his hands) meticulously with sterile wipes and sanitizer. Yet three days later, he has a runny nose – the first of the COVID-19 era. 'Get him tested', she is told.

Quarantined, as they await results. She calls family and friends – anyone who has had even the most distant interaction – to warn them of what might be an imminent result. Plans and appointments are cancelled. We wait.

There is an unspoken guilt rising in her – 'what if …'

The tensions of maternity – now all mothers wonder 'what if …'

(betrayals of the good mother?)

A child on a swing, in the era of COVID-19.

'Stay home, mum!'

His test is negative. And the cycle of watching and caution resumes. No more swings.

(performances of the good mother.)

There are more runny noses in the months to come – with her oldest, at 3, now in school in September. More tests. More waiting.

'Stay at home!'

Will she bend or break?

What is the good mother?

Where are the regions of certainty? […] for the children.

(11)

Diana:

(i)

The ache on

the other side

of tomorrow

when the wind
chills

the islands
of her destiny
contract

shores that
press her
fragile flesh

(ii)

where does
she end &
the water
begin;

what are her
limits

her breaking point?

when does
the dust
settle?

where does
her ground
begin?

(12)

Diana:

A light for her sons; they hold to her body, in the certainty of her presence. As schools reopen in February, after an extended break, her oldest, now 4, states that he prefers online school. He gets to 'Stay home with Mum'. Getting him out the door each morning, for an early classroom start, requires all her motherly wiles on a wintery day.

His ardent plea: 'I want to stay home, Mum!!'

And she always does. She does not cling; they must find their own way. Yet, in the absence of certainty, she is a ground of hope, an oasis her children return to – again, and again.

Steve:

I have little desire to return home, physically, though appreciate that parts of me feel that connection privately. The small-town fishbowl turns others' gaze upon me as subject too often; I need space to find myself and then to explore and grow.

'How did you escape?' asks a queer co-worker when I tell him about my 'formative years'. 'You were so brave!'

'I don't know about that. I don't feel brave, at all. I just knew that I couldn't stay.'

Conclusion

In their telling, our stories unsettle and reveal tensions of maternal performances. Nestled in a patriarchal world as mother and mothered, we disrupt this space to challenge notions of the 'good' mother and who she might be – when she stays home and when she does not. Where does her attention go and how does she choose to honour it? We wonder after the deconstruction, or the possibility for it, once the gaze turns toward the constraints and expectations heaped upon maternity, if she might make a move to rebuild a new house, one that makes new visions possible.

<div align="center">

(i)

Sometimes

she hears

the bloods

of other times

chiming

their distant

calls

raising her

to a fury

of light

</div>

PERFORMING MATERNITIES

against
the backdrop
of shadow

in the now

(ii)

she dances
a blaze
upon the black

lifting all
things

in her path

REFERENCES

Adams, T. E. (2008), 'Learning, living, and leaving the closet: Making gay identity relations', Ph.D. dissertation, Tampa, FL: University of South Florida.

Adams, T. E., Holman Jones, S. and Ellis, C. (2015), *Autoethnography*, Toronto: Oxford University Press.

Ahmed, Sara (2006), 'Orientations: Toward a queer phenomenology', *GLQ*, 12:4, pp. 543–74.

Barthes, R. (1981), *Camera Lucida*, New York: Hill and Wang.

Blommaert, J. (2013), 'Enough is enough: The heuristics of authenticity in superdiversity', in J. Duarte and I. Gogolin (eds), *Linguistic Superdiversity in Urban Areas: Research Approaches*, Amsterdam: John Benjamins, pp. 142–60, https://doi.org/10.1075/hsld.2.10blo.

Bochner, A. P. and Ellis, C. (1992), 'Personal narrative as a social approach to interpersonal communication', *Communication Theory*, 2:2, pp. 165–72.

Bochner, A. P. and Ellis, C. (2016), *Evocative Autoethnography: Writing Lives and Telling Stories*, New York: Routledge.

Boylorn, R. M. and Adams, T. E. (2016), 'Queer and quare autoethnography', in N. K. Denzin and M. D. Giardina (eds), *Qualitative Inquiry through a Critical Lens*, New York: Routledge, pp. 185–98.

Boylorn, R. M. and Orbe, M. P. (eds) (2016), *Critical Autoethnography: Intersecting Cultural Identities in Everyday Life*, New York: Routledge.

Butler, J. (1993), 'Critically queer', *GLQ*, 1, pp. 17–32.

Denton, D. (2005), 'Toward a sacred discourse: Re-conceptualizing the heart through metaphor', *Qualitative Inquiry*, 11, pp. 752–70.

Denton, D. (2006), 'Re-imagining the wound: Of innocence, sacrifice & gift', in W. Ashton and D. Denton (eds), *Spirituality, Ethnography, & Teaching: Stories from Within*, New York: Peter Lang, pp. 131–39.

Denton, D. (2011), 'Betrayals of gravity: The flight of the phoenix', *Qualitative Inquiry*, 17:1, pp. 85–92.

Denton, D. (2014), 'Transformative pathways: Engaging the heart in contemplative education', in *Contemplative Learning and Inquiry across Disciplines*, New York: State University of New York Press.

Denzin, N. K. (1989), *Interpretive Biography*, Newbury Park, CA: Sage Publications.

Denzin, N. K. (2018), *Performance Autoethnography: Critical Pedagogy and the Politics of Culture*, New York: Routledge.

Ellis, C. (2007), 'Telling secrets, revealing lives: Relational ethics in research with intimate others', *Qualitative Inquiry*, 13:1, pp. 3–29.

Ellis, C., Adams, T. E. and Bochner, A. P. (2010), 'Autoethnography: An overview', *Forum Qualitative Sozialforschung/Forum: Qualitative Social Research*, 12:1, https://doi.org/10.17169/fqs-12.1.1589.

Holman Jones, S. and Harris, A. M. (2019), *Queering Autoethnography*, New York: Routledge.

Hwang, D. H. (1988), *M. Butterfly*, Markham, ON: Penguin.

Lorde, A. (1984), 'The master's tools will never dismantle the master's house', in *Sister Outsider: Essays and Speeches*, Berkeley, CA: Ten Speed Press, pp. 110–14.

Ryder, S. (2010), 'I didn't have to play football to be hurt: An inquiry concerning the disjunction between public and private self', *Qualitative Inquiry*, 16:5, pp. 314–24.

Simpson, J. and Weiner, E. (eds) (1989), *The Oxford English Dictionary*, 2nd ed., Oxford: Oxford University Press.

Spry, Tami (2001), 'Performing autoethnography: An embodied methodological praxis', *Qualitative Inquiry*, 7:6, pp. 706–32.

6

Remember Me? Creative Conversations with Clothes

Jenni Cresswell

I am fascinated by the stories that dresses can tell. I watch for one to start up a conversation with me: is that a whisper of its previous owner there in a small tear? The tail end of a thread of narrative which I gently pull on to unravel. Dress are great conversationalists if you learn how to read the marks of alterations and wear recorded in their fabric like scars on skin: a worn-out hem, the skirt too long for the wearer, or a bright slice of fabric showing the vibrancy of the original material showing where the waist was let out, or the ghost stitch marks left behind from an unpicked seam.

Dresses not only tell stories about themselves, who has worn them, and what the dress and wearer have done together, but they can take you on journeys through time and place, magically sweeping you up and depositing you in 1989 at that party across the globe, or perhaps showing you a glimpse into the future at that interview next week on Zoom. Clothes are like trees; their lifespan reaching across centuries, and this long-lived life allows them to absorb memories of everyone they have been touched by: 'The fabric holds the memory' (Epp Buller 2020: n.pag.). And in turn with just with one glance, they can transport us to any one of their memories 'collapsing time' (Sontag in Benjamin 1979) and moving us backwards and forwards within one's life history; to move through time, Tardis like (Stanley 1992).

I have learnt a lot about myself during my dress conversations, and I've been to all sorts of times and places. Dresses help give voice to some of my own most revealing narratives, giving me the courage to rip off the sticking plaster even though I know it's going to hurt, as the autoethnographic process can be an 'emotionally painful and potentially self-injurious act' (Sparkes 2018: 208). They can be a bit like the three spirits who visit Scrooge on Christmas Eve. *Three Green Dresses* transported me to a time before I was born to meet my long-dead ancestors. The *DNA Dress* whooshed me back to my childhood and then held my hand

as I fully accepted my future as the last of my genetic line: an only child of parents in their 80s and no children of my own. And they have also been able to open a door to an alternative future where I have been able to conjure a daughter and imagine her growing up through three children's dresses representing three key milestones in her life (Figures 6.1 and 6.2).

My projects usually start with an inspiring dress, or a gifted garment; perhaps rifling through a charity shop or seeking out a specific outfit. And although *The Daughter's Dresses* seemingly started like this, in reality it started quite suddenly some months earlier without me realizing, and with what I can only describe as a vision. In 2016 my partner and I were trying some last-ditch fertility treatment. I had left it rather late to attempt a family and at 45 I was told my options were limited and a resulting positive outcome was a long shot. I had just completed my third and final round of fertility treatment. We had decided if this wasn't successful, there wouldn't be another attempt. On my way to a meeting, stepping off a bus into bright spring sunshine, I realized that I had got my period and that childless I would remain (Figures 6.3–6.5).

This brought a wash of emotions: relief (I wouldn't have to find out if I was any good as a mum or argue with my partner about the best way to brush their teeth); regret (I wouldn't be a mum); failure (I shouldn't have had that glass of wine; I should have tried harder); disappointment (no new adventure with this brand-new person).

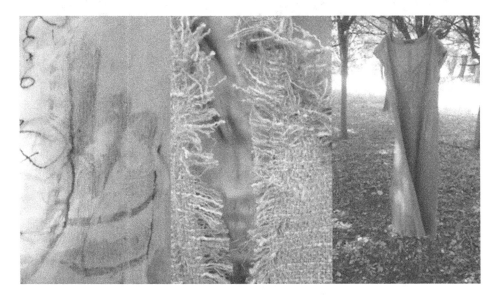

FIGURE 6.1: Jenni Cresswell, *Three Green Dresses*, 2016. Film still.

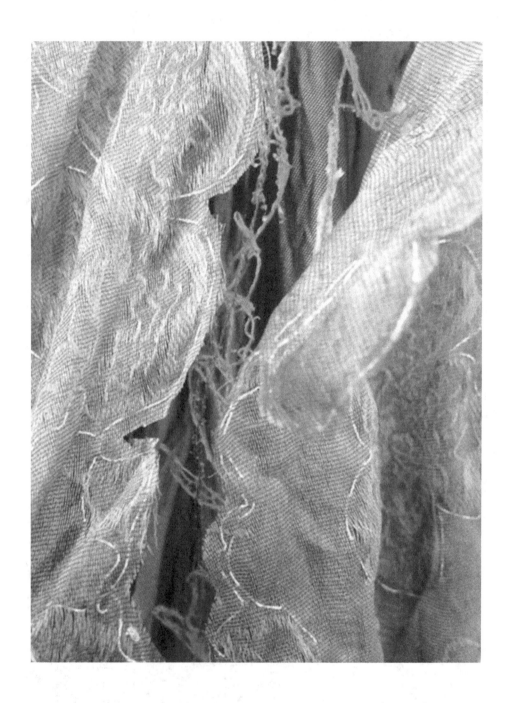

FIGURE 6.2: Jenni Cresswell, *The DNA Dress*, 2018. Textile.

FIGURE 6.3: Jenni Cresswell, *The Daughter's Dresses*, 2019. Photograph superimposed over textile.

FIGURE 6.4: Jenni Cresswell, *The Daughter's Dresses*, 2019. Photograph superimposed over textile.

FIGURE 6.5: Jenni Cresswell, *The Daughter's Dresses*, 2019. Photograph superimposed over textile.

I wasn't devastated by the news; I had long felt ambivalent about motherhood, but somehow had expected that it would 'just happen'. Actively going about trying to make it happen consciously somehow put a dampener on the whole thing.

In the same instance as all those emotions were playing out in my mind, as I stepped from the dark of the bus's interior into the sun's glare, I saw fleetingly the figure of a young girl semi-silhouetted, smiling at me. She bore a striking resemblance to me at around age seven: blonde bob, big smile, crinkly nose. I knew without any sense of rationale that this was my daughter: the daughter I would never have, my flesh and blood. Now, anyone who knows me will recognize that I am not given to such flights of fancy as visions; I don't consider myself to be a seer. Try as I might, I am not a very spiritual person and you're unlikely to find me checking the constellations to find out how that job interview will pan out. I am, I like to think, a pragmatic person. So, I found myself in the tricky situation of relating to others my total belief that I had experienced an actual memory of a daughter who doesn't exist and can never exist. Except for me she really does. Somewhere. Sometime.

To demonstrate my perspective, let me refer you to the television series *Ashes to Ashes* (2008–10), where the protagonist Alex – a very pragmatic police DCI – is thrown backwards in time by 30 years because of a gunshot wound to her head. The entire story is based around her living out her resulting head trauma and coma in the past which she experiences as entirely real, while being fully aware that she is in fact only a child in the same year and is fighting for her life 30 years hence. Alex experiences utter conviction that the world she is living in *c.*1982 is as real to her as the world she came from, while simultaneously knowing with equal conviction that she is in the hospital fighting for her life in her own time.

This is the kind of reality I am trying to describe about the 'vision' of my daughter, who I can only refer to as my real/not real daughter. I don't know her name, I've never met her, so she's not real. But as sure as I know that I am real, I know her to be too. The only differences between me and Alex are that her traumatic event transported her backwards in known time for what seemingly passed as months, my event (much less traumatic) threw me into an unknown future, just for a split second.

This set up is rather mind bending and the concept of parallel universes and being in two places in the spacetime continuum at once has been explored by countless writers, scientists, philosophers, scholars, and artists in myriad ways. Sci-fi TV, films, and books alone (think *Dr Who*, *Back to the Future*, *Quantum Leap*, *Star Trek*) are too numerous to fully list. Suffice to say, I'm no physicist and therefore won't attempt to unpick the quantum conundrum of the literal possibility of my experience. What I can say, is I'm in good company when it comes to imagining alternative dimensions of reality.

Collins and Gallinal state that we make sense of the world through making stories, with memory at the heart of this narrative. As Ken Liu observes, '[w]e spend our entire lives trying to tell stories about ourselves – they're the essence of memory' (2016: viii). Collins and Gallinal describe memory as a flawed version of reality but that this doesn't mean those memories are not true (Collins and Gallinal 2012). Could it be that my vision of my future daughter is simply a memory that just hasn't happened yet? This puzzle over memory is another subject area with authors and specialisms too numerous to mention. It seems there are as many theories of memory as there are people; memory is essentially – and necessarily – a personal experience. Thompson examines this phenomenon 'what people imagined happened, and also what they believe might have happened – their imagination of an alternative past, and so an alternative present – may be as crucial as what did happen' (2000: 162). I feel this can be extrapolated in my experience to an alternative future. Here Boym's idea of prospective nostalgia bolsters my experience of fluidity across time and space outside of conventional perceptions (Boym 2001). King discusses the fleeting nature of memory, that in trying to pin memories down, they are destroyed much like pinning butterflies in a display case. But these fragile states can allow us to live in another's memory (King 2000). Does my real/not real daughter only exist in my memory? Or perhaps my experience is more like a form of post-memory described by Hirsch (2012) that we inherit stories, images, and relationships from the past and that we can own other's memories as if they are our own. Can we, therefore, also borrow them from the future?

Whatever the explanation for my vision, the point of this story is how a fleeting, impossible memory of my biological daughter triggered an ongoing conversation with her through a series of dresses. Let me explain a bit about my approach to work. I favour using second-hand garments to inspire me, deconstructing them and then embellishing them, usually using text, print, photographic images, and hand embroidery. I often further layer the project by creating films from stills and close ups of the work, blurring images over each other and producing further narratives from the pieces. I might collaborate with other people, telling their story about their relationship with the item, or I might be inspired to create a back story for an inherited garment. Or the piece of clothing might simply be the backdrop for narratives I place upon them. I often work with garments I have to hand, but on this occasion, I needed to source items more carefully. I was, after all, buying clothes for my real/not real daughter, they needed to be items I liked. So, join me back in the charity shops, rifling through the rails of children's clothes.

I felt rather fraudulent while I was doing this, almost creepy. To the casual observer just another mum looking for a bargain for her ever-growing child. Except I'm not a mum. Or am I? I worked fast choosing dresses I found attractive,

trying not to linger too long. Although the task was made harder by the sea of pink and purple frocks. Where were the funky bright colours I wanted for my real/not real daughter? She's not going to want to wear *pink*. At the same time, I half wondered what I would say if someone asked me about who the clothes were for. Would I be honest and say I was working on an art project, or would I boldly strike up a conversation at the till about my real/not real daughter: '[O]h yes, she's starting school in September.' But then I realized I had a whole range of age-related garments; how could I explain that? As it turned out my fears were unfounded, and my purchases prompted no comments. In the end, I sourced half a dozen or so items, and set to work, producing three pieces using a baby grow, a denim dress, and a navy pinafore. These garments allowed me to converse with my real/not real daughter, to have conversations with her about how she got her name, share tall tales of long-dead relatives punctuated by family sayings, and listen to all the exciting things she'd learnt at school that day (she particularly likes sewing). The dresses give me a window into the life of the girl I saw in my vision, recalling future memories of my real/not real daughter at a few weeks old receiving her name with an expression of an aged wise woman, at eighteen months stumbling over her first sentences and at 5 years old bursting with letters of the alphabet and all the learning that brings.

On reflection, I wonder if the project has given me enough experience to fully qualify as a real/not real mother. Like buying the clothes for the project, I feel like a fraud contributing to a publication around motherhood. I know the term mother is a broad church encompassing women whose children are conceived but not born, or born but don't survive, to those who foster or adopt other people's biological children. But what about women who choose not to have children, or those who desperately want them, but cannot; the child-free and the childless. Denise Felkin explores these complexities through her powerful photography in *Mum's Not the Word* (Felkin 2018).

But where does my story fit? I am not a mother grieving for a miscarriage, or a happily child-free woman. I am not bereft by the lack of a child, but neither am I entirely at peace with my status. I already miss not having the relationship I experience with my mum with a daughter of my own. Not having grandchildren. Not having a place in the future. Behar observes that '[w]omen think back through their mothers' (1996: 94). If this is true, who will think back through me? I can see that I strive to achieve this through my work with dresses. Using them as confidents and the bearers of my stories to others long after I am gone. Without the project I wouldn't have got to meet my real/not real daughter; to really give her substance from that one future flash. I got to create memories without the sleepless nights, self-doubt, and constant worry children seem to bring to my friends who do have kids. But is it enough?

Returning to my observation that the lifespan of our clothes is synonymous with those of trees, I am heartened that my real/not real daughter will live on through the garments she would have worn/will wear, these time travelling dresses. I can revisit key milestones of her life through each of her dresses whenever I like, just by looking at them. They can whisper to me stories of her adventures and antics, her innermost thoughts and fears, and I am safe in the knowledge that I would have been/will be the perfect real/not real mum.

REFERENCES

Ashes to Ashes (2008–10, UK: Kudos Film and Television and Monastic Productions, in association with British Broadcasting Corporation).

Behar, Ruth (1996), *The Vulnerable Observer: Anthropology that Breaks Your Heart*, Boston, MA: Beacon Press.

Boym, Svetlana (2001), *The Future of Nostalgia*, New York: Basic Books.

Collins, Peter and Gallinal, Anselma (eds) (2012), *The Ethnographic Self as Resource: Writing Memory and Experience into Ethnography*, Oxford and New York: Berghahn Books.

Epp Buller, Rachel (2020), 'Writing maternal futures through epistolary praxis', University of Brighton, Centre for Arts & Wellbeing, 13 November.

Felkin, Denise (2018), 'Mum's not the word. Childless childfree', http://www.denisedenise. co.uk/mums-not-the-word.htm. Accessed 28 June 2021.

Hirsch, Marianne (2012), *The Generation of Post Memory: Writing and Visual Culture after the Holocaust*, New York and Chichester: Columbia University Press.

King, Nicola (2000), *Memory, Narrative, Identity: Remembering the Self*, Edinburgh: Edinburgh University Press.

Liu, Ken (2016), *The Paper Menagerie and Other Stories*, USA: Saga Press; UK: Head of Zeus.

Sontag, Susan (1979), 'Introduction', in W. Benjamin (ed.), *One Way Street and Other Writings* (trans. E. Jeffcott and K. Shorter), London: NLB, pp. 7–28.

Sparkes, Andrew (2013), 'Autoethnography at the will of the body: Reflections on a failure to produce on time', in N. Short, L. Turner and A. Grant (eds), *Contemporary British Autoethnography*, Rotterdam: Sense, pp. 203–11.

Stanley, Liz (1992), *The Auto/biographical I: The Theory and Practice of Feminist Auto/biography*, Manchester: Manchester University Press.

Thompson, Paul (2000), *The Voice of the Past: Oral History*, Oxford: Oxford University Press.

7

How to Tell a Tricky Story about Birth Trauma: Transforming My Lived Experience into a Mythical Epic

Michelle Hall and Teresa Izzard

Introduction

The process of making *The Dirty Mother: A Post-punk, Post-natal Descent Story* tracks back to an instinct for 'self' preservation. To preserve my 'self' required expression and the telling of my story. The questions that permeated my processes were: How do I tell this intimate birth story? How do I share this story in a culture that seems to fear birthing bodies as too primal, too graphic? How do I share this story in a public arena, for a live audience? These questions and perspectives come from my personal, lived experience of trauma during childbirth.

It is from this personal experience that I write, as someone who is active in confidential birth trauma communities. These are private online groups, where people post their stories of birth trauma, often saying they don't feel safe to share them in their daily lives. Many people living alongside those of us with birth trauma experiences, have little awareness of the effect (mental or physical) that our injuries may be having on us beneath the surface, nor of the effort it takes to navigate birth trauma while trying to 'snap back' to 'normal life'. Many people in the online groups share accounts of being reprimanded for not trying hard enough 'to get over it'.

I can remember my own partner saying to me, three months postnatal, '[y]ou're terrified of everything!' He was angry because I wouldn't take our newborn on the train, through peak hour traffic, to London Olympia to show our baby off to his colleagues. To my partner the trip was a cause for celebration, to me it was a

cause for hypervigilance and exhaustion. My partner was right, I was a bit scared of everything and now I know that the words 'birth trauma' exist and that they mean something serious, I know my feelings were justified. I speak here as someone who has a lived experience of what those words actually mean – the trauma of things going wrong during labour and fearing for your baby's life. It is also the trauma of trying to recover in a society that doesn't realize that recovery takes time; it is not just your body that needs to heal, it is also your mind and this requires allowing your story to be witnessed and validated.

To share my story, I made a show about pregnancy and birth trauma, a show that carefully walks us down into the postnatal underworld of my maternity. With this story, I celebrate the power within birth, the endurance, determination, and physical strength of people who convey a new life into the world. Birth and birth stories are a place where we can feel connected to our origin: we were all born and we all have a birth story. My creative process took two years, but I sat on the story for seven! Therefore, it is impossible for me to go through everything I read and thought about. However, what I can do is give you an overview of the show and share some core dramaturgical ideas that informed the making process and theatrical structure on the road to recovering my 'self' and realizing *The Dirty Mother: A Post-punk, Post-natal Descent Story* (Hall 2020).

Overview of the show

The Dirty Mother is a multidisciplinary performance using choreography, voice-recorded story, projection, and live music that busts apart the taboo of telling unclean stories from maternity. The action dramatizes my physical and psychological metamorphosis between Michelle Hall and versions of myself: Pregnant Clown, Yummy Mummy, and Haunted Cow until I finally transform into *The Dirty Mother*. It takes place in a black box theatre with a microphone stand at stage right. At stage left sits guitarist Sze Tsang, driving the action with their electric guitar riffs and motif melodies.

Into this fertile space, Michelle first appears dressed as a 'normal woman'. She then undresses and becomes Pregnant Clown. What follows, is that the audience witness Michelle performing the graphic details of her transition through pregnancy, labour, and into new motherhood. We see Pregnant Clown's dainty, kiss-blowing game with the audience disrupted by an involuntary, vulvic scream and a shapeshift into a beastly, fruit-smashing maenad. At the end of a guttural roar, a sudden snap of consciousness (along with new-age music and soft lighting through the haze) reveals a third form, the Yummy Mummy. Yummy Mummy yoga poses her way down into the postnatal underworld, where Michelle appears again, and relives her

experience of medical neglect in 'the system' as a pregnant woman. As she moves through myriad procedures she is transformed into a mooing, Haunted Cow. When Michelle arrives at the hospital to give birth and receives an epidural, she hears a voice that demands a bargain for the life of her unborn child. Multiple things 'go wrong' and Michelle hits rock bottom. The audience witness the undercutting of Michelle's confidence at the hands of materno-phobic doctors, a baby born not breathing, an absent partner, hostile-in-laws, and the power (devoid) of 'care' in an under-resourced hospital. From the outer universe of her birth trauma reality, Michelle is visited by her friend Emma Boor who speaks from the future and affirms 'you're going to be okay'. With this tiny flame of hope and friendship, Michelle propels herself out of crisis and, amidst near death and the nappy shite of new life, transcends the mental scars of her birth trauma to return from her postnatal underworld, rebirthed as *The Dirty Mother*.

First dramaturgical stop: Baubo

The first dramaturgical discovery was also the first discovery en route to recovery back in 2010: humour. At a playgroup, I met my friend Emma,[1] who became someone I could laugh with, rather than shrink back apologetically, when I spoke about the mess of maternity; leaking boobs, stitches, loose stools. Through laughter, we reclaimed our 'crap births' and messy bodies. We repurposed our maternity narratives from social taboo to hilarious, encouraging entertainment.

While reading Clarissa Pinkola Estes's short version of the Demeter-Persephone myth[2] (1992: 337–40), I discovered Baubo[3] the little belly goddess, purveyor of smutty jokes and crude, tale-telling vulva. When Demeter, the Olympian goddess of grain, goes wandering after the abduction of her daughter Persephone and sinks into postpartum depression, she cannot help but laugh at the jiggly dancing Baubo who appears before her by a dried-up well. Baubo approaches Demeter front-on, all fanny and boobs, putting it on show, 'wiggling it' in the glum face of Demeter until she laughs. This female, sexual, bawdy comedian was a lot like Emma and me, making comedy gags at our projectile breastmilk mishaps and our postnatal libido confessions. It is the laughter between the clown and the sad mother that shifts the world from barren to fertile again. The laughter is a force that moves Demeter, fires her up to start asking questions, to resume searching for her daughter, Persephone, who has been kidnapped by the King of the Underworld, Hades.

The idea of Baubo affirmed my impulse to employ humour. I envisioned elevating my story through comical play: self-parody and ecstatic mocking.[4] These became the techniques through which I could make a show that reimagined maternity as dynamic, endowing it with the authenticity it embodies. The playfulness

FIGURE 7.1: Pregnant Clown (Hall 2022).

within my clowning amplified my innocence and set me up as a harmless fool, a semi-naked, likeable idiot; a naïve Persephone[5] type. The embodied comic poetry[6] of my own wiggly-jiggly form bopping about the floor, would loosen the tension around the taboo of maternity and reframe my birth story as funny, entertaining, and maybe even relatable. The discovery of Baubo inspired the image of me taking off my clothes, baring my postnatal body, and turning myself into a messy, bombastic figure of comedy, *The Dirty Mother* (Figure 7.1).

Then ... clown

I have a memory of doing these spontaneous dress-up sessions where I would laugh at the sight of myself and take pictures as I modelled ridiculous floral and flounce maternity wear, circa Mothercare 2009. Prescriptive pastels, frills, and swirls and the only pants big enough for my 35-week gestational frame, hot pink mega knickers.

Rather than take me seriously or feel depressed about what were fairly diminishing and alienating 'mumsy' clothes, I played into it. I 'played at' becoming the picture of 'ideal feminine pregnancy'. And then I pushed it further. I became a Bouffon,[7] an extreme caricature creation, I took the piss,

I mocked those images of yummy mummies in lingerie; I showed off too much baby belly, smiled too wildly, and laughed too loudly. I ecstatically waddled my way across the line of appropriate mum-to-be, to disastrous weirdo, a chaotic body just a step away from leaking a fluid or dislodging an engorged mammary. I expanded and took up space. The mocking started as a guilty pleasure and became a dirty, uncouth rebellion: an act of civil disobedience. When 'playing at' maternity in pregnant clown I could confidently navigate this astonishing experience, this 'show of pregnancy'. When adapting my story into a theatre performance I reached back to this strategy of mildly menacing, mischievous oversharing which I had enjoyed in my friendship with Emma, and I used it as fuel for humour.

And, finally, punk maternity

These attitudes of mischief and menace harboured personal power and pleasure. They were energies I channelled, to generate my own aesthetic, Punk Maternity. The Bouffoning, the action of doing things too big, too loud, too messy, and uncensored, was a way of upscaling my experience of maternity through the energy of playful resistance. In the first episode of the show Part 1: Yummy Mummy, after I have stepped away from the mic and moved into the centre of the stage, I perform a scene where I dress up, dress back in time, into my former pregnant clown self. Surrounding this image, my recorded voice narrates the audience towards the setting: 'The Summer of 2009, in Oxford, in the UK [...] I was ready for this baby to come out. I'd enjoyed eating cake in the sunshine, but I was ready for the labour' (Hall 2020: n.pag.).

As I unpack my exact clothes from 2009 and become 'Michelle from back then', a giant image of pregnant Michelle in the same hot pink mega pants, spreads across the whole back wall of the space. Baubo-esque Michelle becomes a giant pregnant body of epic proportions as the smaller, three-dimensional, real-time Michelle begins the fun of self-parody. This Lucille Ball[8]-inspired moment is an invitation for the audience to play, to laugh, and share my pleasure; humour connects me to the audience and builds trust. The clown act serves as a little birth rehearsal for the audience and me in our budding relationship, a taster of how the show is going to work. Rather than be humiliated by my public displays of pregnancy 'erotica', the audience can relax in my safe storytelling hands. My pregnant clown can be the scapegoat, the absorber of any shyness or awkward feelings that may arise at the sight of my semi-naked, middle-aged, faux-pregnant, postnatal body. At the same time, I reclaim my 'self' because I hold the power to make them laugh, to feel something, whether that's discomfort, jollity,

or pleasure. I have flipped the dynamic, I have loosened the tension and shrunk the distance between them and me.

Pregnant Clown primes the audience to trust me – for now! Unbeknownst to them, far darker moments are on their way. There is going to be pain without laughter to entertain it away. So next, I prime them for danger, I release a loud, horror movie scream. Disrupting what was a space of fun and gentle bonding, pregnant clown erupts into a maenad-esque[9] dance, a bombastic explosion of fecundity, a mad self-abduction ritual. As the audience hear the sound of Polystyrene[10] shouting 'I'm a cliché, I'm a cliché, I'm a cliché' … I jolt my body through a seizure of sex shapes and birthing positions, heaving snorty breaths, speaking gobbledegook. Absurdly, I feign birthing a pomegranate and then I smash my fruit baby, wiping its seeds and flesh all over my face, breasts, and belly. Stomping like an enraged cavewoman, I reach the mic and I roar in death metal tones, 'The Dirty Mother Part One; Yummy Mummmmmmmmaaaaaaaaaaaaaaaaay!' (Hall 2020: n.pag.).

In this moment of unpredictable violence, I show off another one of my skills, my powers – I can shapeshift! I morph into a chaotic, pseudo-creature, 'a single oversized antagonist' (Ehrenreich 2007: 29) and this expressive illogic is the life force energy that lives inside the aesthetic of Punk Maternity.

Punk Maternity allowed me to take the story of a difficult birth, a body in extreme, animal transition, and 'shove it' in people's faces. I didn't set out to create an aesthetic. I started making the show and as I was creating antisocial images of maternity, I discovered a way of working and being that emerged as punk maternity. Viv Albertine, of punk band The Slits,[11] writes in her memoir, 'I hadn't been taught an instrument, so I was literally making it up as I went along' (Bullman 2009). I was also making it up as I went, trying to make a show in motherhood, with no resources, no childcare, no rehearsal space, no artistic support, and this unleashed a wild, dissenting freedom that fuelled my determination to tell this story out loud, whatever the consequences. It's only now that I can separate out the process from the product and so at this point, I propose that punk maternity doesn't just exist in *The Dirty Mother* (Hall 2020), it's an aesthetic that is transferable and I will use it again to make my next show about #MomRage (Figure 7.2).

Memory and narrative gestation

'Hi. I'm going to sort of tell the taboo of all stories, the story you're not supposed to tell. You're supposed to have this story and then forget about it, so I thought ah, I'd buck that trend' (Hall 2020).

HOW TO TELL A TRICKY STORY ABOUT BIRTH TRAUMA

FIGURE 7.2: Punk Maternity (Hall 2022).

How do you capture a birth trauma memory?

In 2011, I sat outside my house away from my partner and baby and I wrote down the whole story from start to finish. Then I lost that diary and moved back to Australia. Seven years later I wrote the story down again and I told it to a small audience of punters at a pub for *Bare Faced Stories*.[12] In parallel to developing Pregnant Clown and Punk Maternity, in those seven years between, I was gestating the story's narrative structure. The recording from that first-ever public telling became the spine around which I built the intersecting worlds of *The Dirty Mother* – the worlds of my memory and imagination.

The live pub recording works to anchor the audience to where we are in time, process, and location; it is a reminder that this story was told/has happened, elsewhere. In the live theatre performance, the space is furnished with the laughter and groans of the pub punters, who can be heard, but not seen – who were here, but are not here now – they are ghosts or echoes. Like a meta narrator, the recording continues to frame and reframe what the audience are seeing. On the screen is a slideshow plethora[13]; pictures of 2009 Michelle, 2018 Michelle, medical diagrams, factory farm cows, Medusa's screaming mouth, Michelle's screaming mouth. On stage, is live physical storytelling from my body, the main archival source of the

story. I access visceral memories and shapeshift through the people, places, and feelings from each stage of my labour. My body resurrects them in choreographed re-enactments and versions. I translate my memory of being left in the waiting room, bleeding and in pain, through character-dance gestures: hands over my face to indicate crying, a melodramatic hand to my forehead for fear, fists to my mouth for helplessness. In other places, I use simple pedestrian movement and muscle memory to replicate my gait in late pregnancy.

To evoke an aura of mystery I first appear as a stranger, a sleuth. From within a darkened void (backstage), the audience first hears the clack, clack, clacking of my suitcase. They see a red spot of torchlight shining out onto the stage – revealing an empty space between me and sixty strangers – there is my body, a shadowy outline, standing in a doorway hesitating to cross the threshold. The recorded voice announces me, '[p]lease welcome to the stage Michelle Hall' (Hall 2020: 2). As the recorded audience clap for me, a spotlight encircles a microphone on a stand waiting … the woman, Michelle Hall, steps forward. I am fully lit, standing at the mic, in my jeans and jumper, the exact outfit I wore at the original pub storytelling night. At this moment, I am not an actor, I am both the real person and the replica, with an air of imposter syndrome. Totally exposed, on trial, I scan the audience and I share my vulnerability front-on (Figure 7.3).

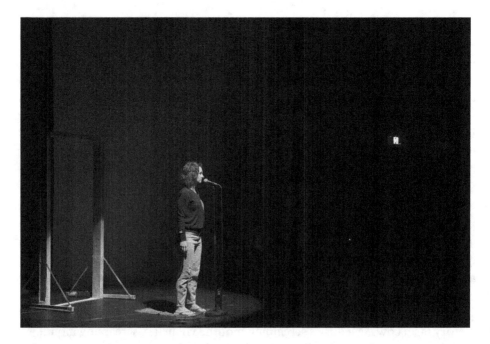

FIGURE 7.3: Opening scene (Hall 2022).

The recorded voice speaks, 'Hi'. The live voice speaks, 'Hi' (Hall 2020). They are both my voice, but there is a delay, I do not quite catch myself. As I re-enact, the mystery escalates, I am speaking here and now but I am an echo of what was said before. I create confusion: which is the real story, the real Michelle? An inconsistency that perhaps evokes curiosity and collective self-consciousness. My live voice is less confident than my recorded voice, and with the speech delay I manufacture a stammering effect, repeating words. A mild stammer was one of the first effects of trauma that manifested for me in social situations. In the performance, I allow that brain glitch, that injury, to come through. I stammer my way into a testimony of my birth trauma story. This is the first refusal to conform, to resist presenting a polished, predictable performance. This is where Punk Maternity begins in the show, though you might not know it because my actions appear contained, but the sound of my stammer is voluminous, my impediment so public, it is cringeworthy. I resist clear speech. I make mistakes. I make things unsafe. I undress. I raise the stakes. I am a semi-naked woman at a microphone with a stammer about to tell her very personal story about childbirth, what could possibly go wrong?

Second dramaturgical stop: Demeter-Persephone as the story template

The Demeter-Persephone myth did more than influence the performance style and aesthetic through the figure of Baubo. The full-length version retold by Clarissa Pinkola Estes (The Creative Fire 2005) also influenced the way I structured the narrative.

In order to make sense of the bodily experiences of my birth story, I used the narrative structure of the Demeter/Persephone myth as a kind of memory mirror. The template helped me find clarity by serving as a container for the events of my labour through narrative and visual images and I allowed its viscerality to fill that structure.

Initially, I had been interested in Demeter and the phase of depression that she sinks into when Persephone is stolen. As I read further into the story my interest turned to the figure of Persephone, her optimism and naivety, her creativity and playfulness, her ingenuity to adapt to the darkness of the underworld[14] (Pearson 2015). These qualities resonated with me when I remembered how I approached birth prior to entering the hospital system; I was enthusiastic, trusting, hopeful, seeing through rose-tinted glasses, perhaps? Or maybe I just expected a hospital experience like the one I had been shown on the tour, with the nice staff and the birthing rooms that had windows that could open and shut.

In contrast, being admitted into the hospital system caused an accelerated loss of hope, a weighty, pulling-down feeling. There was an accumulation of ongoing complications; no rooms to birth in, long periods of time waiting for the third and then the fourth midwife to come back, an anaesthetist who would only talk to me through the midwife, being told to put my clothes back on during labour, a third-degree tear that no staff seemed to know how to stitch up, being left in stirrups for who knows how long while a surgeon was found and a baby born not breathing. The birth plan I had been told to compose at the NCT[15] group was a total joke on me in this scenario. My entry to the hospital marked the beginning of my abduction and the descent that was to follow.

Third dramaturgical stop: Meet the haunted cow

[A]nd I thought um, back, to the week before when I'd been at the NHS hospital sort of lined up with thirty other women kind of like a herd of cattle waiting to pee in a cup and be given a number, just to see a doctor, not an obstetrician, just a bog-standard doctor.

(Hall 2020)

The image of the haunted cow came to me while I was pregnant: I felt like I was the embodiment of an unnecessary burden that was deemed necessary to control. I harnessed the memory of this feeling to create a scene paralleling the industrialized processing of pregnant women through the hospital system, with the cow in factory farming. I drew on my experience of clinical routines I had undergone; the mechanical poking, inserting, injecting, testing, shuffling; a herd of pregnant inductees moving in and out of waiting rooms, queuing, submitting urine pots and body parts for inspection; a cumbersome bulk moving too slowly, gaining too much weight, consuming too much time, slowing down the process, agitating the system (Figure 7.4).

The cow metaphor, dramaturgically, serves to condense and heighten what it felt like to experience all this on repeat. In tandem, this image of me captured both my naivety and my diminishing sense of agency. Further, the haunted cow image reflects back a manufactured maternophobia, one that permeates patriarchal society, promotes collective fear and repulsion towards birthing bodies and female reproduction. Sharpe and Sexon in their work around *The Monstrous Feminine in Contemporary Horror Films and Late Medieval Imagery* discuss a transhistorical, socially engineered maternophobia that can be traced back to medieval Christian imagery, and, feminine tropes found in 1970s horror movies such as *Suspiria* (Argento 1977) and *Possession* (Zulawski 1981), '[t]he female

HOW TO TELL A TRICKY STORY ABOUT BIRTH TRAUMA

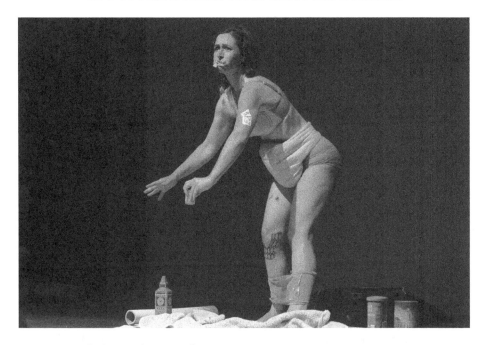

FIGURE 7.4: The haunted cow (Hall 2022).

body collapses the boundaries between self and other via reproduction [...] In socio-cultural terms, these traits cast the mother figure as an abject monster: that which dissolves the borders between the flesh and the world' (Sharpe and Sexon 2018: 3). Haunted cow, represents the moment in my experience where I felt my most dehumanized. In the show, it is the moment I physically morph into a cow, and 'moo' like a trapped, breeding animal, a monster of maternity captured by the medical system; a pawn in the apparatus of the Christian patriarchal imagination.

In superimposing my birth experience onto the Demeter-Persephone myth as a story map, this is the moment where I reach my rock bottom. I became both Demeter the barren and Persephone the abducted, the mother and the daughter. Yet, despite this heavy, sad part of my story, the Demeter-Persephone template holds within it Persephone's irrepressibility, her optimism and her adaptability. Persephone claims an alternative ending, one where she self-initiates in the underworld by recasting herself from victim to queen. She discovers she has the power to initiate[16] the dead, the lost souls as they transition to their new reality. In writing the story of my birth trauma experience, I was inspired to follow Persephone's lead and engage my own narrative intelligence, to adapt and recast. I transform into the victim, the haunted cow, then morph into the Maestra, a storyteller who not only self-initiates but initiates the audience into the hidden world of medical

neglect. I survive haunted cow and live to tell the tale, performing it as a DIY birth rite, transcending traumatic memory through embodying, adapting, and retelling.

Fourth dramaturgical stop: Nekyia, descent, and my postnatal underworld

In *The Dirty Mother*, Persephone becomes an archetypal metaphor for Hillman's claim that humans compartmentalize or repress our more difficult stories to a psychological underworld, '[r]epression is the concept psychology uses for describing the fact that a host of *eidola* or "images" are kept on the other side. What takes place in this other "mental province" (NIL, 0, 96) gives our waking life anxiety' (Hillman 1979: 17). What is buried may well rise up to the surface and revisit you, at some point. This may be a deep-rooted personal fear, a traumatic experience, or a societal fear that become taboo like maternophobia which is kept alive by the attitudes of the collective. It's my belief that to transform this or shift the narrative, you have to dig down into it, you have to descend.

I take the audience down with me into my postnatal underworld, the place where my memories are stored and here, together, we look at the hidden 'bad dreams' of my trauma. Enrique Pardo, of Pan Theatre,[17] speaks about Nekyia as, the Greek word for descent into a pagan hell [...] the abode of the dead. Pardo refers to Nekyia as, 'a place, a ghostly agora, a theatre where true dreams and counterfeits mingle [...] exchange ideas and scenarios [...] A transit airlock, a caravanserai for night travellers'. On stage, I become all the ghostly figures that populate my hospital nightmare, I become Teresa the giant midwife who helps me 'shit out my baby'. I become my partner Ed doing his Hugh Grant impression in the car park. I become the burning, pregnant martyrs of medieval Oxford, haunting the cobbled streets that lead to the hospital. I become 'counterfeits mingling' in an animated, boundaryless realm where my memory and imagination make postnatal dream scenes.

To choreograph the events that make up my descent I sketched a storyboard of episodes from the various sections of the voice-recorded story. I ordered these episodes into a kind of plot-score, a progression of the story's action as challenges, triumphs, and setbacks for Michelle to overcome, to birth her baby and keep her 'self' alive. I was adamant that the action should be as visceral as possible, that I would show/tell/describe/share the memory of the life-and-death stakes that were raised through the stages of my labour. For example, in the amniotic 'water-bursting' scene the audience listen to my recorded voice telling them about what it was like to have my waters burst, I describe the hook as, 'this big, like one you see at a butcher's shop', the audience hear me change

into the midwife's voice as she explains that she's going to, 'insert this hook into your vagina' (Hall 2020).

While this is being heard, what the audience see is me standing, looking back at them, a few tears brewing in my eyes as I remember the procedure and morph again into the haunted cow. My body goes down, further, slowly, onto all fours, the cow cries out and children's voices sing a disturbing, amateur rendition of Bowie's *Space Oddity* (1969). The descent is in motion and now Michelle, together with the audience as her witness, is in free fall, unanchored and alone. In this place of the Nekyia, I share my darkest moments, I put my trauma on stage, I share the very low points in my birth process, the ones that brought me down and still echo-back as phantom pains in my body. It is the act of sharing that allows some of us there to grieve together[18] while others insulate that grief as quiet observers.

Fifth dramaturgical stop: Beyond the underworld, womb dreaming

Deeper and clearer than the noise and discombobulations of the hospital experience, was the growing feeling of connection to my baby. I wanted to somehow capture and illuminate this feeling that my 'self' was blurring into a boundaryless bond with the little unborn 'self' turning in my womb. I was entranced by the morphology scan photos, from the twenty-week scan,[19] the texture of watery translucence my baby was floating in, inside me. In response I improvised choreography where I began tucking inwards, turning upside down, mimicking him floating. I had the idea to make an animation from those ultrasound images which I would project above and around me, bringing to the surface a vision of the baby spinning in utero, as I spun in unison with him, ex utero, on stage. My collaborator, Megan Hyde, created a static effect by playing with lighting while filming my ultrasound copies. While working on animating the baby scans photos, Meg noticed a subtle blue static effect coming from a TV screen being watched in the far corner of the room. When she tweaked the lighting, she found it created a background of reflecting blue pixels, a flickering texture, an illuminous lining within which the spinning scan babies could be planted. I decided to project the static over my body (on stage) as an illusion of an expanding womb space, a symbol of my connection with my baby, an internal shield from the external world where we were safe within a glittering, cubic membrane.

On my descent, static works as a light source and a psychosomatic map, illuminating my internal experience and intuitive awareness of my unborn baby. It captures the sensed intimacy that characterized my pregnancy at its final stage (Figure 7.5).

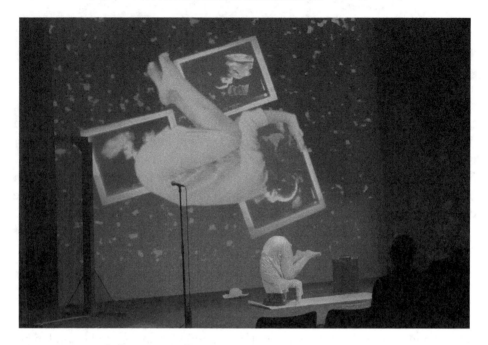

FIGURE 7.5: Womb dreaming (Hall 2022).

The road ahead: Rebirthing the narrative

Thinking about how I could enter the performance space, bringing my complicated and graphic story about birth, I thought about the way I had carried it around with me for so long. And so, I shrunk the story down and pulled it along behind me in a small, very light, wheelie suitcase. From this suitcase, I would deliver my metaphysical afterbirth – my emotional baggage symbolized by toy-like objects – evidence of my life in the United Kingdom. I unpacked my Big Ben toffee tin, my English rose China mug, my Royal Mail biscuit tin, and my Mothercare maternity clothes. The audience was invited to examine the forensic evidence of this mystery as I built a picture of a faraway world and laid it out around me. In contrast to the miniature world of my memory, I sat amongst the ornaments, a giant pink-clad girl, on her way to becoming a golden goddess, a mother. I made the everyday seem magical and the intimate seem epic. I took the gravity and the enormity of childbirth, the vast opening edge of the human life cycle and I made it portable and lightweight. My mission was to transform the immense, profound and unseen into packable, digestible proportions. On the other hand, I wanted *The Dirty Mother* to supersede outdated depictions of maternity, like those sanitized TV births we've all seen. I wanted to make a show that humanized a woman in labour in all her awesome messiness.

The Dirty Mother transforms a bare, black box theatre into a ritualistic arena, a space that echoes back through millennia of birthing bodies, of people who take themselves to the interface of life and death to deliver their babies. Nekyia and my postnatal underworld open up a space of emotional fecundity and honesty, where 'we' can commune, laugh, grieve, celebrate, and feel the profundity of our own births, perhaps recognizing birth as our first rite of passage on the road to becoming our 'self'. *The Dirty Mother* proffers the idea that 'self' is an assortment of times, places, experiences, and identities and that perhaps this story about childbirth and trauma, this story about recovering 'self' is in some way relevant to us all. Perhaps we are all descending, looking to understand, examine our dreams, meet our ghosts, and transform our inner victims into empowered narrators who make the everyday magical and the intimate epic. For those who have experienced birth trauma, I hope that *The Dirty Mother* shines a light as you find your way back up, and, in this way becomes a model for reimagining ourselves beyond crisis.

Acknowledgements

Thanks go to Dr Teresa Izzard for her efforts in supporting me to write this article.

The original development and live performance of *The Dirty Mother: A Post-punk, Post-natal Descent Story*, was supported by The Blue Room Theatre, Perth, Western Australia

The digital reimagining of the show was supported by The University of Melbourne Theatre Guild, with special thanks to Annie Fitzgibbon.

The 2020 'Fringeworld' Festival performance at The Blue Room Theatre, was created in collaboration with the following team:

Michelle Hall, writer, director, performer, producer
Danielle Cresp, co-director and movement coach
Sze Tsang, musician and performer
Alexa Taylor, dramaturg and co-director
Megan Hyde, visual artist
Georgi Ivers, digital visual artist
Katie Moore, technical operator
Catherine O'Donoghue, technical collaborator ('Winter Nights' development)
Liz Skitch, collaborator
Asha Kiani, marketing and publicity

The 2020 Melbourne Fringe Festival, digital performance, 11–21 November, was created in collaboration with the following team:

Michelle Hall, writer, director, performer, producer
Georgi Ivers, digital director
Catherine O'Donoghue, technical operator
Sze Tsang, musician and performer
Alexa Taylor, co-director
Danielle Cresp, co-director and movement coach
Megan Hyde, visual artist
Roger Miller, live sound mixing
David Downey, camera operator
AJ, camera operator
Asha Kiani, marketing and publicity
Jenny Bylund, camera support
Noemi Huttner-Koros, dramaturgical support and boom operator
Nini Ramirez, hero image photographer
Asha Kiani and Elham Eshraghian, hero image designers
Set construction, Murray Hall (doorways)

I would like to thank my mum Hellen Hall. Also, Murray Hall and Ed Miles. I dedicate this work to Max Miles-Hall.

NOTES

The digital version of *The Dirty Mother: A Post-punk, Post-natal Descent Story* can be viewed on request. Please contact the book editors for access details.

1. Emma Boor, in the play, becomes my extra-terrestrial oracle. At the depths of my postnatal depression, her massive face appears from outer space. Emma delivers a forecast of hope from the future, telling me that I am 'going to be okay'. Emma's message propels me to ascend into the universe where I sing Karen Carpenter's 'Calling Occupants' with the audience singing along in a burst of intergalactic karaoke.
2. Estes's short Cantadora version of the Demeter-Persephone myth tells the story of how Persephone, the daughter of the Earth Mother Demeter, is forcefully stolen by the King of the Underworld, Hades. This version focuses on the appearance of Baubo to a grief-stricken Demeter who has been unable to find her missing daughter. Baubo shakes her breasts and tells juicy jokes 'through her talking vulva which causes Demeter to laugh, drawing her out of her depression' (1992: 338).

3. According to Estes, Baubo is a goddess from ancient Greece, the so-called 'Goddess of Obscenity', also known as Iambe. The only popular reference to Baubo that still exists is the one in the Demeter-Persephone myth (1992: 337).

4. Ecstatic mocking is a term I acquired from training with clown pedagogue Giovanni Fusetti, Helikos School, Italy. I participated in a workshop lead by Fusetti, 'Bouffon: The Ecstasy of Mocking'. The principle ideas that I am working with around mocking are based on Fusetti's teaching that mocking is a 'poetic dynamic [...] found in the uniqueness of Bouffon folly'. Moving through 'levels of play', mocking allows us to explore the pleasure and cleverness of 'punching' the audience with the outrageousness of the genre (of Bouffon) (Fusetti 2018: 2).

5. Persephone is the daughter of Demeter, Goddess of Agriculture, and Zeus, chief God of Olympus, in the Demeter-Persephone myth. Persephone eventually became the wife of Hades and Queen of the Underworld (Britannica.com/Persephone-Greek-Goddess. Accessed 3 December 2023).

6. My clown teacher Giovanni Fusetti speaks of Embodied Comic Poetry in these terms: '[E]verybody carries themes that are profoundly expressive, embodied in everyday movement as physical patterns. There is a web of physical and emotional "background noises" within each person's movement and physical presence [...] They contain a drama: an action [...] a tempo, voice, attitudes, emotions and poetic world' (Fusetti 2017).

7. 'Bouffon is a form of expression, performance and clowning. My understanding of Bouffon is based in Giovanni Fusetti's teaching that Bouffon work belongs to the realm of satire... they see and play with everything. In a Bouffon piece, often the audience gets entertained and provoked at the same time [...] its very nature is to bring hidden things to the surface and to unmask the collective games that lie beneath events, beliefs and behaviours' (Fusetti 2018; Helikos.com/pages/workshops. Accessed 12 December 2023).

8. Lucille Ball was an American actress, comedian, and producer. She was the star of the television sit-com *I Love Lucy*. Ball was famous for her whacky, physical comedy skills and her perfectly executed 'disaster' sequences (wikipedia.org/wiki/Lucille_Ball. Accessed 12 December 2023).

9. Maenadism is the ancient Greek women's frenzied worship of Dionysus whose 'single most shocking feature [...] was its reputed violence. At the height of their frenzy, the women worshippers were said to catch wild animals in the woods, tear them apart while still alive, and eat them raw' (Ehrenreich 2007: 36–37).

10. Polystyrene is the lead singer of the British punk band X-Ray Specs formed in 1976.

11. While I am inspired by the female punk movement of the late 1970s in the United Kingdom. I wouldn't claim to be a punk mother. That to me feels very unpunk. Viv Albertine remarks that The Slits rejected labels and fixed notions of punk, because 'punk' was defined primarily through images of male 'rock stars' along with venues, record labels, and tours controlled by (mostly) male promoters (Bullman 2009).

12. *Bare Faced Stories* is a live storytelling night held monthly in Perth, run by actor and broad-caster Andrea Gibbs (www.barefacedstories.com. Accessed 12 December 2023). It was Andrea Gibbs who randomly, in passing, asked me if I had a story.

13. Plethora, from Lehman's work on *Post Dramatic Theatre*, is defined as: 'Exceeding the norm, just as much as undercutting it, results in what could be described less as a forming than a *deforming figuration*. Form knows two limits: the wasteland of unseizable extension and labyrinthine chaotic accumulation' (2006: 90, emphasis added).

14. Pearson's discussion of Persephone, in her book *Persephone Rising*, focuses on Persephone's skills of adaptability, letting die what must die, and renewal, 'Persephone's ease in moving back and forth between the worlds and the season can be a model for our gaining ease in shifting between multiple roles [...] and life stages' (Pearson 2015: 190).

15. NCT stands for National Childbirth Trust.

16. When she was in the underworld, Persephone 'would initiate the dead into the deeper myster-ies that only those who have sloughed off their material forms can know' (Pearson 2015: 10).

17. Pantheatre is an organization based in France. It is described by its founders Enrique Pardo and Linda Wise as 'a context for performance, training and study'. Pardo and Wise have established the workings of Pantheatre around three main foundational tenants: the work of James Hillman on archetype and mythology, Roy Hart's work on voice, and Xavier's Papais work on contemporary anthropology of the spirit-mind (Pardo and Wise 2021; https://pantheatre.com/-/. Accessed 12 December 2023).

18. Collective grief during the performances of *The Dirty Mother* wasn't always obvious, some-times people openly cried, sometimes not. But I did receive some letters that feed back to me how members of the audience were able to cry for their own birth traumas, losses, and painful postnatal experiences.

19. The twenty-week scan is an ultrasound scan procedure that occurs at nineteen to twenty weeks during the gestational period. The scan detects a heartbeat, measures the foetus, and reviews the position of the placenta (ultrasoundcare.com.au. Accessed 12 December 2023).

REFERENCES

Argento, Dario (1977), *Suspiria*, Germany: Seda Spettancoli S.P.A Rome.

Bowie, David (1969), 'Space Oddity', *David Bowie*, vinyl, UK: Mercury Records.

Bullman, Janine (2009), 'Girls unconditional', *Loud and Quiet*, 3:8, pp. 28–31, http//:issuu.com/loudandquiet/docs/issue8. Accessed November 2022.

Ehrenreich, Barbara (2007), *Dancing in the Streets: A History of Collective Joy*, London: Granta Books.

Estes, Clarissa Pinkola (1992), *Women Who Run with the Wolves*, London: Random House.

Estes, Clarissa Pinkola (2005), *The Creative Fire (audiobook)*, Boulder, CO: Sounds True.

Hall, Michelle (dir.) (2020), *The Dirty Mother: A Post-punk, Post-natal Descent Story*, The Blue Room Theatre, 17–23 January.

Hillman, James (1979), *The Dream and the Underworld*, New York: HarperCollins

Langley Schools Music Project (1976–77), 'Space Oddity', composed by D. Bowie, *Innocence and Despair*, digital file, British Colombia: Bar/None Records Manimal Vinyl.

Lehman, Hans-Thies (2006), *Post Dramatic Theatre*, Oxon: Routledge.

Pardo, Enrique (2018), 'Nekyia Festival 2018', Enrique Pardo Blog, 11 April, http://enrique-panblog.wordpress.com/2018/04/11/nekyia-festival-2018. Accessed 1 November 2018.

Pearson, Caroline (2015), *Persephone Rising*, New York: HarperCollins.

Sharpe, R. F. and Sexon, S. (2018), 'Mothers milk and menstrual blood in *Puncture*: The monstrous feminine in contemporary horror films and late medieval imagery', *Studies in the Maternal*, 10:1, pp. 1–26, http://doi.org/10.169995/sim.256.

Sulawski, Andrej (1981), *Possession*, Germany: Gaumont, Oliane Productions, Marianne Productions and Soma Film Productions.

X Ray Spec (1977), 'I Am a Cliché', composed by P. Styrene, vinyl, Germany: Virgin.

8

Rhetorical Uteri:
A Comparative Visual Analysis of Next Nature Network's 'First Artificial Womb for Humans' and Ani Liu's *The Surrogacy*

Yvette Chairez

Upon first glance, the 'world's first artificial womb for humans' (Devlin 2019: n.pag.) being tested by Máxima Medical Centre (MMC) in the Netherlands strikes as severely sci-fi. This prototype is not a singular structure, though. In the official promotional and exhibition photo (Figure 8.1), it is clearly an arrangement of *four*. These 'wombs' are deep red, rubbery, and abnormally large for what they are professing to replicate; also, they are floating in place, held together by tangles of bronze wires plugged into what look like step stools and toilet plungers. Philosopher Patricia de Vries of Maastricht University remarks, '[i]t is of importance – and tragi-comic – that the artificial womb prototype has more likeness to dangling testicles than to the shape of, say, a womb' (2020: n.pag.). Because of science fiction's long history of misogynist depictions of women and demonizing representations of mothers (Kechacha 2020), it is to be expected that any individual with a uterus may react similarly to de Vries, or be put off by the image of the artificial womb (AW) all together. I wondered myself, as someone who has birthed four children, including one premature and one high risk, and miscarried another, could something so visibly inspired by popular sci-fi renderings of AWs end up negating the serious conversations that will inevitably engulf it – conversations about mothers' bodily autonomy, foetus' rights, reproductive justice, and family planning both within and beyond the cis heteronormative assumptions of the nuclear family? Artificial wombs in science fiction are overwhelmingly cast in a negative light and involve either absent mothers or the absence *of* mothers, adding to the stigmatization of individuals who seek reproductive interventions

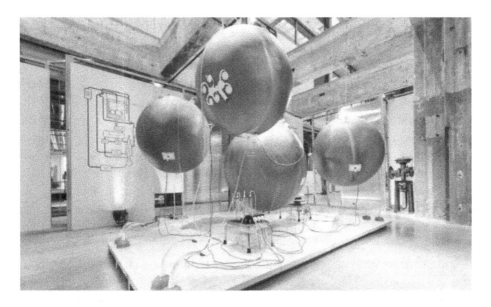

FIGURE 8.1: NNN, AW prototype, 2018. Rubber balloons, wires, wood. Droog Amsterdam. ©NNN. Photo depicts the AW as it was exhibited in a skylighted steel, concrete, and drywall room at *Reprodutopia*.

and assistance. An artificial womb that is visually and rhetorically related to the mother of all sci-fi tropes risks sparking a dialogue that inevitably centres on the faults and horrors of the artificial wombs of science fiction fame. However, the art collective responsible for the visual design of Máxima's AW, the Netherlands' Next Nature Network (NNN), a setup of 'makers, thinkers, educators, and supporters' touting the byline 'Technology is our next nature' (NNNa 2019: n.pag.), claims to want to change the conversation by asking, '[h]ow will reproductive technologies, such as artificial wombs, change our ideas about intimacy, gender equality, relationships and human nature?' (NNN 2018: n.pag.). Noble (albeit fairly generic) as this sounds, the endeavour did not start out that way. As the main exhibition draw to their show *Reprodutopia*, NNN asked in regard to the AW, is this 'a feminist dream or frankenstein nightmare?' (NNN 2018: n.pag.), thereby adding to the problematic nature of discourse surrounding AWs in western societies and pointing even further to the troubling tendency of creators outside of the obstetrics and gynaecology communities to hijack/co-op artificial wombs for their own gains (Sedgwick 2017) rather than placing the focus squarely on the pregnant person and their family.

Nicholas Maradin (2017: 2) writes that in recent years, 'the notion of having an artificial limb has come to be portrayed as a positive – and even enviable – characteristic'

and marketers of prosthetics have relied heavily (and successfully) on the cool factor that sci-fi depictions of bionic limbs and other prosthetic inventions have lent to their campaigns. The AW has not received the same fanfare, embroiled as it is in debates over religious beliefs, feminist principles, and reproductive politics. Though both types of technologically rendered artificial human body parts are intended to improve a person's quality of life, or even save it, the schism between how the two categories have been received is massive. One is able to be worn as a hero's badge of honour; the other is mocked on YouTube, for example, with comments like '[i]magine how you'll be made fun of for coming from an artificial womb' (The What If Show 2020: n.pag.). Furthermore, as sites of ongoing contestation, wombs, artificial or not, generate controversy and conversation that 'taps into a range of political and ethical questions and considerations about birthing, reproduction, parenting, sex, relationships, and of course motherhood' (de Vries 2020: n.pag.).

I intend to join this conversation through a feminist visual rhetorical comparative analysis using *The Surrogacy (Bodies Are Not Machines)*, a womb sculpture created by research-based artist-mother and speculative technologist Ani Liu, as a lens for (re)looking at the AW, using the rhetoric of science fiction in the West's pop cultural imaginary as my frame of reference for analysis. Feminist posthumanist thought will necessarily be the theoretical framework through which I approach this study, and 'maternal knowledge' will also serve as a rhetorical tool of inquiry. I have chosen Liu's work as a lens on the grounds that she is a mother who makes artwork that critically interrogates scientific innovations, particularly those in the realm of reproductive interventions. As a mother and rhetorician, I suspect that the sci-fi design aesthetic of the AW may cause cognitive dissonance, wariness, and distrust among those whom the AW is purported to support. This is the motivation for my analysis.

My chapter will begin with brief statements on the terms 'visual rhetorical analysis', 'feminist post-humanism', and 'maternal knowledge', followed by an overview of the artificial womb debate, along with introductions to the AW prototype being tested by the Netherlands' MMC and *The Surrogacy*. From there, I will launch into my proposed analysis of the two visual texts.

Terms

Visual rhetorical analysis

Following Kristie Fleckenstein's assertion that '[e]ssential to all rhetoric is vision, both in terms of a shared way of seeing and a shared network of visual images' (2017: 11), I am attending to the 'interinanimation' (2017: 8) of the AW with the

West's collective cultural imaginary, looking at how elements of the image trigger responses rooted in science fiction rhetorics that, due to their ubiquity, have had a hand in our socialization and now form part of our belief systems. Following in the tradition of fellow feminist visual rhetoricians I come into this project with the following guiding question: What rhetorical messaging about women and individuals with uteri is being transmitted by the appearance of the AW?

Feminist post-humanism

I find the field of object-oriented feminism (OOF) particularly useful here as the topic concerns an invention created to assist with reproduction, thereby bridging a connection between objects and a key focus of feminism: reproductive justice. A marriage of feminism, post-humanism, and thing theory, OOF is an outgrowth of object-oriented ontology (OOO), a line of thought materialized by four white male philosophers 'dedicated to exploring the reality, agency, and "private lives" of nonhuman (and nonliving) entities' (Kerr 2016: 5) and to asserting that *things* may be agentic in and of themselves and ought to be valued and evaluated as such. Katherine Behar, who coined object-oriented feminism, says OOF is a response to OOO's refusal to engage in politics, making the movement appear 'as an act of privilege' leaving 'some readers with a bad aftertaste and feelings of frustration' (Kerr 2016: 7). OOF, instead, posits that new materialism's object-oriented theories and obsessions are a natural fit for feminism:

> After all, doesn't feminism already deal with objectification? [...] [I]t has always involved inward ways of orienting politics through subjectivity, whether translating private domestic practices into the public sphere of politics or advancing inner personal affect as a sources of knowledge.
>
> (Kerr 2016: 10)

It is this rumination on the implications of objectification that I will employ the most here.

Maternal knowledge

In her 1989 book *Maternal Thinking*, feminist philosopher Sara Ruddick introduces 'maternal knowledge' as grounded, methodological thought formed by neurological and weighted processes akin to scientific hypothesizing. With this Ruddick pushes against the ever-popular trope of the hysterical female with her unruly, unreasonable passions (Kapsalis 2017). The mother, in her efforts to harness and apply her knowledge, Ruddick says, 'asks certain questions rather than others; she establishes criteria

for the truth, adequacy, and relevance of proposed answers; and she cares about the findings' (1989: 70). She speaks at length about the choices mothers must weigh and the conflicting, contradictory nature of these choices, along with the conflicting, contradictory feelings that may result. Further, she is guided or inhibited by outside sources and ethical dilemmas as she reckons with 'the fragility of the lives [she] seeks to preserve' (Ruddick 1989: 73). Accordingly, I will honour the mothers I quote in this chapter as respected rhetors and consider the knowledge they share to be a valid, invaluable and critical tool for analysis; and I firmly believe that consulting with those who possess maternal knowledge (and/or a womb) ought to be of utmost importance when embarking on any sort of research into medical interventions that are meant to mimic a maternal (and/or uterine) function.

Background on the AW debate

From philosophers engaging in conversation around the topic in the early 1900s, to the steady popularity of speculative arts pieces dwelling on (or in) sci-fi wombs, to the way the AW is depicted in media outlets, it is important to understand that attitudes and reactions to the first AW for humans are being influenced in western society by what the rhetoric from these varied channels have prepared people to expect. For the general population, the rhetoric presumably depicts a dystopian world where technological entities are beginning to replace humans – enter *The Matrix*. Though feminists point out the positive potential for gender and sexuality equality that the AW carries, we despair that an invention like this signals a futuristic misogynist fantasyland where men control what people do with not only their physical wombs but their artificial ones as well. Even incubators, the precursors to fully Aws, drew criticisms from the patriarchy. In the late 1800s, 'attempts to recreate the womb were accompanied by early obstetricians' concerns that mothers themselves, with their unsanitary practices, irresponsible behaviour, and anxious fussing, might pose a danger to their infants – a danger that could be curbed by placing the uterus-incubator firmly in the doctors' hands' (Horn 2020: n.pag.). Thus, as a result of the introduction of incubation environments for premature babies, two complementary medical opinions began to form about mothers who wound up needing the support of an incubator: (1) They were failing at what they were born to do (carry a baby to term) and (2) they were shirking their female duties by having someone else care for their baby while in incubation (Horn 2020).

Modern-day discussions on 'assisted reproduction' date back to 1924 when English biologist J. B. S. Haldane coined the term 'ectogenesis', or the growing of foetuses outside of a womb, in his lecture 'Daedalus, or Science and the Future' at Cambridge University. Unsurprisingly, his vision of ectogenesis was not meant to be liberating

for women. His lecture was, after all, an argument against what he saw as the rapid acceleration of science. Reading from an essay written by one of his students about a speculative future, Haldane surmises: 'Had it not been for ectogenesis there can be little doubt that civilization would have collapsed within a measurable time owing to the greater fertility of the less desirable members of the population in almost all countries' (1924: 63). Ectogenesis, then, was not conceived of as a gender equalizer but as a weapon of reproductive control – and one way to wield it involved removing 'fresh ovaries' from dead women to fertilize in vats (Haldane 1924: 64). So began a decades-long conversation on ectogenesis among scholars, writers, and intellectuals such as Virginia Woolf, Aldus Huxley, Dora Russell, and radical feminist Shulamith Firestone, who wrote in her 1974 book *The Dialectic of Sex* – which Ani Liu was reading while pregnant – that 'the only way to achieve true equality between men and women is to outsource pregnancy to machines' (1974: 183).

Today, western media coverage of advancements in artificial womb technology demonstrates that sentiments like these still persist. However, the conversations now invoke any number of the multitudinous works of sci-fi that have depicted ectogenesis since then (Davis 2019; Dimitropoulus 2020; Lehmann-Haupt 2019; Sawbridge 2019). Many male-authored works, like Huxley's *Brave New World* in 1932, began featuring horrifying scenarios involving reproduction as the ectogenesis debate and scientific advancements to reproduction took off in England and the United States: artificial wombs in Philip K. Dick's *The Divine Invasion* (1981), 'designer babies' in Frank Herbert's *The Eyes of Heisenberg* (1966), birthing evil creatures in Dan O'Bannon's film *Alien* (1979), and the capturing of women for reproduction purposes in Takashi Doscher's pandemic film *Only* (2019). Though women writers and creators have steadily been gaining traction in science fiction, misogynistic representations of women and reproduction in much of the genre's early oeuvre are now considered canon and thus constitute the 'norm' by upholding the conservative, holy order that designates men as the heads of households and governments and women as being necessary only to populate the earth.

MMC's 'first AW for humans'

According to Dr Guid Oei, lead gynaecologist of the Dutch project, the AW was conceptualized to help bring precariously premature babies to full term in order to increase the chances of survival of extremely premature babies in the period of 24–28 weeks. As Dr Oei told NNN,

> [a]t this moment, these chances [of survival] are low: 61 per cent dies [at] 24 weeks and 43 per cent [at] 25 weeks. The babies that survive, often suffer from [...] brain

damage, chronical breathing problems, retina problems and possibility of blindness [...] Every week we can prolong the growth of a 24-week-old foetus in an artificial womb, we increase the chances of survival with 18 per cent [...] If we can extend this to 28 weeks the biggest danger of premature death is probably gone.

(NNNd 2018: n.pag.)

It is expected that a baby born before the week of viability (37 weeks) can be directly transferred into the fluid-filled 'balloon', as Dr Oei calls it, then hooked up immediately to an artificial placenta, and artificial umbilical cord, to continue the process of gestation. Dr Oei believes this will help save a portion of the 50 per cent of premature babies who are too small to thrive outside of their mother's (or perhaps surrogate's) womb and whose systems are too weak to survive the harsh oxygen environments of a hospital's neonatal intensive care unit (NICU). While Lisa Mandemaker, lead designer on the project, predicts that the creation and viability of the AW signal a huge leap for reproductive rights and gender equality (Devlin 2019: n.pag., 3:40), Dr Oei says it is not practical to think of this invention as a vehicle for such progressive issues (Devlin 2019: n.pag., 4:16). I contend that this makes the AW more of a glorified incubator than a human-less, foetus-growing apparatus as the name implies.

Kayleen Devlin's short documentary on Máxima's AW opens with: 'It's a very thin line between a dream come true and a horrific science fiction film' (2019: 0:22). Though it is now being used as an actual working prototype approved by the governing agencies in the Netherlands, the AW was originally conceived as part of NNN's travelling *Reprodutopia* exhibit. NNN also has in its repertoire a mock job agency for robots, a VR experience of techno-habitats for humans, and a fantasy cookbook with recipes involving in vitro meat (NNN 2019: n.pag.). While these creations are rooted in real world concerns about, and possibilities of, the interactions among humans, technology, and nature, NNN's imaginings may be considered quite cheeky.

Oei approached NNN and Mandemaker, who was commissioned to create the AW on behalf of the collective and is not a mother, about using their AW design for his incubation project. From *Reprodutopia* to Oei's lab, the AW does not appear to have undergone any design updates. It has remained in its sci-fi form from inception to actual medical research use, and continues to be called an 'artificial womb' rather than an incubator that, say, attempts to offer a womb-like environment, which would be more accurate. Mandemaker, a speculative designer who 'makes prototypes that invite people to think about different possible futures' (Geuze 2022: n.pag.), says of her design concept:

Emerging reproductive technologies such as artificial wombs, genetic editing techniques and artificial sperm and egg cells will not only affect the ways in which we have babies. Their use will change our experience of sexuality, gender, relationships

and family. [...] New questions arise; should men be able to get pregnant and carry a baby? How would you choose your partners when you no longer need them to produce offspring? And should your kin even be human?

(Mandemaker 2022: n.pag.)

While there is certainly validity to the points she makes and the questions she asks, these do not align with the vision and proposed function and value Oei describes in Devlin's film. Since the prototype's inception, Mandemaker's website has not been updated to state that the AW is currently being tested to save the lives of premature foetuses. Both on her site and in interviews she speaks only of its showstopping importance to the *Reprodutopia* exhibition and its achievement as a speculative design – and even admits that it is inspired by *The Matrix* (Geuze 2022: n.pag.), a film where humans are 'grown' in pods and harvested for their bioelectricity in service of the computers that now run the world (*The Matrix* 1999). Relatedly, 'the Latin word for "mother", originally meant "pregnant animal" or "breeding female" and was later generalized to mean "womb"'.[1] This misalignment of messaging and rhetorics between the two primary angles of coverage and conversation around the AW adds to the cognitive dissonance experienced in viewing the prototype.

Ani Liu's The Surrogacy (Bodies Are Not Factories)

Ani Liu's sculpture, along with the rest of the work in her 2022 exhibition *Ecologies of Care* at Cuchifritos Gallery in New York City, plays with the idea of mothers feeling like machines (like a milk machine, for example, to parents who lactate) and of mothering feeling like a deed that simply serves to uphold predatory capitalistic power (Figure 8.2) (aniliu.com 2022: n.pag.). Liu follows this path of thought to its absurdly logical conclusion of a controlled gestation scenario that is (to the best of my knowledge) unattended to by the science fiction of popular culture: 'a future in which genetically engineered livestock might someday incubate our children' (aniliu.com 2022: n.pag.). *The Surrogacy* looks disarmingly similar to a particular type of toddler teething toy: a ring of a half dozen or more large, squishy beads filled with clear liquid, often with small, colourful trinkets trapped inside. Liu's sculpture is coiled a bit like a toy snake; one end looks like the end of a balloon, and the other looks to have caterpillar antennae. The oval-shaped beads are translucent, each with an identical cream-coloured object inside. Upon closer inspection, the viewer will notice the objects are actually miniature human foetuses. And a quick read of the sculpture's exhibition plaque will inform that the playful-looking creation is actually a 3D printed replica of a pig uterus.

FIGURE 8.2: *The Surrogacy (Bodies Are Not Factories)*, Ani Liu, New York City, 2022. Installation view, 3D-printed polymers, 5.6 × 11.4 × 4.84 inches. ©Ani Liu.

While opponents of AW research and technology push against it as unnatural and unholy (Haldane 1923), *The Surrogacy* asks what the consequences of forcing women to serve as incubators might be. The rise in popularity of outsourcing pregnancy to surrogates means this debate continues to be at the forefront of reproductive discourse, unfortunately, as ethical controversies within the surrogacy 'industry' have been on the rise (Fenton-Glynn 2019: n.pag.).

The analysis

It is in considering *The Surrogacy*'s themes of outsourcing and mechanization and the ethical issues they bring to the fore that a thematic connection is forged between Liu's piece and the AW in its infancy as an installation on view at *Reprodutopia*.

The visuality of Liu's *The Surrogacy*, when held up against that of the AW's, provides opportunities for a more nuanced discussion that incorporates the maternal knowledge of its creator. In other words, the knowledge gained from Liu's experience as a mother implores viewers to think more deeply about the lived experiences and positionalities of the individuals who may commission the services of the AW in its final form as an actual medical intervention. My analysis will examine the two main themes that arose when reading the AW through the lens of *The Surrogacy*: the design dilemma and reproductive justice.

The design dilemma

In explaining scientists' attempts to develop lambs in an AW, or biobag, Kathryn MacKay explains,

> in 2017 a team of researchers made a significant leap in ectogenesis when they successfully gestated a lamb in an artificial uterine environment for four weeks [...] So, what was once perhaps mere science fiction is now much closer to reality.
>
> (2020: 347)

Without any discussion of science fiction prior to this statement, MacKay ends the introduction to her article with a claim that is positioned as a given, as being inherently true. MacKay never again mentions science fiction in her article. Presumably, she feels confident that every reader will agree AWs have always been mere science fiction fodder. As Bell and Dourish attest, '[e]ven for those who are not immersed in the genre, science fiction shapes popular imaginings of the future' (2013: n.pag.). Suffice to say, then, that even for viewers who may not be familiar with the genre, NNN's AW design gives off sci-fi vibes, and this poses a problem. Inspired as it is by *The Matrix*, the AW falls in line with this tradition of life-imitating (science fiction) art. '[F]act and fiction can swap properties', Julian Bleecker insists, ruminating on all the ways that science fiction has influenced 'science fact' (2009: 4):

> Design fiction is a mix of science fact, design and science fiction. It is a kind of authoring practice that recombines the traditions of writing and story telling with the material crafting of objects. Through this combination, design fiction creates socialized objects that tell stories [...] Design fictions help tell stories that provoke and raise questions. Like props that help focus the imagination and speculate about possible near future worlds.
>
> (2009: 8)

I argue this 'combination' has come to fruition with the AW. But in doing so, in opening up a speculative conversation around an invention-cum-'socialized-object' (or, essentially, an art piece) that is being claimed to no longer be speculative, the maternal function the AW is meant to perform is being undermined, causing it to function still as more of a social experiment, ala its *Reprodutopia* days. The visuals and textual representations of other socialized objects like Amazon's Alexa have long served a rhetorical function in pop culture, 'influencing the meanings, attitudes, and values associated with new technologies based on the extent to which they resemble the function and form of their imagined science fiction analogues' (Maradin 2017: iv). Therefore, in this case, if the AW *does* succeed in Máxima's trials, audiences may perceive its success as an affront to their reality and their future.

The major design flaw, then, is the absence of any natural visual connection between the AW and human life – save for a cis man's testicles, as de Vries points out. To an unsuspecting foetus, the AW is assumed to be, or will be interacted with as, an extension of the mother. Despite this intimate connection, the AW, as presented at *Reprodutopia*, is understood to be quite separate from the foetus itself, and certainly from the mother whose child it is carrying to term. This rhetorical void is exacerbated by the lack of proximity in design to anything womb-like, humanistic, or even motherly. As Horn points out, 'when we fantasise about ectogenesis, the relational features of human pregnancy – the entangling of pregnant person and foetus – usually go unremarked' (2020: n.pag.).

The link between woman and cyborg cannot be overlooked here. Donna Haraway coined the term 'cyborg feminism' with her 1987 essay 'A manifesto for cyborgs', wherein she expresses both concern and, eventually, optimistic fascination with the seemingly inevitable idea that cyborgs may very well live among us one day. Thus, she calls upon Marxist and socialist feminists to come together in unity around the cyborg feminism these groups seem clearly (to her) to be inching toward anyhow. Haraway rationalizes this call to action by stating blatantly that '[c]ontemporary science fiction is full of cyborgs [...] Modern medicine is also full of cyborgs, of couplings between organism and machine [...] And modern war is a cyborg orgy' (Harraway 1985: 66). Here she is not only speaking of the physical addition of prosthetic limbs or ectogenesis structures to human bodies, for Haraway also sees the 'analysis of scientific and cultural objects of knowledge' – housed often as they are in computers or mechanical safety units, and reliant as society was becoming on coding as a form of communication across space and time; not to mention the demands made of a woman's family life and sex life by the United States' 'new technologies economy' (1985: 24) – as part of what constitutes our eventual transformation into cyborgs as inevitable and, strikingly, already occurring (1985: 18).

But embracing a cyborgian race, gender, or politic poses problems for modern-day feminist post-humanists who may argue any merging of woman with machine diminishes, rather than raises, a woman's social agency and value. Unlike the general population of (cis male) post-humanist scholars (such as Brown 2017), object-oriented feminists resist the post-human pull to grant full agency to objects, or the particles within them; instead, they remain aware of how objects may shape us and our experiences. OOF considers how objects relate to and even cast themselves upon humans, becoming actants to their subjectivities, and honour the shape our stories take because of them (Behar 2016). It also makes clear that *objects* are knowable and therefore easier to understand and theorize about, whereas *things* are ephemeral and more difficult to grasp. I position the AW as an object, as objects by definition imply the existence of *subjects*. When the AW is positioned as a thing, it is more likely to be taken less seriously – as I argue NNN has demonstrated. When it is positioned as an object, we search for the subject, in this case usually *the mother*. Ironically, but also fittingly, a feminist object is one that resists objectivism. As a female-gendered object by nature of its function, AWs unintentionally conjure and absorb from critics the types of sentiments and resentments typically harboured toward women – attitudes that result in the objectification of this object, causing a possible disavowal of the life it is meant to carry inside. The cyborg-woman, then, will inevitably become objectified, as many objects that become associated with women do, like the womb.

While the AW may appear to be solitarily performing the function of keeping a foetus alive, we must not forget there is a person beside it whose body underwent significant trauma due to premature labour. Though they will not be connected to the machine in a cyborg-esque scenario their body will nonetheless be experiencing, synchronously, the months-long effects of afterbirth and the postpartum period, meaning the parent who birthed prematurely is not altogether separate, or disconnected, from the continued process of gestation the baby will be experiencing in the artificial womb. What horrors, then, might be enacted upon the AW, or through it, or against the individuals who eventually use it, because of the nefarious thingness science fiction has ascribed to it? As Irina Aristakhova (2016) theorizes, the subject is the one the other (or object) depends on, typically. Logic would have it, then, that the person with the physical womb would be the *subject* and the AW the *other*, with agency not inherent to it but, rather, assigned to it by the person's consent to have it harbour their premature baby. Sci-fi rhetoric, however, has flipped this. Because traditional sci-fi texts have already othered mothers and all genders with wombs, the needs of this group come second to the successful gestation of the child – which nullifies the argument that the AW will usher in a fairer future. US birthing culture has always privileged the foetus' health over the mother's. NNN's post-human AW design approach, then, has subjected women to

further objectification – something a traditional incubator does not do. In the era of #metoo and #timesup, I would personally expect any reproductive or maternal and foetal health innovation to be a product of diligent research and design aimed to steer clear of perpetuating women's objectification. But, furthermore, I would expect it to fight the stigmas surrounding reproductive interventions and also act to intervene in issues of pregnant people's hospital care.

Reproductive justice

In speaking of her inspiration for *The Surrogacy* and the *Ecologies of Care* exhibition as a whole, Liu recalls, '[a]ll these Donna Haraway vibes came up for me – I am an animal-human-machine complete cybernetic creature' (Kaganskiy 2022: n.pag.). A literal, physical example of Haraway's theory. However, where many cyborg feminists call for an embracing of the technology they hope will make womanhood more bearable – which is in line with Shulamith Firestone's aims in The Dialectic of Sex (1970) – Liu's recollection of early motherhood cannot quickly be determined as an endorsement of cyborg feminism, though, given her upbringing as the daughter of immigrant parents from Communist China. As Hilary Malatino points out, 'for many minoritized peoples, cyborg ontology is experienced as dehumanizing rather than posthumanizing' (2017: 179). This is due to the intersectional clash of being both a 'minority' and, for Liu, a woman, as the objectification of women in post-human rhetoric works much the same for racialized individuals, and racialized individuals face discrimination in hospital care too.

Liu's work becomes critically important here when she explains, '[i]n using the pig as a vessel, it felt almost like equating my own body with that of livestock [...] I wanted to show that we don't actually need artificial wombs, we really need better policies' (Kaganskiy 2022: n.pag.). Because the AW would be a medical intervention, its foray into countries like the Netherlands (The Commonwealth Fund 2020: n.pag.) and the United States where income and healthcare inequality threaten the lives of millions of already-born citizens, it is not beyond the scope of this analysis to think about what the sci-fi appearance of the AW signifies to families of dangerously premature foetuses that already do not have access to basic prenatal care – like families of colour and families of lower socioeconomic status. Neera Bhatia and Evie Kendal address issues of distribution of access, asking, '[w]ill artificial wombs receive government funding? If it does, who should decide who gets subsidized access? Will there be a threshold to meet?' (2019: n.pag.). Not to mention many will claim AWs go against their religious (and patriarchal) ideals, as Sarah Digregorio points out: 'On the political right, the argument against artificial wombs centers more on religious or traditional ideas about pregnancy and motherhood' (2020: n.pag.).

The AW's testicular design foreshadows these concerns. While the Republican Party in the United States, for example, has long championed legislation interfering with women's and LGBTQ+ individuals' bodily autonomies, Republicans have also long participated in the fearmongering of 'illegal immigrants' (code for non-white, non-European) coming into the United States and out-birthing, and thereby overrunning, the dwindling white majority. In a perfect world of their doing, mothers of colour and/or foetuses of colour would surely not have easy access to an AW. Where Sue Hum speaks of white viewers as engaging in thought gymnastics that rationalize racial appropriations (2017), here with the AW we may see a turning point where the targeted race to produce and commodify will be white. The Surrogacy tells us as much. With its milky-skinned miniature foetuses occupying every bubble of the pig's uterus, there is certainly something being inferred about the replication of the white race. For failing to make room and considerations for intersectional identities (a rampant, consistent criticism of white feminism), the great gender equalizing function of the AW, as Mandemaker and Firestone both imagined it, likely cannot be realized.

Misuse of the AW will also come, of course, in the form of government-sanctioned gender discrimination. In order to uphold systemic patriarchal rule, legal denial of use could predictably begin criminalizing women who use artificial wombs. Questions such as '[w]hat did she do to cause the premature birth?' will inevitably lead to questions such as 'can states mandate that a woman seeking an abortion transfer the foetus to an artificial womb?' (Cohen 2017: n.pag.). At the time of writing this, in a post-Roe United States, feminist media outlets have been reminding readers of lawmakers like those in Ohio who introduced a bill requiring the embryo of an ectopic pregnancy be dragged from the fallopian tube and deposited in the womb rather than terminated (Glenza 2019: n.pag.), and those like Todd Atkin of Missouri who once said with much conviction that a woman's body has ways of stopping itself from becoming pregnant after being raped (*The Week* 2015: n.pag.).

These two entirely inaccurate scenarios sound very sci-fi in their own rights: Bodies that can reject both evacuation and invasion. Or, more precisely, human eggs that can go beyond their function of releasing for menses or reproduction to reimplant themselves elsewhere and refuse to leave their chamber when they recognize that the human body they inhabit is being violated. It is interesting indeed that Republican lawmakers in the United States align with this post-human outlook on the inherent agency and freewill of *things* but reject either for anyone with a uterus. The egg's post-humanistic, self-determinant attempt to usurp its manifest destiny, if you will, suggests that, as a female-gendered object by nature of its function, artificial wombs may become subject to similar anthropomorphic characterizations. Behar's conjecture that *things* maintain agency until humans

feel threatened enough by them to put a stop to it is important here. At this point, things pass into objecthood where they become objectified and hence conjure and absorb from critics the types of sentiments and resentments typically harboured toward women. In the AW's case, this objectification signals a possible disavowal of the life it is meant to carry inside, rather than 'only' the life of the pregnant person it is meant to assist. All of this is helped along, and made harder to overcome, simply because of the way it was designed.

Going forward

The key takeaway from my analysis is that maternal knowledge is imperative in visual design, particularly if the design will involve reproduction. Although, I am beginning to see that maternal knowledge would be beneficial in the research and development phase of all innovations. Laura Forlano asks of post-humanist design,

> [w]hat if, rather than understanding the needs of humans, designers are tasked to understand what chickens want? What expertise or theories might be needed in order to address this problem? What models, methods, frameworks, and sensibilities might be essential for exploring possible solutions? What new languages, questions, and alternatives might emerge in the pursuit of such a project, and how might it form the basis for new kinds of design knowledge?
>
> (2017: 18)

I share this perspective and as an outcome of my analysis I am stressing that Forlano's approach to design deftly describes the considerations that should have been taken when designing an artificial womb for humans. Though the AW is arguably a creation rooted in new materialism, until it can actually function without the pregnant parent gestating the foetus first, its design, I believe, still must attend to the human side of the equation. I answer that, if we resituate Forlano's questions in the context of the AW, *mothers* will hold the answers to them all.

The secondary takeaway is that we as a society need to elevate the voices of mothers in both science fiction and science thought. Along these lines, I call for a rereading of Haraway from a *matricentric* intersectional feminist standpoint, a concept coined by Andrea O'Reilly (2016) as a call for more serious consideration of mothers in mainstream feminism (though I added in the 'intersectional' part myself). Case in point: Haraway states, 'the cyborg is our ontology; it gives us our politics', and the very idea of it has the capacity to provide 'pleasure in the confusion of boundaries, and for responsibility in their construction' (O'Reilly 2016: 3) – a statement equally applicable to a newborn. Being pregnant is political;

with all the interference from lawmakers over reproduction rights, what our children are learning in school, and how we should raise our LGBTQ+ children, parenting is now political. There are other moments in this landmark essay where the argument seems uniquely fitted for mothers, or seems it may be expanded by the application of maternal knowledge, yet mothers are left out of post-human and cyborg feminism conversations. Haraway declares, '[w]ho cyborgs will be is a radical question; the answers are a matter of survival' (O'Reilly 2016: 6). The answer(s), the AW and *The Surrogacy* seem to say is *mothers*.

NOTE
1. https://www.vocabulary.com/dictionary/womb. Accessed 1 July 2001.

REFERENCES
Aristakhova, Irina (2016), 'A feminist object', in K. Behar (ed.), *Object-Oriented Feminism*, Minneapolis, MN: University of Minnesota Press, pp. 39–63.

Behar, Katherine (2016), *Object-Oriented Feminism*, Minneapolis, MN: University of Minnesota Press.

Bhatia, Neera and Kendal, Evie (2019), 'We may one day grow babies outside the womb, but there are many things to consider first', *The Conversation*, November, https://theconversation.com/we-may-one-day-grow-babies-outside-the-womb-but-there-are-many-things-to-consider-first-125709. Accessed 1 December 2020.

Bleecker, Julian (2009), 'Design fiction: A short essay on design, science, fact and fiction', *Near Future Laboratory*, March, https://drbfw5wfjlxon.cloudfront.net/writing/DesignFiction_WebEdition.pdf. Accessed 1 February 2021.

Commonwealth Fund (2020), 'International health care system profiles: Netherlands', June, https://www.commonwealthfund.org/international-health-policy-center/countries/netherlands. Accessed 1 November 2021.

Davis, Nicola (2019), 'Artificial womb: Dutch researchers given EU 2.9m to develop prototype', *The Guardian*, October, https://www.theguardian.com/society/2019/oct/08/artificial-womb-dutch-researchers-given-29m-to-develop-prototype. Accessed 4 December 2023.

Devlin, Kayleen (2019), *The World's First Artificial Womb for Humans*, UK: BBC 100 Women Project.

de Vries, Patricia (2020), 'The speculative design of immaculate motherhood', *Digicult*, June, http://digicult.it/design/the-speculative-design-of-immaculate-motherhood/. Accessed 1 September 2020.

Digregorio, Sarah (2020), 'Artificial wombs aren't a scifi horror story', *Slate*, January, https://slate.com/technology/2020/01/artificial-wombs-science-fiction-pregnancy-premature.html. Accessed 1 December 2020.

Dimitropoulus, Stav (2020), 'Artificial wombs are getting closer to reality for premature babies', *Leaps*, September, https://leaps.org/artificial-wombs-are-getting-closer-to-reality-for-premature-babies/particle-1. Accessed 1 January 2021.

Dourish, Paul and Bell, Genevieve (2014), '"Resistance is futile": Reading science fiction alongside ubiquitous computing', *Personal and Ubiquitous Computing*, May, https://www.dourish.com/publications/2009/scifi-puc-draft.pdf. Accessed 1 February 2021.

Firestone, Shulamith ([1970] 2003), *The Dialectic of Sex: The Case for Feminist Revolution*, New York: Ferrar, Straus and Giroux.

Fleckenstein, Kristie (2007), 'Testifying: Seeing and saying in world making', in K. Fleckensteim, S. Hum and L. Calendrillo (eds), *Ways of Seeing, Ways of Speaking*, West Lafayette: Parlor Press, pp. 155–78.

Forlano, Laura (2017), 'Posthumanism and design', *Journal of Design, Economics and Innovation*, 3:1, https://doi.org/10.1016/j.sheji.2017.08.001.

Geuze, Susanne (2022), '"Design helps us to talk about new technology": Lisa Mandemaker as designer-in-residence at UT', https://www.utwente.nl/en/news/2022/2/435024/design-helps-us-to-talk-about-new-technology. Accessed 1 July 2022.

Glenza, Jessica (2019), 'Ohio bill orders doctors to "reimplant ectopic pregnancy" or face "abortion murder" charges', *The Guardian*, November, https://www.theguardian.com/us-news/2019/nov/29/ohio-extreme-abortion-bill-reimplant-ectopic-pregnancy. Accessed 1 February 2021.

Haldane, J. B. S. (1923), *Daedalus: or, Science and the Future; A Paper Read to the Heretics, Cambridge on February 4th, 1923*, n.p.: E. P. Dutton.

Harraway, Donna ([1985] 2016), *A Cyborg Manifesto: Science, Technology and Socialist Feminism in the Twentieth Century Socialist Review*, Minneapolis, MN: University of Minnesota Press.

Horn, Claire (2020), 'The history of the incubator makes a sideshow of mothering', *Aeon*, June, https://psyche.co/ideas/the-history-of-the-incubator-makes-a-sideshow-of-mothering. Accessed 1 January 2021.

Hum, Sue (2007), 'The racialized gaze: Authenticity and universality in Disney's *Mulan*', in K. Fleckensteim, S. Hum and L. Calendrillo (eds), *Ways of Seeing, Ways of Speaking*, West Lafayette: Parlor Press, pp. 155–78.

Kaganskiy, Julia (2022), 'Artist Ani Liu has some radical suggestion for what pregnancy could look like', Artnet, July, https://news.artnet.com/art-world/ani-liu-2153297. Accessed 1 September 2022.

Kapsalis, Terri (2017), 'Hysteria, witches, and the wandering uterus: A brief history', *Lithub*, April, https://lithub.com/hysteria-witches-and-the-wandering-uterus-a-brief-history/. Accessed 1 November 2020.

Kechacha, Rym (2020), 'The pram and the portal: Motherhood as depicted in science fiction literature', *Den of Geek*, February, https://www.denofgeek.com/books/motherhood-in-science-fiction/. Accessed 1 November 2022.

Lehmann-Haupt, Rachel (2021), 'A womb with a view', *Neo.Life*, April, https://neo.life/2021/04/a-womb-with-a-view/. Accessed 1 May 2021.

Liu, Ani (2022), Review in Brooklyn Rail, April 2022, https://ani-liu.com/new-news/tag/2022. Accessed 4 December 2023.

MacKay, Kathryn (2020), 'The "tyranny of reproduction": Could ectogenesis further women's liberation?' *Bioethics*, 34:4, pp. 346–55.

Malatino, Hilary (2017), 'Biohacking gender: Cyborgs, coloniality, and the pharmacopornographic era', *Angelaki: Journal of Theoretical Humanities*, 22:2, https://doi.org/10.1080/0969725X.2017.1322836.

Maradin, Nicholas Richard (2017), 'Human by design: Bodily prosthetics and the rhetoric of science fiction cool', Ph.D. dissertation, Pittsburgh, PA: University of Pittsburgh.

Next Nature Network (2017), '1999: Ectogenesis enters *The Matrix*', https://nextnature.net/magazine/story/2017/1999-ectogenesis-the-matrix. Accessed 1 September 2020.

Next Nature Network (2018a), 'Reprodutopia: Design your future family', https://nextnature.net/projects/reprodutopia/. Accessed 1 September 2020.

Next Nature Network (2018b), 'What an artificial womb may look like in the future', https://nextnature.net/story/2018/artificial-womb-design. Accessed 1 September 2020.

Next Nature Network (2018c), 'Towards a design brief for the artificial womb', https://nextnature.net/story/2018/design-brief-for-artificial-womb. Accessed 1 September 2020.

Next Nature Network (n.d.), 'Philosophy', NextNature.net, https://nextnature.net/philosophy. Accessed 1 September 2020.

O'Reilly, Andrea (2016), *Matricentric Feminism: Theory, Activism, and Practice*, Ontario: Demeter Press.

Tikkanan, Roosa, Osborn, Robin, Mossialos, Elias, Djordjevic, Ana and Wharton, George A. (n.d.), 'International health care system profiles: Netherlands', *Commonwealth Fund*, https://www.commonwealthfund.org/international-health-policy-center/countries/netherlands. Accessed 1 July 2022.

The Week (2015), '"Rape can't cause pregnancy": A brief history of Todd Akin's bogus theory', January, https://theweek.com/articles/472972/rape-cant-cause-pregnancy-brief-history-todd-akins-bogus-theory. Accessed 1 February 2021.

The What If Show (2020), 'What if we could grow babies in artificial wombs?' *YouTube*, January, https://www.youtube.com/watch?v=gwPvSNA_nIg. Accessed 1 April 2021.

9

Seeds from My Grandmother's Womb

Suzi Bamblett

Autoethnography is a qualitative research method allowing the author to write in a highly personalized style. Simultaneously both researcher and researched, she engages in writing the self while drawing on her own experiences to extend awareness about risks associated with maternity.

Using a variety of techniques, this chapter draws data from diaries and journals spanning a 60-year period. Autofiction ensures anonymity and allows the story to be told in a creative, evocative, and dramatic way. The author demonstrates how the autoethnographic process promotes self- reflection, an understanding of others, qualitative inquiry, narrative writing, and creativity.

Crossing the bounds of autofiction and autoethnography, this three- generational creative reflection interweaves the voices of grandmother, mother, and daughter. As their words are knitted together, a quilted applique panel emerges. Together these creative works illustrate the joy and anticipation of becoming a mother and grandmother while acknowledging that, despite medical advances, maternity continues to be precarious.

Source palette and fabrics – cotton in sunshine yellow.

'You're going to be a granny. You must be over the moon.'

Am I? How do I feel? Thrilled, excited, and yet … I'm a career woman, a deputy headteacher. I remember my own grandmother being incredibly old.

Clickety clack. Grandma always knitting. Rainy Sunday afternoons watching *Bonanza* on the television – rustling, foil-wrapped chocolate toffees. Remember that day her false teeth got gummed together? Summer holidays on the beach, cavorting in the waves. Grandma sitting in a deckchair, wrapped in her coat and headscarf. Knitting. Clickety clack.

Grandma whispers in my ear and, dutifully, I buy knitting needles and wool to knit matinee jackets while reflecting on my own pregnancies. Morning sickness

from the get-go – three months of retching then a brief respite in the middle before chronic heartburn during the third trimester. Preparing the nest with hand-me-down baby clothes and stacks of snow-white terry nappies (no disposables back in the day). Stitching baby nightgowns and knitting booties and stowing them away in a bottom drawer like a trousseau. Evening soaks in the bath, a sense of communion with my baby and knowing that I'll never again be alone.

Assemble blocks diagonally – when life happens, the world is skewed.

A baby born with a gestational age of less than 30 weeks has an 85 per cent chance of survival (Hornik et al. 2016: 27–30). My grandson arrives eleven weeks early weighing a mere three pounds. He's immediately transferred to the NICU and, within 24 hours, he's off oxygen and breathing by himself. I visit, give him cuddles, and read *Guess How Much I Love You?* On the sixth day, he smiles.

Besotted, I negotiate a three-day working week leading to my early retirement. I've always wanted to write and this will be my opportunity. Three days of teaching, one for writing, and a day with my grandson. The weekly granny day forges strong bonds between us. Can this special connection between grandmother and grandchild be scientifically proven?

Chilean writer and filmmaker Alejandro Jodorowsky presents a controversial theory – we are attached to our maternal grandmother through our genes (Jodorowsky 2014: n.pag.). Apparently, the mitochondrial DNA information (the DNA that comes from the mother) is at its greatest when the embryo is formed. By twenty weeks gestation, the foetus has developed its reproductive system and, for females (although not scientifically verified) a lifetime supply of eggs.

American drummer, Layne Redmond shares a similar view (Redmond 2018: n.pag.). 'We vibrate to the rhythm of our mother's blood before she herself is born'. Redmond claims, 'our cellular life as an egg begins in the womb of our grandmother' with 'each of us spending five months in our grandmother's womb'.

Lucy Mary Martin – maternal grandmother, avid reader, seamstress, knitter. Was her creativity passed down to me? Did my seed, through some invisible umbilical, originate in Grandma's womb?

Expectancy at the centre. Mother-to-be blooming.

Grandma is on my mind as I'm about to become a grandmother for the second time. My daughter telephones after her twelve-week scan. 'They found thickness

at the back of the neck [...] it can be an early indicator of Down's [...] but the other one is fine'.

Other one? Twins? I'm ecstatic. My mum always wanted twins. When I was pregnant myself, I shared that secret yearning. There's something so magical about twins.

Red velour for the womb.

I'm naïve. I don't realize how risky twin pregnancies can be. 'Multiple pregnancies are about 2.5 times more likely to result in a stillbirth and over 5 times more likely to result in a neonatal death, in comparison to singleton pregnancies' (Antiniou 2017: 11). As parents, we want to keep our children safe and happy, and that doesn't stop just because they grow up. Oblivious of the increased risks, I share joy and excitement as we prepare for the twins, become anxious as things go wrong and experience heartbreak, loss, and devastation when things get worse.

Survival for infants with a gestational age of 22 weeks is 15 per cent (Hornik et al. 2016: 27–30). At 22 weeks in a grotty train station toilet, my daughter's waters break. We're supposed to collect her and her fiancé from the train to view a wedding venue. Instead, we drive them to Accident and Emergency.

'If the babies come today', we're told, 'they're not viable'.

What do you mean, not viable? You're talking about my grandsons. I've already imagined them at 1 day, 1 month, 1 year old. Glimpsed them in my dreams – their first day at school, graduations, wedding days ...

Things settle down. I spent the next week Googling survival stories about babies who've lost some or all of their amniotic fluid. Soon I'm an expert. Another granny in the States, whose own grandson survived similar circumstances, becomes my new best friend.

Twenty-three weeks and my daughter's back in the hospital – 3 cm dilated and contractions coming fast.

'They are not viable', – the doctor shakes his head – 'I'm sorry but we won't intervene'.

'But they're so close', I say. 'My grandson was born at 29 weeks and he's completely fine'.

They send six medics to argue but I am Granny, fearless, a lioness fighting for her cubs. I will not back down. Eventually, they agree if the boys weigh at least 500 grams they will do what they can.

Her contractions lessen. Steroids, pain killers and antibiotics are administered. If my daughter can hold on until the morning ... I visit the hospital chapel to light candles. Flames flicker before growing strong. I pray. 'Lord, please save our little boys, so loved, so wanted, so perfect'. I am convinced I hear His reply. 'Never give up hope'.

Hand applique narrative with clockwise cadence – joy to fear to despair.

My daughter's transferred to the antenatal ward. Every day she hangs on is a blessing, taking us nearer to the magical 24 weeks. Perhaps we're buoyed up by false promise? After the miracle of my grandson's birth, expectations are high. At 23 weeks and four days, from a toilet cubicle outside the ward, I heard my daughter's scream.

Daughter's Journal – 2nd October 2012
Suddenly I feel something coming that I can't hold in, then he's there, in my hands. My beautiful first born and he's alive! I see him moving. He's so small. Everything's fuzzy in my head like I'm drunk. They're yelling for help and suddenly there's shouting, doctors everywhere. Daddy tells you it will be okay. I keep saying the same thing, 'it's okay darling' I'm thinking, I didn't drop you, you could have gone down the loo or hit the floor. I caught you and you're alive.

The doctors sit me down. I'm shaking uncontrollably.

'Your baby is too small', they say, 'there's nothing we can do'.

I crumple into Daddy's shoulder. I should have asked for you then. I should have held you then.

They take me and Daddy to a room. Then Granny brings you in. You're beautiful but so small, like a little bird. You have dark hair and a little pea head like Daddy but you have my nose. You're so pretty but you're already going cold.

Everyone's there. Lots of people looking at me sympathetically, like they're waiting for me to do something. What do they want me to do?

Baste batting and backing. Stitch in the ditch.

The sun beats down on a sunny October afternoon as I walk to Hamleys – my mission to buy teddy bears. My daughter's words haunt me, for my darling grandson Jacob will never see the cream teddy bought to accompany him in his tiny coffin. I choose a blue bear for George, on whom we've pinned the last vestiges of hope. I go to the chapel to light more candles. I make deals with God to gladly give my own life that George might live.

Daughter's Journal – 6th October 2012
At 24 weeks and one day, I become very unwell. I'm freezing cold, shivering and nauseous. My infection levels are through the roof.

The doctors think the delivery will be quick due to his size. It's not. George is in a difficult position, trying to come down with his head and shoulder. Eventually he's here.

'Your baby is very bruised', the doctor says.

We watch as they weigh him and our hearts leap when we see he's 670g, well over the 500g viability marker.

Then we're told there's no sign of life. George has not survived the delivery. He's stillborn. We hold him and gaze at his poor bruised face. He looks like he's been in a boxing match but he's still beautiful.

The hospital bathe and dress the boys and bring them up together in a lovely basket. We give them teddies and photos of our families. We have photos taken with them, the four of us, the family we'd dreamed of.

After two days I'm allowed to go home. I sit in the taxi clutching two memory boxes instead of our babies.

I watch my future son-in-law unwrap his dead sons and examine every millimetre of their bodies, marvelling at tiny fingers and toes. I'm unable to tear my eyes away. When it's my turn, I cuddle the boys and tell them how much I love them. It's not until later I realize how much this helps. A small cremation follows the family and close friends.

The pain in my heart is a gaping wound that can't be fixed for, 'in the case of pregnancy loss, it is the loss of one we have just begun to love, of having imagined loving' (Seftel 2006: 58). I'm okay when I'm busy but whenever I stop it feels as if there's no point. Seeing your daughter suffer and knowing you can't put things right makes the pain seem doubled. Grandparents are 'the forgotten grievers' (Gyulay 1975: 143) caught between grief at the loss of their anticipated grandchild and pain for their own child's suffering. How could this happen to us? We feel utter helplessness because we're unable to fix things.

For the first time, I'm glad that my mother's not here to go through this. I don't know how she'd cope watching her granddaughter suffer. But perhaps I under-estimated her. My mother knew things could go wrong. Mary was born the year before me and lived only three months.

Mary's Story

My mother had her first intimation something was wrong a little after the birth. The doctor told her she was being over imaginative but, when her baby went blue, he agreed to have her looked over by a child specialist.

After an agony of waiting, the sister returned with pills and an extraordinary sort of tight bodice. She said I would have to be brave. My baby had a deformed heart; a valve that wasn't working. She'd always be subject to heart attacks and might die at any time.

Her chest was tightly bound, and she was given pills to make her milk go away. *I was given sleeping pills too but I cried myself to sleep. Why did this have to happen to us? As I lifted Mary in my arms, I experienced such a surge of joy. I was so thankful to have her and determined to keep her alive.*

Once home, they settled into a routine of sorts. Mary was a quiet baby. She never cried and showed signs of pleasure from a young age.

Mary loved bath time, moving her hands gleefully in the water. She still had occasional heart attacks although they were less frightening to witness. Now she'd go pale, almost like wax. The worse thing was the little gasping sounds as she struggled for breath.

On 6 October 1953, the doctor called. After examining the baby, he told my mother he could offer little hope.

After he'd gone, I held Mary in my arms and wept. I knew my baby was going to die. I didn't want her to suffer, but how could I bear to let her go? I tucked her up with a warm hot water bottle, gently rocking the pram so she might feel my presence. I prayed with all my heart, my eyes never leaving her face. Suddenly Mary stopped gasping and sighed. She opened her eyes wide with a look of true wonderment. I said, 'what can you see, darling?' and she was gone.

If Mary had been born today, she might have survived. 'Congenital heart disease is one of the most common types of birth defect occurring in almost 1 per cent of births' (Knowles et al. 2012: n.pag.). In 1959–63, infants comprised 63 per cent of CHD deaths. By 2004–08, this had reduced to 22 per cent. Now 75 per cent of babies born with critical CHD survive to one year and 69 per cent to eighteen years.

Embroider finer details – the scream, five stages of grief, a grandmother's tears.

The journey through grief may involve a series of active tasks (Worden 2008: 283) – acceptance, experiencing pain, adjusting to a changed world, and maintaining an enduring connection. Often there is a need 'to have a tangible and lasting part of their lost child' (Seftel 2006: 103). Engaging in acts of creativity, such as writing letters or making memory boxes, allows parents and grandparents to build this enduring connection while embarking on a new normal.

In the early 1960s, my mother offered *Mary's Story* to a magazine. In her submission letter she wrote, 'if it would be of help to anyone suffering the loss of a baby in similar circumstances then Mary's life will have been of some use'. Sadly, the magazine declined but, after my mother died, I arranged to have the story featured on the Tiny Tickers website.

My own path through grief also involved creativity.

Sixth of October

On this day, a lifetime snatched away
as Mary's three-month heart
takes its final beat.

On the same date, bearing scars of war,
no breath from George.
He is stillborn.

Hope lays bruised, flaps fragile wing.
Crushed, beneath hobnailed boot.
Mothers conclude, there is no God.

Pain cannot be cauterized.
Helpless, hopeless, angered, lost.
Light fades from their eyes.

Resilient in face of adversity.
They wave goodbye to naivety,
along with the lie.
Bad things don't happen to us.

Allegedly there are 'five stages of loss' (Kubler-Ross 2014: ix) – denial, anger, bargaining, depression, and acceptance – although not necessarily experienced in that order. For many, grief is a cyclic transition. One mum (Twins Trust 2020: n.pag.) explained how it seemed comfortable to stay in the first phase. 'A sense of numbness is a detachment – a coping mechanism'. Another mum voiced no inclination to transition. 'It's like I don't want to finish grieving.'

In addition to writing poetry, I created a quilted applique panel (see the figure) weaving together women's voices from three generations on a shared journey. My mother kept a 'rag-bag' of sewing off-cuts, and it was from here that I sourced the palette for the panel – pastel shades reflecting hope, celebration, and joy; flowers blooming in expectancy. The construction of the umbilical cord was an invisible conduit between my grandmother and myself. As a child, she taught me to make this trim and I used it to adorn many doll's dresses. Setting squares on the diagonal represented how life may be easily skewed. Basting and batting the squares was therapeutic, as was the repetitiveness of 'stitching in the ditch'. I struggled, blinking through a grandmother's tears, as I stitched ruby red and bleakest black, representing the gaping hole in the womb, aching arms, and primeval screams. The quiet process of applique and embroidery accompanied the passing of time, allowing stillness and reflection.

Bind raw edges. Women hold hands – a rainbow of hope.

Emerging from the depths of grief, I applied myself to binding raw edges and embellishing the panel with a chain of paper dolls holding hands, butterflies, and

a rainbow. For my family, the invisible cord between grandmother, mother, and daughter is tangible. We are spiritually united in loss and love.

My daughter's bereavement journey led her to become a Twins Trust befriender, counselling other mums facing the same terrible predicament. Having offered support as a granny befriender, I am in awe of the strength, compassion, and generosity of parents who provide this service. In tribute, I constructed another quilt, *The Quilt of Lost Dreams*, as a lasting memorial to many tiny lost souls.

Most women sail through pregnancy and deliver a healthy baby without any issues. Sadly, a few become members of a club nobody wants to join. Some are blessed with rainbow children. Others strive to find silver linings in signs such as angel feathers, butterflies, or rainbows. My daughter has since given birth to two healthy daughters, although their big brothers will never be forgotten. When my mother lost my sister, her doctor told her the best thing she could do was to have another child right away. 'When he tried to plant in my mind the idea of having another baby', she wrote, 'I thought he was the cruellest man I knew'. But she took his advice, and that child was me.

This work does not seek to cause anxiety for pregnant women or those about to become grandmothers. However, despite medical advances over the past 70 years, it is important to acknowledge that there are still risks associated with maternity. For me, each pregnancy is a miracle, every birth a matter of life and death.

FIGURE 9.1: Suzi Bamblett, *Seeds from my Grandmother's Womb*, 2021. Patchwork appliqué panel.

NOTE

Where possible, names have been concealed to ensure anonymity. With the exception of the author, any similarities between persons living or dead are entirely coincidental.

REFERENCES

Antiniou, Evangelia (2017), *Twin Pregnancy and Neonatal Care in England: A TAMBA Report*, November, London: Twins and Multiple Birth Association.

Bamblett, Elisabeth (2010), *Mary's Story*, https://www.tinytickers.org/category/your-stories. Accessed 20 March 2011.

Hornik, Christoph, Sherwood, Ashley, Cotton, Michael, Laughton, Matthew, Clark, Reese and Smith, Brian (2016), 'Daily mortality of infants born at less than 30 weeks' gestation', *Early Human Development*, 96, https://www.ncbi.nlm.nih.gov/pmc/articles/PMC4862884. Accessed 24 October 2022.

Jodorowsky, Alejandro and Costa, Marianne (2014), *Metagenealogy: Self-Discovery through Psychomagic and the Family Tree*, Rochester, VT: Park Street Press.

Knowles, Rachel, Bull, Catherine, Wren, Christopher and Dezateux, Carol (2012), 'Mortality with congenital heart defects in England and Wales, 1959–2009: Exploring technological change through period and birth cohort', *Archives of Disease in Childhood*, 29 June, https://adc.bmj.com/content/97/10/861. Accessed 21 March 2021.

Kubler-Ross, Elisabeth (2014), *On Grief and Grieving: Finding the Meaning of Grief through the Five Stages of Loss*, New York: Simon and Schuster.

Redmond, Layne (1997), *When the Drummers were Women: A Spiritual History of Rhythm*, New York: Three Rivers Press.

Seftel, Laura (2006), *Grief Unseen: Healing Loss through the Arts*, London: Jessica Kingsley.

Stewart, Alison and Dent, Ann (1994), *At a Loss: Bereavement Care When a Baby Dies*, London: Bailliere Tindall.

Twins Trust (2020), 'Bereavement support', Facebook, https://www.facebook.com/TwinsTrust. Accessed 8 March 2021.

Worden, William (2008), *Grief Coaching and Grief Therapy*, New York: Springer.

10

Delivering across Geographies: How Faith, Age, Friends, and Space Carry Birthing

Noor Ali

The experience of performing maternities is shaped greatly by the space in which it occurs, even as it remains within itself an all-consuming enormity. While carrying, labouring, and birthing have their own innate realities, each in their own way disconnected and isolated from the universe; the mother is the sole carrier of creation and must experience it with her own presence – these very experiences are also situated in the physical spaces that surround us. These physical spaces extrinsically lend themselves to colouring this very intrinsic experience.

Employing a personal narrative autoethnography, I explore and narrate the diverse ways labouring occurs in Pakistan, Malaysia, and the United States, while inherently remaining the same experience. What follows are personal journeys of labouring and delivering my children in three different countries. Birthing in distinct geographical spaces shaped the experience in profound ways, even as it remained the same performance of maternity. Isbir (2013) utilizes autoethnography in the autobiographical exposition of her own birthing story and posits that doing so enables the readers an insightful, empathetic understanding of an experience that is often feared and considered traumatic or chaotic. Additionally, Uotinen (2011) explicates that bodily knowledge 'is based on the idea that all experiences, thoughts, and actions, consciousness and connections to the surrounding world – and also knowledge as such – take place through the body' and that autoethnography is an apt tool for the analysis of such experiences where the informant is the researcher herself (2011: 1308). Uotinen suggests that 'autoethnography can be used to describe the writer's personal experiences and to place them within their social and cultural context' (2011: 1308). Similarly, situating the performance of maternities and its intersections with faith, age, friends, and

space, has provided me a unique lens into how birthing is not an enclosed occurrence, but rather one that is rendered to its final unique form by several variables at play. Like Underhill-Sem, the concept of place in this chapter is not only one 'that involves consideration of fixed and physically bounded areas, but "place" which also exists as a process of social relations' (2001: 451).

Shared in this chapter are stories from a small Christian hospital in Pakistan where I laboured an early term birth in an office room, to a small private Muslim clinic in Malaysia, where I rapidly went into labour and was delayed by the doctor's late arrival, to my experience of ten days in the antenatal wing before going into preterm labour and living in the neonatal intensive care unit (NICU) for a month in the United States.

Moonshine

A few months into my marriage, I was pregnant with my first child at age 22. The look of disdain on my mother's face, as I giddily shared the news with her, had left me a little hurt. I didn't understand then the lifetime angst of maternal responsibility, which she of course was acutely aware of. I was naive to how life-changing this event would be, of how it de- and reconstructs one's identity, and how the introduction of new humans into this world, through your own body, can shape the course of your life.

Lahore was my own birth town and surrounded me with support like only one's home can. Near the end of the first trimester, I started bleeding. While complete bedrest was prescribed, the fact that it was a threatened miscarriage was not shared with me. In Pakistan, the family gets to decide what you are told about your own medical condition; and mine decided that it would cause me distress to know the truth. Ironically, I found out about the diagnosis accidentally, and then had to pretend for the rest of my pregnancy that I didn't know what I was going through. My mother practises denial with firm belief – with maternal ferocity. She believes that if you don't label or acknowledge something, it will cease to exist; you can render the truth and presence of anything to ashes, smother it to non-existence, if you refuse to see it. Anytime, any one of her children would fall sick or be in crisis, she would annihilate it by making it a non-issue. The performance of maternity had in fact begun, but at a cultural stage set in the theatrics of familial love.

At the time of my first pregnancy, I was in a graduate programme, and continued the classes from home while on medical leave. In the absence of online education in 2002, this meant my classmates came over daily to share class notes and materials. I lay down in a dingy office on campus to take my exams at the end of the term. By some teachers, I was penalized for being pregnant, for going through a threatened miscarriage – we saw that in the grades they gave me.

At 22, quietly experiencing a threatened miscarriage throws you into a realm of uncertainty. I remember crying with anxiety about whether the baby would make it. It was too early to tell, and nobody knew that I knew how precarious the situation was. It was in the throes of uncertainty that faith was summoned. I opened the Quran to any page that it would take me to, seeking solace in words and knowledge larger than my own, and the verse before me read, 'we give you the glad tidings of a boy'. The Quran had opened to the story of Abraham, where he is told by God that despite his old age, he was going to father a male child. The improbability of this is where the miracle lay for Abraham. I needed no other solace beyond that, received the revelation as my own personal gift, and was convinced before any ultrasound would reveal the gender that this would be a boy. And it was.

A month before the due date, my water broke completely, jolting me from sleep. My doctor was my own aunt; she rushed over to our house to examine me and called the small hospital she worked at to make space for me. I was taken into a tiny empty room, put on oxygen, and induced for labour. I had become hypertensive in the previous month and was medicated during labour to put me to sleep. A pill was placed physically to induce labour, and after one unsuccessful and one successful attempt my contractions began. It was a small Christian hospital, and there was one Christian nurse, my aunt (the doctor), my mother, and my husband in the room. I had brought along with me a card inscribed with a collection of Quranic prayers to recite during labour. These were prayers made by Abraham, Mary, and Zechariah, for their progeny. I remember the impressed expression of the nurse as she commented how in all her years, she had never had a patient pray so intentionally while being in labour. The most vivid memory I have of my labour is one of vagueness. The sleep medication was forcing me to sleep to keep my blood pressure from spiking; however, my litany that night was about wanting to stay awake. I'd oscillate in and out of sleep, waking with the profound pain of the contractions, crying about why I kept sliding into sleep, and then sliding into sleep, only to repeat the same loop.

It was time for the daybreak (Fajr) prayer, and my husband went to the mosque to pray in congregation, while I was hustled into the labour room. My son left my body to enter the world with four pushes, while I heard the *adhan* (call to prayer) being called at the mosque. My husband rushed back as soon as the prayer ended to find his son had already arrived. I am told that I, too, was born when the Fajr *adhan* was being called. The baby was 5 lbs in weight, but my aunt decided that incubating and keeping him in the hospital was a bigger risk than sending him home. I was wheeled out of the labour room and made to rest in a small office space for observation. Relatives had already begun to come into the hospital, and I remember how an older distant aunt of my husband brought a thermos of hot tea and warm boiled eggs along.

A few hours later, we were taking our baby home, and as friends and family poured in, we tried desperately to keep people from touching him. In Pakistan, the mother stays at her mother's house for 40 days (*chilla*), where she is pampered, given postnatal massages, and fed healing herbal concoctions. The fourth trimester unfolds under the watchful eyes of extended family, the diapering and bathing of the baby are taken care of by the family, and the woman returns to her home, after having taken a ritual cleansing bath marking the end of the *chilla*.

Sunshine

Three years into our stay in Malaysia, I was pregnant with my second child. This was a pregnancy away from family. My husband was studying at an international university there at the time, and the village hill that we lived on was full of rentals where other international students with families found cheap lodging. My first child was 2 years old, and he and I spent our slow days with other young mothers and their children on this international hill. When you are in the family of an international student husband, the most distinct feature of that existence is a minimalist sense of temporariness. We lived in a bare apartment, and without family or work to tend to, the days were filled with unending time. Everything lasts longer when there's no rush, and the pregnancy also seemed to drag on. I was 26 when I birthed my second child, and the first labour seemed to have provided no prior knowledge, as this experience was completely unique to the first.

This pregnancy was also a threatened miscarriage, where I was whisked in an ambulance to the hospital after I started bleeding in the first few months. After hours of lonely triage in a public hospital, I was told by medical students that the cardiac flicker was visible in the ultrasound and that I needed to be placed on bed rest again. After a full-term pregnancy that left me very big and very tired, I complained to the doctor about when it would be over. The doctor conducted a vaginal examination and without telling me what exactly she had done, said that she had helped. I came back home from the doctor's visit, began discharging shortly after, and returned to the private clinic in a few hours having gone into labour. My guess is that the doctor had conducted a membrane sweep without informing me.

After delivering my child I wrote this account to a friend saying:

> Momin is so beautiful. That newborn thing in him. Delivering him was immensely hard [...] first labor was nothing compared to this second one. In the first one I had extremely high blood pressure so they gave me some stuff to put me to sleep. Every contraction would force me to wake, but I didn't know when I dozed off again. When I woke up, I cried that I didn't want to sleep. Momin's labor was five hours only, but

when I went in, they thought I was in false labor. One week before, I had landed in the hospital with false labor as well. This time too, the cervix was hardly open. I said *maghrib* (dusk prayer) sitting, *isha* (night prayer) sitting, had dinner all the while having contractions, and the nurses kept pestering me to lie down. If I lay down, labor was too hard, I wanted to take it sitting, but when I had had enough of them, I said 'fine, I'll lie down'. When I did, I died! The contractions didn't give any relief period – it was constant and excruciating, and there I was, howling like an animal, praying for whatever to happen. I kept praying to Allah, saying 'just do anything, do anything at all'. Ammi (mother) had said I was so brave in the first labor, and that this time I freaked everyone out. In that one hour my cervix opened suddenly and *pura* (all of it), I could feel Momin's head coming out. They took me to the labor room, and I refused to get out of the wheelchair and lie down this time, so they couldn't see how ready I was to deliver. But when I went into the labor room, they had put Surah Mariam (the chapter of Mary from the Quran, which describes her birthing of Jesus) on the player, and I shut up. I couldn't scream over the point where Hazrat Isa (Prophet Jesus) was being born and Allah was saying *kun fayakun* (Be, and It is). I signaled to her to turn it louder, and one beautiful nurse kept reciting Yunus' ayah (the verse of Jonah when he is stuck in the belly of a big fish and seeking God's help and mercy to help him) to me. It was like a chant and I let her hold my hand. I think Adnan (my husband) started breathing again at that time. I hadn't let anyone touch me for over an hour. He was staring at me with a lump in his throat. Everything had melted everything inside me. I got on the bed and they all stared at me in disbelief, they could see Momin's head, they called in the doctor (who had just arrived after 5 hours). The first thing she did was take my hand and made me feel his head right there. I broke into a smile which relieved all the tense nurses around me whom I had been growling at. And out came Momin. The doctor was singing the adhan (the call to prayer is traditionally performed by men), and they all (the nurses) do this chant of various things (reciting prayers and litanies while delivering), as she held Momin, all white in vernix and placed him in my hands. He was born with his hand on his face and he still likes to keep it like that. Then they cut the cord. Here they wrap up the placenta and give it to you to bury.

<div align="right">(Personal records)</div>

As I had sat that night in the wheelchair, defeated in pain, and whimpering at the recitation of the story of Mary, I remember begging them to give an epidural or anything for the pain, to which I was told that they only had some antihistamine to offer. I felt a helplessness sink within. We were outsiders in this land, knew nothing about what the norm of medical practices was, and here I was in this small, isolated clinic, completely incapacitated by pain, with nothing else holding me together other than the recitation they were playing. I understood later that it was not the norm

to be as loud as I was, and that women birthed with a patient and stoic grace that I was unable to exhibit as my body was tearing itself to deliver. In a study exploring why mothers chose unassisted home births in Malaysia, the authors posit that prior hospital deliveries had sometimes left the women feeling unempowered and uncertain about what practices were being used, and that faith provided them a greater sense of trust than medical care itself (Ahmad et al. 2020). The performance of maternity was one gingerly placed on faith and trust because in the face of uncertainty and helplessness there was nothing else to hold on to. The narrative recitation of the birth of Jesus was a reminder of that very performance; Mary held on with faith and trust as she absorbed the enormity of her lonely circumstance.

Just as I was about to deliver, our neighbours called my husband to tell him that our older son had woken up (it was around 10:30 p.m.) and was crying for us, so my husband left to pick him up and bring him to the hospital. By the time he arrived at the hospital with my older son, Momin had entered the world, a pink baby with a head full of thick, black hair. My ecstatic mother, who I had just an hour ago screamed at and pushed away, told me that as she waited outside the labour room, knew the very moment Momin exited me and entered the world because she heard a soulful chanting through the walls. We were the only family in the clinic that night. I was left with four external stitches, and the doctor told me she didn't keep track of how many she gave me inside, with and without numbing.

Momin came home to the village hill full of international neighbours. The Nigerians, Indians, Bangladeshis, Lebanese, Sri Lankans, Indonesians, Malaysians, and so many more. Each one brought their traditional wisdom and herbal concoctions, massage stones, and wraps along to put me back together again. All these cultures centred around strengthening and nurturing the mother and child, increasing the production of milk, and getting the belly back in. The Nigerian sisters soaked one pound of cloves in water and had me drink that, the Indonesians took six yards of cloth and tightly wrapped me, the Malaysians heated up an oblong stone, wrapped it, and pushed the uterus in, while the desi sisters created warm milk drinks with nuts and turmeric. My mother had travelled to be with me, but other than her, my husband, and my son, there was no other family there. That was the case for everyone, so all of us temporary neighbours for a few student years, would lean in, extend ourselves, and share joys like we would with our own family. We were all strapped for funds, so gifts were few, but love and company were never lacking.

Starshine

Living in the United States for thirteen years, I had just finished my doctorate when I received a surprising phone call from the doctor's office informing me that I was

pregnant. At a routine annual physical, when I had remarked my period was a few days late – this was totally the norm for me – they were compelled to test for pregnancy. The first test gave no clear answer, the at-home tests gave ambiguous lines as well, and finally the fourth test showed clearly that I was in fact pregnant at age 39.

This was a surprise pregnancy, and one that we had neither expected nor planned. I was provided diligent care during the months that followed, given complete information and options throughout the process, and tested very frequently. After developing gestational diabetes in my last trimester, I was placed on a rigorous nutrition plan and required to test myself four times daily. Two months prior to my due date, my water began leaking and I was rushed to the hospital, given steroids, and relocated to another hospital that had a NICU equipped with that early delivery. Within a few hours, I was informed that I would stay in the antenatal wing until the baby was born, which could be at anytime. We were trying to let 72 hours pass, so the steroids could do their magic and hasten the lung development of the baby. We also knew that we would have to induce labour in a few weeks' time if I did not go into labour until then, as the risk of infection is heightened with a ruptured membrane.

Ten days passed. Friends kept swinging by to the hospital to visit and give company. When I would get lonely, I would reach out to people; I think this unabashed asking is the gift of age. Food was being cooked on a rotation by loving friends so that my family would not have to worry about it in my absence. I was a principal at a small non-profit school at the time and ran my administrative tasks from the hospital. The nurses became my friends in those ten days there and could tell when I was despondent.

When I entered antenatal expecting a two-month premature birth for Amal, on the very first night, the Director of NICU, himself came down to my room to tell me what to expect and how attentive the NICU care would be. He had me convinced that she would grow, be fed, be held, and breathe on her own. I asked him if his team would do everything, what was I going to do. I felt useless, as if I had failed the performance and was being prepared to leave the stage. His answer was sublime. He said, 'you will love the baby'.

That's what I did. I loved. I held on to his words as tightly as I held on to hope in the days and months that followed.

Eight days into the antenatal unit, I cried my eyes out at the loneliness, a slow uncontrollable crying all day long. The nurse that night recognized it and stayed by my bedside just engaging me in a conversation about anything and everything. We talked till 2:30 a.m., by which time I had tired myself enough to be able to sleep. On the ninth night, I started feeling feverish, the nurses kept checking in on me, bringing in the doctor at 4 a.m. to announce that it may be time to induce me.

It seemed like my body was beginning to fight the onset of an infection, the steroids had been in me long enough for the baby's lungs to be developed. I mentioned that I was feeling slight contractions as well. By 5 a.m. I was in the delivery room – hooked up to medications. They asked me to call my husband because I may deliver before noon. As my contractions came closer together, I mentioned that my previous labours had been eight and five hours long, to which the doctors responded by telling me to call my husband immediately.

We were without family here as well, so my husband was managing the boys' schedules with the help of friends. One such friend came into the labour room before my husband arrived and played Surah Maryam (a chapter of Mary birthing Jesus in the Quran) for me. Even though they had determined they would induce me earlier, I was told then that they had not started inducing me and had just given me a slight dose of medication to get the edge of the pain. My contractions were occurring naturally and induction was unnecessary. I told them this time I wanted to take an epidural because I was afraid ten days in the hospital had left me with no stamina. I was done being strong in the first two labours and would take whatever assistance was available. And, then just like that it was 6:45 a.m. and I was too close to delivering to be able to receive an epidural. The door opened and nine people walked in, nurses and doctors for me and nurses and doctors from the NICU.

I had always joked that the only reason I would have another baby would be so my husband could see my labour and birth. I wanted him to see maternity performed. There he was being told to hold up my leg and see his beautiful baby girl enter the world. I prayed for her as she entered, the doctors checked her, gave her to me for skin to skin for two minutes and then whisked her to the NICU to put in a central line, a feeding tube, an oxygen monitor, and place her in the most intensive care part of the NICU. I named her Amal – Hope.

Amal was born prematurely at 3 lbs 4 oz. The NICU was her home for the month that followed. Our life was measured and celebrated in an ounce gained, in every millilitre of feed increased, in every degree of temperature regulated. Each day, I left her on the fifth floor with doctors and nurses. Each day we peaked, picked, and poked at her. Each day, I wondered if she knew me better than the beeps and alarms and wires and tubes of her new world. Each day, I cried and cuddled. None of that strength would be possible without God, trust in the awesome staff, and all the friends who still came to my baby-less home to congratulate me. I pumped and pumped milk for her. I attended every doctor's meeting, I went to see her, and be with her each day. Again, my mother had travelled all the way from Pakistan to be with me, her baby. She watched me learn the ways of the NICU. My mother has been there for all three entrances of her grandchildren. She has mothered me as I corrected her mothering of my children, she would sit in the NICU with me and take pictures of me, when I'd just be looking at Amal.

She watched my disappointment when Amal would not be able to suck on her own and be amazed at all the support the staff offered. While there is angst in the uncertainty that surrounds us, the presence of family and friends forces you to engage in a performance that may inhibit your fears from drowning you.

Gradually, Amal was moved from the most intensive sections to the enclosed incubators, to the open crib. And one day, which happened to be my birthday, the nurses announced that she had taken a bottle, and they were going to have me stay at the hospital for two nights, so I could nurse her. Over those two days, the wires came off, she was nursing, and able to sit in the car seat for two hours without any problems. She was passing all the tests, and I was terribly scared of what would come next.

I bawled my eyes out at the NICU, in the elevator down to parking, and all the way home, the day I brought her home. They take such good care of your baby, that you doubt if you can ever match it yourself. All monitors and wires off, means you trust your gut, and I was petrified of that responsibility. The team spent hours convincing me that I was ready, like coaches before a marathon. As we entered our house, my mother cried looking at me cry – at my relief and joy and fear. The baby was meeting her brothers for the first time. In the NICU they had only allowed a total of five people to ever see her. My husband had not visited her much either, because he had been processing the experience in his own way, while I was holding on to the instruction of loving her with complete devotion. Our small apartment was splitting at the seams with a daily influx of friends wanting to come and see the baby and finally rejoice.

Conclusion

In all three performances of maternities, I remained uncertain. The first experience was one where I didn't know what a threatened miscarriage and early labour entailed, the second also a threatened miscarriage, away from home and family, and in a labour room where my labouring was being resisted, and the third where the premature birth and time in NICU meant remaining in the hospital before the birth but being sent home after without the baby. Personal faith in Pakistan, systemic faith in Malaysia, and then personal faith again in the United States remained central to the experience as I navigated the uncertainty that riddled all three. The beauty in how all three spaces accommodated prayer, whether it was my Christian nurse in the Catholic hospital in Pakistan, or the Muslim doctors and nurses in Malaysia who centred the whole experience around recitation, or my request in a secular hospital in the United States, while a basketball game was on TV in the labour room is not lost. From being 22, 26, to being 39 and how my

fears remained the same, but my asks became unrestrained, I found that I grew into the performance.

The differences in how Pakistani and Malaysian medical practices did not find it obligatory to share all information, whereas the American practice of complete disclosure of information, scheduled testing and procedures, and choice, throughout are very distinctly diverse. Regardless of how disempowered I may have felt in Malaysia or Pakistan because of lack of information or choice, and how well informed I was in the United States, I still did not feel empowered in the face of uncertainty. While the medical system may be providing an element of trust, the experience of maternity is so powerful in the creation of human life, that it leaves one utterly powerless and humbled simultaneously. The largeness of your action remains entirely nestled in the smallness of your capacity.

In reading these three narratives, we may be tempted to value one performance over the other. Bagelman and Gitome caution us against this leaning as they point out that as a result of geographical bias there exists an abject absence of reproductive representation of some maternities and sought to provide a 'deeper understanding of heterogenous reproductive lives' (2021: 352). The authors state, 'even as the literature on reproduction becomes more diverse, it nonetheless remains tilted towards northern geographies', and 'where southern geographies are visible, the birthing body is all-too-often framed in abject terms, flattened of lived complexity' (Bagelman and Gitome 2021: 353). The rich narrative experience is often left unshared when it comes to southern geographies, and when it is represented, it is in work that relates to performance measured in medical statistics. Bagelman and Gitome posit that 'reproduction has historically been a matter of and for population studies' where it has focused on questions of fertility patterns as well as demographic growth and decline, resulting in feminist scholarship arguing 'for a diversified approach to reproductive issues' (2021: 352–53). The authors further suggest that 'while geographical attention has begun to account for thick understandings of women and their birth stories, we contend that this understanding is still reserved primarily for those located in the Global North' (Bagelman and Gitome 2021: 353). This stilted representation 'reifies a misguided image of "the north" as a site of relative reproductive privilege [...] as producers of reproductive knowledge while "the south" is positioned as a site yet-to-be-developed' (Bagelman and Gitome 2021: 354). Another risk that a stilted reading of narratives leaves us with is that it decontextualizes the performance of maternity from its social and cultural context and focuses on the medical experience alone. Challinor (2018), used autoethnography as that very diversified approach to share her birth narratives to regain her power over that experience. She had written journal entries at the time of her pregnancy and labour and used that narrative later to create her autoethnographic piece, similar to my utilization of the narrative

I share from Momin's birth. Challinor (2018) urges us in her work to recentre birthing as a medical experience that hinges on authoritative medical knowledge, to a lived experience of maternity performed within a sociocultural context. Medical practices themselves are formed by the contexts they are placed in, so a reliance on expertise in the United States, and a reliance on community and faith as birthing is treated to be an organic and fluid phenomenon in Pakistan or Malaysia are represented in the offerings made in all these geographical spaces. The unsaid, unrecorded, unshared, invisible parts of birthing narratives are perhaps the most central part of the experience, and autoethnographic accounts that allow us to capture the layers of experience provide scope for this contextualization (Ellis et al. 2011).

The performance of maternity touches, scars, heals, and forces us to morph and grow into another lifeform and using autoethnographic personal narratives are like testimonies that give 'both insiders and outsiders insights into what it is like being there' (Richards 2008: 1722). Uotinen states the 'greatest asset of autoethnography is that it offers tools for researching themes that are difficult or even impossible to study' and is an 'excellent method for researching those practices that have become invisible because of their ordinariness or repetitiveness' (2011: 1309). Carrying, labouring, and birthing are extraordinary occurrences that occur distinctly but frequently – they are the everyday business of life, and capturing the narratives of uncertainty, disempowerment, hope, faith, trust, and support is similarly difficult. The mother, despite who is present or not, labours and delivers through her body, and her experience still remains contextualized in the larger stage where she is situated.

REFERENCES

Ahmad Tajuddin, N. A. N., Suhaimi, J., Ramdzan, S. N., Malek, K. A., Ismail, I. A., Shamsuddin, N. H., Bakar, A. I. A. and Othman, S. (2020), 'Why women chose unassisted home birth in Malaysia: A qualitative study', *BMC Pregnancy Childbirth*, 20, p. 309, https://doi.org/10.1186/s12884-020-02987-9.

Bagelman, J. and Gitome, J. (2021), 'Birthing across borders: "Contracting" reproductive geographies', *Dialogues in Human Geography*, 11:3, pp. 352–73, https://doi-org.ezproxy.neu.edu/10.1177/2043820620965825.

Challinor, E. P. (2018), 'Exploring the power of the written word: On hospital birth and the production of birth narratives', *Etnográfica*, 22:3, pp. 669–90, https://doi.org/10.4000/etnografica.6077.

Ellis, C., Adams, T. E. and Bochner, A. P. (2011), 'Autoethnography: An overview', *Historical Social Research*, 36:4, pp. 273–90.

Isbir, G. G. (2013), 'My birth story is like a dream: A childbirth educator's childbirth', *Journal of Perinatal Education*, 22:1, pp. 23–29, https://doi.org/10.1891/1058-1243.22.1.23.

Richards, R. (2008), 'Writing the othered self: Autoethnography and the problem of objectification in writing about illness and disability', *Qualitative Health Research*, 18, pp. 1717–28.

Underhill-Sem, Y. (2001), 'Maternities in "out-of-the-way" places: Epistemological possibilities for re-theorising population geography', *International Journal of Population Geography*, 7:6, pp. 447–60, https://doi.org/10.1002/ijpg.241.

Uotinen, J. (2011), 'Senses, bodily knowledge, and autoethnography: Unbeknown knowledge from an ICU experience', *Qualitative Health Research*, 21:10, pp. 1307–15, https://doi.org/10.1177/1049732311413908.

11

'These Nipples Are Wasted!'

Chan-hyo Jeong

Two months after I came back from my dad's funeral, I found out I was pregnant. The news surprised many people who asked me why I still didn't have a child. During the traditional three days funeral, people I have not seen before asked me if something went wrong and suggested an herbal medicine doctor. I was in my late 30s, and I was with my partner for fifteen years.

Soon after I met with a gynaecologist, I learned that I had thrombocytopenia.[1] My dad passed away from leukaemia and I knew what a platelet count meant by then. A gynaecologist sent me to a specialist who informed me of the risk if I have to go through a major surgery, such as a Caesarean section. I received a thick file of documents about my body that were full of words that I have never heard before. I gave them to my nurse husband, who understood all the Latin words and numbers in red. He gave me an injection every day; it was the first thing he did after he came back from his night shift. Soon my pregnant belly looked like I was punched repeatedly after those injections in the morning. I had to go to several clinics for different reasons, and every time I showed my belly, nurses and doctors wanted to make sure that the bruises had nothing to do with my husband.

My mom, who went through a long mourning process, saw my pregnancy as a sign from my dad. I called her every day so that I felt like I was doing something great for her. My aunts praised me as a filial daughter. Yet I had no idea what was happening to me. I had no family nearby except my husband. In the meantime, I had to write up my Ph.D. dissertation, and find an apartment with one more room. My mom raised three children, but she said she forgot how her pregnancy was. I downloaded an app to learn about my body and the baby. Every night I kissed a baby illustration on my smartphone app goodnight.

In the end, I did the C-section, not after nine months but after seven months, in a German hospital. Don't be alarmed. I am here writing this, while my son is sleeping in his room. It is just that I did not tell anyone, including myself, how scared I was until now and how comically unprepared I was to meet my child two

months too early and fifteen years too late. Right after a visit to Ikea to buy a baby's crib, I was transported to the intensive care unit in an ambulance, bleeding. When a doctor said I would have 'die Entbindung²' in 45 minutes, I asked him what it meant. I learned German in school, but I have never heard that word before.

I didn't even know that I had to pump my breast right after I gave birth. The doctor was furious. 'Golden milk' he said, the first milk full of magical nutrition that will strengthen a prematurely born baby's immune system. But the task was rather tricky. I was not allowed to walk yet, and I had to share the pump with my neighbour, Ms. Chen, whose son shared the same birthday as mine. Her parents came to the room at 8 a.m. and stayed in the room till 8 p.m. She had many visitors and the man I thought to be her husband said he was just a venture capitalist working for her. He came with the parents of Ms. Chen and ran errands while she was talking on the phone. Ms. Chen said sorry about the visitors, but the private room was fully booked.

On my tenth day in the hospital, finally I was able to get out of the bed. I have never been outside of the room, and the only visitor was my husband who needed to leave me in the afternoon for his shift. There were flowers and balloons in the corridors, and I realized only then everyone else was going to in-house 'courses' to learn about childcare with their newborns. In the silent lactation room, I was sitting without my baby, but with my breast pump pushing air out loudly, while a mother came in with her baby. She smiled like a Goddess in a Renaissance painting and managed to dress like one. Her cornrowed hair was blond and wrapped in matching fabric with her dress. I felt ashamed with my greasy hair that couldn't be washed for almost a week. I don't know how she could manage to look like that. I was wearing the hospital gown and trying to collect every drop of the golden milk. I asked my husband to bring my clothes but now none of them fit me.

Looking at my child was supposed to help lactation, the doctor said. The children's ward was in a different building, so someone had to push my bed all the way to a preemie station while I was still lying on it. My tiny baby was connected to tangles of colour-coded wires. His feed tube was attached with a heart-shaped plaster. The room was shared by two other babies, and the room was rather small. I put my pump next to the garbage bins. My hospital gown was down on the floor and my breasts were on full display. Why not? All of the Chen family saw my boobs. Who really gives? Then all of a sudden I burst into tears, while the pump made the funny noises. Psheeshe. Psheeshe. Nurses came and asked if I was OK. Psheeshe. Psheeshe. The baby was sleeping in the hospital romper, two sizes too big. Psheeshe. Psheeshe. I continued pumping. Psheeshe. Psheeshe. The other parents came into the room to see their babies. Psheeshe. Psheeshe (Figure 11.1).

For four weeks, I visited my baby every day to do kangaroo care. I couldn't walk properly yet and the bus ride was rather long. The nurse told me that it is important to get a car for a baby. People asked me if South Korea has big hospitals like Germany

FIGURE 11.1: Preemie Station (Chan-hyo Jeong, 2023).

and I wanted to say that if I were in South Korea, the hospital food would be way better, but I zipped my mouth shut. I texted my family, and they asked me to send the pictures of the baby, but not the mother. My mom texted that I was a bad photographer and I needed to get better photos of this precious grandson.

The first time that I had to change the baby's nappy, I completely panicked. I had no idea what to do with all the wires, and the baby was crying so loud that the alarm went on as his heartbeat was above 200. I rang for a nurse, but no one came, and I sweated while I tried to untangle the baby from the crib. Later, my husband, who is a nurse, came and changed a nappy. He did not sweat a single drop, and the other nurses saw him and praised his meticulous techniques. When the hospital people knew my husband understood their medical lingo, they spoke to him about my body, while I was silently listening. As a part of the protocol to let the baby to go home, one nurse came to check if I could change the nappy properly. I sweated again as if I was taking a job interview (Figure 11.2).

When I finally learned about the different cables around the baby, nurses said the milk was still not enough – but I could not meet the production quota. I had to write a daily report on the quantity and the production time. I felt guilty about all the plastic milk bottles, pump tubes, and flanges that I had to throw away after one use. At home, I could use reusable breast pumping kits, but I felt too exhausted

FIGURE 11.2: Kangaroo care (Chan-hyo Jeong, 2023).

to handwash them thoroughly. I woke up every three hours to fill up bottles, then put them in the fridge. I watched YouTube videos about breastfeeding in between and transported one or two bottles in the thermobag every day.

Still, it was simply not enough.

The doctor sent me to lactation consultants and even internal acupuncturists. I felt embarrassed to show my unshaven legs to the acupuncturists while I had no problem being half naked in front of strangers in the preemie station by then. I received a leaflet with recommended meals for breastfeeding moms. I cooked chicken soups and drank malt beer every day. Nurses told me I had perfect nipples for suckling, yet the baby was so little that in the end he still had to drink milk through his nose. A senior nurse sighed after all those unfruitful endeavours and said to me in all German seriousness: **'Too bad that these nipples are wasted!'**

NOTES

1. A low platelet count which can affect blood-clotting function.
2. It means a childbirth in German.

12

Macomère Narratives: Mothering in Higher Education

Janice B. Fournillier

This autoethnographic multi-voice piece, 'writing stories narratives' (Richardson 2001: 959), describes the mothering role I perform as a Black Caribbean higher education professional working in the United States. These narratives allow me to examine how I become embolden to embrace macomère as a theoretical/conceptual frame and more. The movement from a classroom teacher in the Caribbean to a university professor in the United States propelled me to find ways to perform my duties without losing my sense of self and belief that teaching is indeed a vocation. The various memories of and knowledge gained from those individuals who mothered me; the narratives of students I mentored in my mothering way; and the theoretical and conceptual frames of Africana feminist-womanist scholars (e.g. Amadiume 1997, 2005; Oyěwùmí 2016, 2005, 1997) and Africana Womanist scholar (Hudson Weems 1995) author me while I author the text. The theoretical concepts of matrifocality, matricentricity, and mothernity allow me to rethink 'identity' beyond the patricentric framing and make meaning of my teaching/ mentoring style. Indeed writing as the method of inquiry (Richardson and St Pierre 2005) brings me to the realization that mothering is central to my teaching mode and is more than a biological function. However, in my writing and reading about the experiences, I uncover 'my attitudes, concerns, dispositions, and patterns of conduct' (Stout 2009: 3) rooted in the Caribbean macomère tradition. In the chapter, as I move in and out of my experiences of being mothered and the narratives of graduate students, I realize how 'mothering' in higher education worked for me as a Black woman of the Diaspora.

Sankofa

As a self-identified Black woman of the Diaspora who, after 28 years of teaching at all levels of the educational system in the Caribbean, migrated to the United States, I was very aware of the central role that mothering[1] played in my upbringing and my training as an elementary school teacher. Given my ancestry, I am taking the liberty of being considered Africana[2]. I was indeed encouraged, having realized that Africana womanist-feminist scholar (Oyĕwùmí cited in Diakité 2013: 61) extended her discourse on mothernity to encompass the Caribbean tradition of macomère – an integral aspect of my upbringing. How could I not, given that my mother's macomère was the woman who mothered me from infancy to adulthood. Millicent Foncette was my godmother[3]. My biological mother entrusted my safety, education, and well-being to someone she knew as a friend but who would take on a mother's responsibility. And so, I called her 'mother' and my biological parent, mummy. Indeed, there was a big difference. My mother's macomère was the one who ensured that I was what she called well rounded. I remember:

> I went to the countryside during August vacations, and I sat by the lamplight and listened to the stories my great grandmother told; I attended multiple churches and heard individual versions of biblical stories; I sang and performed on stages in these different denominational churches; I recited the text for the day after returning from church on Sundays; I taught my younger siblings what I knew; I learned how to sew, do needlework, crochet, knitting, baking of cakes for the community; I read the daily newspaper; I visited the orphanages where my biological mother worked and read for the children; I paid visits to the hospice where older folk who had no one to care for them lived. I gained all of these experiences because of how my godmother, my mother's macomère, thought I would be a well-rounded, educated young woman. It was for her a way of mothering a child for whom the only thing she did not do was 'give birth'. She paid close attention to not just my academic but my total development.

It is with the memory of these experiences as a learner/teacher that I was able to embrace Diakité's interrogation of the term mothering as one whose 'semantic purview expands well beyond the literal to register the metaphorical and the socio-ontological' (2013: 62). I did not need to go to the Eurocentric frame to explain how I performed as a professor in higher education. There were positives in the Diasporic traditions that I knew but never owned that I could now use to make meaning of my teaching strategies. Like the character Sethe in Morrison's novel *Beloved*, I am writing about not just time but 'a time'.

I was talking about time. It's so hard for me to believe in it. Some things go. Pass on. Some things just stay. I used to think it was my rememory. You know. Some things you forget. Other things you never do. But it's not. Places, places are still there. If a house burns down, it's gone, but the place – the picture of it – stays, and not just in my rememory, but out there, in the world.

<div align="right">(Morrison 1987: 88)</div>

The central question that frames this narrative is: What kind of teaching practices do I use as a higher education professional in the United States? I do not want to forget what and how I believe I use 'mothering' as a teaching practice, and so I am creating a re-presentation that will stay 'not just in my rememory but out there in the world'.

Using a traditional African philosophy and my indigenous ways of knowing, I retell the story using my memories and some of the students I have taught. Indeed, I am, in so doing, using SANKOFA, which roughly translates as 'return to the source and fetch'. I combine Sankofa with the theoretical and conceptual frames of Africana feminist-womanist scholars (Amadiume 1997, 2005; Oyěwùmí 2005, 1997) and Africana womanist scholar Hudson Weems (1997). Consequently, I make bold to claim that while I author the text of the narrative, these philosophies and theories are also authoring me. They resonate with how I view my teaching/learning practices and the descriptions of students who have shared their memories with me.

Moving back and forth: Navigating the transition

My transition from the Caribbean to the United States as a Ph.D. student and then an assistant professor in higher education was challenging. It was a cultural shock that I had to overcome quickly and find a way forward. My third-year review, which categorized me as 'British' and therefore having certain high expectations and possibly not adjusting to the US context, surprised me. As I write this paper and reflect on the changes I made, I recognize that I needed an approach to teaching in the US context at that moment in time. I began my journey then of returning to the source and using frames that I brought with me, not as a colonial subject, but as a woman taught by individuals who 'mothered' me. As Tedla reminded me, '[t]he source is our culture, heritage and identity' (1995: 1).

I heard the voice of one of my esteemed mentors, '[w]hen the pupil is ready, the teacher will arrive!' It appears I forgot that Ancestor Daphne Pilgrim Cuffy, one of my first academic mothers, taught me that educators were not only those in brick-and-mortar classrooms. My first oral history assignment was a study of

Audrey Jeffers,[4] the woman who started school feeding programmes in Trinidad and Tobago. Audrey, according to Daphne, was an educator and another 'mother'. Daphne taught me social studies and science in her backyard while she fed me the food she prepared in her kitchen. Daphne saw the person before me, the student. Daphne provided me with material to take with me as I travelled the Caribbean with the folk choir. She took care of my physical, psychological, and educational needs. Yes, she taught a young woman the philosophy of education, curriculum design and instruction, content knowledge, and research methods in her living room and garden. It would be this same lecturer, the educator who sat with me many nights during the last days of my pregnancy with my third child. Education did not begin and end in the walls of the Teachers Training College. This ancestor reminded me regularly that some women made choices that prevented them from being the success they were meant to be. She spoke in riddles and parables and told stories. I gained another mother in the Teachers Training College, and the lessons stayed with me. I know now I was being prepared for my role as a professor in higher education in the United States. I still needed a baptism of fire that came from teaching a course online: 'Reclaiming and Celebrating What Works a Black Education Congress: An Initiation'.

> Each of us is called upon to embrace the conviction that we have the power within us to create the world anew.
>
> (Boggs n.d.)

Writing for me is a method of inquiry (Richardson and St. Pierre 2005). So as I read graduate students' responses to my call for reflections, I immediately thought of Andre Tanker's music and the sense of liberation that came from the praxis of A Black Education Congress and my participation in the events. I was ready to ring the bell for freedom and justice and hold on as I navigated working in higher education:

> From Trinidad to North Carolina [Hold on, hold on]
> From Panama to Richmond, Virginia [Hold on, hold on]
> Pole to pole and corner to corner [Hold on, hold on]
> Behind the bridge and across the border [Hold on, hold on]
> Sayamanda,[5] sayamanda, sayamanda, ring the bell.
>
> (Andre Tanker)

The Congress intended to give explicit attention to intergenerational collaboration, elevate and celebrate 'what works' and 'pass the torch' to those coming behind us. The Congress represented the vision of a network of educators and

activists – in the United States, Canada, and the Caribbean. The vision for the Congress affirmed the imperative and efficacy for educational models in which academic and cultural excellence serve the community and are global in view. In this space, I began to feel that what I brought with me from the Caribbean as a woman of African ancestry mattered and was valuable. I was not only a teacher but a learner in this space. I felt the mothering of the co-instructors of the course, particularly my mentor, a liberation fighter, and the participants at the Congress. I, like Walter Rodney, realized that 'it was necessary to come to grips with the way in which one's being, and the presentation of one's being, was so hopelessly distorted in the sources to which one went for scholarship' (1990: 13). I was free to teach differently and to use my localized approaches of my Africana academic mothers from the Caribbean and the Diaspora.

As part of the Congress, we offered a for-credit course designed to prepare a cadre of graduate students and in-service teachers to work effectively on behalf of students of African ancestry – as teachers, researchers, and advocates. The course 'Educating Students of African Ancestry for Academic and Cultural Excellence for the New Millennium' used the theory and practice of Black educational excellence traditions, grounded in African philosophical and cultural constructs, as a foundation for effective teaching. According to Diakité, Africana womanist-feminist scholars, with whom I was becoming familiar, demanded 'localized approaches to gender justice and human flourishing' (2013: 62). My experience of being part of this community was similar to Carmen Kynard's whose blog post exemplifies my feelings:

> I realize today the weight of an experience that I seldom receive, an experience that maybe I have never had [...] being in a room filled with concentric circles, nested cyphers, filled with people of Afrikan descent who have the education and well-being of Black children first and foremost in their heart, mind, spirit. Just imagine it! It might sound simple, *but how many times have you actually experienced THAT?*
>
> (Kynard Carmen 2013: n.pag.)

It was within this context that I experienced of preparing students to do research that was ethical and social justice-oriented. It forced me, even more, to attend to being human in the process and to be more than just one who provided content knowledge. Being human for me was always associated with the 'mothering' I received from my mother's macomère and the multiple mothers I associated with throughout my journey as a student and teacher in the Caribbean. There was what Hillard (1998) called a reawakening of the African mind. I lost the fear of stepping out and owning my indigenous ways of knowing and being. However, my

graduate students' narratives alerted me to the role I played in their lives when, according to my mother 'I was busy thinking' I was teaching.

My mentees/graduate students' narratives

What were these approaches to teaching and learning that I went back to fetch as I made my way in this new space? How did the students view the approach? How was it impacting them? These were some of the questions I asked myself and the graduate students. And the students responded in poetry and narrative personal communications.

> Mothers love, mothers guide,
> Mothers teach, mothers provide.
> Mothers care, mothers inspect,
> Mothers share, mothers protect.
> Mothers model, mothers test,
> Mothers correct, mothers invest.
> Mothers push and pull out the best,
> Mothers accept nothing less than success.

(Syreeta Ali McTier 2021)

> I did not go into the academy looking for a mother. Nevertheless, I found a mother. She was hard on me, because she loved me, she was sometimes angry, and disappointed in me, and she lets me know. Not so much to inform me but to push me to do better. I learned that a mother is more than the biological. Mothering manifest in the complexity of love and care.

(Kenneth 2021)

Similar to Kenneth, I did not go to Training College to find a mother but indeed there was a woman who mothered me and provided the support I needed as a young woman in my teens who was preparing to become a teacher. Kenneth reminded me in his reflection of how I cared for him as a mother. I had totally forgotten that incident. He wrote:

> During the course, I had several interactions with her, some were good and some, not so good. But one helped me to see her not only as a professor but as a mother.
> About mid-semester, my family increased significantly. My wife and I was in the hospital for the birth of our children and was not able to get to class on time. It was my turn to present my work, and I did not have enough time to request a change.

The work was complete, but I could not get to class. I did not want to leave my wife in the hospital alone, and I did not have anyone to baby sit my other children. At the last minute I got someone to help me, and I went to class. I explained my situation to the professor and apologize for being late. To my surprise, she looked at me and said, 'I am impressed by you. It shows me the type of person you are, and your work ethics. You did not have to come to class, but you still came'. After my presentation, she told me to go home.

The element of humanity that mothers bring to the table was for me an important aspect of teaching and so I fought to not just teach courses but teach people a course and so tried to ensure that I lived it out. Kenneth continued his story:

As with any mother with multiple children, some students got more than others. I know I got more. I needed more than many of my classmates, and she was willing to give me what I needed. I can re-member, how she came to my first conference presentation. She sat in the audience and cheered me on through the entire presentation. I was so afraid that I could not re-member what I was supposed to say, and I could not read the words on the paper. I felt so disappointed, and embarrassed, but she kept cheering me on. I was able to regain my composure and finish the presentation. I knew that she went above the role of a professor. She was a mother.

Indeed, Renée's poem seemed to acknowledge what I thought I was trying to achieve as she saw our relationship as:

Teacher-Mother of a Creative & Determined Scholar-Daughter
A teacher-mother recognizes the potential of her daughter-scholar.
I am creative and determined.
She bases her guidance on my nature and not on that of another.
To be creative, I must be free, which means that there is no hand holding.
[...] even the freedom to fall to help [re]imagine something greater.
Her questions, resources, and tools feed[back] the necessary correction to start again.
Tapped into a greater work, her vocation is a teacher-mother.
She stokes my ruminating thoughts of social justice with the timbers of Black scholars.
(Renée Jordan 2021)

It seemed only fair and just to use the voices of the graduate students whose reflections made me realize why for me teaching has always been a vocation. And so, I feel humbled and yet honoured that students chose to regard me as an 'academic mother' and 'In my mothers' garden' came to mind as I read the following piece.

I met Dr. Fournillier at a time when I felt empty, unguided, and aimless in what direction to go with my research. How did she know I needed a mother's hand and heart of guidance?

When that aimless feeling appears in my studies, I hear her calm voice remind me to focus: 'What is the issue?' That question is a familiar one that she poises to deepen her students' thinking.

The spiritual and philosophical guidance of ubuntu influences the ways in which Dr. Fournillier mentors, mothers, and advises her students – even those who are not her own advisees.

Dr. Fournillier gracefully accepts her students as her children. As a wise mother with strong vision, she guides them to find their strength within inner selves. That is where the research lives. That is where the fruit of Dr. Fournillier's planting grows.

It began with the melodic sound of a Trinidadian 'Yes' and sustained feelings of a warm embrace. The kind of embrace that instantaneously overwhelms, causes you to laugh to prevent the flow of tears, and comforts like a long overdue family reunion. Dr. Fournillier, opened not only her intellectual space of guidance to me, but her emotional space of nurturing when she agreed to be/come my advisor. Upon hearing 'Yes, I took a step towards Dr. Fournillier to thank her with a hug from my heart and paused'. I quickly re-membered that we were standing in the Georgia State University Educational Policy Studies Library, a professional place of work. A place where I had heard laughter shared between professors and students, but yet to witness the depth of nurturing that supersedes a pat on the back, handshake, and kind words. So, I paused and silently questioned, is it appropriate? It was as if Dr. Fournillier heard my silent question fumbling around in my head, and replied, 'Yes, you may hug me'. Her words and arms 'freed me' to move forward [in my intellectual journey and today the melodic sounds of her words continue helping pave paths of liberation in my personal and professional journeys].

(Chell 2021)

Looking inside: Seeing through

I always felt that my various mothers never just looked but 'saw through me' and knew how I was feeling before I could even say it. To me that was a quality that made them different from anyone with whom I interacted. It seemed somewhat strange therefore that those whom I taught believed that I was doing the same thing with them.

The stories continued to inspire and shed light on my practices:

My life changed on January 9, 2017. I re-member sitting in a small classroom in a building on-campus nervously waiting for class to start. The professor, Dr. Fournillier, had a reputation of being tough. According to stories I had heard, she expected perfection, a deep understanding of all reading material, and preparation for each class. This was not what made me nervous. I could meet those expectations. What made me nervous was the experience of being in a space with a brilliant mind – one that could quote literature without a second thought, one that was always thinking, one that was always watching. Even as she entered the classroom, she was watching everyone. At first this was very unnerving.

Eventually, I began to feel more comfortable in the class and with Dr. Fournillier. At the beginning, I was too focused on being perfect – taking great care to try to turn in perfect assignments. The main lesson learned that semester – qualitative research is not perfect, and neither are you. The assumed expectation dissipated as I experienced week after week in the classroom with Dr. Fournillier (Kerry 2021).

Regretfully, I cannot re-member the first time I heard Dr. Fournillier's voice, the first statement that caused me to look her in the eyes as she spoke, the first time I understood how she balanced the tone and pitch of her voice as she presented a question or offered a sly remark. I also don't re-member when I changed her name from 'Dr Janice B. Fournillier' in my cell phone to 'Dr Janice Fournillier | Mommy'. The latter has been in my phone, a recent message, a recent call, or a constant reminder that I needed to get something done.

Our earliest experiences together where in a first-level qualitative methods course. At that time, I can re-member a straightforward, direct, and often humorous spirit who poised questions that required you to think and apply the knowledge you gained from reading text assigned in the course and common knowledge you often overlooked when considered its relevance to our discussion. At the time, probably like dozens of other students, I felt attracted to her spirit, her love for methodology, and her love for her students. Like so many others, we rushed to join her for experiences in qualitative methods 2, 3, and every other offering with Fournillier listed as the instructor.

I would like to think that my stint as her son began as early as the first week in Qual 1, but I'll save it for the summer or spring that she agreed to be on my committee. I'm settling with this point in our times together because I changed from a constant presence in her classes to an academic child. I use the term academic child because although Dr. Fournillier did not birth me, the pains of encouraging, supporting, and being a member of my dissertation committee are not to be overlooked or dismissed.

A professor instructs and a mentor advises and counsels. A mother does all these things while guiding you and growing you with resilience, intentionality, and purpose at a higher level of detail and care. In other words, a mother tends to you with expertise, love, and compassion that waters your soul. This is what Dr. Fournillier has and continues to do for me, and I thank God for her (Hotep 2021).

I re-member her looking around the class to see how we were all doing each week. She didn't just glance at us; she looked into our eyes. At least, she looked into my eyes. If I said I was okay, but I didn't sound okay, she would look at me – almost through me – and see if I really meant it when I said I was okay. Dr. Fournillier opened her home to other grad students and me, fostering a supportive academic community as we partook of callaloo and sorrel. She was present for two of the most significant moments in my later adult life – she hooded me for my graduation at GSU, and two years later, she flew from Atlanta to Detroit to attend my wedding. I can't help but to think of her often because whenever one of my students starts to get overwhelmed by all that they have to do to finish their dissertations, I simply tell them, 'drop by drop, you fill a bucket up' (Adrienne 2021).

The end is the beginning

As I read and reflected on the narratives of multiple graduate students, the words of Baba Asa Hillard, one of my academic parents and an ancestor who continues to mother me, came back to me in true SANKOFA style:

> Being a teacher is simply one of the greatest things in the world. Is it a job? Is its purpose to prepare students for the world of work? Yes and yes, but those things are minimal. It matters greatly how teachers think about who they are, who children are, and why they are here. It is my fondest hope that those who intend to enter teaching will learn about its enormous power, awesome rewards, value to students and their families, and personal fulfillment for teachers.
>
> (Hillard 2006: 88)

I was now unafraid and seemed to have cracked the walls of the matrix that Baba Asa Hillard described and might be on the road to freedom as I am to fulfil his dream. 'I dream that new teachers will crack the walls of the matrix, to go over and beyond, around beneath, and far above those of us who are stuck in neutral and spinning our wheels in a bad place' (2006: 101). Yes, somewhere along the way, as I read my early student evaluation reviews and my third-year faculty evaluation, I decided that it was time for a change. I needed to be free to go back and fetch what is positive and what works as I move forward to the future. The profundity of what *mothering, mothernity*, and being a *macomère* meant to me as a woman of African descent born in the Caribbean struck me. I could now make bold to reveal how my students' narratives represented my attitudes, concerns, dispositions, and patterns of conduct seemed to reflect the tenets of these constructs. And like Ginott, I have come to the frightening conclusion that

I am the decisive element in the classroom. It is my personal approach that creates the climate. It is my daily mood that makes the weather. As a teacher, I possess tremendous power to make a child's life miserable or joyous. I can be a tool of torture or an instrument of inspiration. I can humiliate or humor, hurt, or heal. In all situations it is my response that decides whether a crisis will be escalated or de-escalated, and a child humanized or dehumanized.

(1972: 15–16)

So, to be a professor in higher education in the United States does not take away what it means to be a 'teacher'. It is a vocation (Harding 1990) and one in which there is character, critical consciousness, and humanity – all characteristics of the ones who 'mothered' me. Indeed the end is the beginning and so I close with these words that remind me to be even more committed and responsible. '[Let us] begin to think with our own minds, and not the mind of the manipulators, and consequently free ourselves from "miseducation"' (Armiya Nu'man cited in Akbar 1999: Introduction).

NOTES

1. Mothering is also referred to as 'matricentricity' (Ifi Amadiume) and 'mothernity' (Oyeronke Oyěwùmí).
2. An inclusive term for African descended persons, cultures, and practices and so on from Continental Africa and the wider African diaspora (Diakite 2013: 61).
3. One's god-mother is the individual who takes you to the church to be baptized and signs the baptismal paper. She is supposed to be the one who will take care of you if there is a need.
4. Audrey Jeffers (born 1898) was the first Afro-Trinidadian woman to be elected as part of the Port of Spain City Council. She obtained her diploma in social sciences at Alexander College, North London, and founded the Union of Students of African Descent (later became the League of Coloured Students). After returning to Trinidad in 1920 from London, she used her family home to start a junior school. A year later, she established the Coterie of Social Workers of Trinidad and Tobago, an organization that started off giving free lunches to underprivileged children and went on to build homes for the blind, elderly and homeless (https://nationaltrust.tt/home/location/audrey-jeffers-house/?v=d-f1f3edb9115. Accessed 12 December 2023).
5. According to an explanation by Guanaguanare (2016), Sayamanda was a nonsense word that Tanker improvised while he was composing the tune, planning to replace it with more meaningful lyrics later. But it sounded right, and later he interpreted it to state, '[i]s I a man there', meaning that '[w]e're all human. We all have a common kind of feeling; we can identify with what's happening in another place' (https://charterforcompassion. org/truth-political-and-social-activists/truth-grace-lee-boggs. Accessed 4 December 2023).

REFERENCES

Akbar, Na'im (1999), *Know Thyself*, Tallahassee, FL: Mind Productions and Associates.

Amadiume, Ifi (1997), *Re-inventing Africa: Matriarchy, Religion, and Culture*, London and New York: Zed Books.

Amadiume, Ifi (2003), *Politics of Sisterhood*, Trenton, NJ: Africa World Press.

Boogs, Grace L. (n.d.), 'Additional quotes', *Charter for Compassion*, https://charterforcompassion.org/truth-political-and-social-activists/truth-grace-lee-boggs. Accessed 4 December 2023.

Diakité' Stewart, Dianne M. (2013), 'Matricentric foundations of Africana women's religious practices of peacemaking, sustainability, and social change', *Bulletin of Ecumenical Theology*, 25, pp. 61–79

Ginott, Haim (1972), *Teacher and Child: A Book for Parents and Teachers*, New York: Macmillan.

Harding, Vincent (1990), *Hope and History: Why We Must Share the Story of the Movement*, Maryknoll, NY: Orbis.

Hilliard, Asa G. (1998), *SBA: The Reawakening of the African Mind*, Gainesville, FL: Makare Press.

Hilliard III Baffour Amankwatia II, Asa G. (2006), 'Aliens in the education matrix: Recovering freedom', *New Educator*, 2:2, pp. 87–102.

Hoffman-Kipp, Peter, Artiles, Alfredo J. and Laura, López-Torres (2003), 'Beyond reflection: Teacher learning as praxis', *Theory into Practice*, 42:3, pp. 248–54.

Holt, Nicholas L. (2003), 'Re-presentation, legitimation, and autoethnography: An autoethnographic writing story', *International Journal of Qualitative Methods*, 2:1, pp. 18–28.

Hudson-Weems, Clenora (1995), *Africana Womanism: Reclaiming Ourselves*, Troy: Bedford.

Kynard, Carmen (2013), 'A Black education congress', *Education, Liberation & Black Radical Traditions for the 21st Century*, 13 October, http://carmenkynard.org/tag/a-black-education-congress-abec/. Accessed 7 July 2021.

Morrison, Toni (1987), *Beloved*, New York: Alfred A. Knopf.

Oyěwùmí, Oyèrónké (1997), *The Invention of Women: Making an African Sense of Western Gender Discourses*, Minneapolis, MN: University of Minnesota Press.

Oyěwùmí, Oyèrónké (2005), *African Gender Studies: A Reader*, New York and London: Palgrave.

Oyěwùmí, Oyèrónké (2016), *What Gender Is Motherhood? Changing Yorùbá Ideals of Power, Procreation, and Identity in the Age of Modernity*, Basingstoke: Palgrave Macmillan.

Richardson, Laurel (2001), 'Getting personal: Writing-stories', *International Journal of Qualitative Studies in Education*, 14:1, pp. 33–38.

Richardson, Laurel and St Pierre, Elizabeth A. (2005), 'Writing: A method of inquiry', in N. K. Denzin and Y. S. Lincoln (eds), *The Sage Handbook of Qualitative Research*, Thousand Oaks, CA: Sage Publications, pp. 959–78.

Rodney, Walter (1990), *Walter Rodney Speaks: The Making of an African Intellectual*, Trenton, NJ: Africa World Press.

Rottenberg, Biri, Schonmann, Shifra and Berman, Emanuel (2017), '"Rememory" and meaning: The narrative of a mother giving birth to her own subjective identity through weblog writing', *Journal of Poetry Therapy*, 30:2, pp. 84–94.

Stout, Jeffrey (2009), *Democracy and Tradition*, Princeton, NJ: Princeton University Press.

Tanker, Andre (1996), 'Sayamanda', *Children of the Bang*, CD, Trinidad and Tobago: Rituals of Trinidad.

Tedla, Elleni (1995), *Sankofa: African Thought and Education*, New York: P. Lang.

13

Bitter-Sweet Embrace: Documentary Film of Artist-Clinician Sophia Xeros-Constantinides Presenting Her Postgraduate Fine Art Exhibition Exploring the Darker Side of Motherhood

Sophia Xeros-Constantinides

This chapter centres around a sixteen-minute documentary film[1] co-directed in Melbourne, Australia, by filmmaker Anna Grieve and artist-clinician Sophia Xeros-Constantinides.[2] The artist is interviewed in front of her *Bitter-Sweet Embrace* exhibition work, at the MADA Gallery[3] in June 2016. The exhibition comprises the practical component of the studio research for Sophia's fine art Ph.D. thesis, which is entitled 'Strangers in a strange land: Envisioning the darker side of motherhood'.[4]

In this documentary film, the artist is located within the Gallery space and introduces the audience to her exhibition of collages, drawings, and prints that have taken ten years to create. Sophia discusses key pieces of artwork and her inspiration and intent in the work: to refashion depictions of procreative women and birthing women, to find metaphors for the functions of containment and provisioning that women fulfil in maternity, to depict through collage the 'undoingness' of maternity, to place women's fecund bodies within the landscape of (male-envisioned) imagery so that their contribution to new life is not overlooked as it has often been in the past, and to use collage as a metaphor for procreation, where diverse elements are brought together, juxtaposed to create new imagery through 'magic and mystery'.

The artist talks about her strengths in drawing and collage, and about her trip to Italy with fellow postgraduate students, where inspiration and collage material for the *Natura Morta* and the *La Figura nella Veduta* collages were discovered.

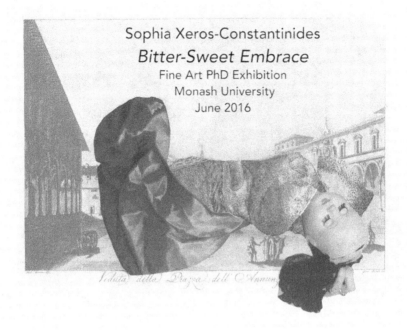

FIGURE 13.1: *Bitter-Sweet Embrace* fine art Ph.D. exhibition. Image shows detail of Xeros-Constantinides's collage #2 *Veduta della Piazza dell'Annunziata* (2012) from the series *La Figura nella Veduta* ('The Figure in the Landscape'). Grieve & Xeros-Constantinides (2016).

The artist discusses her collage works *Occasional Images from a Birthing Chamber*, and imparts some 'gems of wisdom', born of years of clinical work in psychological medicine with mothers and babies:

> Being impregnated, having a baby, it divides a woman from herself. She's no longer who she was before, and she's not sure quite who she is yet. She has work to do then, to discover who she is in relation to this baby being delivered.
> (Xeros-Constantinides 2016: n.pag.)

Finally, the artist confides in her audience that through the making of the work, she remembered a connection with the family heirloom print (Figure 13.2) that her maternal grandmother *Yiayia Evdokia* had shown her when she was just 6 years old. The print depicts the bloody massacre of Smyrna, Asia Minor, in September 1922, which rendered *Yiayia*, her husband *Papou Bayliss* and their babe-in-arms stateless. The baby subsequently died of pneumonia after

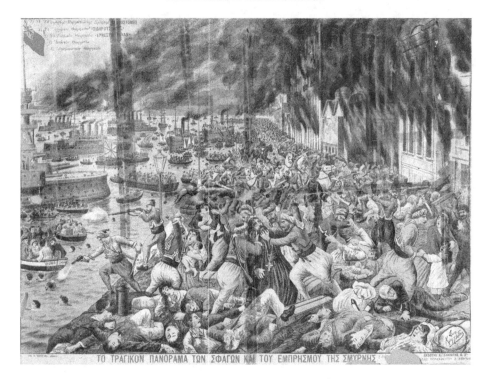

FIGURE 13.2: Coloured lithographic family heirloom print (damaged) on paper, originally owned by the artist's maternal grandmother, *Yiayia* Evdokia, showing *The Tragic Panorama of the Slaughter and Incineration of the Smyrna People*. Artist name (lower right corner) Sot. Chrizidis. Printed in Athens (post-13 September 1922) by Ekthotis K. Alikiotis, unframed size 45 cm × 61 cm (irregular). This archival print was framed and exhibited in the *Bitter-Sweet Embrace* exhibition, hung alongside Sophia's poem to her Uncle Nick entitled 'The Intergenerational Legacy: My Grandmother *Yiayia*'s Asylum-Seeker Baby' (see poem later in this chapter).

their escape. Thus began *Yiayia*'s chequered obstetric history – fourteen pregnancies out of which just five survived infancy. *Yiayia*'s second baby, Nicholas, was a 'survivor-baby' – born in Melbourne just weeks after *Yiayia* landed at Port Melbourne Pier, the destination of her long refugee journey by boat from Piraeus in the Mediterranean.

Transcript of the documentary interview

Bitter-Sweet Embrace: A documentary film made in 2016 by Anna Grieve and artist Sophia Xeros-Constantinides, with camera work by Claire Gorman.

BITTER-SWEET EMBRACE

> ### SUMMARY OF THE VISUAL RESEARCH
>
> Maternity is often idealized within society, where motherhood 'myths' paint unachievable pictures of maternal perfection and blissful union with baby.
>
> My art making looks behind the mask of maternal perfection, at what real women have said and shown of their actual experiences of maternity.
>
> In this way, I have examined the darker side of motherhood, and created visual metaphors for the vulnerability and un-doingness that women experience, when their bodies are colonized and hi-jacked to play host and protector to new life.
>
> Through picture-making, I find new visual forms for maternity, based on the metaphor of journeying to connect with baby, and on the use of collage to give visual form to the disruption of the status-quo for the woman-mother.

FIGURE 13.3: Summary of the visual research. Grieve & Xeros-Constantinides (2016).

The film begins with a quote by Charles Zeanah (2009: 124) that alludes to the 'knife-edged' quality of pregnancy and birth for women-mothers:

> On the one hand, this time (pregnancy) of enormous transition, transformation and re-organisation is one of hope and possibility and on the other, it is a time of crisis and potential disorganisation.
>
> (Zeanah 2009: 124)

Sophia Xeros-Constantinides speaks about her fine art Ph.D. (studio research) exhibition

I think the inspiration appeared to come to me from my work with mothers in the perinatal period. I've worked with mothers therapeutically and through artmaking, art expression, with mums who have somehow found the journey difficult.

I've had the good fortune to go to Italy on several occasions, so my work and my approach to my work has been inspired by those beautiful iconic Renaissance images of mothers and babies.

My strengths were in drawing and collage, so in time I realised there was nothing better than representing the disruption to women's reality and to their status quo than

195

FIGURE 13.4: The artist speaks about her work and inspiration in front of her print from a collage entitled *Cavort* (2010) from the *Boudoir* series. Grieve & Xeros-Constantinides (2016).

through the cutting and tearing and slicing, and remaking that collage allows – it just grew (one from the other).

The inspiration for this work came from the (strong red) colour and the idea of a joyous connection of people, and that attraction that forms part of sex and then leads to the making of babies … that was partly the idea. This is where the trouble begins with 'Cavort', and I thought that was a lovely entrée then into some of the work that appears later on in the show, where I am inserting women's bodies into the landscape and where I am showing women as containers and providers, because they contain and provide for the baby once colonisation occurs.

In front of the 'Autograph' self-portrait charcoal drawings 'Foundling'

There are some people who actually find the work quite confronting. I understand, depending on people's histories and sensibilities, that the work can be experienced as totally undoing and overwhelming. It's not work where you can come in and say 'I'm an expert, I know exactly what's happening'.

The work undermines that expert, authoritative position (in the same way that colonization by a fertilized ovum alters and undermines the authority of the fecund woman in relation to her own body and experiences). So, the work says 'I could

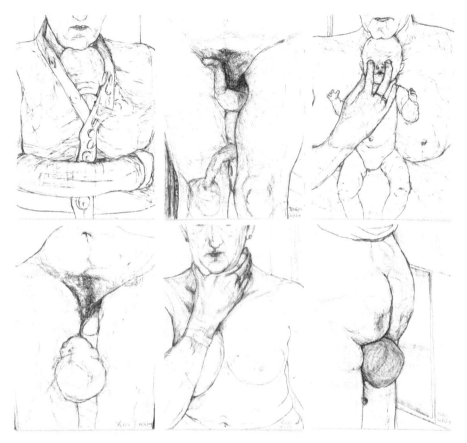

FIGURE 13.5: Six-part drawing by Xeros-Constantinides in charcoal on paper entitled *Foundling* (2009). Grieve & Xeros-Constantinides (2016).

be this [...] I could be that [...] I might be this [...] this is a little odd or uncomfortable'. So the whole time I'm trying to make good art that actually undermines and disrupts the position of the viewer (as the authority).

I feel a little bit more at home if women are looking at the work, because I'm trying to show the perspective of the (procreative) woman and her experiences within her body. So I think I am speaking more to women when I make the work, and perhaps that comes across.

In front of the 'Natura Morta' works

In making these works behind me, which are the 'Natura Morta' works from the series 'Earthly Delights' ... 'Natura Morta' meaning 'Still Life' – I've disrupted or

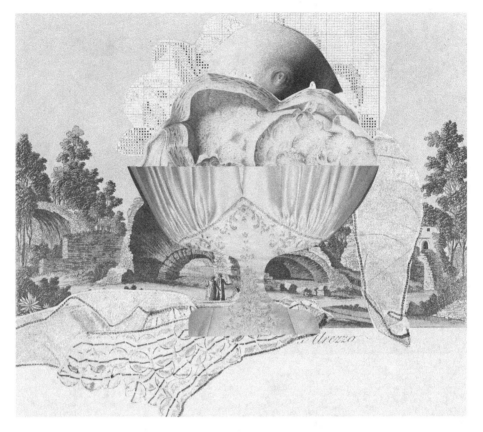

FIGURE 13.6: Detail of *Natura Morta #1* (Veduta dell'Anfiteatro di Arezzo) (2011) from the collage series *Earthly Delights* by the artist. Grieve & Xeros-Constantinides (2016).

reinterpreted the meaning of 'still life'. Here I've introduced into the landscape setting a vessel, which is a metaphor for the woman and her ability, or function really in maternity, of containment and nurturing.

These works were inspired by a trip to Italy with the Monash University Prato group of postgraduate (fine art) students, where I came across a set of three volumes of reproduction prints of views of Tuscany. The background of each print is a reproduction of a vista, or a view, which is the sort of thing that a visitor to Italy would have purchased as a souvenir as part of the Grand Tour that they might be undertaking. These sorts of views were male-envisioned, and they weren't really about women and women's reproductive experiences. I thought it was about time that we put something about women and their reproductive experiences into the 'picture', and that's what these works do. (See Figure 13.7.)

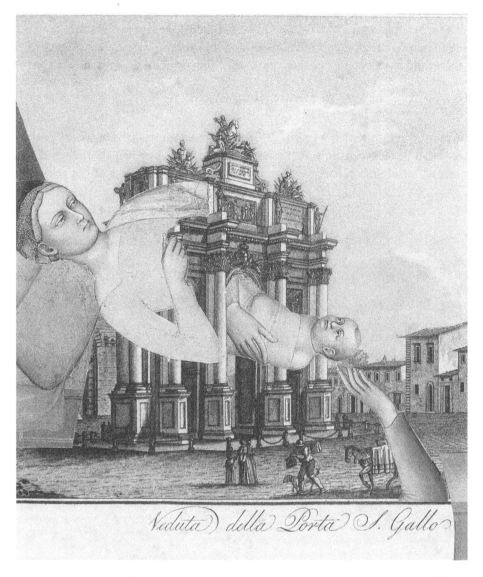

FIGURE 13.7: Detail of #5 *Veduta della Porta S. Gallo* (2012) from the series *La Figura nella Veduta* ('The Figure in the Landscape'), collage on found printed paper bifold by the artist.

I am a 'paper-&-scissors' girl. I do enjoy just having the primary material, paper, and sourcing that. I take delight in visiting bookshops, the Camberwell Market, those lovely street stalls in Italy that sell hundreds of beautifully illustrated books.

Bringing diverse elements together for me is a metaphor for procreation. You can't make a baby without a sperm and an egg, and they come from different places. When a sperm and an egg come together, that's when the magic and the mystery begins.

In front of *Swoon*

This work here is called *Swoon* (2009) from a series of collage works entitled 'Occasional Images from a Birthing Chamber'. This women-mother, she's got someone feeling her pulse, she's got two pairs of hands cutting at the abdomen.

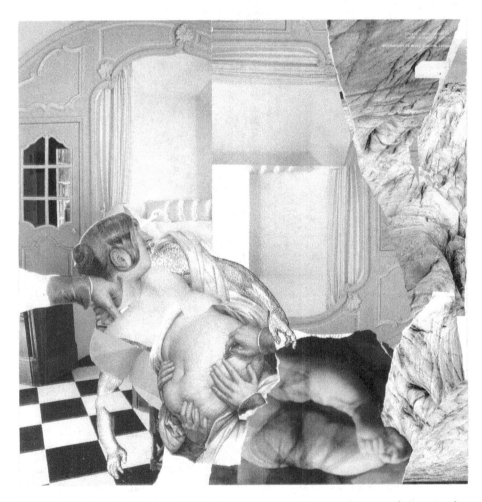

FIGURE 13.8: Detail of *Swoon* (2009) from the series *Occasional Images from a Birthing Chamber*, collage on paper. Grieve & Xeros-Constantinides (2016).

There are some legs here that could be her own legs, or the baby's legs, it's not entirely clear, and she's coming apart. That's what I'm trying to say in these works – the business of birthing rips women apart, one way or another. It's not all easy, it's not all automatic, it can be called a natural thing, but it has consequences for women. I think it's really important that we don't act in society like you can have a baby and be back at work the next day … like women are being asked now to go home (from the hospital) within four hours (of giving birth). So the arrangements that hospitals find themselves in, in terms of funding, impacts on the support that women get before and after birth.

In front of 'Feet First'

This work is called 'Feet First' (2009) from the series 'Occasional Images from a Birthing Chamber'. So here we have a woman who is being delivered of a baby feet first. That's actually a medical emergency, and in the olden days many women would have died from having a pedal presentation of the pregnancy. I've shown her here with her 'angel wings', which might be about her being about to go to heaven, or it might be about the magical work that women do having babies. She's also composite and a bit 'undone'. She does have two strong hands here helping the baby. I'm hoping that she can have some therapy afterwards to help her cope with what's obviously a very demanding experience.

In front of 'Succour'

This work here is entitled 'Succour' (2015). It's a collage on paper, and I've collaged into some imagery that was in a book showing archival photographic pictures of Australia, from 1877, of a hospital that had opened in Sydney … I think it was Prince Alfred Hospital. I decided it was time we had some women patients represented, and I put this lady here in the bed, in the middle of her birthing process. We have the Nurse here (on the right) represented by the green uniform/clothing, the hand of the accoucheur helping to deliver the baby, and the woman herself is shown fractured (through the face). (See Figure 13.9.)

Being impregnated, having a baby, it divides a woman from herself. She's no longer who she was before, and she's not sure quite who she is yet. And so that fracturing that happens through her face – in some of the other works the fracturing happens through the imagery, for me that's a metaphor for that undoingness, and that separation from herself. She has work to do then, to discover who she is in relation to this baby being delivered. She is also shown to be provisioning, she provides succour for the baby, that's represented visually by this little still life on her abdomen.

PERFORMING MATERNITIES

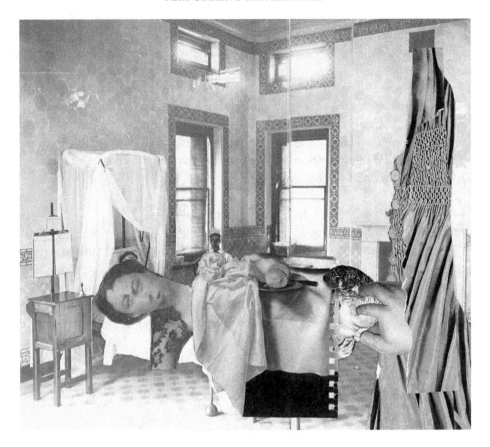

FIGURE 13.9: *Succour* (2015), collage on printed paper by the artist.

Early influences on the work

In making this body of work, which has taken ten years, I came to understand increasingly with writing up the thesis that actually, at the heart of my production, at the heart of my artmaking about mothers and babies there's an experience when I was five or six related to my maternal grandmother. I've come to understand that in a way I've been making art about her trauma and her loss as a refugee migrant.

When I was five or six my grandmother *Yiayia Evdokia* drew me aside at the bottom of the stairs where she had a 'baoolo' chest, and she opened the chest and unfolded this print and showed it to me (I could see fire, fighting, blood, and bodies). They had lived for generations in Smyrna, Asia Minor (as part of the Greek diaspora), and in September 1922 the Nationalist Turkish movement turned

BITTER-SWEET EMBRACE

against the Armenians and the Greeks, and there was a slaughter and there was a burning (Horton 1985: 96–99). At that time, my *Yiayia* had her first-born babe-in-arms and she had to flee. She actually lost her first-born baby in Athens – the baby subsequently died in a cellar from pneumonia.

That began my *Yiayia*'s story, her history, of trauma and loss. She had fourteen pregnancies and five babies survived infancy to become children and adults. And she showed me here this Turkish soldier who is holding a baby up by one leg, and his cutlass is about to slice through (the baby). And I remember that from when I was little, and I realized towards the end of the Ph.D. writing – *this* is what I'm responding to. For me, it's quite heartfelt, obviously, and it's been an amazing experience to realize that my early experience with my grandmother (when I was 5 or 6 years old) can have affected me as an adult, from so many years ago.

After losing her first baby, my grandmother again became pregnant, and she was pregnant on the ship *Carignano* when they migrated from Piraeus to Melbourne as refugees (Xeros-Constantinides and Cambel 2018: 42–47). The baby she gave birth to two weeks after their arrival (in Melbourne after months at sea) was my Uncle Nick.

Intergenerationally, the trauma and the loss, it is communicated. It's communicated subconsciously, It's communicated consciously. That's why, too, this exhibition is dedicated to my grandmother and her babies, it's dedicated to my Uncle Nick, to my mother Maria and to all those women who find themselves in the world in situations where they are suffering war and persecution.

As I continued to make the work, I realized that underpinning it all obviously is my own experience of maternity – giving birth to a premature baby boy who nearly died twice. So that comes into it, but also I uncovered, through the making of the work, a reconnection with my maternal grandmother and her chequered obstetric history.

[Transcript ends here.]

Film Dedication:

This visual research honours the memory of my maternal grandmother,
Yiayia Evdokia
(1901–1972)
who exhibited such fortitude and endurance in the face of
forced dislocation and repeated peri-natal losses.

I dedicate the work to Yiayia's children, living and lost,
especially to my mother Maria and my Uncle Nick.
They were touched by their parents' lament for the homeland they were forced to flee,
Smyrna in Asia Minor.

PERFORMING MATERNITIES

May safe haven be provided to all those babies and their mothers world-wide
who, like my Yiayia, find themselves in fear and dispossessed,
through no fault of their own.
To my husband Dick and our two children Sebastian Philip and Bianca Shelley,
in the hope that one day
they too may know the eternal wonder and bitter-sweetness
associated with creating new life.

Sophia's poem

THE INTERGENERATIONAL LEGACY:
MY GRANDMOTHER *YIAYIA*'S ASYLUM-SEEKER BABY[5]

DEAR little Nicholas …
Would that I'd been able to touch him then
It didn't manifest 'til later in life
I came to glimpse it after my visit to Birmingham when I took him a plant in a pot
as a present
and he told me to take it away
He wasn't resourced to look after another living thing
Allergic to the responsibility of it
And he'd recoiled
He had his reasons
beyond his control.

WISE Marx his hero knew:
People make their own history
but they do not make it just as they please
They do not make it under circumstances chosen by themselves
but under circumstances directly encountered
given and transmitted from the past
The tradition of all the dead generations
weighs like a nightmare
on the brains of the living.[6]
A *Ghosts in the Nursery*[7] thing
You see she was replete with grief herself,
his mother

MY maternal grandmother
managing her own nightmare losses

after first-born *Elephtheria*
Liberty
died of pneumonia as a baby when they fled
the sacking of the Greeks in Smyrna
1922
She showed me the print of the slaughter when I was four or five
Used to take it out of the old *baoolo* chest at the bottom of the stairs
where she secreted it away from sight
but not from mind
I saw the red blotches of blood spurts and the way the Turkish soldiers were hold-
ing the
babies up-side down by one leg as they sliced through their tender bodies with
cutlasses
It looked bad to my little eyes.

I realised
he was imprinted from way-back when an infant himself in the arms of my *Yiayia*
ever vigilant
he couldn't help it and I forgive him, my surrogate father,
a baby
in emotional terms himself

FOR hurting me so.

In memoriam Uncle Nick from his loving niece Sophia Xeros-Constantinides,
Melbourne, July 2010

In Conclusion

In this chapter, I have contributed to the envisioning of maternity in contemporary
art, with a focus on the impost and cost to women-mothers of their procreative
endeavours. Many refashionings of the maternal body are presented, through
collage and drawing, using collage as metaphor for the 'undoingness' of maternity.
Informed by clinical work with distressed mothers, and by a traumatic family
refugee history with postnatal loss, the art production focusses on the darker
side of motherhood, including destabilization of the self, perinatal trauma, and
loss. The film captures the artist performing maternity through the visual output
she has created and displayed, and in her conversation with the viewer, where she
communicates her influences, passion, and visual intent.

NOTES

1. Here is a link to sixteen-minute documentary film: https://vimeo.com/195909868. Accessed on 17 December 2016. Note that password required to access this private video film on Vimeo is 'BSE' (stands for Bitter-Sweet-Embrace).
2. Camera work by Claire Gorman.
3. MADA Gallery is the Monash University Art, Design & Architecture Gallery at the Monash University Caulfield Campus, Melbourne, Australia.
4. The Ph.D. degree in fine art (studio research) was subsequently awarded in February 2017 by Monash University.
5. Displayed in 'Bitter-Sweet Embrace' exhibition next to *Yiayia*'s Smyrna Print shown in Figure 13.2. This poem was recognized in August 2010 by the Australian Association for Infant Mental Health (Victorian Branch) with the award of equal first place in the inaugural Ann Morgan Prize for a piece of writing 'contributing to our understanding of the inner world, and the relational world, of the infant'. The poem appears in Sophia's Ph.D. (Xeros-Constantinides 2017) in the introduction (35).
6. Karl Marx (1852).
7. Fraiberg, Selma, Adelson, Edna and Shapiro, Vivian (1975), 'Ghosts in the nursery: A psychoanalytic approach to the problems of impaired infant-mother relationships', *Journal of the American Academy of Child Psychiatry*, 14, pp. 387–421.

REFERENCES

Horton, G. (1985), *Report on Turkey: USA Consular Documents*, Athens: The Journalists' Union of the Athens Daily Newspapers.

Grieve, A. and Xeros-Constantinides, S. (2016), '"Bitter-Sweet Embrace" fine art PhD exhibition of artist-clinician Sophia Xeros-Constantinides', documentary film co-directed by Anna Grieve & Sophia Xeros-Constantinides with camera work by Claire Gorman, produced in Melbourne, Australia. Private video film on Vimeo at https://vimeo.com/195909868. Note that password required is 'BSE' (stands for Bitter-Sweet Embrace).

Xeros-Constantinides, S. (2017), 'Strangers in a strange land: Envisioning the darker side of motherhood', Ph.D. thesis, Melbourne: Monash University, https://doi.org/10.4225/03/58abd47f4e537.

Xeros-Constantinides, S. and Cambel, M. (2018), 'A unique migration story: Bayliss & Evdokia Xeros and Aristides & Anastasia Kampaklis', in L. Cariddi (ed.), *What Happened at the Pier: Recalling the Journey II*, Melbourne: Multicultural Arts Victoria, pp. 42–47.

Zeanah, C. (ed.) (2009), *Handbook of Infant Mental Health*, New York: Guilford Press.

14

Comadreando:
Entangling the Web of Our Lives

Freyca Calderon-Berumen and Karla O'Donald

F: Text: Can you talk?

K: Text: Yep.

F: Phone call: *¿Qué pasó? ¿Cómo te fue en la conferencia?* (What's up? How was the conference?)

K: It was fine. We presented in a round table and we had about ten people. The papers were interesting, but I need to read more on whiteness studies. I just don't know enough, and I am not sure I agree. *¿Qué onda con las niñas? ¿Qué dijo J?* (How are the girls? What did J decide?)

F: We are still waiting on her decision. We are not sure, *tú sabes* (you know), *esa es ingobernable* (she is unruly).

K: I love that show. Have you finished watching it?

F: Not yet. I don't have time now.

K: She (the actress) is coming out with the second season of *La reina del sur* (queen of the south). Just what we need, another narco-telenovela. She was on with Jimmy Fallon and he asked her about el Chapo. She gave him a polite answer and moved on. When Latino reporters ask her about el Chapo, she gets defensive and rude. *Pero no con Jimmy* (But not with Jimmy). She was all laughs and smiles and gave a polite answer to the

questions. I guess we (Latinos) do that in some ways. We utilize polite *máscaras* (masks) to talk with those we hold outside our 'safe' circles. On the contrary, we do not refrain to answer to anyone in Spanish. We know we have the language to confront and respond to anyone in any way we want.

F: I need to watch it.

We are two *amigas, comadres,* who, at times, can communicate with glances and grunts at each other and don't need to utter words to understand. We have become the family that provides support and understanding in this foreign land in which we live. Still, our relationship goes beyond our friendship. Our *hermandad* (sisterhood) developed, grew, and continues to bloom because we share our personal and academic lives at multiple levels. So, once again, we are embarking on a new project aiming at exploring the different levels of connection that we maintain to nurture, sustain, endure, and strengthen our individual and communal *hermandad* within the diverse contexts of which we belong, through the lens of Chicana feminist epistemology (Anzaldúa 2009; Delgado Bernal 1998; Villenas et al. 2006) and Critical Race Theory (Solorzano 1997; Perez Huber and Solorzano 2015; Delgado and Stefancic 2017).

We are writing this critical reflection through duoethnography (Norris and Sawyer 2016), an approach that allows us to create meaning and uncover understandings of our lives as Latinas, mothers, academics, and feminists immersed in dominant societies. We seek to theorize our gatherings, both face to face and virtual, as moments in which we go to *Nepantla* (Anzaldúa 1987) looking for that third space that nurtures and invigorates us. Studying this process can allow us, and others, to ponder on the development of our *Nepantlismo* as our motivating agency and praxis. Becoming a *Nepantlera* is a complex transformation that we could not have accomplished without the companion and *confianza* we share. The conversations that we include in this writing effort will allow us, and others, to investigate, question, and value the necessity of friendship while becoming and developing as *Nepantlera*. Throughout our reflection, we juxtapose the tenets of duoethnography (Norris and Sawyer 2016), with the path of conocimiento (Anzaldua 2013), to explore and expose the similarities, contradictions, hurdles, and gifts that our partnership has brought us. Before immersing in our dialogical exchanges, we introduce important conceptualizations that frame our understandings and making-sense processes.

Comadreando

Kingsley Scott conducted a research project on the relationship of women's communicative tactics within issues of health in remote communities of Bolivia

and noticed that 'neighborhood women routinely engaged in a form of intimate talk they call *comadreando* or "co-mothering" speech' (2017: 172). Scott explains that this form of speech is performed by women that have deep friendly relationships founded in *confianza* (trustworthiness). He defines *comadreando* as

> a kind of everyday interactional ritual that activates the sympathetic forms of mutual trust and recognition called *confianza*. When neighborhood women 'co-mother', they commiserate, and in this way affirm bonds of *confianza* that go beyond the immediate situation to encompass a broader set of social relations, not only between women but between the households they head.
>
> (2017: 172)

Traditionally, a common understanding of the word *comadreando* entails an exchange of personal opinions and judgements without basis. Scott highlighted that *chisme* (gossip) and *comadreando* share some communalities, but the participants of the study were emphatic that these two modalities of speech did not serve the same communicative tactics or objectives. *Chisme*, accordingly to Scott, is the communicative modality based on an evaluative position that creates ideas or comments based on opinion without any concrete information or outcome. *Chisme* is a superficial view of a situation or a person, and this form of speech is not meant to have any direct impact or importance on the person or the situation. However, *comadreando* is much more complicated since it weaves different levels of engagement that flow between the personal and communal positions of participants. Scott highlights his description of *comadreando* and writes that co-mothering is 'sympathetic staging of deep interiority becomes the ground for reworking intersubjective relations between self and others' (2017: 175). In *comadreando*, women morphed and embodied the position of sympathetic listener and become witness, *testigos*, to the emotional and disruptive event that is occurring to the person without requesting or offering any solution or advice to the situation. Scott recorded in his study a description of the etiquette that needs to be followed when women co-mother, as one of the women participants explained to him:

> It would be imprudent, she insisted, to offer a consoling hand or too much council or advice to the distraught speaker. Instead, the appropriate stance was to listen with compassion, articulated in limited gesture and feedback but mostly quiet, attentive listening, a sort of bearing witness to the other's pain.
>
> (2017: 175)

The lack of advice imparted to the distraught party turns *comadreando* into a reflective activity that seeks and demands a contemplative position from all individuals engaged in *comadreando*. Also, all communicated information shared during

the act of *comadreando* remains in *confianza* (trust), which must exist among the participants in such an engagement. Reciprocity to this act can and would be shown when role reversal occurs and the kindness and care of *comadreando* could be engaged and shared again. Scott also emphasizes that comadreando goes beyond the personal encounters among women and that the issues, knowledge, and effects of *comadreando* connect, merge, and strengthen all aspects of women's lives. Scott writes, 'Comadreando, then, is a poetics that enacts politics, with ramification beyond the realm of the domestic [...] it creates in-group solidarities in broader spaces of enmity emanating from those with whom one, nevertheless, shares community' (2017: 178). Compounded on the communal act of *comadreando*, Scott recorded in his investigation that within the practice of 'co-mothering', women use more personal communicative registrars that blend the different languages these women speak. The use of Spanish and original people's languages infused a particular vernacular providing comadreando among the women of Bolivia its own distinct form of expression.

Nepantlismo

Nepantla is a Náhualt word meaning *a place in the middle*. It is one of Anzaldúa's major contributions frequently compared to Bhabhas's (2012) notion of a liminal third space. *Nepantla* is the place where the person goes to seek refuge, as one meets borders that create confusion and dislocation. Encountering these borders presents multiple realities that crash and collapse one's understanding of the world, creating turmoil. According to Anzaldúa 'to be disoriented in space is to be in *Nepantla*' (Anzaldua 2009: 181). She continues, 'the world as we know it "ends". We experience a radical shift in perception, otra forma de ver' (2015: 16). This clash of ideas is what pushes you to dwell in the third space. Although still full of contradictions, *Nepantla* is not a place of isolation. It is a place from where to (Mignolo 2003) ponder, reflect, assess, and wage what is at stake as the border inevitably crosses the self. *Nepantla*, for us, is a place of recovery, where we find a supportive community that enables us to find the courage and agency to act. It offers the opportunity to cultivate wisdom and spark praxis. In *Nepantla*, one evaluates on the meaning of the realities unveiled at the clashing borders exposing social categories enacted by the dominant culture (Delgado Bernal and Elenes 2011). Román-Odio explains *Nepantlismo*, as the experience of living in *Nepantla*, which entails the process of understanding the pain that comes from clashing borders leading to develop the awakening consciousness, providing thereby a 'thinking space of possibilities' (Odio 2013: 55). In *Nepantla*, one could (re)construct, (re)consider, and (re)create possibilities for personal and social transformation (Buricaga 2007). There, one is 'exposed, open to other perspectives, more readily able to access knowledge derived

from inner feelings, imaginal states, and outer events and to see through them with a mindful holistic awareness' (Anzaldúa 2002: 544). Through this process is how one develops the *mestiza consciousness*, a process of acknowledging the contradictions and developing new ways of thinking and acting. Once one recognizes such personal transformation, one becomes a *Nepantlera*. As a *Nepantlera*, one can question unjust structures and seek social transformation, '*Nepantleras* make possible new forms of community and new types of social action' (Keating 2005: 6). Realizing we are in the throes of *Nepantla*, we are compelled to enter into profound inner and communal dialogues. This is the process reflected in our conversation below. Such a process enables us to confront the dominant narratives and engage in complicated conversations that challenge dehumanizing views of minoritized beings and legitimize other ways of existing in the world.

Our herstories

As *Nepantleras*, we have overcome the singularity of self-identity and learned how to be present in all our forms with and among others (Calderon-Berumen and O'Donald 2018). Our performance of *comadreando* contains many of Kingsley Scott's recorded characteristics such as the mixing of languages, the weaving of all aspects of our lives, and the reflective space we call *Nepantla* (Anzaldua 1987). Further, our *comadreo* even goes into the morphology of the word. The communal connection of our friendship gets represented by the 'co' in *comadreando* since we, together, raise our children, support our partners and household, and comfort each other in our professional endeavours. The part of the word 'madre' obviously represents our knowledge, understanding, and performance as mothers, particularly to our children, but it also entails parts of our upbringing that are connected to our first language and culture. In addition, it provides us with the performance and application of our femininity and feminist views as educators that embrace a *mestiza* consciousness (Anzaldúa 1987), which not only benefits us but allows us to advocate for a democratic liberatory experience for our children as well as our students. The suffix 'ando' which is the gerund of the word, expresses the ongoing, never-ending, dynamic pace of life and our efforts to *comadrear* together in order to sustain our identities and cultures. We both work at embracing our (mis)understandings and embodying Anzaldúa's *Coyolxauhqui* state that

> let's us put our dismembered psyches and *patrias* (homelands) together in new constructions. It is precisely during these in-between times that […] the interweaving of all minds and hearts and life forces create the collective dream of the world and teach us how live to out *ese sueño*.
>
> (2015: 22)

Within the hope and fearless dream of creating alternative avenues for our children, our students, and our work, we mother, work, question, create, deliver, resist, and fight for new perspectives and multiple options to define our private and public positionalities. In the next section, we embody our methodology and wish to share it with others in complete vulnerability to once again be catapulted into the arms of *Nepantla* and present our (im)perfect lives.

Crossings/Travesías

> For silence to transform into speech, sounds and words, it must first traverse through our female bodies [...] When she transforms silence into language, a woman transgresses. Women of color in the U.S. must not only transform silence into our native speech, but as immigrants [...] we must learn a foreign tongue, a language laden with alien ideologies which are often in direct opposition to those in our own cultures [...] Mujeres-de-color speak and write not just against traditional white ways and texts but against a prevailing mode of being, against a white frame of reference.
>
> (Anzaldúa 1990: xxii)

As we present our duoethnography (Norris and Sawyer 2012) through dialogical exchanges reflecting on our friendship and ways of mothering, we highlight its tenets and follow the path of conocimiento, which 'allows individuals to venture into a journey of coming to new ways of thinking that requires self-reflection and attention to sociohistorical and political realities' (Gaxiola Serrano et al. 2019: 344).

Path of Conocimiento

1. Arrebato ... rupture, fragmentation ... an ending, a beginning

A step that usually involves 'a shock that knocks one of your souls out of your body, causing estrangement. With the loss of the familiar and the unknown ahead, you struggle to regain your balance, reintegrate yourself, and repair the damage' (547).

F: Remember the first time I asked you about how long it took you to feel a little bit at home again, that day when we were walking towards the parking lot after class? You laughed at me.

K: Yes, I remember. I wasn't laughing at you, I was just recalling my own experience. I hadn't shared with you the trauma of my arrival at the time because I did not know it was trauma. Now I know that my parents provoked this trauma on my siblings and me. This was our *arrebato* that I have been able to theorize. My parents still can't understand it.

F: Y vaya arrebato! Not one that you could ignore or avoid.

K: Ha, ya think!

F: I can't imagine. You were too young, but at the same time, not so young that you could not understand your parents' decisions. Do you think it would've been easier had they told you about it?

K: There is no easy or hard, nor good or bad. It is a fact of life. *La vidad del peregrino inmigrante. Siempre como la tortuga, con la casa en la espalda.* (The wandering immigrant's life. As the turtle, always carrying home on her back).

F: That's when you go to *Nepantla*. You need to be in this space to make sense of what is going on, *para entender* (to understand) *las* borderlands. But you cannot theorize about it, about the life experiences, until you go through the whole process.

K: *Claro, pero yo tengo ese privilegio de poder tener el conocimiento* (Anzaldua, 1987) *y la oportunidad de reflexión y escribir acerca del proceso que empieza con el arrebato* (Of course, I have the privilege of being able to have el conocimiento and the opportunity to reflect and write about the process that starts with *el arrebato*). I spoke in Spanish and now we are going to have to translate this in the paper. I hate doing that because meaning will be lost.

F: Now we have the fancy 'academic' words to intellectualize the trauma, so you can call it an ontoepistemological process, when in more practical terms is self-reflection.

Ya sabes, esa que haces mientras andas the chofer con los niños, vas al súper, y estas pensando en lo que tienes que escribir (You know what I mean, those moments when you are driving the kids around, buying groceries, and really you are just thinking about what you are supposed to write next).

Tenet Currere:
'Duoethnography views a person's life as a curriculum. One's present abilities, skills, knowledge, and beliefs were acquired/learned, and duoethnographers recall and reexamine that emergent, organic, and predominantly unplanned curriculum in conversation with one another' (12).

Path of Conocimiento
2. Nepantla
'In the transition space of nepantla you reflect critically, and as you move from one symbol to another, self-identity becomes your central concern. Nepantla is the site of transformation, the place where different perspectives come into conflict and where you question the basic ideas, tenets, and identities inherited from your family, your education, and your different cultures' (548).

Tenet trustworthiness found in self-reflexivity:
'Duoethnographies portray knowledge in transition, and as such, knowing is not fixed but fluid. Truth and validity are irrelevant. What exists is the rigor of the collaborative inquiry that is made explicit in the duoethnography itself' (20).

> **Path of Conocimiento**
>
> 3. The Coatlicue State ... desconocimiento and the cost of knowing
>
> 'As your perception shifts, your emotions shift – you gain a new understanding of your negative feelings [...] As you begin to know and accept the self uncovered by the trauma, you pull the blinders off, take in the new landscape in brief glances [...] begin to act, to dis-identify with the fear and the isolation' (552).

K: ¡Ándale! Just like that.

F: So, that time when I was asking you about feeling at home was when you did that presentation talking about that trip you made to Mexico driving with your family, and you were coming back, and as soon you crossed the border, you thought you were home, but it was confusing because you were coming *from* home. So, I just wanted to know when this foreign land was going to start to feel like home for me. I was completely lost. I didn't know who I was anymore.

K: That moment was so painful. Where is home? Why is this place that I love and hate home now? What makes it feel like home? Is it because of the people that are in it? Is it because I was coming from a place where now I had become *other*? *Ni de aquí ni de alla, como la tortuga* (Neither from here nor there, again like the turtle). Always on the move, carrying the load of past, present, and potential future lives. The work is surviving the crossing and enduring the violence and damages to the body and the mind. This is part of la vida del immigrante. *¿Cuánta gente no muere cruzando?* How many people have died during the crossing, both physical and symbolic, *Caminando en el desierto físico*, walking in the desert.

When I arrived here to this city, I was really in the middle of a desert; an arid dry place that presented unknown dangers, but a place I had to cross in order to survive.

> **Tenet difference:**
>
> 'The difference between duoethnographers is not only encourage but also expected [...] Through the articulation of such differences, duoethnographers make explicit how different people can experience the same phenomenon differently. In addition, such a juxtaposition of difference aids in keeping the text open. Readers are provided with these and antitheses and the reader can form their own syntheses' (17–18).

F: Right. My experience was slightly different. I also came here in order to keep the family together, but it was my own decision, my kids were little, and they knew we were coming to stay. However, I also felt the desert. There was a void in my life, in my self, that I had no idea how, or even if, I was ever going to be able to fill it. I was isolated.

K: Yes! That solitude, as described by Octavio Paz (1998) that Mexicans have endured and experienced by being colonized and turned into

foreigners in their own land, doubles and is tougher when the Mexican, one more time, crosses to be colonized again. Her/his existence gets diluted again and again, making her/him ghost-like, *La Llorona* incarnate. You feel utterly helpless and hopeless, and it drives you to think that nobody understands you or has gone through the same pain.

F: ¡Exacto! I was losing it because I didn't have anybody to talk about *esta mierda, necesitaba la mano amiga, el hombro donde llorar.* This shit needed a friendly hand, a shoulder to cry on. You know somebody who can sympathize with you, who really listens, and offers support. *Una comadre en quien poder confiar! Cuando la encuentras ya estas del otro lado* (A comadre to confide on! Once you find her, you've made it).

K: *Entiendo de encontrarte* (I understand the act of finding each other). This is the interesting part. By finding you, what I was really doing was recovering myself.

F: Beyond our friendship, I think the best thing that could happen to us was that our children, independently from us, developed their own relationships. Your kids became the extended family that mine didn't have in this country, and I'll be forever grateful for that.

> **Path of Conocimiento**
> 4. The call ... el compromise ... the crossing and conversation
>
> '[Y]ou begin to define yourself in terms of who you are becoming, not who you have been [...] As you learn from the different stages you pass through, your reactions to past events change. You remember your experiences in a new arrangement. Your responses to the challenges of daily life also adjust. As you continually reinterpret your past, you reshape your present' (556).

> **Tenet trust:**
> 'Trust is a vital element in duoethnography. One does not want to reveal "warts and all" to an unreceptive and uncaring person [...] Without trust, disclosure is withheld, preventing a rich discussion of the phenomenon under investigation' (23).

Moreover, our husbands found in each other a cool friendship, which was like the cherry on top for us. This opened a different door for us that enhanced our intellectual, professional, emotional, and personal connection and strengthened our *confianza.*

K: That is a major gift. Perhaps our families, partners, and children do not fully understand our scholarship and praxis, but they

> **Tenet polyvocal and dialogic:**
> 'Promoting heteroglossia – a multivoiced and critical tension – dialogues are not only between the researchers but also between researcher(s) and artifacts of cultural media' (14).

are part of our agency. As we co-mother our households, our families become learning sites where we apply, implement, and assess our theories because we know they are safe spaces that will provide us with sincere feedback.

F: Or absolute rejection sometimes.

K: Right! Remember watching that show about Alicia? I can't remember the stupid show's name after football on Sundays. Nobody would sit down to watch the show with us but everyone had a visceral response to the issues that revolved around women's rights and feminism. Contentious but loving arguments would exude, and together, we *comadreamos para poder enseñar a nuestros hijos la importancia de la igualdad de géneros* (to teach our children about the importance of gender equality).

F: Of course I remember how they were so judgmental, almost irrational, refusing to see her reasons despite his betrayal!

Tenet dialogic change and regenerative transformation:

'Duoethnography recognizes the tyranny of reductionism ... Duoethnography, therefore, makes one's current position problematic. One's beliefs can be enslaving, negating the self, but the act of reconceptualization can be regenerative and liberating. Duoethnography recognizes the need of the Other to liberate the self from the self' (18).

And maybe it is a generational thing, but the kids get it way better and faster than the adults, meaning our husbands. It is also a cultural thing. The macho mentality *no los puede dejar ser* (does not allow them to see otherwise). Our children have been exposed to more diverse perspectives than we did. They have encountered multiple 'others' that their understanding of otherness is different than ours. Now that they are entering a new stage in their lives, sometimes they are teaching us more than we are teaching them. They have entered in the co-mothering game.

I am amazed by the way that J recognizes the microaggressions she faces now as a young adult. The last time she was home, she talked about the ways she was brainwashed by the Whiteness mentality in her early schooling years, and how she is shaking it off now, reconstructing herself and redefining her identity.

K: I bet. Every time someone says something racist, antifeminist, just anything prejudice, one of us utters, 'I am glad J is not here' because we would all be talking her down from a major argument with some inopportune stranger. I believe that all of our children have the same feelings and reaction as J, but J takes it to the next level, which is something to be proud of but concerning for her mental and physical safety.

F: Oh, I know that. Yet, I love that we can have this type of conversations and re-construct our stories together as we realize the assaults endured and the resilience we didn't know we had and developed almost unconsciously because we just had to survive.

K: *Es que encontrar a alguien con quien puedes confiar y saber que no te va a juzgar sino que verdaderamente te entiende y que comprende cómo y de qué se sufre y lo que te causa ese sufrimiento que no desaparece jamás y que cada vez que lo piensas la herida* (Anzaldua 1987) *te duele otra vez. Las cicatrices de tantas agresiones te avivan el dolor en el alma y el corazón lo recuerda entre remolinos* (Anzaldua, 2004) *emocionales que ofuscan el jucio y que te transportan a estar enfrente del cuchillo de obsidiana de la Coyolxauhqui para una vez más cuestionar y evaluar tu posición. Mierda!* (Finding someone you can count on and that is not going to judge you, but instead, understands the 'how and why' the pain is present, grasp the source of your suffering and comprehend that it does not simply go away, that each time you think about it, the pain just grows. The scars acquired from the multitude of aggressions intensify the pain that targets your soul and heart and recalls emotional swirls (Anzaldúa, 2004) that cloud your judgment and position you in front of Coyholxauqui's obsidian dagger to question and evaluate, one more time, your position in the world. Shit!) The translation does not do justice to my words in Spanish. I can tell there is emotion missing that cannot be explained and therefore not truly represented. How can I explain all the hurt in a language in which I cannot express my feeling fully?

F: *Claro*, (of course) we don't want to translate every single word because it loses its meaning to us, its intensity and emotions embedded in them.

Path of Conocimiento

5. Putting Coyolxauhqui together ... new personal and collective 'stories'

'[O]ngoing reconstruction of the way you view your world […] challenging the old self's orthodoxy is never enough, you must submit a sketch of an alternative self […] your resistance to identity boxes, leads you to a different tribe, a different story (of mestizaje) enabling you to rethink yourself in more global-spiritual terms instead of conventional categories […] your story's one of la busqueda de conocimiento' (560–62).

Path of Conocimiento

6. The blow-up ... a clash of realities

'[L]as nepantleras know their work lies in positioning themselves – exposed and raw– in the crack between these [opposite] worlds, and in revealing current categories as unworkable. Saben que las heridas que separate and those that bond arise from the same source' (567).

> **Tenet audience accessibility:**
> 'Duoethnographies then, are a form of praxis writing in which theory and practice converse [...] Duoethnographies do not end with conclusions. Rather, they continue to be written by those who read them' (21).

As usual, we have to look for a place that is open to include other languages in their publications, a place that embraces counter-narratives or validates our stories in our own language, in our own terms. I know we are contending an academic tradition that tends to validate only the *lengua franca*. Nonetheless, the cacophony of stories engulfing and flowing around us are multilingual. As *Nepantleras*, we must keep our efforts toward legitimizing counternarratives and breaking down dominant social categories while we continue searching for more options to disseminate and expand our work and that of others in similar situations.

> **Path of Conocimiento**
> 7. Shifting realities ... acting out the vision or spiritual activism
> 'When a change occurs your consciousness (awareness of your sense of self and your response to self, others, and surroundings) becomes cognizant that it has a point of view and the ability to act from choice... This conocimiento gives you the flexibility to swing from your intense feelings to those of the other without being hijacked by either' (568–69).

We are academics, and a part of us, the scholar identity, subsists in the ivory tower of this elitist realm while the rest of our identities demand to stay true to our language and culture that informs our every decision. Straddling the borderlands of diversity and inclusivity that we cherish, our ways of being and living in the world are juxtaposed to the ways of being of the dominant culture which aims to strip us from ourselves pushing us to assimilate to the rigours and confines of the cannon.

As Freire (1996) said, we learned to read the world and the word. Within this framework, Berry (2019) tells us, 'we are fixed'. We learned the language of the master, legitimized by a few letters after our names while they still struggle to pronounce our *Spanish* names. With that knowledge, we can now walk the path of *conocimiento*.

> **Tenet disrupt metanarratives:**
> 'Duoethnography, by being polyvocal, challenges and potentially disrupts the metanarrative of self at the personal level by questioning held beliefs. By juxtaposing the solitary voice of an autoethnographer with the voice of an Other, neither person can claim dominance or universal truth' (15).

K: We are fixed indeed. Fixed from our alignment of divergence, our queerness, away from our *mestiza conciouness* and the *facultades* (Anzaldua 1987) that we have

acquired traveling the borderlands. Fixed! ¡Qué tontería! Silly! Remember that we were at a conference and I lean towards you in a presentation and I told you, no, we are *Nepantleras*!

F: Yes.

K: Remember that we both were perturbed by that realization because we knew the heavy *compromiso* (commitment) we had to carry; como *la tortuga*. This responsibility still keeps me up at night because I still fight and struggle with accepting the pain that this commitment requires.

F: Yes, but there is always the option to go to *Nepantla* to heal, recharge, to understand and renew ese compromiso as we continue *comadreando*.

K: I know that I am not alone in the fight because I know we are together. There is no fixing us. We are complete. We are certainly not complete according to their hegemonic standards but that is where our counternarrative starts again.

Time has passed and our children, and us, have grown up. They don't need us the same way as they did when they were six or ten. They come to us with grown-up questions and issues that are, at least for me, difficult. A mixture of love and distress inundates my senses which is not a surprise, but for some reason is always unnerving. I have to think, breath, and pay attention to the voices. These voices that give me the wisdom and strength to face the issue at hand. One of those voices is yours, and I appreciate that immensely. I know that I can call and you will hear, and you will stay steady, not silent, but still, and just somehow, walk me out of the fog that my emotions have cause and help me to remember all that I know and hold me up through this new mothering moment.

F: The sentiments are reciprocal. You do the same for me. We dwell together in *Nepantla*, and nurture our ways of co-mothering for our young adult children, and students. It is our place to create and find meaning for our decisions, to find courage and resilience, to empower ourselves.

Beginnings

This conversation will not end anytime soon; that is our hope. It will continue as long as we keep co-mothering and sustaining each other. We have presented here a sliver of our continuous effort to tell and display alternative ways of expression from our own ways of mothering. Our complex world compels us to complicate the conversation and contend traditional ways of being as well as stereotypes. The Latina Feminist Group (2001) showed us the powerful

potential of taking out our *papelitos guardados* – old secrets, thoughts, memories – and bringing them to the table to not only enhance them but also (dis)entangle the conversations and create re/new(ed) narratives of our lived experiences. We summon other *amigas, comadres,* comrades, colleagues, and all those *hermanas* who haven't found home yet, to join us in our efforts to keep these conversations alive and ongoing, and to continue building solidarity and sorority. We need to keep complicating the conversation through revolutionary *comadreando* by building alternate outlets that support our *tortuga* ways of inhabiting the world.

REFERENCES

Anzaldúa, Gloria (1987), *Borderlands: The New Mestiza. La Frontera*, San Francisco, CA: Aunt Lute Books.

Anzaldúa, Gloria (1990), *Making Face, Making Soul/haciendo caras: Creative and Critical Perspectives by Women of Color*, San Francisco, CA: Aunt Lute Books.

Anzaldúa, Gloria (2009), *The Gloria Anzaldúa Reader*, Durham, NC: Duke University Press.

Anzaldúa, Gloria (2013), 'Now let us shift … the path of conocimiento … inner work, public acts', in *This Bridge We Call Home*, London and New York: Routledge, pp. 554–92.

Anzaldúa, Gloria (2015), *Light in the Dark/Luz en lo oscuro: Rewriting Identity, Spirituality, Reality*, Durham, NC: Duke University Press.

Berry, T. (2019), 'Joy, pain, and hope in curriculum theory: A critical race feminist lyrical message', *Keynote Presentation, Bergamo Conference*, 10–12 October, Dayton, OH.

Bhabha, Hhomi (2012), *The Location of Culture*, New York: Routledge.

Calderon-Berumen, F. and O'Donald, K. (2018), 'Criando y Creando', in F. Calderon-Berumen, L. Jewett and M. Espinosa-Dulanto (eds), *Critical Intersections in Contemporary Curriculum & Pedagogy*, Charlotte, NC: Information Age, pp. 225–38.

Delgado Bernal, D. (1998), 'Using a Chicana feminist epistemology in educational research', *Harvard Educational Review*, 68:4, pp. 555–83.

Delgado, R. and Stefancic, J. (2017), *Critical Race Theory: An Introduction*, New York: New York University Press.

Freire, P. (1996), *Pedagogy of the Oppressed*, New York: Continuum.

Gaxiola Serrano, T. J., González Ybarra, M. and Delgado Bernal, D. (2019), '"Defend yourself with words, with the knowledge that you've gained": An exploration of conocimiento among Latina undergraduates in ethnic studies', *Journal of Latinos and Education*, 18:3, pp. 243–57.

Keating, A. (2005), 'New Mestiza, Nepantlera, beloved Comadre: Remembering Gloria E. Anzaldúa', *Letras Femeninas*, 31:1, pp. 13–20.

Mignolo, W. (2003), *The Darker Side of the Renaissance: Literacy, Territoriality, and Colonization*, Ann Arbor, MI: University of Michigan Press.

Norris, J. and Sawyer, R. D. (2012), 'Toward a dialogic methodology', in J. Norris, R. D. Sawyer and D. Lund (eds), *Duoethnography: Dialogic Methods for Social, Health, and Educational Research*, Oakland, CA: Left Coast Press, pp. 9–39.

Paz, O. (1998), *El laberinto de la soledad*, México, DF: Fondo de Cultura Económica.

Pérez Huber, L. and Solorzano, D. G. (2015), 'Racial microaggressions as a tool for critical race research', *Race Ethnicity and Education*, 18:3, pp. 297–320.

Román-Odio, C. (2013), *Sacred Iconographies in Chicana Cultural Productions*, Berlin and New York: Springer.

Scott, S. K. (2017), 'The politics of commiseration: On the communicative labors of "co-mothering" in El Alto', *Journal of Linguistic Anthropology*, 27:2, pp. 171–89.

Solorzano, D. G. (1997), 'Images and words that wound: Critical race theory, racial stereotyping, and teacher education', *Teacher Education Quarterly*, 24:3, pp. 5–19.

Villenas, S., Bernal, D. D., Godinez, F. E. and Elenes, C. A. (2006), *Chicana/Latina Education in Everyday Life: Feminista Perspectives on Pedagogy and Epistemology*, Albany, NY: SUNY Press.

15

Interrogating Constructions of Good/Bad Mothers through Popular Spanish Culture: The Case of Concha Piquer (1908–90)

Mercedes Carbayo-Abengózar

Introduction

The relationship between women and music is imbued with long-standing cultural significance. According to Drinker, 'the art of music may have begun in the singing of magic by women […] women were the first musicians and perhaps for some time, the only ones' (1995: 63). Lamenting, mourning, and wailing during funerals and other cultural events have always been associated with women: '[T]he tonalities and rhythms of many *gritos* ('shout, cry') incited nineteenth-century listeners to intellectual and emotional cognition around sadness, melancholy and suffering' (Haidt 2019: 219). One image that comes to mind when discussing laments and suffering is that of the young girl in Andersen's fairy tale *The Little Match Girl* (1845), which was later reflected in Concha Piquer's self-portrayal as a poor gypsy street vendor in her biopic *Filigrana* (dir. Luis Marquina 1949). This narrative is far removed from period dramas in which young aristocratic women entertain audiences with their musical talent. This essay centres on the *gritos* and rhythms of the socially disadvantaged women represented by Concha Piquer, their capacity to connect with emotions and to protest women's conditions. The main aim is to demonstrate the significant role that Concha Piquer played in the construction of alternative images of hegemonic womanhood, and in particular, her disruption of normative ideas about (good) motherhood.

Concha Piquer (1908–90) was a Spanish film star, a diva, and a *folklorica* (Woods 2004: 41) who peaked in popularity during the Franco's regime (1939–75). She rose from humble origins to professional success and international recognition.

Born in Valencia, her talent was spotted by a Spanish producer who organized her debut tour of Mexico and New York when she was only 13 years old. When she returned to Spain in 1926 during the dictatorship of Miguel Primo de Rivera (1923–31), she performed American music hall numbers in English, and *cuplés* and *coplas* in Spanish (both English and Spanish were acquired by Piquer in later life, as Valencian was her native language). She continued to perform throughout the Second Republic (1931–36), the civil war (1936–39) and Franco's regime, ultimately becoming the 'queen of *copla*' until her retirement in 1958.

According to the *Dictionary of Current Spanish*, a *copla* is defined as '[a] poetic composition that has a *cuarteta de romance, a seguidilla, a redondilla* or any other short combination of verses and that is commonly used as the lyrics in popular songs' (Manuel Seco et al. 1999, translation added). Originating in the Middle Ages, *coplas* became very popular in the eighteenth century in the form of *tonadillas*; performative pieces sang or recited by women during the intervals of plays. The popularity of these pieces soon transformed them into separate songs that grappled with issues of class and survival and promoted a sense of nationalism. They were popular tools used against the Italian opera; an institution that was supported by the aristocracy and represented by the celebrated Italian castrato Farinelli. As Manuel Román states:

> *tonadillas* appeared spontaneously as a reaction against the musical dictatorship of Farinelli [...] They were born to protest against the abuse of the powerful, to talk about historical moments, to highlight traditions, landscapes or religious motives; but the most common theme was love.
>
> (2000: 16)

It was during the twentieth century when *coplas* developed into their current form as declarative three-minute songs performed mainly by women. They are narratively coherent; traditionally conveying a full story with an introduction, body, and conclusion. *Copla* narratives are varied, but they tend to focus on themes that mass audiences identify with: '[I]t might be an exaggeration, but I dare to say that there is not a personal or social situation that has not been discussed in a *copla* "Copla is wherever I go, the singing voice of the people"' (Peñasco 2000: 31–32, translation added).

If we understand popular music as the product of an ongoing conversation with the past (Lipsitz 1990: 90) we can explore the way in which *coplas* have historically established the terms of that conversation in order to negotiate with the ongoing powers. *Coplas* reached their peak popularity under the Franco regime, hence the focus of this essay. However, they are still an important part of the Spanish popular culture heritage. More importantly, they are a site of women's memory

as shown in the recent volume of Lidia Garcia *İAy campaneras! Canciones para seguir adelante* ('Ay! Bell ringers. Histories to carry on') (2022). Moreover, recent graphic narratives including Ilu Ros's *Cosas nuestras* ('Our things') (2020) and Carla Berrocal's *Doña Concha, la rosa y la espina* ('Concha, the rose and the thorn') (2021), play homage to these songs and their impact on women's everyday lives under Franco: 'Some of today's most riveting feminist cultural production is in the form of accessible yet edgy graphic narratives' (Chute 2010: 2).

This research focuses, therefore, on the performances and public persona of Concha Piquer, who reflected the experiences of, and thereby forged connections with, mass audiences. As Dyer suggested, 'Stars matter because they act out aspects of life that matter to us; and performers get to start when what they act out matter to enough people' (2004: 17). Concha Piquer became a star because she acted out aspects that matter to many women in Spain under Franco through the medium of traditional music, specifically the well-known *coplas*. Historically, the songs of those classified as popular female artists may have enabled listeners to identify with themes of sadness and suffering. Such artists, like Piquer, communicated with women about their shared trauma propagated by a patriarchal society. However, the singers also addressed pleasure, joy, and power in their performances, thereby subverting the hegemonic discourses of self-sacrifice and abnegation that have been historically attached to mothers. My interest lies in exploring how music, specifically *coplas*, envisioned as a traditionally feminine form of entertainment, provided women with relief from daily subjugation and facilitated uncensored resistance to dominant discourses about gender roles. I will discuss the way in which her ambiguous status as diva, folklórica and film star allowed Concha Piquer to subvert the Catholic and fascist definitions of women and in particular that of (good) mothers.

Concha Piquer: Coplas *and Franco's regime*

Francoism was an ultraconservative Catholic dictatorship that emerged in opposition to Spain's Second Republic, which was predicated on supposedly modern values that had positive implications for women. After three years of civil war, the triumphant fascist regime ruthlessly imposed itself onto an exhausted and impoverished population. Its repressive understanding of womanhood was promoted through systematic censorship, conventional gender roles and an obsession with creating a 'new woman' through a process of regeneration:

> The Spanish woman is Catholic because she is Spanish. Today when the world is shaken by a whirl of war diluting morality and prudence, it is such a comfort to see

the 'old and always new' image of Spanish women, always restrained, house-proud and discreet.

(Isero in Martín Gaite 1987: 25, translation added)

This 'new', Catholic woman had to reject the advances of the first feminist wave and agnostic Second Republic through which women had achieved political power and social visibility, to embrace 'old' feminine values such as marriage and motherhood. Motherhood was not only the essential mission of women as explained below:

Woman in the strict sense of the word is maternity. There are two manners in woman: that of bringing a being into the world, and another of taking him and educating him for life. Understand here the double sense of spiritual and corporeal maternity.

(Pérez de Urbel 1952: 110, translation added)

Motherhood was also a social mission and, as such, had to be supported and controlled by the State and the Sciences, as doctor Luque mentioned in the main publication of the Feminine Section, *Y*:

In the State, mothers should be the most important citizens [...] we are aware of the great importance of having great numbers of healthy children from strong mothers. We want to get there not only with words but also with actions [...] It is about having a lot of children but of course, the harvest needs to be healthy so to avoid contaminating the fruit, we have to start by the tree.

(Cited in Basauri 1980: 54, translation added)

The right hand of the regime was the Catholic Church with the aid of the fascist women's organization *La sección femenina de Falange* ('Falange's feminine section') (SF), which sought to educate and control women. Pilar Primo de Rivera (1907–91) was the president of the association until its dissolution in 1977. Shortly after the end of the war in 1939, she gave an inaugural speech in front of Franco in which she set out the core objectives of the movement:

The mission that women have in the Patria is to stay at home [...], to make men's family life so agreeable that they will find at home what they never had before and therefore they will not need to seek it in bars and casinos [...]. The SF will teach women to take care of their children [...] who are God's servants and future Spanish soldiers. The SF will also teach women to look after the house and to love manual chores and music.

(Primo de Rivera 1942: 43, translation added)

It is important to highlight two interesting aspects of this extract. The first aspect is the omission of daughters among the children who need attention (only boys – future Spanish soldiers – are worth mentioning) despite the SF and its associated publications being fundamentally about women's control and education. The second aspect is the recognition of music as a specifically feminine chore. In this way, songs in radio programmes and Spanish films, together with specific women's publications were used to shape gender roles in the new Spain. *Coplas* were appropriated by the regime which highlighted their traditional and nationalistic undertones as representatives of new Spanish popular culture and therefore intrinsically associated with women who carry the 'burden of representation' (Mercer 1990: 45) of the new State. Although *coplas* were heavily scrutinized by censors and consumed through publicly controlled media during the Franco regime, they were not considered dangerous. In this way, while the regime focused on historical epics and military films to shape the emerging cultural identity of new Spain, folkloric singers and musicals were left to their wiles (Woods 2004: 40), facilitating the creation of a *folklorica* stardom that functioned relatively autonomously.

Concha Piquer was a *folklórica* and probably 'the first Spanish artist who lived the American dream without knowing it. She triumphed on Broadway as a teenager and grew up in the demanding world of show business' (Candía 2020). As mentioned above, on returning from America, Piquer performed songs from American music halls as well as the overtly sexual and humorous French *cuplé*. However, with the decline of *cuplé* and American music halls during Franco's regime, the sentimental form of *coplas* regained a high popularity:

> With the death of *cuple* the good sense of humour and gracious women also died, most of them born in misery but with enough self-esteem to avoid prostitution. Instead, the Spanish song arrived in its Andalucian and 'flamencoish' version apt for the censors and protectors of family.
>
> <div align="right">(Alcalde 1996: 129, translation added)</div>

As I have outlined in previous publications (Carbayo-Abengózar 2007, 2013) Alcalde seems to overlook the power that the Andalucian versions acquired in the hands of women who managed to gain some traction in show business. Following Santiago Lomas and Asier Vázquez 'it seems more than likely that the most powerful female stars in Spanish cinema were not merely puppets manipulated by men, and therefore were able to make decisions about their own careers' (2021: 2). This was the case of Piquer, who graciously sung *cuplés* in the 1920s and 1930s and later became the most iconic representative of sentimental *coplas* which enshrined her place in the performative arena of the 1940s and 1950s, guaranteed her economic survival and allowed her to fulfil the role of sole breadwinner of her

family. Besides a *folklórica* and a cinema star who occasionally produced her own films (Lomas and Vázquez 2021: 2), Piquer was a diva, 'a glamorous and skilled female performer who wins resonance in the spectators and thereby gains fame and fortune [...] The diva embodies symbolic values congruous to her time and society and is thus full of contradictions' (Hélène Ohlsson 2020: 39–40). Indeed, she was a difficult woman, complex, disruptive, and at times, unkind as her many biographies suggest.[1] Her life story is full of anecdotes that show her strong character and innate contradictions, but as Helen Lewis states: '[W]e cannot celebrate women by stripping politics – and therefore conflict – from the narrative' (Lewis 2020: 1). Piquer was, overall, a skilful communicator who portrayed everyday issues that concerned women. Berger and del Negro refer to the significance of Rita Felski's work on everydayness: '[T]he main advantage of Felski's work is that emphasizes that everydayness is a concept with a strong ideological significance, one tied specifically to the issue of gender' (1996: 9). The everyday thematic and the gendered nature of these songs, as well as the perception of them as nonthreatening towards Francoism, allowed artists to express their oppositional stances to the hegemonic discourses of the SF.

> Concha Piquer, who sung that she preferred to dream than to know the truth was always on the radio and in her own way she offered recipes to make life more bearable [...] *Coplas* of those radios introduced models and images very precise; under the appearance of happiness and abnegation, they hid a terrible feminine world.
>
> <div align="right">(Rivière 1998: 55–56, translation added)</div>

One of the everyday themes that *coplas* explored was motherhood. In contrast to the male-defined and controlled concept that is deeply oppressive to women, they explored mothering as female-defined concept that could potentially empower women (O'Reilly 2014: 185).

Coplas *and motherhood*

It is often assumed that women have a maternal instinct that distinguishes clearly between good and bad motherhood; a notion that underpins the reductive idea that only deviant women are bad mothers. However, history demonstrates that the transition to motherhood is not necessarily driven by an innate maternal instinct, and the emergence of motherhood studies as a unique and interdisciplinary field of inquiry has highlighted the significance of social and cultural (particularly religious) forces in shaping notions of mothering. Concepts of good and bad motherhood have been understood as patriarchal constructions. According to María

Flórez-Estrada Pimentel (2014: 284), motherhood in ancient times included the right to abandon and kill children for reasons imposed by men such as inheritance. Later, Christianity (Catholicism, in particular) shifted the singular patriarchal discourse into a collective one that used the concept of honour to define motherhood. Equally, Shorter (1976: 168) asserts that mothers often observed the development of their children with indifference in traditional societies, whereas modern societies strongly encourage women to take primary responsibility for successfully prioritizing child welfare. For Francoism, the patriarchal institution of motherhood was defined by the Francoist apparatus through the rigorous control of the SF:

> Motherhood is reached through pain as heaven is reached through renouncing [...] Motherhood is a constant martyrium, but a creative and disturbing one. It starts with the first smile of the *son* and only ends when the immense eyes of the mother close for ever [...] The perfect woman knows how to be a mother. If in the agreeable path of an easy life women only learn how to be in the triumph of salons, her victory would be a poor one.
> (José Juanes in Martín Gaite 1987: 137, translation and emphasis added)[2]

Voluntarily childlessness, abortion, and teenage or unmarried pregnancies signified noncompliance with normative moral codes, in particular for the disadvantaged, as class and gender intersected in situations of abuse and disempowerment of women. This has been highlighted by recent research on 'stolen children' in Spain.[3] The research shows how women labelled as 'bad mothers' had their children adopted at birth so that they may be raised by 'good mothers'. In Spain, such decisions were made by the *Patronato de Protección a la mujer* (Women's Protection Centre), a network of centres established by religious orders in 1941 and headed by Franco's wife as honorary president. Women who were identified as noncompliant with gender norms were usually sent to these centres by their families or authorities, although there were also cases of self-internment as revealed by the writer and activist Consuelo García del Cid Guerra in her book *Las desterradas hijas de Eva* ('The exiled Eva's daughters') (2012). *Folklóricas*, who generally came from disadvantaged backgrounds, developed strategies to reconcile their 'triumph of salons' with their expected role as good mothers. In order to maintain a respectable image, some of them had their own mothers as chaperones and publicly performed the Cinderella myth, like the well-known singer Isabel Pantoja.

Virtuous/good mothers, as defined by the regime via the idea of abnegation and sacrifice, were glorified on the radio. This glorification was often voiced by male performers: '*Como mi mare ninguna*' (Pepe Pinto), '*Madre hermosa*' (Juanito Valderrama), '*Madrecita María del Carmen*' (Manolo Escobar) ('Nobody like my mother', 'My beautiful mother', 'Good mother', 'M. del Carmen', added translation). Alternatives

to this monolithic view, emerged in the performances of popular women singers, particularly the iconic Concha Piquer. The lyrics that she performed for her devoted public were diverse in thematic nature, but the most iconic were those describing her complaint, protest, and non-satisfaction with heterosexual relationships alluding at the same time to more fluid versions of masculinity (Carbayo-Abengózar 2007). As the writer Carmen Martín Gaite explained in her memoirs:

> In the anaesthetised world of Spanish post-war [...] there was at times an unexpectedly bleak wind in the voice of Conchita Piquer in the stories she told. Stories about girls who did not resemble the girls we knew, girls who were never going to enjoy the sweetness of a peaceful home about which we were supposed to dream like middle-class girls [...]. Those women did not have names or surnames [...] They were shielded behind nicknames that they defiantly carried: *La Lirio, La Petenera, La Ruiseñora* [...] They appeared to us to be more of flesh and blood [...] those women made us feel uneasy by always alluding to a world where loyalty and the enduring or continuity was not the norm.
>
> (1988: 151–53, translation added)

As this quotation suggests, *coplas* managed to both open a window to women's imagination and to simultaneously highlight and protest the patriarchal system women were forced to live under. Manuel Vázquez Montalbán compares the transgressive, even the political component of these songs against a prescribed normative, ordered life:

> *Coplas* were songs sung by overworked women. They were non-commercialized protest songs, a protest against the human condition, against their own condition of being *Carmenes de España* waiting for husbands condemned by History, against an ordered life.
>
> (1998: 39–40, translation added)

Concha Piquer was a single mother. Her relationship with a well-known married bullfighter who later became her manager was public knowledge. Her position as *folklórica* and diva, the ambiguity of being on the one hand a mother and on the other professionally ambitious, directing her career towards public success rather than towards marriage and children, provided a space to discuss the role of mothers in society. Unlike other *folklóricas*, she never used a chaperone (apart from at the start of her career as she was underage) nor did she perform the Cinderella myth. Her character and her abilities as a performer and businesswoman empowered her and gave her the authority to question hegemonic models of motherhood and marriage while validating experiences alternative to the Francoist normative ones.

PERFORMING MATERNITIES

As mentioned, her most iconic songs alluded to a world in which women departed from the discreet and homely image to harness agency and expressed desire. True to her notoriously difficult character, Piquer preferred to pay a fine for singing songs such as *Ojos verdes* ('Green eyes') rather than accepting censorship. *Ojos verdes* was written for her by Valverde, León, and Quiroga and performed for the first time in 1940. The song refers to a prostitute choosing a man and thus reversing the roles of power and choice. Its tone fashions her as the maker of her own desire and destiny:

> Leaning on the brothel's doorjamb
> I watched the May night ignite
> Men passed and I smiled
> Till at my door your horse stopped.
> [...]
> I would like to give you something
> To buy yourself a dress
> And I told you, you have already fulfilled me
> You don't need to give me anything else.
> [...]
> You got on your horse, and left
> And I have never lived
> A better May night.

<div align="right">(translation added)</div>

In this song, the narrator explicitly talks about pleasure and self-assurance. She invites the stranger to take fire from her: 'come and take it from my lips and fire I will give you' and refuses to take money for her service. The story subversively departs from glorifying the self-sacrificing, dependant and suffering maternal figure who only finds meaning (and pleasure) in marriage and motherhood to present a sex worker in a positive light and in control of her choices: 'we have the whore,[4] the challenger, the unreachable and ultimately the desirable woman, a woman in control of her life' (Carbayo-Abengózar 2007: 434). In the alternative version preferred by the regime and exempt of fines, the word 'brothel' was substituted by 'door' which in a reversed way was even more subversive as it showed an ordinary woman getting pleasure and joy from a stranger. As Álvaro Ferrari suggests, censorship during Franco was based on portraying 'correct traditional thinking' (Ferrari 2004: 860–85) overlooking interesting transgressions in its obsessive focus on correction.

This song is also echoed in *Tatuaje* ('Tattoo'), a famous track composed by the aforementioned writers in 1941. In this well-known piece, full of melodramatic tones, a woman decides to spend her life, rather than securing a position as wife and

230

mother, wandering from harbour to harbour looking for a 'blond like beer' sailor whom she has fallen in love with and whose name she has tattooed on her arm:

Perhaps you have forgotten me
But I never will
And until I find you
I will never rest.

(translation added)

These two very popular and iconic songs are an example of vindicating a free, non-normative life. The protagonists are flesh and blood women, in the words of Carmen Martín Gaite, who take ownership of their destiny, and reject the ordered existence that Montalbán and Gaite described as wives and mothers. If there is, however, an iconic song in Piquer's repertoire, it is 'Romance de la otra' ('Ballad of the other'), written for her by Quintero, León, and Quiroga and performed in 1943. The lyrics recount Piquer's story as the 'other' in the triad of her lover and his official wife:

I am the other, the other
I have no rights
Because I do not wear a ring
With a date inside
I have no law to defend me
Nor door to knock on
And I feed myself in hiding
With your kisses and your bread
So long as you live in peace
Who cares if I am dying?
I love you being the other,
As the one who will love you most.

(translation added)

In this song, she appealed to her audience by sharing her personal experience as an unmarried woman without legal status. The already mentioned documentary *Imprescindibles* (2011) describes this performance as unforgettable. She appeared on stage dressed in black, mirroring the first verse of the song: '[W]hy is she wearing black if nobody has died' (min 36). When asked the reason for this, Concha Piquer explained her intention to show that women in her situation had no rights under the law and were driven to loneliness and pain. Her presence on stage, dressed in black, appropriating the – male-authored – lyrics with

her gaze and her 'voice of velvet and bronze [...] beautiful voice, the unconfused voice of Concha Piquer' (Blas Vega 1996: 57) defies societal mores by publicly taking claim of her situation and therefore challenges the patriarchal system that would prefer her to suffer in silence. Equally, the very famous piece 'I Love You despite Everything' composed by Quintero, León, and Quiroga for the famous Juanita Reina, who sang her for the first time in 1948, became an iconic piece in the performances of Concha Piquer. In this song, the protagonist admits that she did not follow anyone's advice: 'I was told thousand times, but I never wanted to listen'. For that reason, 'I never reproached you anything [...] I only asked you if you still loved me'. Once again, the protagonist faces her decision and publicly admits it, in total opposition to the 'always restrained, house-proud and discreet' woman described by Isero above. As the song progresses, we discover a selfish, womanizing and insensitive man: 'you live with other women and do not care about my loneliness'; a man who, unlike her, refuses to face his responsibilities: '[Y]ou know you have a son, but you have not given him a surname'. This song powerfully highlights the plight of single motherhood, whereby women who follow their desires are submitted to the injustice and ostracism of society while men face no social or legal implications. As Margarita Rivière mentioned above, under the guise of the protagonist's abnegation, lies a terrible reality for women. When Concha Piquer appeared on the stage as a rich, successful, and powerful single mother, this song became a vindication of women's desire and choice. In this sense Concha Piquer contributed to the construction of 'a space where women in the 1930s and 1940s could imagine alternative subjectivities and formulations of sex, work, and class, even if they could not live them' (Eva Woods 2004: 42).

Conclusion

Coplas intertwine literature and (women's) history with popular music, and therefore can be productively understood as something like an intoxicating dolly mixture, alluding to both the twee (excessive and sentimental) pop element of the 1970s English band and the multicolour and oddly shaped sugar-coated jellies. *Copla* performers were very different, but they always appeared in colourful dresses and complements and sang about everyday issues that affected women. For that reason, *coplas* were considered a minor genre in comparison with the serious and masculine flamenco.[5] When performed, the often-melodramatic tone and the display of emotions such as pain and humiliation evoked by patriarchal forms of oppression were relived and easier to share with and be received and evaluated by audiences.

Concha Piquer became a star whose image/public perception changed at different periods of her career. Her stardom transcended and outlived her: 'star images have histories, and histories that outlive the star's own lifetime' (Dyer 2004: 3). She went from the American dream where she encapsulated the image of a 'modern' woman, independent, sophisticated and a fashion referent to the 'queen of *copla*' adapting her image to a more traditional although still sophisticated style to become the representative of the traditional Spanish song during Francoism when *coplas* became national songs. Her stardom empowered her to become a moral figure, respected and charismatic when she addressed the community of women whose issues she knew well. Somehow as a magic woman, she appropriated the lyrics of male middle-class poets like Rafael de León to dismantle the boundaries between the intellectual middle-class milieu wherein the songs originated and the working-class world that they represented. The metacommunicative techniques used by Piquer when performing the songs allowed her to talk about the disadvantages of being a woman (and a non-normative mother) in Francoist Spain and at the same time the performances suggested more pleasurable forms of femininity than those celebrated by the regime. Her fame and prominence blurred the lines between her private and public life and her success was partly defined by the perceived sincerity of her performances and by how truthful her songs were deemed. Those songs about imperfect wives and mothers might have helped to imagine alternative subjectivities, to vindicate mothering rather than motherhood and somehow to redefine womanhood.

Concha Piquer was the inheritor of María Antonia Vallejo Fernández (1751–87), also known as *La Caramba* ('Good heavens!') who 'entered the world of legends and romances', and whose story 'was reinterpreted in literature, theatre, cinema and in the voice of another unforgettable *tonadillera*: Concha Piquer' (Blas Vega 1996: 13, translation added). Like *La Caramba*, Piquer was an icon, a role model for future performers and an important contributor to Spanish popular cultural heritage.

NOTES

1. Most studies of *copla* in general make references to Concha Piquer's life: Manuel Román, *La copla* (Acento, Madrid, 2000) and *Memoria de la copla. La canción española. De Conchita Piquer a Isabel Pantoja* (Alianza, Madrid, 1993); José Blas Vega, *La canción española* (Taller El Búlgaro, Colección Metáfora, 2, 1996); Rosa Peñasco, *La copla sabe de leyes* (Alianza, Madrid, 2000). Specifically about her life, Martín de la Plaza, *Conchita Piquer* (Alianza, Madrid, 2001), and the latest Manuel Vicent, *Retrato de una mujer moderna* (Barcelona, Alfaguara, 2022). Of particular importance for the archival information both in paper and images, the documentary about Concha Piquer's life and work shown on Spanish Television under the series called *Imprescindibles* ('Indispensable') in 2011.

2. I have characterized the language used to indoctrinate the population and women in particular under the Franco's regime as baroque (Carbayo-Abengozar 2001: 75): rhetorical, very elaborated and highly dramatic. It was grandiloquent claiming to be poetical by using a misorientated dramatism to seek attention. This complicates translation as it is full of 'empty' meanings.
3. Research about the lost children of Francoism has been extensive and published mainly under the auspices of the Association for the Recovery of Historical Memory funded in 2000 with a wide media cover.
4. In the cited article, I make a reference to the contrast between the images of virgin versus whore that pervaded Francoist discourse, hence the use of the word.
5. Manuel Román accuses the well-known flamenco singer Juanito Valderrama of having falsified his style for choosing *coplas* over the 'good singing': 'Juanito Valderrama, one of the best flamenco singers, instead managed to move his regular audience with melodramatic and popular coplas' (1993: 113).

REFERENCES

Alcalde, Carmen (1996), *Mujeres en el franquismo*, Barcelona: Flor de Viento.

Andrada, Amy (2020), 'Woman and (un)partnered mother, in C. Zufferey and F. Buckanan (eds), *Intersections of Mothering: Feminist Accounts*, London: Routledge, pp. 44–57.

Basauri, Garcia Mercedes (1980), 'La Sección Femenina en la guerra civil española', *Historia*, 16:50, pp. 45–56.

Berger, Harris and Del Negro, Giovanna (1996), *Identity and Everyday Life*, Middleton, WI: Wesleyan University Press.

Blas Vega, José (1996), *La canción española*, Taller El Búlgaro: Colección Metáfora.

Candía, Bibiana (2020), 'Concha Piquer: la folclórica que vino de Broadway', *Jot Down. Contemporary Culture Mag*, July, https://www.jotdown.es/2020/07/concha-piquer-la-folclorica-que-vino-de-broadway. Accessed 1 April 2021.

Carbayo Abengózar, Mercedes (2001), 'Women, the Baroque language and the Franco regime', in *Nations and Nationalism*, vol. 7, Oxford: Blackwell, pp. 75–93.

Carbayo Abengózar, Mercedes (2007), 'Epitomising the modern Spanish nation through popular music: *Coplas* from *La Caramba* to *Concha Piquer*, 1750–1990', *Gender and History*, 19, pp. 419–41.

Carbayo Abengózar, Mercedes (2013), 'Dramatizando la construcción nacional desde el género y la música popular: la copla', *Anales de la Literatura Española Contemporánea*, 38:3, pp. 509–33.

Chute, Hillary (2010), *Graphic Women*, New York: Columbia University Press.

De la Plaza, Martín (2001), *Conchita Piquer*, Madrid: Alianza.

Drinker, Sophie (1995), *Music and Women: The Story of Women in Their Relation to Music*, New York: Feminist Press.

Dyer, Richard (2004), *Heavenly Bodies: Film Stars and Society*, 2nd ed., London: Routledge.

Felski, Rita (2000). *Doing Time: Feminist Theory and Postmodern Culture*, vol. 11, NYU Press.

Ferrari, Álvaro (2004), 'La vida cultural. Limitaciones, condicionantes y desarrollo. El franquismo', in J. P. C. Martín (ed.), *Historia contemporánea de España. Siglo XX*, 2nd ed., Barcelona: Ariel, pp. 860–85.

Flórez-Estrada, María (2014), 'La maternidad en la historia. Deber, deseo y simulacro', *Cuadernos Intercambio sobre Centroamérica y el Caribe*, 11:2, pp. 259–88.

Gaite, Carmen Martín (1943), *Usos amorosos de la posguerra española*, Barcelona: Anagrama.

García del Cid Guerra, Consuelo (2012), *Las desterradas hijas de Eva*, Granada: Algón Editores.

Haidt, Rebecca (2019), 'Singing and street cries from eighteenth-century *naranjera* to twentieth-century *violetera*: Aural paradigms of gender, poverty and affect', *Journal of Spanish Cultural Studies*, 20:3, pp. 209–25.

Imprescindibles: Concha Piquer (2011, Spain: RTVE Play).

Lareau, Annette (2003), *Unequal Childhoods: Class, Race and Family Life*, Los Angeles, CA: University of California Press.

Lax, Ruth (2006), 'Motherhood is unending', in M. Elizade (ed.), *Motherhood in the 21st Century*, London: Routledge, pp. 1–10.

Lewis, Helen (2020), *Difficult Women: A History of Feminism in 11 Fights*, London: Vintage Digital.

Lipsitz, George (1990), *Time Passages, Collective Memory and American Popular Culture*, Minneapolis, MN: University of Minnesota Press.

Lomas Martínez, Santiago and Gil Vázquer, Asier (2021), 'Authorship and female stardom in Spanish cinema under Franco: Sara Montiel and Marujita Díaz', *Feminist Media Studies*, https://doi.org/10.1080/14680777.2021.1979066.

Martín Gaite, Carmen (1988), *El cuarto de atrás*, Barcelona: Destino.

Mercer, K. (1990), 'Welcome to the jungle: Identity and diversity in postmodern politics', in J. Rutherford (ed.), *Identity, Community, Culture, Difference*, London: Lawrence & Wishart, pp. 43–72.

Ohlsson, Hélène (2020), 'Diva', *Lambda Nordica*, 25:1, pp. 38–42.

O'Reilly, Andrea (2014), *Mothers, Mothering and Motherhood across Cultural Differences: A Reader*, Bradford: Demeter Press.

Peñasco, Rosa (2000), *La copla sabe de leyes*, Madrid: Alianza editorial.

Pérez de Urbel, Justo (1952), *La Sección femenina. Historia y organización*, Madrid: Sección Femenina, FET y de las JONS.

Primo de Rivera, Pilar (1942), *Escritos*, Madrid: Gráficas Afrodisio Aguado.

Rivière, Margarita (1998), *Serrat y su época*, Madrid: El País Aguilar.

Rodrigo, Antonina (1992), *Marría Antonia La Caramba: El genio de la tonadilla en el Madrid goyesco*, Granada: Albaida.

Román, Manuel (1993), *Memoria de la copla. La canción española. De Conchita P Piquer a Isabel Pantoja*, Madrid: Alianza Editorial.

Román, Manuel (2000), *La copla*, Madrid: Acento.

Ros, Ilu (2020), *Cosas nuestras*, Barcelona: Lumen.

Seco, Manuel et al. (1999), *Diccionario del español actual*, Madrid: Santillana.

Shorter, Edward (1976), *The Making of the Modern Family*, London: Collins.

Vázquez Montalbán, Manuel (1998), *Crónica sentimental de España*, Barcelona: Grijalbo.

Vega, José Blas (1996), *La canción española*, Madrid: Taller el Búcaro.

Vicent, Manuel (2022), *Retrato de una mujer moderna*, Barcelona: Alfaguara.

Woods, Eva (2004), 'From rags to riches: the ideology of stardom in folkloric musical comedy films of the late 1930s and 1940s', in A. L. Reboll and A. Willis (eds), *Spanish Popular Cinema*, Manchester: Manchester University Press, pp. 40–60.

16

Looking for Laura:
The Generational Transmission of Sexuality

Valerie Walkerdine

Working with a visual family archive

I begin with one photo found amongst the plastic bag of old photos I took from my family home after my mother's death. The photo is simple – it is of a seaside scene in which a man holds hands with a woman, accompanied by another woman and a teenage boy and a teenage girl. I calculate from the ages of the children that it must have been taken by a seaside photographer in the early 1930s.

I ponder on the photo, which shows my maternal grandfather holding hands with the lodger, accompanied by my maternal grandmother, my mother, and uncle. I knew the lodger as a child as Aunty Daisy, a single older woman who babysat my sister and me on a Saturday night when my parents went to the pub – their only night out. Aunty Daisy, as we called her, was a stable presence in my life growing up but who she was was never explained.

The photograph had not been destroyed but no one ever talked about the fact of this complex relationship. I started to work with this photograph as part of a visual project exploring issues relating to the transmission of what I might call a sexual disturbance down the maternal line from my grandmother via my mother to me. I had presented the photo at a conference on working with qualitative data archives and intergenerational transmission to show that visual evidence was not always what it seemed and I asked the question of how we can work with the slipperiness presented when we know little and can easily misinterpret. This is far from Barthes and takes us into a realm more akin to the realm of post-history as defined by Marianne Hirsh (2012) or the work with the visceral transmission of affects via photographs presented by artist and psychoanalyst, Bracha Ettinger (2006).

How might we explore affective and visual traces via a kind of affective genealogy or affective history (Walkerdine 2016) conducted via the production of semi-autobiographical artwork? My aim here is to explore affective entanglements (Walkerdine 2022) through a series of tracings, bodily symptoms, and archival documents, to find in the present that for which we can find traces that could not be spoken. Is it possible to undertake a kind of affective embodied history of the present, which asks not so much for some causal chain, as psychoanalysts make use of to explain the presence of a symptom, so much as the recognition of patterns of the unsaid that are disentangled through the creation of an archive that is at once imaginary and documentary?

The concept of intergenerational transmission has been explored a great deal of late in the humanities and social sciences (e.g. Frosh 2013). In addition, art history and cultural theory have also been used to explore the topic (see e.g. Pollock 2008; Hirsch 2012; Ettinger 2006), while Avery Gordon (2008) has used a concept of 'haunting' to think about the ways in which the social world is haunted by the traces of the past within the present.

This relates to the development of work on affect in which methods of exploring affective transmission beyond discourse are sought (Clough and Halley 2007; Blackman and Venn 2010). In this context, emphasis is placed on bodily transmission (Blackman 2012). In this context, the visual arts would seem a useful way of engaging with the embodied transmission of affect across generations. A number of artists engage with intergenerational transmission (e.g. Kentridge 1995; Simpson 2003; Akerman 2005; Tucker n.d.; Ettinger 2006; Loftus 2011; Markiewicz 1992). Some of this work (e.g. Kentridge, Loftus) has a strong narrative component, where a hidden and secret story is revealed) and other work uses the concept of layering (e.g. Akerman, Ettinger) and veiling to suggest the complex transmission of embodied knowledge across time. Particularly relevant to my own work is Ettinger's link between psychoanalytic theory and artistic practice. Ettinger's concept of the matrixial borderspace posits a feminine (as opposed to anatomically female) space in which bodily sensations (affects) pass between bodies (as in the space of the pregnant womb). She posits this borderspace as a zone that acts as

> a transforming borderspace of encounter of the co-emerging I and the neither fused nor rejected uncognized non-I that gives us a shareable dimension of subjectivity, co-emerging and inhabiting a joint space. [...]
>
> A matrixial encounter engenders shared traces, trauma, pictograms and fantasies in several partners conjointly but differently, accompanied and partially created by diffuse matrixial affects; it engenders nonconsious readjustments of their connectivity and reattunements of transubjectivity.
>
> (Ettinger 2006: 11)

I find this work helpful because it suggests an experience of connection that is felt but not in a conscious way, which allows us to think of embodied material passed down across generations and the need to find ways to access what has been transmitted but cannot be known in a simple conscious or rational way. She posits the matrixial as a zone in which non-conscious connections are made and traces, traumas, and fantasies are transmitted across bodies (conjointly but differently), particularly across the feminine (by this I mean in a feminine mode as well as through women's bodies). This bears some resemblance also to the work of Christopher Bollas's concept of the 'unthought known' (Bollas 1987), as well as Bion's (1959) concept of 'minus K', since both, in their way refer to what is known in the body in the sense of traumas lodged there, so known at an embodied level but not able to be brought to consciousness and thus not yet able to be thought.

This work is particularly suggestive for engaging with those embodied aspects of transformation across generations through the feminine. Thus, the work has particular relevance for artistic practice as a space for the exploration of the complex, wordless, embodied aspects of transmission along the feminine. My own experience of artistic practice is that by working with the body, it can allow that which had been known but unthought to emerge as thinkable, in a way that simply does not work if one begins from thoughts rather than from a more intuitive practice (Walkerdine 1991). Thus, we might ask if the artistic practice can allow the feminine body to reveal non-consciously intergenerationally transmitted material and make it available for thought.

Performing intergenerational transmission

Given the above, it would seem that performance might be a good basis for exploring the embodied aspects of transmission. While most of the artists mentioned above do not use performance, there are a small number of 'performance artists' whose work is useful to thinking about how to proceed. While most recognized as a photographer, Jo Spence's (1992) work using Phototherapy included exploration of herself as, for example, her mother, in a way that performatively allowed her to think what this inhabiting of her mother's body might entail and what it had transmitted to her. She did this by dressing up and posing as her mother. Spence understood that performance might be able to assist some transformation in the understanding of what had been transmitted to her, which is why she named it 'therapy'. Gillian Wearing's (2012) work specializes in her embodying others, in crossing boundaries in self–other relations and in acting out previously painful experiences and encounters. In her film, *Self Made*, she hires a method-acting coach to work with six volunteers to be able to act a scene of their own devising based

on material gathered through method acting techniques. The resultant cameos are deeply moving. While method acting is a technique that uses certain practices to recall and embody one's own memories in order to get close to a character for the purposes of acting, Wearing shows us how these embodied memories used performatively can have a moving and cathartic character. Thus, it would seem potentially useful to explore the use of performative techniques to engage with intergenerational transmission through the feminine, as they seem potentially able to allow an embodied link between one's own and another's material to surface through the body and be able to be experienced and engaged with.

The remainder of this chapter goes on to describe the development of the use of performative methods by the artist to engage with how the body might reveal aspects of transmission unavailable to her by means of other methods.

Performing Laura

Laura was my maternal grandmother. This performative work began by my being struck by a photograph of her aged about 20 or 21, taken in a studio in about 1917 in which she adopts a pose that seemed to me uncharacteristic of feminine poses of that time. Her legs are open and although she is wearing a skirt, the pose is very bold. The facial expression however struck me as vulnerable – the eyes, made up with kohl are big and the lips parted to convey to me an expression of vulnerability. I decided to begin to explore intergenerational transmission by beginning with this photograph. My idea was that exploring my link to this photograph performatively would allow me to explore those aspects of embodied transmission that were transmitted through what Ettinger calls the matrixial borderspace. I decided to attempt to perform this photograph by getting into the position myself. My work on this photograph then took me through a number of stages, which I will recount as a methodology for exploration (Figure 16.1).

Stage 1: Me as Laura

My initial engagement was to attempt to pose in the same position as Laura. This proved far more difficult than I had imagined. Her legs are open and her arms resting on the legs in a very solid pose, while her face looks at the camera with a partly open mouth and large eyes. While I found the facial expression relatively easy to embody, it produced a sensation of incredible vulnerability at my solar plexus, thus was not pleasant to experience. However, when holding this expression, I could not get into the position of the legs without feeling extremely angry, which negated the facial expression. I was shocked at how difficult I found the

FIGURE 16.1: Remembering my youthful sexuality.

pose and surprised by how much the attempt to embody it aroused strong feelings and evoked difficult bodily sensations. I had discovered that a friend had no angry feelings in embodying the position of the legs when I asked her to pose, so decided to move to stage 2.

Stage 2: Others as Laura

I decided to set up a studio session in which I asked others to pose as Laura, while I photographed and filmed them. I asked both women and men to pose, on the basis that it would be interesting to understand what was conveyed by the pose when men as well as women attempted to embody this particular feminine. What emerged at first disappointed me because no one seemed to need to feel angry to get into the legs nor did they feel vulnerable in relation to the face. At first, I did not know what to make of this. However, what I began to understand is that this pose conveyed certain things to me not only as my grandmother's granddaughter, which would not be experienced by others, but also that what was conveyed resonated with issues of my own and these would be different for others. Thus,

we understand that intergenerationally transmitted material emerges in relation to and in many ways, as, one's own embodied experiences.

However, this is not to say that the studio session produced nothing of worth. Far from it. The two women remarked that the open-legged pose was unfamiliar and that this was a pose in which they felt uncomfortable. While neither remarked on the face, they were working from a projected image and it was perhaps more difficult for them to recognize the detailed aspects of this. The two men I asked to pose both remarked that the position of the legs was familiar to them and that thus they had no difficulty with this. However, one man and one woman mentioned the position of Laura's back, the weight of her breasts and at least one wondered if she was pregnant in the photograph.

One male participant felt moved to send me a long email of his thoughts. I reproduce extracts below:

I found my attempt at empathising with her blotted out access to my feelings and, a day later, this continues. I am unable to discard my regard of her [what a great woman to have by one's side] and get past my dressing up. Once I had stopped paying attention to the hems brushing my ankles and the silkiness of the blouse on my arms, I then became aware that I really needed big boobs and bum. I could not imagine them. These incoming sensations disappeared as I tried to imitate her posture. I felt I got the angle of the back if not the legs. I am intrigued to see how close my imagined imitation actually measures up. I did have a glimpse of the feelings of pleasure the feminine in me would feel were I adulated and adored but could not get into it long enough, or repeat it, for your camera. I think she exhibited a wonderful balance of introversion and extroversion, manifested in the pic by her cocky calm [Yes?]. That's pretty difficult to act into. Did my mouth [ajar] and my eyes [intense?] get anywhere close?

In order to adopt her pose more closely, I want to become her. I can see some of the iconography of her dress – modest top both giving a prim and proper message as well as concealing her large bosom; long skirt conventionally conservative and concealing large hips; hat summery and gay but sitting prim too; shoes I did not see. From the close-up face, you pointed out parted lips and strong gaze, I saw a wandering eye. The pose itself attempts but just fails to give an air of restrained nonchalance, perched as she is on one cheek, right leg supporting weight, left cocked on stool strap, both apart enough for her to rest her hands in her crotch thereby both concealing it with her hands and attracting the eye to the cross actually pointing to her altar that is formed by her fingers. The four fingers of her left are gently laid over her slightly bunched or clenched right. In toto, not a position one can comfortably hold for long. I think she has just found it for the reasons below.

What struck me most forcibly was, first, the angle of her back and then her expression. I spoke to an osteopath later and he agreed that, from my description, it could be that Laura had lower back pain caused by the weight of her boobs and that, perching up on the stool, she had found temporary relief from this pain by leaning forward thereby stretching those tightened up muscles. You can see how she is slightly out of kilter as her centre of gravity – the most comfortable resting position – is just above her right hip.

Her expression opens up myriad possible tales but my favourite is that she has been brought for the first time to this new-fangled technology by her husband to celebrate her birthday but more to celebrate his love for her and their little child. She has just found, after perching for too long as the photographer has fiddled, this pain relieving position, and is actually talking when he snaps. A second thought there makes me remember that she would be told to hold her pose for, I think, 60 seconds for the film to absorb her image. That makes her mouth lascivious – could it be that her husband is the photographer? IF so, she is clearly sending him a come on.

What is striking to me about this is, apart from anything else, the mixture of embodiment of the strange feminine body, mixed with an empathy with her, a desire for her as other and a fantasy about the occasion. He experiences the feel of the pose, the fabrics on his skin, which leads to a fleeting embodied experience that he imagines as feminine but cannot hold in his body for long. But this is mixed with his gaze at her ('what a great woman to have by one's side'), in a way which seems both to desire her (lascivious mouth) and want her support (maternal?) as well as invoking a fantasy about what was going on (her back, her husband as the photographer). In some ways, this can be understood through classical male fantasies of the feminine (e.g. Mitchell and Rose 1985) which are resonant with the cinematic fantasies explored by Mulvey (1975). However, the more difficult-to-reach material (*I did have a glimpse of the feelings of pleasure the feminine in me would feel were I adulated and adored but could not get into it long enough, or repeat it, for your camera. I think she exhibited a wonderful balance of introversion and extroversion, manifested in the pic by her cocky calm [Yes?]. That's pretty difficult to act into. Did my mouth [ajar] and my eyes [intense?] get anywhere close?*) in which he does try, however fleetingly, to feel the embodied feminine, takes us to a mode which is difficult to think. Thus, his experience appears to contain aspects of sexuality that relate to male fantasies of representations of the feminine, but also other material that relates to more heterosexually taboo aspects of being the feminized object of an adoring gaze (or even a maternal gaze?). The performative therefore seems a potent way to engage with connections that may be hard to think or feel in other ways (Figure 16.2).

FIGURE 16.2: My grandmother, Laura.

Stage 3: Me as Laura again

In the studio, I decided to attempt to pose as Laura again. Apart from taking some shots in modern dress and in costume, I wanted to pose naked with her photograph projected onto my body. While technically not entirely successful, this pose was a revelation to me at that point because I realized that the position of the hands shielded her genitals (the above email only came AFTER the session and although he makes the same point – he did not make during the session), though this was not obvious through the skirt and helped me because I had a strong desire to hide my genital area from the camera. I felt both free naked and inhibited by a desire not to produce a pornographic image. Having done some research on nude photography of women in that era, they are often photographed from the side or in a pose that hides the genital area. It is the mixture of freedom and propriety which most struck me in the nude pose.

Stage 4: Using method-acting techniques

The decision to take this further using method acting techniques was initially not mine but suggested to me by my studio adviser. However, it proved to be a very important development. I used three techniques from the method acting arsenal (Stanislavsky, Strasberg). These were relaxation, sensory memory, and affective memory. In the relaxation phase, the artist relaxes the whole body through concentration on body parts and a conscious attempt to relax. This is followed by concentration on memories, but in particular in recalling sensations. According to http://www.theatrgroup.com/ (accessed 13 October 2022), which I found at the time as a way to begin the method acting work, sense memory is 'the remembering by the five senses of the sensory impressions experienced by the individual organism in everyday life'. The actor is instructed to recall the sensory impressions by concentrating on stimuli associated with them. 'After relaxing, the actor begins a Sense Memory exercise that will help with the recreation of the remembered event. The more specifically the actor creates the objects of the memory, the more fully the Affective Memory will work'. Thus, the actor is encouraged to pay full attention to the sensory aspects of elements in the memory, such as where it took place, describing the place in detail. What one was wearing, feeling in detail the feel and look of the clothing, thinking also about the season, the time of day, the objects around, by imagining their touch, smell, and taste. It is suggested that this process of exploring and reliving the event will mean that the associated emotional experience is triggered. Of course, the concept of triggering has also been related to the experience of trauma (Laguardia et al. 2017), but in this instance is understood as a basis for method acting.

In following these instructions, I found it extraordinarily easy to remember a large number of events and their associated affects. What this showed me was that the connections between my own history and that of my grandmother were far greater than I had imagined. In particular, while my grandmother had met a man who was married and had a child with him, only marrying him later, I started to remember scenes relating to a possible pregnancy, affairs with married men, and shame surrounding the emergence of my own sexuality. I wrote these impressions down as soon as they came up, using my laptop computer as a notebook. I reproduce some of the notes taken below:

I am sitting in the garden of the house where I grew up and in which my mother still lived. It is a pebbleddashed semi detached inter-war house. I am with P, my then boyfriend and the first man I slept with. I am perhaps 22??? In my mind's eye, Everything is grey except the small square patch of grass which makes up the lawn is very very green. My period is late. We are discussing an abortion. P's worldly wise friend has told him what to do. P says that we will tell our children when we have them. I can't let mum hear. I am frightened. P is the first man I slept with. I keep thinking of a photograph of me in a school uniform with my dog, Skippy, in the front garden. Yet this was some years earlier.

I am sitting on the grass, my legs are folded so that my knees are in front and my fit to the side facing back. It is all grey. I feel exposed. My mother must not hear. I am aware of so much space around me and yet this pane of glass called a window is a small barrier – what if she hears. I am ashamed and I need to keep a secret. I feel sick.

An affair with a married man

The illicit aspect of it was much more exciting than the actuality of the sex, which was nothing for me, because I had no idea what to do. The one that I will retell here was while I was a student, undertaking holiday work in the USA. I went to Herb's Electric and said 'Herb's Electric – may I help you' down the phone. I couldn't type. Herb hired me to say that. Perhaps he hired me to fuck me. We went to lunch I think, drank a lot, went to a motel.

G liked Bowie and had been reputed to wear make-up. He wanted to do 'heavy petting'. We are on the settee at his house. His penis is out. Are my knickers down? His parents come back. Nothing is said. I am driven home. Were the feelings good? I don't remember. I can't feel anything. I can't feel anything. I can't feel anything [...]

The first time I had sex.

We are in my bedroom in the hall of residence. The bed is small. There is a wash basin, a desk. We are on the bed. He is on top of me. I want to do this. Why? His

penis is huge. I lie there and it is not erotic. He puts his penis inside me. All I remember is that it was not enjoyable and I wondered what the fuss was about. I feel rigid and tense. Can't remember any more.

A number of issues emerge which make me realize that my experience is much closer to that of Laura than I had been able to see or admit. Issues of lust, longing, desire, shame, and secrecy link me to her in ways that I had not imagined.

Stage 5: Write a treatment that engages the imagination of events through an affective connection

After exploring and writing memories, I found that I was quickly able to make an imaginative connection with Laura. I was able to write notes towards a treatment for a short film that explored her meeting her future husband, their affair, and subsequent pregnancy. I was surprised by the speed with which I was able to do this and thus make in fantasy an embodied connection to her which linked my life to hers and made it possible to sympathetically imagine her life through my own experience. These are my very first notes written at the time of the method acting session, again entered directly into my laptop:

Laura is at the bar. She is behind the bar, pulling a pint. The man is flirty. She is sensuous, excited but also vulnerable and longing. No father, I know the thing about no father – it is an aching longing – look after me, don't go away. Be there, please always be there. Whatever you do, don't go.

It is a mixture longing and lust (lust in a good way, libido, sexuality, freedom).

He is married, experienced. She is a handful, a challenge.

The sounds of the bar. Clinks of glasses. Snatches of music: popular tunes about love, spooning, marriage.

The colour is at once heightened and grey/misty (do I mean misty? I mean somehow veering between very clear and almost over-saturated colours and grey and not easy to see).

There is a lascivious kiss, stolen in a cupboard/entrance hall, dark corner.

He is not like other men. He is cocky, sure of himself, outrageously seductive.

They are in Blackpool. He has taken her there for a day trip. She is confident in the studio. She looks at him beside the camera. She is strong and sure of herself and deeply vulnerable at the same time. It is exciting because he has slipped away from his wife, from his job. The thrill of the hidden, illicit.

It is a cheap hotel. She wears a ring. She lifts her skirt, she shows her legs. She wants to be seduced slowly but he tears at her. He throws her on the bed. She tries to stop him, she is rigid and afraid and surrenders. In two minutes it is over. She cries.

He tells her he loves her. She wants him to herself, she wants him never to leave her, she wants to beat the other woman (the wife, who currently has him). She becomes pregnant. Nothing can ever be talked about.

This could be still photos as movement through editing like a peep show/flick book. I am wondering about intercutting this with scenes from my own biography:

The first meeting, the first sex, the possible abortion, the affair.

I could add in photos taken by men […] (or if Laura's story is in colour, mine could be in black and white or the reverse?)

I was also able to make some images that related to my own remembered scenes.

Conclusion

I suggest that the progression of techniques explored in this chapter allows us to think about how a performative practice might be a useful way of exploring embodied intergenerational transmission, particularly that aspect of the matrixial borderspace identified by Ettinger. In particular, we can see that the various parts of this emerging method allow what was known but embodied to be able to be thought. We cannot know if the connections made are transmitted from Laura to me, but, in engaging my own material and its links to her, we see how the same kinds of issues emerge for a different generation to be reworked in different ways. these performative methods engage the body to allow to emerge what the body knows but may not yet be able to tell. Thus, we might think about the maternal line in this case as a set of co-emerging threads that link one generation to another but in ways that are lived and embodied differently for different generations in different moments and cultural landscapes. It is the working of the imaginative connection that allows us to understand a transmission that might otherwise not make sense. When I started the process of looking for Laura, I had no sense of the similar or shared struggles that began to emerge. The performative practices allowed a rich seam of connection across generations to become able to be recognized.

REFERENCES

Akerman, C. (2005), *To Walk Next to One's Shoelaces in an Empty Fridge*, New York: Marian Goodman Gallery.

Bion, W. (1959), 'Attacks on linking', *International Journal of Psychoanalysis*, 40, pp. 308–15.

Blackman, L. (2012), *Immaterial Bodies: Affect, Embodiment, Mediation*, London: Sage.

Blackman, L. and Venn, C. (2010), 'Affect', *Body and Society*, 16:1, pp. 7–28.

Bollas, C. (1987), *The Shadow of the Object: Psychoanalysis of the Unthought Known*, New York: Columbia University Press.

Clough, A. and Halley, J. (2007), *The Affective Turn*, Durham, NC: Duke University Press.

Ettinger, B. (2006), *The Matrixial Borderspace*, Minneapolis, MN: University of Minnesota Press.

Frosh, S. (2013), *Hauntings: Psychoanalysis and Ghostly Transmissions*, New York and London: Palgrave.

Gordon, Avery (2008), *Ghostly Matters*, Minneapolis, MN, University of Minnesota Press.

Hirsch, M. (2012), *The Generation of Postmemory: Writing and Visual Culture after the Holocaust*, New York: Columbia University Press.

Kentridge, W. (1995), *History of the Main Complaint*, London: Tate Gallery.

Laguardia, F., Michalsen, V. and Rider-Milkovich, H. (2017), 'Trigger warnings: From panic to data', *Journal of Legal Education*, 66(4), pp. 882–903.

Loftus, B. (2011), *Sigismund's Watch: A Tiny Catastrophe*, London: Phillip Wilson.

Markiewicz, L. (1992), *The Price of Words, Places to Remember*, London: Bookworks.

Mitchell, J. and Rose, J. (eds) (1985), *Jacques Lacan and the Ecole Freudienne: Feminine Sexuality*, New York: Norton.

Mulvey, Laura (1975), 'Visual pleasure and narrative cinema', *Screen*, 16:3, pp. 6–18.

Pollock, Griselda (2008), 'The long journey home', *Jewish Quarterly*, 55:3, pp. 62–64.

Simpson, L. (2003), 'Corridor', video installation, *Salon 94*, New York.

Spence, J. (1992), *Cultural Sniping: The Art of Transgression*, London: Routledge.

Tucker, J. (n.d.), 'Spectres on the beach in conjunction with the international symposium', *Catchment/PLaCE Mapping Spectral Traces*, University of the West of England, Bristol: Organized by Iain Biggs and Mel Shearsmith.

Walkerdine, Valerie (1991), 'Behind the painted smile', in J. Spence and P. Holland (eds), *Family Snaps: The Meaning of Domestic Photography*, London: Virago Press.

Walkerdine, Valerie (2022), '"I just wanna be a woman": Some not so simple ways: Families, femininity and/as affective entanglement', *Qualitative Inquiry*, 28:10, pp. 998–1006, https://doi.org/10.1177/10778004221098204.

Wearing, G. (2012), *Self-made*, Manchester: Cornerhouse.

17

Maternal Bodies in the Garden: Transit Spaces

Ruchika Wason Singh

Transit Spaces is an art project that developed out of the co-performative processes of childbearing, gardening, and artmaking (Figure 17.1).

Each of the three states of being – childbearing, gardening, artmaking – have impacted my art, the construction of imagination as well as experiences of pregnancy and the botanical world. Both gardening and pregnancy are related to the notions of the birth of life and nurturing (Figure 17.2).

FIGURE 17.1: Ruchika Wason Singh, pod of desire-I, pencil on paper, 18 cm × 27 cm, 2004.

FIGURE 17.2: Ruchika Wason Singh, pod of desire-I, pencil on paper, 18 cm × 27 cm, 2004.

FIGURE 17.3: Ruchika Wason Singh, womb bloom-III, pencil on paper, 69.9 cm × 105.4 cm, 2004.

In the studio, the state of conceiving a child on the one hand and the act of working with plants on the other, informed my art practice (Figure 17.3).

This resulted in the making of imagery; where metaphors from nature were used to depict human life. The intuitive, the visceral and the spontaneous rhythms of the plant/human bodies characterized the forms that resembled both the tree and the womb simultaneously (Figures 17.4 and 17.5).

FIGURE 17.4: Ruchika Wason Singh, wishful, spaces, oil on canvas, 193.04 cm × 254 cm, 2006.

FIGURE 17.5: Ruchika Wason Singh, womb bloom-II, pencil on paper, 69.9 cm × 105.4 cm, 2004.

Contributors

MERCEDES CARBAYO-ABENGÓZAR is a lecturer in Spanish and Latin American studies at Maynooth University, Ireland. Previously she was senior lecturer at Derby University (1992–98) and Nottingham Trent (1998–2015) in the United Kingdom. She has carried out research under the umbrella of Hispanic cultural studies publishing mainly on the relationship between gender, class, and the nation and focusing on Hispanic writers such as Carmen Martín Gaite, singers like Concha Piquer, and painters like Frida Kahlo. These artists had an interesting relationship with the intersectional issue of motherhood and mothering. For the last ten years, the focus of her research has moved in that direction. She is part of the European Union Horizon 2020 funded project 'Mothernet', which stimulates innovative, cross-disciplinary, and policy-relevant research about motherhood.

* * * * *

NOOR ALI, Ph.D., is an assistant professor at Northeastern University's College of Professional Studies, Graduate School of Education, where she teaches undergraduate, graduate, and doctoral students and leads the transformative school leadership concentration. She has developed a micro-theoretical framework, MusCrit, as a subset of Critical Race Theory where she posits a framing for understanding the lived experiences of Muslim Americans. Dr Ali has published extensively on topics of MusCrit, racialization of religion, demystifying Critical Race Theory, leadership, social justice, and experiential learning. She a veteran K-8 teacher and principal of Al-Hamra Academy. She is also the author of *One Teaspoon of Home*, a book on desi food poetry in the genre of South Asian literature.

* * * * *

ABBY ARNOLD-PATTI earned her Ph.D. at the University of Memphis and is a professor of communication and media studies at Lees-McRae College in Banner

Elk, North Carolina. She uses critical rhetoric, ethnography, and autoethnography to study the complexities of human experience. She lives at the heart of the Blue Ridge Mountains with her husband, three children, and all their pets.

* * * * *

KATE AUGHTERSON has 30 years' experience teaching in UK Universities and is co-general editor of the series Performance and Communities. She is the author of *Renaissance Woman* (1995), *The English Renaissance: An Anthology* (1998), *John Webster: The Plays* (2000), *Aphra Behn: The Comedies* (2003), *Shakespeare: The Late Plays* (2013); co-edited two volumes of the *Journal of Writing in Creative Practice* on place-based writing; co-author of *Shakespeare and Gender* (Bloomsbury, 2021) and *Women's Experimental Narratives: Early Modern to Contemporary* (Palgrave, 2021); co-edited *Jim Crace: Into the Wilderness* (2018); co-edited two special issues of the journal *Performance and Ethos* (2022) on performing maternity during COVID; co-edited two books for Intellect (*Performing Maternities* and *Engaged Practice: Contemporary Case Studies*, both forthcoming); co-edited *Women's Experiments in Theatre* for Palgrave (forthcoming 2024); contributed entries on early-modern women writers for the *DNB*; and written articles on feminist utopian writing, the rhetoric of plain style and gender, gender and drama in the early-modern period, and Shakespeare's late soliloquies.

* * * * *

SUZI BAMBLETT graduated in 2019 from Brighton University with a distinction for her MA in creative writing. Her *Imagined Dialogue* is featured on the Daphne du Maurier website. Suzi writes psychological thrillers and suspense and has published three novels – *The Travelling Philanthropist*, *Three Faced Doll*, and *Prescient Spirit*. Her poems and short stories have been published in anthologies, and her short story 'The Girl on the Swing' was published by *Shooter Literary Magazine* in 2020. Her memoir piece *A Grandmother's Grief* was long listed for the Canadian Amy Award in 2021, and her academic chapter 'How to grow an autoethnographer' was published in *The Performance and Communities Series: Storying the Self*. Besides writing, Nordic walking and generally 'being creative', Suzi is a proud mum and 'hands on' granny.

* * * * *

FREYCA CALDERON-BERUMEN is an associate professor of elementary and early childhood education at Penn State Altoona, USA. Her research centers around

linguistic diversity and multiculturalism in education through the lens of critical-dialogical pedagogies aiming to address social equity and justice. Her scholarship privileges intersectionality approach and qualitative methods exploring possibilities for community building for marginalized and under-theorized groups and contributing to the education field by linking theoretical perspectives with everyday experiences and developing culturally relevant understandings.

* * * * *

YVETTE CHAIREZ is lecturer of English at Texas A&M University, San Antonio. Her research focuses, through a Chicana feminist lens, on new directions in writing and rhetorical studies, but particularly on visual, cultural, and performance rhetorics as they pertain to the representations and the actual lived experiences of US minority populations, including mothers. Chairez's research has appeared most recently in *Composition Studies*, *El Mundo Zurdo*, and *Chiricu Journal*. Her co-edited volume on fashion and subversion in the US-Mexico borderlands is forthcoming from Palgrave.

* * * * *

JENNI CRESSWELL has been having conversations with clothes for nearly ten years after first discovering the secret world of dress stories during her MA course 2014–16. They've had a lot to say: from revealing their own pasts through their wear and tear, providing a canvas for folktales, to being mouthpieces for Jenni's own and other people's stories. She is inspired by the garments she works on: each item has its own history woven into its fabric, buried among its threads. The warp and weft carrying the memories of who made it, who wore it, and what they did in it. Jenni reveals these stories by deconstructing and embellishing, favouring hand-printing and stitching to draw the observer in close. Repeating words or images highlight key messages from the story being told. She also helps interpret some stories through photographs and film. Jenni loves helping clothes reveal their hidden stories; she can't wait to hear what they have to say to you, readers.

* * * * *

DIANA DENTON is an associate professor emeritus at the University of Waterloo in the Department of Communication Arts. She has a Ph.D. in curriculum, teaching and learning specializing in holistic and aesthetic education (University of Toronto, 1996). As a poet, professor and organizational consultant, her research interests intersect the disciplines of communication theory and aesthetic

and holistic education. Holistic and aesthetic education emphasizes the interconnectedness of all aspects of human being (body, mind, emotions and spirit) in the work of communication and learning. Diana's aesthetic perspective draws on the creative resources of metaphor and imagery, in both the arts (performance, poetry, story, etc.) and ordinary language use, to explore social webs of communication in personal and professional contexts. She has co-edited several books, including, *Spirituality, Ethnography and Teaching: Stories from Within* (2006), *Spirituality and Holistic Learning: Breaking New Ground* (2005), and *Spirituality, Action & Pedagogy: Teaching from the Heart* (2004). She has also published a number of journal articles and book chapters, including 'Transformative Pathways: Engaging the Heart in Contemplative Education' in *Contemplative Learning and Inquiry Across Disciplines* (2014). She is a mother of two sons and a daughter, and she has two young grandsons who bring her much delight.

* * * * *

JANICE B. FOURNILLIER, Ph.D., is a professor in the research measurement and statistics unit of the Educational Policy Studies Department in the College of Education and Human Development at Georgia State University, where she has worked for the past seventeen years. A major strand of her research programme centres around leading externally funded interdisciplinary evaluation and research studies. Her research stretches across international borders impacting her academic peers as well as practitioners, graduate students, policymakers, and community members. As a researcher-professor who prepares future researchers, Dr Fournillier's work challenges the many students, whose research work she leads and whom she mentors, to push their thinking in the way she actively models the type of criticality and creativity needed to design and conduct qualitative and quantitative educational research.

* * * * *

MICHELLE HALL is a performance maker, director, teaching artist, and m/other. Writing and co-creating performance with young people and communities since 2003, Michelle's practice centres on devised performance, intercultural collaboration, and creative learning. She has trained in autobiographical theatre with Bryony Kimmings (United Kingdom), in devising with Teatro de Complicite (United Kingdom), in forum theatre with Augusto Boal (Brazil) and in choreographic theatre with Pan Theatre (France). Credits include *Walking on Eggshells* (Pegasus Theatre), *Scarlet Ribbons: An Intergenerational Loneliness Project* (Oxfordshire Touring Theatre), *The Lorax* (Oxford Youth Theatre), *Journeys to Freedom* (African Karibean Kultural Heritage Initiative), *Migration of Me*

CONTRIBUTORS

(Lab Crea & Community Arts Network), and *You're So Brave* (The Blue Room Theatre), among others. Michelle is the author of *Motherfesto: Rights, Access and Inclusion for All Mothers in the Arts and Culture*, a document that aims to dissolve the motherhood penalty in the arts and cultural sector. She is the facilitator of Mothers Who Make Boorloo, an artist-led, peer support group currently in-residency at Midland Junction Arts Centre. Her recent work, *The Dirty Mother*, was nominated for the Tour Ready Award at Perth Fringeworld, Best Theatre award at Melbourne Fringe Festival, and Best Actor at the Performing Arts WA Awards. Michelle's next show *Falling UP!* will be an autobiographical overshare about the intergenerational consequences of war and the problem of how to mother when your heart is being blown apart. She is studying an MA theatre at the University of Melbourne, Australia.

* * * * *

TERESA IZZARD is a theatre/movement director, a dramaturg, a creative producer, and an educator. She is a Certified (Laban/Bartenieff) Movement Analyst (LIMS 2007), a Dynamic Embodiment Practitioner (2015) and holds a Ph.D. in theatre direction and dramaturgy which won the Phillip Parsons Prize in 2013. She has a wealth of experience as a director, movement coach, producer, dramaturg, and theatre educator. Teresa was head of movement at the Western Australian Academy of Performing Arts (WAAPA) in 2014 and a theatre arts lecturer at Curtin University, where she specialized in movement for actors and was a resident director until 2020. Founded in 2015, she is the artistic director and creative producer of Feet First Collective (FFC), an independent theatre company with a training wing, making critically acclaimed work in Perth, Western Australia. She now combines running FFC with teaching into the music theatre and acting courses at WAAPA and independent projects. Her recent production of *This Is Where We Live* by Vivienne Walshe was described as 'complex and tense ... compelling viewing' by Vicki Renner for Arts Hub. Teresa brings her background in somatics to her directorial practice and specializes in creating clear visual and physical dramaturgy for challenging, provocative texts and devised works. She is excited to direct her first solo work *Shadow Boxing* for Sydney Fringe (2023).

* * * * *

CHAN-HYO JEONG, with a Ph.D. in management from the University of Leicester, experienced a surprising twist as her little one arrived nine weeks ahead of schedule. Amidst this unique situation, her email account often finds itself brimming with snapshots of her son, the result of filling up the storage space. Originally from

Seoul, Jeong has traded kimchi for sauerkraut while adeptly navigating her four-year-old's evolving German accent. Her writing journey spans topics such as the challenges of motherhood and the nuances of business school architecture. Notably, her interests take an intriguing detour into dissecting the tactics of humour in mass protest flags. When she's not immersed in untangling toddler language mishaps or decoding architectural blueprints, you might find her savouring spinach burek from her beloved Turkish bakery.

* * * * *

JESS MORIARTY is a principal lecturer at the University of Brighton and course leader on the Creative Writing MA and Co-director for the Centre of Arts and Wellbeing. She has published widely on autoethnography, community engagement and pedagogy in writing practice. Her latest book, *Walking for Creative Recovery*, was published in 2022.

* * * * *

ARIEL MOY, Ph.D., is an academic teacher, doctoral research supervisor, author, and researcher with the MIECAT Institute in Melbourne, Australia. She also works as an art therapist in private practice specializing in maternal experiencing. Her book *An Arts Therapeutic Approach to Maternal Holding* (Routledge, 2017) is tailored to those working with mothers to develop their sense of self and relationship with their child. It introduces the concept of the mother/child 'us' and its practical applications. She is currently excited about the post-qualitative approach to research and therapy. This sits alongside her fascination with mothering, childing, artmaking, and playing within the rich soils of relational experiencing. You can find out more about Ariel at her website www.holdingmatters.com and her recent article/video and podcast interview at https://www.jocat-online.org.

* * * * *

KARLA O'DONALD, Ph.D., is a senior instructor in the Department of Spanish and Hispanic Studies at Texas Christian University. Her dynamic research orbits around the nexus of Chicana feminist epistemologies, igniting sparks that kindle critical pedagogy, decoloniality, foreign language teacher education, and the strategic deployment of Spanish across diverse fields. With a fervent commitment to knowledge dissemination and empowerment, Dr O'Donald remains committed to the pursue of intellectual exploration and transformative education.

CONTRIBUTORS

* * * * *

CLAIRE ROBINSON had read philosophy politics and economics at Lincoln College, University of Oxford. She later studied midwifery at the University of Northampton. Claire's professional life has been spent predominantly within the health and social care sector. This has included managing services for learning-disabled and autistic adults. Since 2014, Claire has worked for the NHS within project and programme management roles. She has also undertaken a facilitation role for Mothers Uncovered, a Sussex-based charity offering opportunities for peer support and creative expression to mothers. Claire's poetry and prose have been published in the following collections: *The Secret Life of Mothers* (edited by Maggie Gordon-Walker and Charlotte Naughton, 2018), *Childbirth* (edited by Tanja Staehler, 2021), and *She of the Sea* (edited by Lucy H. Pearce, 2021). Claire has been commissioned to write for the M/Otherwords project in 2023 and has a poetry pamphlet in planning. In 2023 she commenced a creative writing MA with Hull University. Claire hails from Daventry, in the Midlands. Being drawn to the peripheries, she has since made her home on the West Sussex coast. Mother to three young children, Claire's hobbies and interests include rumination, exasperation, seeking quiet, and dismantling the patriarchy.

* * * * *

STEVEN (STEVE) RYDER is a special lecturer at the University of Waterloo in the Department of Communication Arts. He holds a Ph.D. in Communication from the University of South Florida, Tampa. His dissertation weaves lived experience among close friends to understand HIV disclosure conversations through the lens of relational communication, narrative inquiry and autoethnography. He has a background in theatre and information technology, and draws from this unusual blend of skills to engage storytelling in performative and digitally pervasive modalities. Stories from the margins, from underrepresented, and from often contested standpoints are of particular interest. He is author of several single and co-authored journal articles and hopes, soon, to publish his dissertation research in book form in addition to exploring film, stage and digital media adaptations. In his spare time, Steve enjoys communing with nature and playing video games. He is a well-traveled polyglot, avid cyclist and certified scuba diver.

* * * * *

LENA ŠIMIĆ is a reader in drama at Edge Hill University, Ormskirk. She identifies as a mother/artist, transnational performance practitioner, art activist, pedagogue,

and scholar. Lena is currently researching contemporary performance and the maternal. She has presented her arts practice and research in a variety of academic journals (*Performance Research, Contemporary Theatre Review, n.paradoxa, RiDE, Feminist Review, Studies in the Maternal*) and in various arts venues and festivals. Lena has published six artist books, including *Maternal Matters and Other Sisters* (2009), *4 Boys (for Beuys)* (2016), and *10: The Institute for the Art and Practice of Dissent at Home* (2019). She has published a play *Three Conversations* (2019) with her children Neal and Sid for Climate Change Theatre Action. Together with Emily Underwood-Lee, she has authored *Maternal Performance: Feminist Relations* (Palgrave, 2021) and edited *Mothering Performance: Maternal Action* (Routledge, 2022).
https://lenasimic.art/
https://performanceandthematernal.com/

* * * * *

EMILY UNDERWOOD-LEE is professor in performance studies at the George Ewart Evans Centre for Storytelling at University South Wales, Cardiff. Her work focuses on amplifying little-heard personal stories that may have been marginalized and the difference that hearing these stories can make in policy, practice, and daily life for both teller and listener. She has a particular interest in the performance of the maternal, gender, health/illness, and heritage. Interdisciplinary collaboration is central in her work, and her major funded research projects have been conducted with organizations including Welsh Women's Aid (funded by HLF), Great Ormond Street Hospital (funded by ACE), Swansea Bay University Health Board (funded by ACW), and Cardiff University Brain Research Imaging Centre (funded by Wellcome Trust). Together with Lena Šimić, she has authored *Maternal Performance: Feminist Relations* (Palgrave, 2021) and edited *Mothering Performance: Maternal Action* (Routledge, 2022).
www.emilyunderwoodlee.wordpress.com
https://performanceandthematernal.com/

* * * * *

VALERIE WALKERDINE is a social scientist, writer, and artist. She is distinguished research professor in the School of Social Sciences, Cardiff University, and on the staff of the Transart Institute for Creative Research, an artist-led, practice-based Ph.D. programme. In relation to motherhood, she co-edited, with Elena Marchevska, *The Maternal in Creative Work: Intergenerational Discussions on Motherhood and Art* (Routledge, 2020) based on work

CONTRIBUTORS

presented at their co-organized 'Motherhood and Creative Research' conference in 2015. Her artwork engages mainly with installation and performance, and the work in the chapter is part of a large cycle of work that she calls 'The Maternal Line'.

* * * * *

SOPHIA XEROS-CONSTANTINIDES was born in Melbourne into a family who came from Smyrna, Asia Minor, part of the Greek diaspora in the Mediterranean. Her maternal grandparents had been dispossessed and were made refugees in 1922 in the Smyrna holocaust, before they took refuge in Australia at Mildura, living on the land and growing sultana grapes for the dry fruit industry from 1924. At the age of 11, Sophia moved to the United Kingdom with family for her secondary schooling. She returned to Melbourne to undertake training as a medical practitioner and has worked for over 30 years in psychological medicine with mothers, infants, and families, and with students at the University of Melbourne health service. Together with maternal and child health nurses, she has engaged in group art therapy with mothers in the postnatal period and has published several papers on this work with women. As a mature aged student, she trained in fine arts at Monash University, Melbourne. With a scholarship, she progressed to postgraduate studio-based research and completed her Ph.D. in fine art examining the visualization of women's procreative experiences, using this to inform her own making of imagery pertaining to the darker side of motherhood. Sophia is married and a mother of two, living in Melbourne and travelling to Europe when she can to paint.

* * * * *

RUCHIKA WASON SINGH is a visual artist, art educator, and independent researcher based in Delhi, India. She is a visiting faculty at Ashoka University India. In 2016, Ruchika founded the project A.M.M.A.A., The Archive for Mapping Mother Artists in Asia. Ruchika's ongoing artistic practice focuses on environment through the prism of human habitation. Ruchika's writings have been published in Demeter Press (Canada), Routledge Publishers (UK), and Intellect Books (UK) amongst others. She lives and works in Delhi.

Printed in the USA
CPSIA information can be obtained
at www.ICGtesting.com
JSHW071340270724
67075JS00002B/2